MW01070253

To Bob Solari
with Best
Wishes

Darey L Evan

HAND-WROUGHT

Arts & Crafts
Metalwork & Jewelry

1890–1940

Darcy L. Evon

4880 Lower Valley Road • Atglen, PA 19310

Dedication:

This book is dedicated to my family, friends, and all those who share my enthusiasm for art entrepreneurship and Chicago history.

Cover photos courtesy of Marshall Field & Co. Archives, Chicagosilver.com, Leslie Hindman Auctioneers, Rich Wood Photography and Author.

Copyright © 2013 by Darcy L. Evon

Library of Congress Control Number: 2013946997

All rights reserved. No part of this work may be reproduced or used in any form or by any means—graphic, electronic, or mechanical, including photocopying or information storage and retrieval systems—without written permission from the publisher.

The scanning, uploading, and distribution of this book or any part thereof via the Internet or via any other means without the permission of the publisher is illegal and punishable by law. Please purchase only authorized editions and do not participate in or encourage the electronic piracy of copyrighted materials. "Schiffer," "Schiffer Publishing, Ltd. & Design," and the "Design of pen and inkwell" are registered trademarks of Schiffer Publishing, Ltd.

Cover and book designed by: Bruce Waters
Type set in Zurich BT

ISBN: 978-0-7643-4485-5
Printed in China

Published by Schiffer Publishing, Ltd.
4880 Lower Valley Road
Atglen, PA 19310
Phone: (610) 593–1777; Fax: (610) 593–2002
E-mail: Info@schifferbooks.com

For our complete selection of fine books on this and related subjects, please visit our website at www.schifferbooks.com. You may also write for a free catalog.

This book may be purchased from the publisher. Please try your bookstore first.

We are always looking for people to write books on new and related subjects. If you have an idea for a book, please contact us at proposals@schifferbooks.com.

Schiffer Publishing's titles are available at special discounts for bulk purchases for sales promotions or premiums. Special editions, including personalized covers, corporate imprints, and excerpts can be created in large quantities for special needs. For more information, contact the publisher.

Contents

Author's Note

The Arts & Crafts Movement was a fascinating period in American history that led to unparalleled art commercialization, economic development, and job creation, particularly for women and immigrants. The 1893 Chicago World's Fair heralded this new egalitarian art movement that gave rise to a plethora of metalwork and jewelry companies and studios by the turn of the century. Chicago led the movement by pairing progressive politics with the frenetic pace of industry; there would be no starving artists in this new economy but plenty of good-paying careers and ideal working conditions. The Chicago influence spread throughout the Midwest and from coast-to-coast, as hundreds of art companies and studios showed their works in the annual arts and crafts shows at the Art Institute of Chicago, the leading exhibition venue in the country. The Art Institute also catered to the thousands of aspiring artists nationwide pursuing degrees in the emerging industry of decorative design by maintaining the largest and most comprehensive educational program. Most of the Arts & Crafts Movement proponents also supported women's suffrage. Individuals like Clara Barck Welles from the Kalo Shop were instrumental in Illinois becoming the first state east of the Mississippi to grant women the right to vote in 1913 and the eventual passing of the Nineteenth Amendment to the United States Constitution.

Metalwork and jewelry from the period was made by hand from raw materials, a feat rarely seen today. The designs were exquisite, innovative, and original, as you will see on the following pages. Almost all of the work featured in the book was signed by the artist or company, as unsigned works rarely have sufficient provenance to understand their contribution in a historical context.

The book is an illustrated history of jewelry and metalwork industries in Chicago and the Midwest. Many books exist on the Boston and California movements, even though they were smaller and less influential. In 1977 Sharon Darling wrote *Chicago Metal-Smiths* as a companion to an exhibit at the Chicago History Museum; no other such book has been published in the last 35 years.

The current book introduces dozens of new crafts workers, companies, and hallmarks, and corrects misidentified artisans, marks, and information. Research included dozens of interviews with family descendants; access to the original files for *Chicago Metal-Smiths*; newspaper and magazine archives; municipal, county, and federal court archives; city directories and art directories; vital records, military, and real estate archives; museum and institutional special collections; and study of artifacts from various collections. I have kept end notes to a minimum to improve the readability and usefulness of the book.

Many artisans have been omitted because their works and hallmarks have not been identified. My hope is that the book will lead to many new discoveries and additional publications that will help individuals understand and appreciate this extraordinary art movement and its profound impact on society. For collectors, the book will help build important bodies of work and assist in bringing jewelry and metalwork artifacts to life.

The Park Ridge Artists' Colony
By Darcy Evon

By the early twentieth century, Park Ridge had become an intellectual and artistic haven for some of the most creative, influential, and talented artists in America. Known as the Park Ridge artists' colony, members of this community were in the vanguard of the innovative and progressive art movements that helped transform society between the World Fairs of 1893 and 1933.

Frederick Richardson, the well-known artist, illustrator, cartoonist, and instructor at the Art Institute of Chicago (AIC), was one of the early residents of the colony. In 1897, he moved to Park Ridge to marry Josephine Welles, daughter of former town president George S. Welles. Soon, many other AIC instructors, former students, and colleagues from the art industry came to Park Ridge to live. The early colony included painters, illustrators, poets, writers, sculptors, jewelers, crafts workers and designers.

Richardson introduced George Welles, who was divorced, to Clara P. Barck, a graduate of the AIC who had founded an Arts & Crafts design studio in Chicago called the Kalo Shop. In 1905, George and Clara married and within a few years the Kalo Shop purchased "The Big House" at 322 Grant Place in Park Ridge. Here, Clara established a "a school within a workshop" called the Kalo Arts Crafts Community that offered practical education in the arts, particularly for women. This facility trained and employed dozens of now-famous artists, designers, metalsmiths, jewelers, silversmiths, potters, basket makers, embroiderers, weavers, leather workers and other crafts workers in the Arts & Crafts tradition that promoted individually-made hand wrought objects to beautify the home---as opposed to cheap, mass-produced factory wares.

In 1906, two of Richardson's AIC painting students, Albert H. Krehbiel and Dulah Marie Evans, married and soon joined the artists' colony in Park Ridge. In 1910, Beulah Clute, another well-known artist, joined forces with Dulah to establish an art company in Park Ridge called "The Colony Crafts," where the woman made "Easter cards, Christmas and congratulatory cards of all kinds, birth cards, calendars, and book plates." Later that year, Dulah produced similar items in her "Ridge Craft Studio" with the assistance of a group of women artists dubbed "the Ridge Crafts girls." Albert was a noted muralist at the time working on a prestigious commission to decorate the Illinois Supreme Court building.

In 1914, Alfonso Iannelli, an Italian sculptor and designer, was recruited from California to work on an important commission called the "Midway Gardens" under the flamboyant and famous Chicago architect Frank Lloyd Wright. Iannelli designed the sprites for the gardens, now some of the most recognizable icons of Wright's work. After finishing this project, Iannelli and his wife Margaret moved to Park Ridge, where they operated a leading design studio. Iannelli became one of the most innovative sculptors and designers in the 20th century, and was sought out for many important commissions in Chicago and at the World's Fair of 1933. His work at the fair helped transition Chicago

from a leader in the Arts and Crafts movement to a leader in the Art Deco movement and Modernism.

Many innovative artists and crafts workers lived in the vibrant Park Ridge Artists' Colony, including Louis Betts, John Paulding, Leonard Crunelle, Alfonso Iannelli, James William Pattison, Beulah and Walter Marshall Clute, Albert and Dulah Krehbiel, Clara B. Welles, Julius O. Randahl, Matthias Hanck, Henri and Asta Eicher, Esther Meacham, Mildred Bevis, Grant Wood, and many more. For decades, the community provided an impetus and support network that inspired creativity and entrepreneurship in men and women artists, who went on to become leaders in American art and design.

I

Grand Beginnings:
The 1893 Chicago World's Fair and the
Origins of the American Arts & Crafts Movement

Chicago is alive with artists, and we may look in half a dozen years to a general shifting of the art-center traffic from New York to Porkopolis. No? Well, art has ever followed commerce, and where the most money is spent there art thrives. Really New York is likely to be as conservative as Boston, and there may be conservative notions in Chicago later on, but not until she has tried the art-center business.

—A Boston Post art critic
(1892)[1]

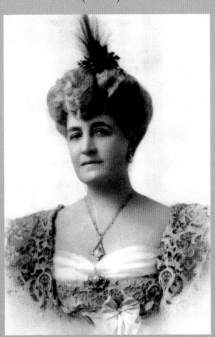

Bertha Honore Palmer (Mrs. Potter Palmer) at the time of the 1893 Columbian Exposition. Author's collection.

The 1893 Columbian Exposition, popularly known as the Chicago World's Fair, was a colossal celebration of America's achievement as a center of democracy, art, technology, and commerce. Chicago architect Daniel H. Burnham transformed a Jackson Park swamp on the city's South Side into the "White City," an expansive and extraordinary settlement of classical white masonry buildings that anchored the fair. On opening day, U.S. President Grover Cleveland noted the unparalleled nature of the exposition:

We have built these splendid edifices, but we have also built the magnificent fabric of popular government, whose grand proportions are seen throughout the world. We have made and here gathered objects of use and beauty, the products of American skill and invention. We have also made men who rule themselves. [2]

The 1893 World's Fair—and Chicago itself—embodied the hopes and dreams of a young nation, and inspired the egalitarianism that lay at the heart of the nascent art industries emerging in the city and throughout the country.

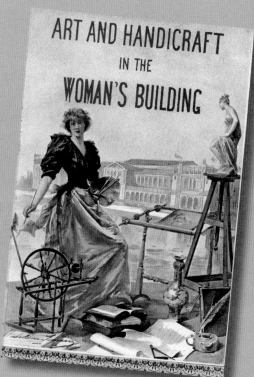

Cover of the Woman's Building book (1894). Author's collection.

owhere was that egalitarian spirit more clearly dramatized than in the liberation of women as artisans and entrepreneurs in the Arts & Crafts Movement. Mrs. Bertha Honore Palmer, wife of one of Chicago's wealthiest men, hotelier Potter Palmer, and an unchallenged leader in Chicago's civic and artistic circles, ensured that women would have a conspicuous and esteemed place at the fair. She insisted on the inclusion of a Women's Building that featured crafts work, sculpture, and paintings by women artists from around the world. Beginning in 1878, when she helped establish the Chicago Society of Decorative Arts, Palmer sought to open new careers for women that would provide them with economic self-sufficiency. A political progressive, she was a vocal proponent of a more democratic society that would benefit from "doubling the intelligence and the mental and moral forces" [3] of the country through the inclusion of women in the workforce. Through her influence, she was determined to help women in the 19th century realize their potential, especially in the arts, and build a stronger America in the process. And the Arts & Crafts Movement would be her vehicle.

The World's Fair showcased a radically new and beautiful city that was destroyed by the Great Fire of 1871: it symboled the "I will" spirit of Chicago. The fair ignited a passion for architecture and art, and exposed more than 27 million visitors to American ingenuity on the nation's own democratic terms instead of as a subordinate child of European traditions—and revealed women in the front ranks of American artisans. Sculptor Julia Bracken set the tone with the unveiling of what became the fair's iconic statue, "Illinois Welcoming the Nations," showcasing her talent along with established artisans throughout the country.

1893 Columbian Exposition bracelet by Gorham. Author's collection.

Jewelry, silver, gold, and metalwork wares were amply represented by well-known firms such as Gorham Manufacturing Co. and Tiffany & Co., but in 1893, women were scarce among jewelry and metalworkers. However, several women exhibitors dazzled news reporters and art reviewers.[4] Sarah E. Posey of Whitewater, Wisconsin, showed clever and original designs in fresh-water pearl jewelry executed with great delicacy and skill. In metalwork, Ann Van Oost and Lily Marshall of New York showed finely colored plaques and sconces worthy of awards, and Louise McLaughlin of Cincinnati showed etched copper and brass. Chicago arts and crafts work was represented primarily by china painters, including Florence D. Koehler, Louise C. Anderson, and Leonide C. Lavaron, all of whom would later become leaders in jewelry and metalwork.

The broader Arts & Crafts Movement benefited from inspiration at the World's Fair with the formation of one of the first arts and crafts societies in the United States.[5] In July 1892, World's Fair artists Max Friederang, Arthur Fendel, Richard W. Bock—all born in Germany—and George J. Zolnay, born in Hungary, organized a society modeled after the Arts and Crafts Society of London, the Arts et Metiers of Paris, and the Kuntz-Gewerbe of Vienna. Members would be practical artisans and makers of industrial art work including furniture, fabrics, jewelry, metalwork, terra cotta, printed works, and lithography. The society planned to launch an arts and crafts school and an art journal that would promote and foster a network of artisans. By the following year, the society evolved into the Art Industry Association and gained broad support. However, the severe 1893 depression, caused in part by over-speculation in railroads and a run on the gold supply, made investors difficult to find, and the association languished as the economy worsened.

While the World's Fair fomented a revolution in spirit, the lack of financial support took its toll on the legion of artists who had made Chicago their home. In 1894, Judge Lambert Tree, a wealthy patron of the arts, sought to reverse the exodus of creative types out of the city, and built the Tree Studio Building on State and Ohio Streets as one of the earliest artists' colonies in the country. Plans were soon underway to renovate and transform the Studebaker automobile showroom, further south on Michigan Avenue, into the Fine Arts Building, a modern-day arts and crafts incubator.

The British Arts & Crafts Movement, a populist initiative that started as a spirited protest against industrialization and cheap, mass-produced factory goods, was well known

by the time of the World's Fair. Many Americans turned to British proponents William Morris and John Ruskin for inspiration in merging fine craftsmanship and design into common everyday objects and home decoration. William Crane, the president of the Arts and Crafts Society in London, noted at the first exhibition of the Society in 1888, "The true root and basis of all art lies in the handicrafts," underscoring the need to unify the arts with the crafts, or artists would lose their creativity. Charles R. Ashbee, founder of the Guild of the Handicraft (1888), was a resident of Toynbee Hall, a social settlement that had a major impact on Jane Addams, who established Hull-House in Chicago along similar lines. Ashbee taught dozens of boys and young men the art of metalwork and jewelry and was a gifted artisan. In April 1897, Ashbee's large collection of works were displayed at Hull-House as part of its handicraft exhibition[6] as well as at the first Chicago Society of Arts and Crafts exhibition in 1898, and at the 1900 annual exhibit of the Chicago Architectural Club.

As the U.S. economy emerged from the 1893 depression, arts and crafts industries developed rapidly, and clubs, guilds, and societies surfaced everywhere. The Guild of Arts and Crafts was established in San Francisco in 1895[7], the Boston Society of Arts and Crafts in April 1897, the Chicago Society of Arts and Crafts in October 1897, among dozens of others. Fledgling jewelry and metalwork industries were best represented in Boston and Chicago.[8] But in Chicago, the movement took on epic proportions because of a unique combination of forces: unbridled wealth and a culture of entrepreneurship, superior educational and training opportunities in design and metalwork, a surge of women and immigrants entering the workforce, a colossal and eager retail and wholesale merchant base, an integrated and diverse social network of artists, craftsworkers and patrons, and the unparalleled support of the civic community. Chicagoans were unwilling to let go of the momentum established by the World's Fair, and, when the economy improved, a grand transformation was underway to integrate the arts and crafts into the entrepreneurial and artistic fabric of the city.

After the World's Fair, an enterprising cadre of women ignited the arts and crafts metalwork industries in the city. In 1895, Madeline Yale Wynne, in her home workshop, fashioned silver tankards, metal screens with flaming dragons, and a variety of jewelry.[9] In 1897, Christia M. Reade, a well-known designer and stained-glass artisan, delved into metal and was a founding member and chief metalworker of the Krayle Co. & Workshops. The Krayle Co. was one of the first arts and crafts commercial enterprises in the city, representing a collaboration of leading artists that included women sculptors, craftsworkers, artists, and metalworkers; by 1900, metalsmiths Henning Ryden and Robert Jarvie joined the partnership. In 1898, Elinor Klapp was noted for her exquisite jewelry that was exhibited throughout the Midwest, Louis C. Anderson was an important metalsmith in the Tree Studio Building, Florence Koehler was experimenting in jewelry, and Jessie Preston showed her outstanding arts and crafts candelabra in her new Fine Arts Building studio.

These pioneering artists laid the foundation for a revolution in art and design. As noted by Chicago writer Elia W. Peattie in the *Atlantic Monthly* (Dec. 1899):

> *The dreams and effervescence of youth are still ours. We hope to embody these visions and excitations in palpable beauty. It does not even matter to us if the rest of the world is amused at our declaration of principles, our confession of artistic faith; for we are elated with the reckless confidence of those who have not yet had a chance to fail.*

The Chicago School of Architecture, Decorative Designing and Arts and Crafts Training Programs

Architect Louis J. Millet, founder of the Chicago School of Architecture and a famous designer of stained-glass,[10] empowered a generation of women—and many men—to become the leading designers, metalworkers, jewelers, and art entrepreneurs of the Arts & Crafts Movement. From 1891 to 1918, he developed and taught the decorative-design degree course at the Art Institute of Chicago (AIC). Based on the French atelier system of "a school within a workshop," he trained hundreds of students, many of whom defined the new art industries sweeping the Midwest. At the 1893 World's Fair, Millet was the superintendent of architectural and decorative exhibits. Trained in the radically progressive atelier of Eugene Train[11] in Paris, Millet challenged the status quo in Chicago in his architectural designs for Adler & Sullivan and others and in his teaching methods. Millet encouraged women students to start their own companies or work for a firm at the forefront of design—and they did, by the hundreds. Their motto was to create works that were beautiful, useful, and enduring.[12]

Portrait of Louis J. Millet, founder and dean of the Chicago School of Architecture, and director of the decorative design program at the Art Institute of Chicago. Author's collection.

Art Institute of Chicago copper and silver class pin, made by C.D. Peacock. Author's collection, photo by Rich Wood.

Stained glass window (with external metal screen) by Louis J. Millet, at the Pilgrim Baptist Church, Chicago.

In 1902, Millet, then 58 years old, and some 500 former students of his decorative-design course, established an alumni association that organized annual arts and crafts exhibitions at the AIC. The shows became the largest and most important exhibition venue in the country, and were responsible in large part for galvanizing the American Arts & Crafts Movement. Coast-to-coast, many of the most significant craft artisans showed their ingenious creations, including Louis C. Tiffany, Gustav Stickley, Douglas Donaldson, Ernest Batchelder, Albert and Wilfred Berry, and Boston, Midwestern and Southern workers. Many of the shows and artisan works were covered in the press and magazines of the era. The annual exhibitions had several name changes over the years, but were hosted by the AIC from 1902 to 1923.

Bessie Bennett, one of Millet's early students, became a noted metalsmith and jeweler following her graduation from the AIC in 1898.[13] She was a member of the Swastica Shop, an early arts and crafts design studio. She also designed jewelry for Juergens & Andersen, one of Chicago's fine jewelers, and she exhibited her work throughout

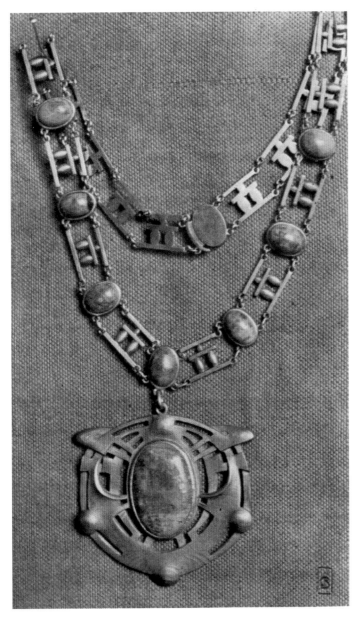

Necklace designed and executed by Bessie Bennett. From *The Sketch Book* (Oct. 1906).

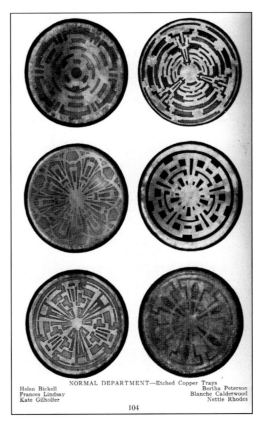

NORMAL DEPARTMENT—Etched Copper Trays

Helen Bickell
Frances Lindsay
Kate Gilholfer

Bertha Peterson
Blanche Calderwood
Nettie Rhodes

104

Etched copper trays by students in the Normal Department at the AIC, 1912. Author's collection.

the country, winning a prize from the AIC for a copper buckle in 1907. Bennett's crafts work included a broad array of jewelry, metalwork, and trophies that were highlighted in exhibitions and in the press, including geometric, cut-out silver necklaces set with stones, and a silver trophy bowl with three dragonfly handles set with lapis lazuli in 1905 for the Jackson Park Yacht Club; she also made a racing trophy for the Club in 1913.

From 1898, Bennett also was a leading figure at the AIC, where she taught decorative design, and, in 1914, at age 44, was named the Institute's first Curator of Decorative Arts. Bennett retired from the AIC in 1937, following a distinguished career that spanned 39 years.

In addition to the AIC, a variety of Chicago schools offered instruction in jewelry and metalwork to prepare students for professional careers in the arts and crafts field or as art and manual-training teachers. By 1898, metalwork classes were taught at Hull-House. In downtown Chicago, T. Vernette Morse founded the Art Craft Institute in 1900 to offer practical training in the evenings and on weekends for career-minded men and women crafts workers.[14] Supported by the Chicago Jewelers' Association and Chicago Furniture Manufacturers, patron sponsors included many prosperous members of the city's civic community and their companies, including J. Milhening, Juergens and Andersen, Benj. Allen & Co., Carson Pirie Scott, C.D. Peacock, Wendell & Co., Sears, Roebuck and Co., and Gorham Co.

Portrait of James W. Pattison, in plaster and a photograph, by Henning Ryden. Author's collection.

Henning Ryden opened the first jewelry and art metal classes at the Art Craft Institute in 1901, instructing students in "drawing, designing, modeling, casting, die cutting, engraving, chasing and every detail of the jeweler's craft." Later instructors included James H. Winn, Herman Hausen, and Edward Trost. Students who couldn't afford the instruction were given scholarships through the generosity of donors, and the school helped graduates secure jobs with local firms. In addition to preparing artisans for professional careers, the Art Craft Institute also touted that it taught many single mothers to make jewelry, buckles, metal novelties, and a broad array of craft articles from their homes, resulting in greater self-sufficiency and improved economic security. By 1910, the school had taught "more than 600 unskilled women home and art occupations that have enabled them to become self-supporting." The motto of the school was to "Help people help themselves."

The Lewis Institute, a well regarded co-educational vocational school that offered day and evening courses, launched an arts department in 1896 under the direction of Chicago artist Marie Elsa Blanke, who taught decorative design, drawing, and painting to hundreds of students over the next 40 years. Chicago jewelers who studied metals and chemistry at the Lewis Institute included Matthias Hanck and Emery Todd. From 1906 to 1913, Blanke was joined by a former student, Jane Heap, who was her main assistant in the decorative metalwork studios. Both women were a part of the large and vibrant Chicago artisan sub-culture of gay life where women eschewed relationships with men, frequently dressed in masculine attire, and pursued romantic relationships with one another.[15] Heap's jewelry made during this period includes a large unicorn brooch, pendant, ring, and bracelet; all are unsigned. Blanke and her sister Esther were also members of the Chicago Artists' Guild, and maintained a downtown studio that featured metalwork, paintings, and a variety of crafts.

Handmade bronze monogram stamp by Marie Blanke. Author's collection, photo by Rich Wood.

The Chicago newspapers played an important role in building an arts and crafts culture of entrepreneurship in the region, and were assisted by leading magazines and trade journals, including *Palette & Bench*, *Arts & Decoration*, and Irene Sargent's feature stories on jewelry and metalwork in *The Keystone.* Also prominent: *Handicraft* from the Boston Society of Arts and Crafts, *The Industrial Arts*, based in Milwaukee, *Fra* by Elbert Hubbard of the Roycroft Community, Gustav Stickley's *The Craftsman*, and *International Studio*, published in London and New York. Most of Chicago's newspapers included dedicated art columns and frequently published feature stories on the arts and crafts. Important Chicago arts and crafts era magazines included *The Arts*, which absorbed the first *Brush and Pencil* in 1893, *The House Beautiful*, a second *Brush and Pencil,* and *The Sketch Book.*

Jewelry made by students at the Applied Arts Summer School in Chicago, 1913. Author's collection.

The Manual Training Department at the University of Chicago, Jewish Training School, League of Industrial Arts, Chicago Academy of Fine Arts, Chicago School of Applied and Normal Art, and several popular engraving schools all offered practical training in metal work and jewelry. Further, the Applied Arts Summer School, the AIC summer classes, and the School of the Kalo Workshop taught many talented artists who became eminent in the field.

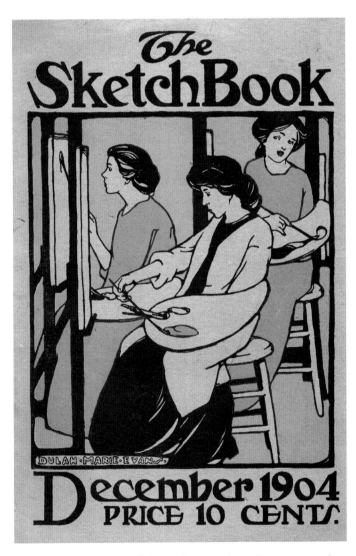

The Sketch Book, one of the early magazines that supported the growing interest in the arts and crafts. Cover design by Dulah Marie Evans, 1904. Author's collection.

II
Hull-House

Portrait of Jane Addams. From *New England* magazine (July 1898). Author's collection.

In September 1889, Jane Addams (1860–1935) and Ellen Gates Starr (1859–1940) established Hull-House, a social settlement situated on the west side of Chicago in one of the city's poorest immigrant neighborhoods. Its mission was "to provide a center for a higher civic and social life, to institute and maintain educational and philanthropic enterprises, and to investigate and improve the conditions in the industrial districts of Chicago." Inspired by the progressive ideals of socialized democracy, Addams used the Toynbee Hall settlement house in London as a model for integrating well educated and successful citizens with the abject poor so that all might benefit by a stronger and more vibrant society. Known as "the Toynbee Hall of the West," Hull-House was distinctive in that it was run and operated by women, and by 1892, had become almost a night-school college, offering more than 30 weekly courses, enrolling hundreds of students to study English and foreign languages, art history, debate, athletics, cooking, political economy, art, and the like. Hull-House was also home to dozens of clubs. Addams, and particularly Starr, believed that art was a vital part of

life, and both embraced the philosophy of John Ruskin, William Morris, C.R. Ashbee, and the British Arts & Crafts Movement.[1] The first building addition at the settlement included an art gallery, and exhibits of paintings began in 1891 and continued through the turn of the century. Hull-House expanded class offerings to include practical instruction in the crafts, exposing masses of neighborhood Greeks, Poles, Syrians, Russian Jews, Bohemians, and Italians to fine art and handicraft. By 1897, Hull-House added popular metalwork classes to its repertoire.

Hull-House became a gathering point in the city for the artistic, much like the Fine Arts Building and the Art Institute of Chicago, and frequently featured guest lecturers on the arts and crafts. In April 1897, the annual Hull-House exhibition of pictures and handicraft work included metalwork and jewelry designed by C.R. Ashbee, the first known exhibition of his work in the United States. A reporter for a Chicago newspaper noted that it was one of the most attractive exhibits, where the commonest materials resulted in the creation of objects of positive beauty, including copper set with amber.

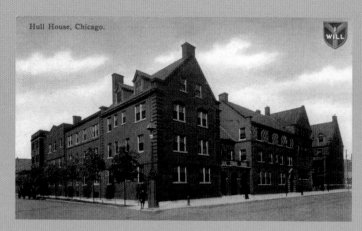

Hull-House postcard. Author's collection.

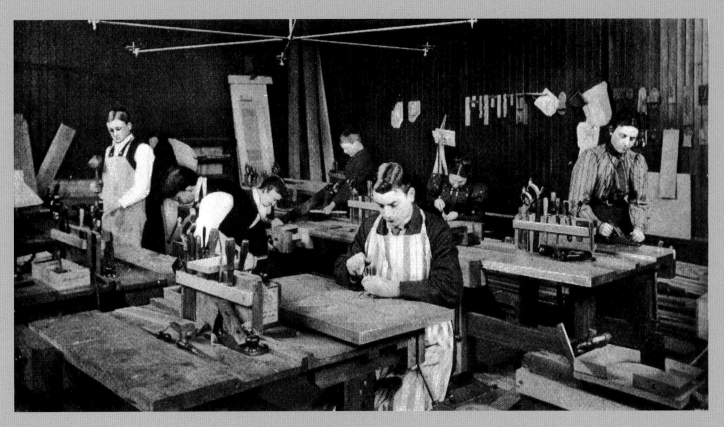

Hull-House manual training workshops. From *New England* magazine (July 1898). Author's collection.

In October 1897, more than 130 leading architects, crafts workers, artists, sculptors, academics, social reformers, and wealthy citizens formally established the Chicago Arts and Crafts Society (CACS) at Hull-House, representing prominent founding members Addams and Starr, Louise Anderson, Augustus and Frances Higginson, Frank Hazenplug, Elinor Klapp, Florence Koehler, Dwight H. and Lucy Fitch Perkins, Christia M. Reade, Edith Sheridan, Prof. Oliver L. Triggs, George M.R. Twose, Ella Waite, Madeline Yale Wynne, Frank Lloyd Wright, and many others.[2] The goals of the CACS were to promote beauty and design in common everyday objects, expand manual training and art education, ensure that the machine would not dominate the worker, hold annual exhibitions, and encourage handicraft among its members. Many of the founders were practicing artists and crafts workers, while many others pursued the crafts with a new philosophical zeal. In 1899, Elia Peattie noted in *The Atlantic Monthly*:

> *This society is composed of men and women who turn the rooms under their mansard roofs into smithies, set up kilns in their furnace rooms, and fashion their own furniture. They aim to do original work or none at all,*

> *and their shaping and carving, their burning and beating of woods and metals, result in many articles which are beautiful and some that are unique. In addition to the work in silver and gold and bronze and wood, some hand-weaving has been done; for the members are lavish of experiments, of which, if the success bring but little glory, the failures bring abundant merriment, and, fortunately, no one takes the pretty achievements too seriously.*[3]

Metalworkers and jewelers involved with the early years of the Chicago Arts and Crafts Society (CACS) and Hull-House were predominantly wealthy and successful women, as well as professional men, almost all of whom embraced the ideals of artistic hand craftsmanship and the philosophy of the British Arts & Crafts Movement. Frank Lloyd Wright was a noteworthy exception, as he thought that machine-made objects were often superior to those made by hand. In 1901, he famously goaded his peers by delivering a CACS lecture at Hull-House titled, "The Art and Craft of the Machine." Although inflammatory at the time, Wright's ideas about technology, art, and design eventually became more widespread, particularly through his design innovations in furniture manufacturing.

The majority of CACS artisans did not need to sell their wares as a means of livelihood. Most of the work was unsigned and known only through exhibition photos or in special collections where provenance has been established. CACS crafts workers received favorable press coverage for their exhibited jewelry and metalwork, including Florence D. Koehler and her students Bertha Holden, Emily Crane Chadbourne and Elizabeth Day McCormick; Dr. Joseph Wassall, a dentist who pursued metalwork in his leisure time; Hugh J. McBirney, a wealthy lead manufacturer; architect Augustus Higginson and his wife Frances; Anne Higginson Spicer, who founded the Mushroom Shop in Kenilworth; Edith Sheridan, who also operated a design studio in the Loop; and Elinor Klapp, who was well known for exhibiting her jewelry in the 1900 Paris Exposition.

Madeline Yale Wynne was one of the most prominent early metalsmiths and arts and crafts workers associated with the CACS, and she gave private classes to a variety of upscale local women, including Isadore P. Taylor. Much of the metalwork by Wynne and members of the CACS is rough and uneven by design. Wynne explained:

> With the copper, I work it, pound it in the shape I wish, and if it is to be a buckle or a pin or a brooch, I aim to have the edges not smooth and sharp, but almost irregular…I want my things to look pliable—as if the fingers had molded them and not as if they were following lines laid down. And I think they do.

From 1898 to 1901, the CACS held formal annual exhibitions featuring the works of its members and guests, until the Art Institute of Chicago (AIC) launched its annual exhibits in 1902, and the shows were combined. In the early 1900s, the CACS also held smaller exhibitions in the Fine Arts Building that were sponsored by the Women's Club. Throughout its existence, the CACS focused on providing practical training in the crafts, and some CACS artisans taught evening courses at Hull-House to local immigrants. Although Wynne and others may have taught metalwork at Hull-House from 1896, the first known instructor was Frances Girvan Higginson, who offered a course in 1898 with George M.R. Twose that attracted 30 students. Others who lectured or taught metalwork and jewelry design before the turn of the century included Wynne's former student, Isadore P. Tayor, who also published on the making of copper objects.

The Hull-House Shops were established in around 1898 as a means of exhibiting and selling arts and crafts work made by artisans and students at the settlement, and operated out of Ella Waite's studio in the Woman's Temple for many years. In 1900, Addams and Starr established the Labor Museum, which soon offered manual instruction in wood and metal work, pottery, bookbinding, and embroidery. Jane Addams recruited nationally and internationally recognized metal workers and silversmiths to teach at Hull-House from 1900, including Jessie Luther, a Miss Vail from the Pratt Institute in New York, Alessandro G. Colarossi, and Annibale Fogliata. Whereas Wynne and her colleagues introduced a free-form metal work style to

Drawing by Frank Hazenplug. From *The Chap Book* (June 1895), author's collection.

the designs made at Hull-House and by its students, the recruitment of Colarossi and Fogliata shifted the focus more toward British arts and crafts silver styles, particularly by advancing repoussé and enamel work. Isadore V. Friedman, a young Russian immigrant who studied at Hull-House, excelled under the specialized training of Colarossi and Fogliata and later became the lead metalwork instructor and veteran entrepreneur.

In 1907, Falick Novick, a Russian Jewish coppersmith, arrived in Chicago and settled near the Hull-House neighborhood. By 1909, he ran the metalwork program for the Hull-House Shops, fashioning decorative items designed by Frank Hazenplug and others. Lucile D. Stein was a designer and Hull-House volunteer who became involved with the metalwork shop, eventually launching her own silversmith company that featured fashionable designs executed by Hull-House silversmiths.

In the 1920s, the prominence of metalwork at Hull-House began to diminish, particularly by the onset of the Great Depression. Textile arts, painting, pottery and the Hull-House kilns dominated the artistic interests of students and influenced new generations of immigrants.

Hull-House silver covered box made for Johanne Loeb, the grandmother of Richard Loeb, on the occasion of her 70th birthday. Marked Sterling Hull-House Shops and engraved *Johanne Loeb 1844–1914*. 2.5" long. Courtesy of Cobblestone Antiques.

Metalworkers and Jewelers Associated with the Chicago Society of Arts & Crafts

Known metalwork and enamel instructors and designers at Hull-House, 1898–1925

> Frank Caruso, wood inlaid with metal, 1904
> Alessandro G. Colarossi, metalwork and enamel, 1902–1905
> Annibale Fogliata, metalwork and enamel, 1904–1905
> Isadore V. Friedman, metalwork, silver, and enamel, 1903–1905, and 1912–1917
> Frances G. Higginson, metalwork, 1898–1899
> Frank Hazenplug, design and metalwork, 1903–1910
> Jessie Luther, metalwork, 1901–1902
> Walter Martin, metalwork, 1925
> Falick Novick, metalwork, c.1909–c.1912
> Julius O. Randahl, silversmith, c.1916–c.1917
> Miss Vail, metalwork summer school, 1903

Alessandro Colarossi silver casket. From *The Keystone* (Nov. 1910). Courtesy of Chicagosilver.com.

Alessandro Gilberto Colarossi (1882–1953)

In 1901, Jane Addams recruited Colarossi from London to teach metalwork and enameling at Hull-House. A nephew of founder of the Academy Colarossi in Paris, his family had a long tradition in art metal work. In Chicago, he worked alongside Frank Hazenplug and exhibited jewelry, a silver bowl and spoon and a copper box in the 1903 annual arts and crafts exhibit at the AIC. In October 1905, Colarossi moved to Philadelphia, where he continued in metalwork and jewelry at the Arts and Crafts Guild while studying painting at the Pennsylvania Academy of Fine Arts. In 1905, he showed a copper and enamel paper knife, belt clasp, and buckle, as well as silver jewelry and a spoon at the Detroit Applied Arts Exhibition. In Philadelphia at the Academy, Colarossi worked and studied alongside noted iron worker Samuel Yellin, and both became active in the Boston Arts and Crafts Society. In 1922, Colarossi married Dorothy Burrows and later became a professor of painting at the University of Pennsylvania's School of Fine Arts.

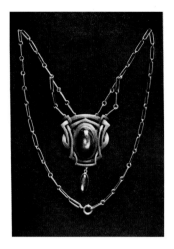

Mary J. Coulter necklace from *California Magazine* (1916). Author's collection.

Frank Hazenplug designed the porringer, which was made by Alessandro Colarossi. Brainerd Thresher of Dayton, OH, made the candlesticks. From *The House Beautiful* (Feb. 1904). Author's collection.

Mrs. Mary Jenks Coulter (1880–1966)

Coulter was known for her jewelry and metalwork early in her artistic career that spanned many mediums, and she exhibited her work throughout the country. Born in Kentucky, Jenks married Frederick Coulter and moved to Chicago in 1902. She initially pursued painting on porcelain, jewelry and metalwork; she also was an instructor and curator of etchings and engravings at the Art Institute of Chicago. In 1909 and 1911, she exhibited gold and silver jewelry in the AIC annual arts and crafts shows. Coulter graduated from the University of Chicago, and, in 1913, she and her husband moved to San Francisco, where she concentrated on painting. She divorced her husband in the 1920s and later married Orton Clark. She died in Amherst, Massachusetts in 1966.

Frances Macbeth Glessner (1848–1932)

The wife of International Harvester executive John J. Glessner, Frances was a society doyen who pursued metal working as an avid pastime from 1904 to about 1915.[5] She took lessons with Frederick Sandberg, Annibale Fogliata, and possibly Madeline Wynne. Glessner made jewelry for friends, particularly gold or silver neck chains, variously set with pearls, blue crystals, blue carnelian, amber, turquoise, garnets or moonstones, and she bought many pieces from Sandberg and Fogliata to give to her family and friends. Her work also included bowls, dishes, jar lids, salt cellars, and hat pins. In 1906, Glessner bought all of Sandberg's tools, including enameling implements, which he showed her how to use. An avid beekeeper at her summer home in New Hampshire, Glessner stamped her silver with a bee inside a G, or her engraved name or initials.

Frank S. Hazenplug (1873–1931)

Hazenplug, a native of rural Dixon, Illinois, was a well-known illustrator, designer, metalworker, and enameler. At Hull-House, he taught dozens of students and provided designs for some of the items made by Hull-House instructors and artisans.

In the 1890s, Hazenplug graduated from various courses of study at the AIC. From 1894 to 1898, he provided art work for *The Chap Book,* an avant-garde magazine published by Stone & Kimbell in Chicago. Hazenplug was a pioneer in creating poster art for the magazine, and branched out into designing book covers for Stone & Kimball and Herbert S. Stone's *House Beautiful* from 1897 to 1904.

Hazenplug was a founding member of the CACS and showed his metalwork in its first exhibitions. From 1903 to 1911, he also was a resident at Hull-House and an instructor in the metal program. He provided designs for pottery, textiles, copper and silver metalwork, jewelry, and enameled decorative work. He served on the jury for the first annual arts and crafts show at the AIC along with Louis J. Millet, Clara P. Barck, and others; his work was shown at the annual exhibits from 1903 to 1908 in conjunction with other Hull-House metalworkers. From 1905, he taught the popular metalwork classes variously with Colarossi, Fogliata, Novick, and Friedman. In 1909, he taught summer school at Byrdcliffe in Woodstock, New York. In 1911, he shortened his name to Hazen and moved to New York, focusing on book illustration until his retirement in 1921. His brother Edward Hazen died in 1924, and the following year Frank moved to Santa Fe, New Mexico, due to his failing health. He died of tuberculosis at Cottage Hospital in Santa Barbara, California, in January 1931.

Frances Higginson designed and made the brass lamp shade and letter box. From *The House Beautiful* (June 1899). Author's collection.

Elinor Klapp and examples of her jewelry, 1898–1900. Photo with large center brooch courtesy of Chicagosilver.com, others from author's collection.

Augustus Barker Higginson (1866–1915)
Mary Frances Girvan Higginson (1868–1905)

From 1895, the Higginsons were at the forefront of the early arts and crafts movement in Chicago. Augustus was a Harvard-trained architect who established a practice in the city following study in Paris, where he met his future wife. He believed in designing total residential environments, including furniture, textiles, and metalwork. His wife Frances was a noted artist who studied with James C. Beckwith of New York, and then in Paris. She was adept at hand craftsmanship, particularly working in wood and metal, and she taught at Hull-House. As founding members of the CACS, the Higginsons exhibited works in the 1898–1900 annual shows, including hand carved boxes, carved oak furniture, brass candle sticks and shades, and copper objects, as well as metalwork from their students and George Higginson, Jr., the brother of Augustus. In 1900, Frances also exhibited a large collection of handmade metalwork in Buffalo. In 1903, the Higginsons were traumatized when Augustus's sister and nephew died in the Chicago Iroquois Theater fire. A year later, they moved to Santa Barbara, California, where Frances died shortly after their arrival in January 1905. Augustus designed several arts and crafts style houses in California and in 1907, married Ednah Sherman Girvan, who was a noted artist, jewelry maker, and the cousin of his first wife.

Elinor Evans Klapp (1845–1915)

Klapp was an accomplished jewelry designer who received an honorable mention for 40 pieces of her jewelry shown in the highly acclaimed 1900 Paris International Exposition, a great achievement for the Chicago woman.[6] She went on to win a bronze medal in the 1901 Pan-American Expo in Buffalo, New York. She made jewelry, but also retained professional jewelers to execute her designs.

The Pennsylvania-born Klapp came to Chicago with her husband and children in the 1870s. In 1897, she was a founding member of the CACS, and her jewelry was exhibited widely throughout the country. An article in 1902 identified her as one of four women in Chicago making artistic jewelry, along with Madeline Yale Wynne, Christia M. Reade, and Frances Koehler. In 1903, she moved to New York and remained active designing and exhibiting jewelry, including at the AIC, until her death in 1915.

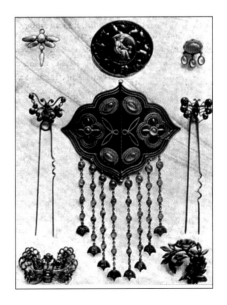

Jessie Luther (1860–1952)

Born in Providence, Rhode Island, Luther served as the first curator at the Hull-House Labor Museum in 1901–1902.[7] Luther's work in the 1901 Chicago Arts and Crafts Society exhibition consisted of copper wares, some decorated with enamel, including "an attractive copper box bearing a red leaf on a green enamel background," and buckles set with opals. She and her sister, Mabel Wilcox Luther, a master craftsman and jeweler active with the Boston Society of Arts and Crafts, exhibited in the annual arts and crafts shows at the AIC. Luther later taught at the Grenfell Mission in Newfoundland and was one of the pioneers in occupational training through her work at Butler Hospital in Providence, Rhode Island.

Isadore Pratt Taylor (1850–1943)
Homer Slate Taylor (1851–1933)

The Taylors were founding members of the CACS, and Isadore Taylor (nee Annie Isadore Pratt) was a vocal proponent of the society. Isadore studied metalwork with Madeline Yale Wynne and excelled at the craft; she gave lectures on copper work at Hull-House.[8] She and her husband exhibited copper bowls, boxes, and utensils in the early CSAC annual shows, and Isadore was listed for metalwork and jewelry in crafts directories. From the 1870s, they lived in Kenilworth, Illinois, a northern suburb of Chicago. Around the turn of the century, Isadore also helped establish the Kenilworth Arts and Crafts Society with Anne Higginson Spicer, originally called the Mushroom Club.

In c.1915, the Taylors returned to their native Massachusetts and lived in Deerfield, where Isadore served as the honorary president of the Deerfield Valley Arts Association at least through 1935.

Metalwork by Isadore Taylor. From *The House Beautiful* (June 1899). Author's collection.

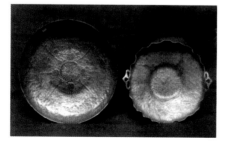

Madeline Yale Wynne (1847–1918)

Wynne was one of the most prominent early metalsmiths and arts and crafts workers associated with the CACS. She shared her time between homes in Chicago and Deerfield, Massachusetts, for decades, and was active in promoting the arts and crafts throughout her life.[9] Her metalwork included copper, brass, and silver bowls, boxes, plates, porringers, and candlesticks. Her jewelry included a necklace made of fine silver chains set with pink and white pearls, fobs, pins, brooches, and buckles set with stones and some with enamel. One of her silver boxes featured Buddha's ascent to the moon, set with jade and decorated with enamel.

Born in Newport, New York, to a wealthy family, Madeline married Henry Winn, a Civil War hero and a lawyer who worked for her father, Linus Yale, inventor of the Yale lock. After they divorced, Madeline changed the spelling of her last name and that of her two sons to Wynne, saying that it was a restoration of the original family name.

Wynne studied art in Boston and at the Art Students' League in New York City. She and her brother Julian Yale lived in Chicago by 1889, when she stayed with the Taylors and exhibited a pastel portrait in the 17th Annual Inter-State Industrial Exposition. She later lived with her brother and operated a home studio at 9 Richie Place. By 1896, she took a studio in the Tree Studio Building on Ohio Street in Chicago and maintained a summer studio in Deerfield, Massachusetts. Wynne offered private classes and taught metalwork to the Taylors, possibly Frances M. Glessner, and her brother, who often exhibited hand-wrought metal goods with her. Wynne also gave lectures on silver work at Hull-House and many other venues. After her brother died in 1909, Wynne gave up the Richie Place house in Chicago and moved to Tryon, North Carolina, with her long-time companion Annie Putnam. Wynne died in Tryon in 1918.

Madeline Yale Wynne hammered silver and copper items with enamel. From *The House Beautiful* (June 1899).

Professional Metalsmith Entrepreneurs

Annibale Fogliata (c.1868-)

Fogliata was an art metal worker living in London, when he was recruited to teach metalwork at Hull-House in 1904. He participated in the annual arts and crafts show at the AIC that year, and gathered a cadre of private students, including Frances Glessner, who also was one of his best customers. In November 1905, she noted in her journal, "Wednesday Fogliata came back and I had my silver lesson. He was overjoyed to get back. We put the bands on the two gavels I have had made for the two beekeepers association..." From 1905 to 1906, Fogliata worked for several months as a chaser for the Gorham Company on its Martele line, while he continued teaching at Hull-House. In 1906, he moved to New York. In 1930, he lived in Manhattan and worked as an engraver for the steel industry.

Isadore Victor Friedman (1885–1956)

Friedman chronology:
- Hull-House, 1900–1908, 1912–1917
- Marshall Field & Co., c.1905–1908
- Pratt Institute, 1908–1909
- Kalo Shop, 1909–1912
- Randahl Shop, 1911–c.1914, 1920s–1950s
- Friedman Studio, 1912–c.1917
- Reade, Christia M., c.1913–1916
- Novick, Falick, c.1920–1929
- Art Silver Shop, c.1920–1930s

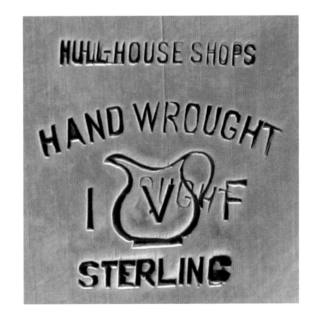

Annibale Fogliata gold and opal brooch with six opal pendants purchased by Frances Glessner, c.1904. Courtesy of the Chicago History Museum.

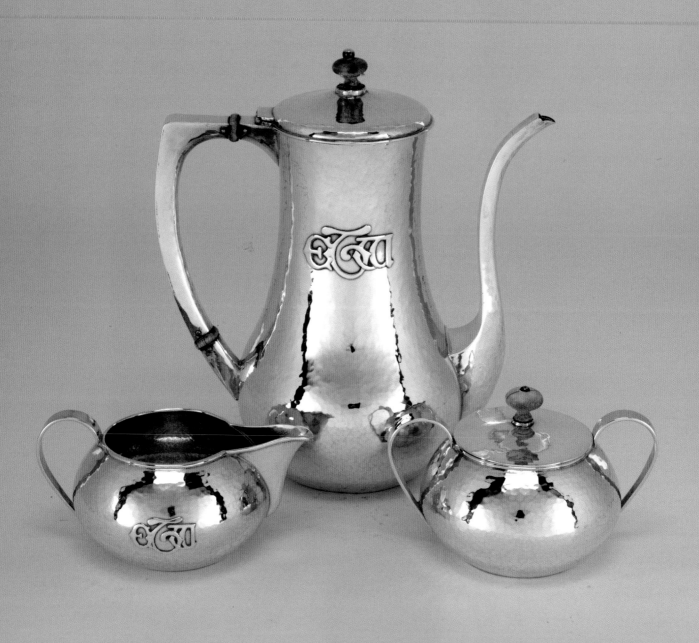

Sterling silver coffee service by the Isadore V. Friedman studio, all stamped with the shop logo. Courtesy of the Charles S. Hayes family, photo by Scott Bourdon Studios.

Born in Kiev, Russia, Friedman and his family moved to Chicago when he was a toddler, settling near Hull-House. From 1900, he became immersed in theater and art metalwork classes at the settlement. He showed remarkable talent working in metals and became a protégé of Jane Addams,[10] who took a personal interest in his development. In the 1903 annual arts and crafts show at the AIC, Hull-House Shops exhibited a copper enameled box that he designed and made—a fine achievement for the 18-year-old. Friedman also featured various copper and silver objects including buckles, spoons, a chased copper tray, an inkwell, and a bowl in the 1904–1905 shows with Hazenplug and Fogliata; he exhibited a silver jewelry set with semi-precious stones under his own name in 1906, and an elaborate hollowware including a silver tea kettle in 1913–1914. Friedman was adept at finely executed repoussé commissions as well as raising silver for larger hollowware pieces. He made most of the jewelry for the Novick studio.

Around 1905, following his training at Hull-House, Friedman began his professional career at Marshall Field & Co., where he met Julius O. Randahl and established a life-long friendship. In 1908, he won a scholarship to study at the Pratt Institute in Brooklyn, New York. When he returned to Chicago the following year, he joined the Kalo Shop in Park Ridge, and from 1911, he also worked for the Randahl Shop in Park Ridge. Friedman stayed at the Kalo Shop until 1912, when he established his own studio in the Palace Theater building at 1145 Blue Island Avenue, adjacent to Hull-House, and he ran the metal shops at Hull-House until World War I. He made items for noted Chicago artisan Christia Reade during this time period as well. He married Florence Norton in 1913.

During World War I, Friedman, like many other Chicago-area metalsmiths, went to work in the San Francisco ship yards. His son noted years later, "My father, small but wiry and athletic in his 20s, was adept at working in almost inaccessible sites on destroyers ("tin-cans") at the San Francisco Navy Yards, 1917–1918."

Friedman returned to Chicago several years after the war and worked for Novick and the Art Silver Shop, but most consistently for the Randahl Shop, until his retirement in the 1950s. In 1934, he demonstrated silversmithing at the Colonial Village as part of the Chicago World's Fair.

Falick Novick (1878–1958)

Novick was a Russian coppersmith who immigrated to New York before arriving in Chicago in 1907. He lived near Hull-House and immersed himself in the settlement's rich social and educational resources, including language and metalwork classes. A proficient and entrepreneurial craftsman, he excelled at Hull-House and became the metalwork instructor for the popular classes. By 1909, he and his brother Samuel established Novick Brothers, coppersmiths, selling their wares from a shop on West 12th Street (Roosevelt Road). They soon realized that Chicagoans preferred silver items over their traditional brass and copper wares and, within a year, Samuel returned to New York. Novick and his wife Tillie operated a 12th Street shop that touted copper, brass, and silver. Within a few years, Novick saved enough money to buy a home and studio at 828 E. 43rd Street, which he operated for the remainder of his life.[11]

In 1914, Novick listed himself as a silversmith in city directories for the first time. In 1915–1916 and in 1920, the Kalo Shop commissioned Novick to make dozens of paper knives, copper bowls and at least one tea set. In the later years of WWI, he worked as a tinsmith for the army, based at a factory in Chicago. In 1919, he was selected to exhibit a hand-wrought copper samovar in the annual arts and crafts exhibition at the AIC. Until the Great Depression, Novick variously employed two to three silversmiths, including his Hull-House colleague Isadore V. Friedman, who made silver hollowware and jewelry. Shop records and correspondence from the 1940s show that he had a steady stream of customers, including Macy's in New York and Otto Dingeldein in St. Louis. Fluted silver bowls were among his most popular items, as well as special orders for weddings and Christmas. In 1944, Frederick Lunning from Georg Jensen U.S.A. asked him to send hollowware samples to sell in his posh Fifth Avenue store in New York, but Novick declined, citing the needs of his existing customers. Novick retired in 1950 and died in 1958.

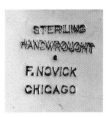

Novick silver and copper hallmarks, author's collection, and mark for Novick Brothers, c.1909–1910, courtesy of Chicagosilver.com.

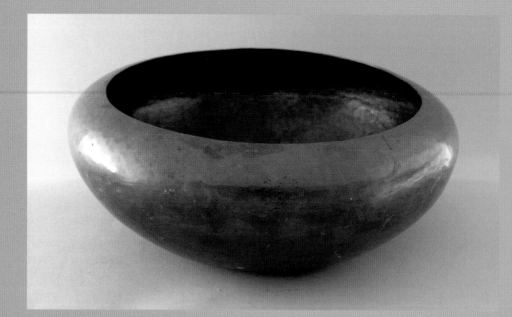

Classic hammered copper bowl marked Handwrought by F. Novick Chicago. 8.5". Author's collection, photo by Rich Wood.

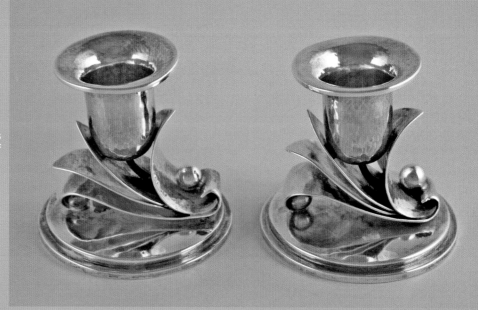

Novick sterling silver candlesticks with a berry design. Courtesy of Chicagosilver.com.

Novick sterling tomato server with applied "L" monogram. Courtesy of Chicagosilver.com.

Novick sterling silver, footed bowl with chased design. Courtesy of Chicagosilver.com.

Novick copper and silver serving spoon. Courtesy of Chicagosilver.com.

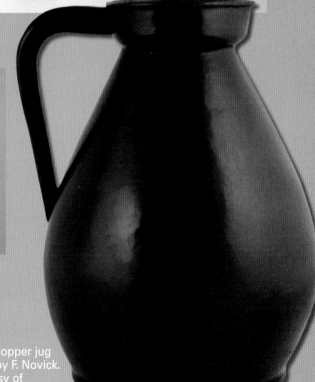

Large copper jug made by F. Novick. Courtesy of Chicagosilver.com.

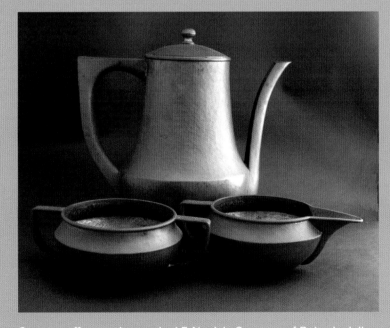

Copper coffee service marked F. Novick. Courtesy of Boice Lydell.

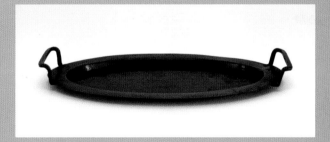

Copper tray with handles marked F. Novick. Courtesy of the Charles S. Hayes family, photo by Scott Bourdon Studios.

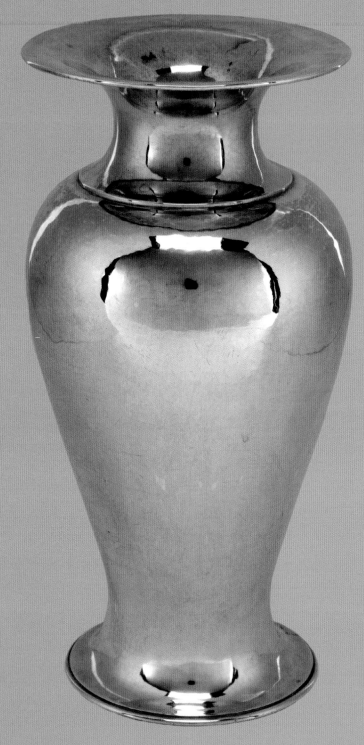

Stein sterling silver vase, 10" high. Author's collection, photo by Scott Bourdon Studios.

Lucile D. Stein Silversmiths

Principal

Lucile Dorothy Stein (Mrs. Samuel B. Ullman)
(1891–1986)

Stein was a designer and entrepreneur who operated a short-lived but prolific silver shop at 25 E. Washington Street, utilizing Hull-House and other Chicago silversmiths to execute her designs. She was born in Chicago to a wealthy family and attended the National Park Seminary, a private girl's college outside of Washington, D.C. After graduation, c.1910, she worked as a volunteer in the craft shops at Hull-House and as a professional designer. From 1914 to 1916, she established the Lucile D. Stein Silversmith company. Many of Stein's artistic designs show a strong resemblance to the Kalo Shop, Mulholland Brothers, and Lebolt & Co., although it is unknown if she was a designer for any of those firms before starting her own company. Silversmiths known to be associated with Hull-House when she established her shop included Isadore V. Friedman and Julius O. Randahl. Stein closed her silver business a year after her marriage and moved to Wisconsin; in 1929 she and her family returned to the Chicago area and she opened a successful interior design company that was highly regarded on the North Shore through the 1960s.

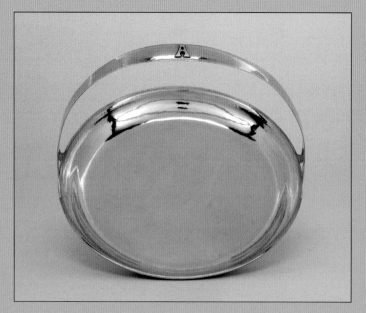

Stein sterling silver basket with applied "A" monogram. Author's collection, photo by Scott Bourdon Studios.

Photo of Lucile D. Stein, 1911.
Courtesy of a private collector.

Hallmark of Lucile D. Stein Silversmiths.
Author's collection, photo by Rich Wood.

Stein sterling silver creamer and sugar. Courtesy of private
collector, photo by Rich Wood.

Stein sterling silver salad servers. Courtesy of private collector,
photo by Rich Wood.

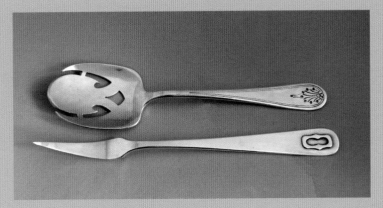

Stein sterling silver spoon and nut pick with applied monogram.
Author's collection and photo.

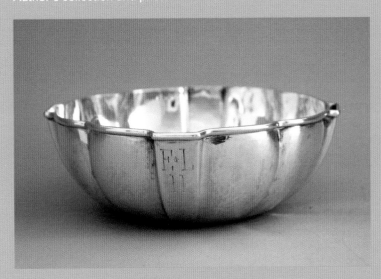

Stein sterling silver bowl, 6".
Author's collection, photo by
Rich Wood.

III

The Fine Arts Building and Artisan Studios

Jewelry and Metalworkers in the Fine Arts Building (FAB), 410 S. Michigan Avenue, and the Auditorium Building (AB), 430 S. Michigan Avenue

Louise C. Anderson, 1891–1896 AB, 1906–1907 FAB

Wilhelmina Coultas, 1912–1918 FAB

Russell Freeman,1909–1913 FAB

Charles A. Herbert, c.1907–1923 AB, 1924–1929 FAB

Magda M. Heuermann, 1900–1921 FAB

The Jarvie Shop, 1905–1907 FAB

The Kalo Shop,1903–1907 FAB, 1920– 1924 at 416 S. Michigan

Lavaron Studio, 1907–1914 FAB

Pratt Studio, 1906–1942 FAB

Jessie M. Preston, 1898–1918 FAB

Christia M. Reade, 1902–1929 FAB

Albert Seror, 1909 AB, 1912 FAB

The Swastica Shop, 1905-V10 FAB

The TC Shop, 1910–1931 FAB

George H. Trautmann, 1913–1917 FAB

Albert H. Wehde, 1911–1917 FAB

The Wilro Shop, 1902–1910 FAB

James H. Winn, 1905–1929 FAB

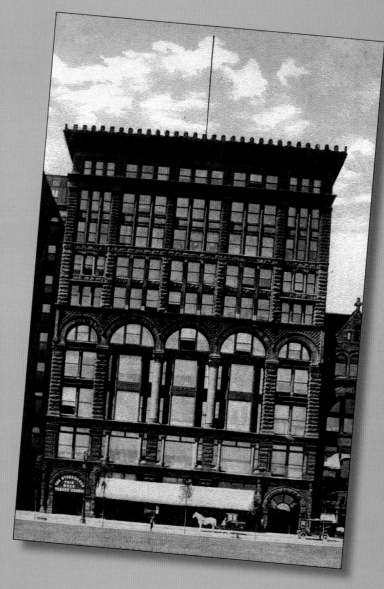

Fine Arts Building postcard. Author's collection.

In the early years of the Fine Arts Building there was a blending of the social with the artistic life in the studios that was truly delightful. We were all prosperous, with plenty of work to do, yet somehow there seemed to be time to exchange visits with our co-workers and take an active interest in the work which each was doing.
—Anna Morgan, *My Chicago* (1918)

The Fine Arts Building, situated in the heart of the Chicago business district on Michigan Avenue, was one of the most visible landmarks that symbolized the commitment of the civic community to the development of a vibrant arts and culture industry in the city. Originally built in 1885 as the factory and showroom for Studebaker, the carriage manufacturing company quickly outgrew the massive Romanesque-style building. Publisher and arts entrepreneur Charles C. Curtiss conceived the notion of an arts center and marshaled the support of the civic community to transform the facility into a temple of art by adding two floors, the Studebaker Theater, two auditoriums, and dozens of studios. In its new incarnation, the Fine Arts Building provided affordable space and fostered a culture of art and entrepreneurship. [1]

Opening on September 29, 1898, the 10-story building soon housed more than 200 painters, sculptors, metalworkers, jewelers, crafts workers, leather workers, musicians, writers, illustrators, cartoonists, architects, magazine and book publishers, and club organizations, as well as an art gallery. Flanked by the Chicago Music College and the transcendent Auditorium Building (AB) complex, the Fine Arts Building (FAB) was a short walk from the Art Institute and the main shopping district on State Street. Denizens in the FAB were closely aligned with artisans located in the adjacent Auditorium office tower, where architect Louis Sullivan also maintained an office, and the studios in Steinway Hall.

From 1898, The Little Room emerged as an important social club based in the FAB. Established as the Attic Club[2] in 1895, an avant-garde association of influential creative types, the organization changed its name to The Little Room in honor of Madeline Yale Wynne's enormously popular and ghostly short story of the same name that was published in *Harpers* in the summer of 1895. The Little Room met on Fridays in Bessie Potter's downtown studio until it moved to Ralph Clarkson's studio in the FAB. Organizers and prominent members included Clarkson, Wynne, Herbert S. Stone, Henry B. Fuller, Jane Addams, Bessie Potter, Harriet Monroe, Hamlin Garland, Lorado Taft, Elia Peattie, Frederick Richardson, and scores of others until it disbanded in 1931.

Authors and publishers in the early years of the FAB defined an American literary renaissance that buoyed the arts and crafts culture in Chicago. Magazines included *The Dial*, *Poetry Magazine* and *The Little Review*, a radical magazine founded by Margaret Anderson and edited by Jane Heap. *The Little Review* was notable for publishing experimental writing, including serializing James Joyce's *Ulysses* and publishing unknown authors at the time, including Ernest Hemingway.

Artist organizations in the FAB included the Artists' Guild of Chicago (est. 1911), the Cordon Club (est. 1915), and the Arts Club of Chicago (est. 1916). These organizations supported artists and significantly boosted sales through exhibitions and permanent galleries. The Artists' Guild membership roster included leading crafts workers, jewelers and silversmiths from the Midwest, Boston and California. The Cordon Club was for women, established in part out of frustration over the Cliff Dweller's Club, an artisan club for men only that was founded in 1907. (Oddly enough, it also was called the Attic Club before it changed its name.) Although the Arts Club moved from the FAB shortly after it was founded, it exists today.

Jessie M. Preston was one of the earliest women craft workers to take a studio in the FAB, and she helped define the progressive nature of the artist colony for the next 20 years. She, Christia M. Reade, Clara B. Welles, Leonide C. Lavaron, Robert R. Jarvie, James H. Winn, and a host of other leading crafts workers shared their studios with other artists, served on boards and committees of art organizations, and exhibited widely—in their home communities, in Chicago, regionally, and nationally—bringing awareness and recognition to some of the best crafts work of the era, as well as serving as a role model for hundreds of women and men who aspired to find profitable careers in the arts.

Wilhelmina Coultas jewelry from the *Chicago Artists' Guild*. Courtesy of Chicagosilver.com.

Wilhelmina Coultas (Mrs. Henry W. Kirby) (1874–after 1947)

Born in downstate Jacksonville, Illinois, Coultas graduated from the AIC in 1901 and became a painter after studying with Martha Baker in Chicago and Frank Duveneck in Cincinnati. After 1904, she studied with Louis Millet and James Winn, becoming an expert jeweler. By 1910, she taught at an art school while living in the same rooming house as the Jarvies. She exhibited in many of the annual arts and crafts shows at the AIC, featuring silver and gold jewelry set with gem stones, carved ivory and amber, and enamel.

In 1912, Coultas moved into the FAB and maintained an active jewelry studio until 1918, when she closed her studio to work as the chief designer and manager for the Cellini Shop in Evanston. The following year, she married Henry W. Kirby, a dentist. She continued to make and exhibit jewelry at least through 1921. She and her husband moved to Florida in the 1920s, and he died there in 1925. Wilhelmina returned to Jacksonville and, from 1941 to 1943, taught for the Works Progress Administration, and later she worked at the state hospital through 1947. Her jewelry hallmarks have not been established.

Necklace by Charles A. Herbert from *Palette and Bench* (March 1909). Author's collection.

Charles Albert Herbert (1880–1936)

Herbert was a jeweler, leatherworker, designer, and crafts teacher who studied at the AIC and maintained a studio at 1100 Auditorium Tower from c.1907 to 1923. He then took a studio in the FAB from 1924 to 1929. He exhibited at the annual arts and crafts shows at the AIC in 1908–1909 and 1914–1915, showing silver jewelry set with stones and tooled leather items, some with copper or silver mounts. He lived in Chicago until he died from a stroke in 1936. Herbert's marks have not been established.

Russell Freeman (1879–1937)

Freeman apprenticed as a jeweler in the Chicago business district and operated a leading arts and crafts diamond and jewelry studio in the FAB from 1909 to 1913, which he shared with Albert Wehde from 1911 to 1912. Freeman's studio was featured in the *Book of the Fine Arts Building*. During the war, he worked as a jewelry salesman for Hyman & Co. and Charles E. Graves & Co. before he reopened a store in 1920. He was listed in John Petterson's order books in the late 1930s, and died in 1937 from influenza. His jewelry marks are unknown and he did not exhibit in the annual shows at the AIC.

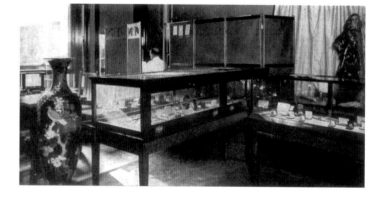

Russell Freeman in his studio with cases filled with jewelry. From *Book of the Fine Arts Building* (1911). Author's collection.

Leonide Cecilia Lavaron
(1865–1931)

Studio Locations
839 MF Building, 1901–1904
704 MF Building, 1904–1907
414 FAB, 1907–1910
516 FAB, 1911–1914
3744 Lake Park, 1914
640 FAB, 1916
802 Marshall Field & Co.
 Building, 1925

Known workers
Harold Siggurd Carlsen, 1905–
 1909
Ferdinand W. Daninger, 1912–
 1913
Edward Helmich, 1912–1913
Frank Louis Kohlhase, 1902
Emil Kronquist, 1906–1907
John C. Krutil, 1911
K. Michelson, 1906
Olaf Nedrelid, 1907
Victor Weinz, 1913
Gustaf Albin Westermark, 1913

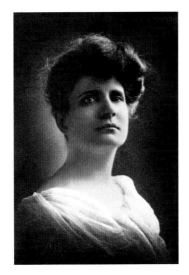

Leonide C. Lavaron portrait from *The Keystone* (June 1905). Author's collection.

Lavaron was a renowned jeweler and metalsmith when she established a studio in the FAB in 1907. She designed elaborate jewelry executed by her and a cadre of experienced silver and goldsmiths. Her metalwork included silver, copper, brass, and bronze candlesticks, lanterns, bowls, urns, acid-etched plates, silverware, and lamps with shell shades. Much of her burnished and chemically treated copper was given iridescent hues, similar to the work of ancient Egypt, and it was known as Lavaron Copper and Lavaron Art Metal.

Born in New York, Lavaron arrived in Chicago with her parents as a child. In 1891, she was a professional artist known for her watercolors and painted china, the latter of which she exhibited in the 1893 World's Fair. In 1900, she taught burnt leather work and crafts to individual students. By 1901, she had delved into art metal work and jewelry, finding it far more lucrative than painting. In 1902, she exhibited her unique iridescent copper at the annual arts and crafts show at the AIC, which was illustrated in *Brush and Pencil.* Other works included scarab jewelry, and an elaborate Brazilian beetle necklace set in green gold that was described as "a necklace reflecting the instincts of savagery but extremely fetching." In 1905, she exhibited her famous peacock tiara made in gold set with opals. She featured her work in many of the AIC shows through 1919, displaying unusual gold, silver, and platinum jewelry set with precious and semi-precious stones, lamps with seashell shades, lanterns, and candlesticks. She adopted seashells in her lamp shade designs after a visit to Pasadena in 1906. Her work was praised coast-to-coast in numerous, illustrated magazine and newspaper articles, including the *International Studio,* and feature articles by Irene Sargent in *The Keystone*. She exhibited in cities as diverse as Boston, New York, Minneapolis, Los Angeles, and Pasadena. Lavaron was a member of the BSAC and the National Society of Craftsmen; she was also

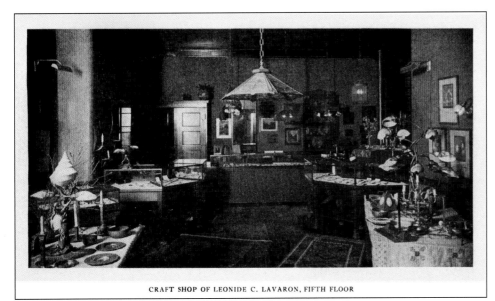

CRAFT SHOP OF LEONIDE C. LAVARON, FIFTH FLOOR

Lavaron Studio illustrated in the *Book of the Fine Arts Building* (1911). Author's collection.

vice chair of the Art Alliance of America. Lavaron juried some of the AIC shows and gave lectures on jewelry up until her death in 1931. Some of her work is signed Lavaron Art Metal.

Card from Lavaron Studio with a hand-written notation. Author's collection.

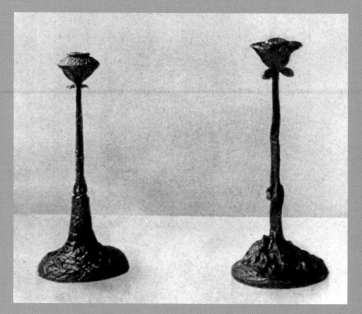

Lavaron lamps, candlesticks and jewelry, including her famous gold tiara with opals. From various early magazines. Author's collection. (Above, below and opposite page)

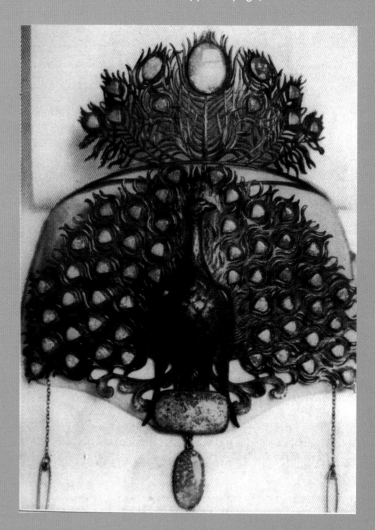

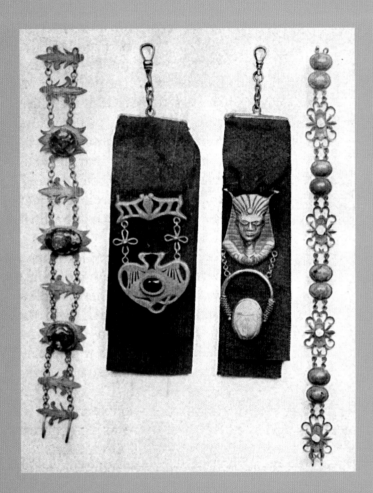

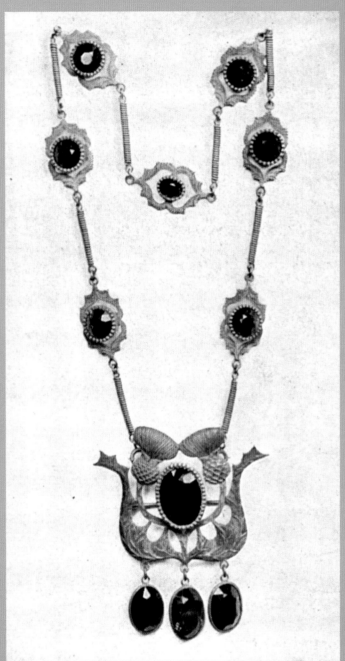

Jessie Marion Preston (1873–after 1942)

Studio names

Jessie M. Preston, 1898–1902
Preston & Brison, 1903–1910
Jessie M. Preston, 1910–1918
The Gift Shop, c.1914–c.1918

Preston's ingenious designs for hand-wrought candlesticks and jewelry epitomized the creativity and inventiveness that defined the nascent arts and crafts industries in Chicago. An honors graduate of the decorative design program under Louis Millet, she formed a design practice and was one of the first residents of the FAB. Her nature-themed, handwrought candlesticks were singled out for their originality and beauty. In less than a week after one of her bronze candlesticks with a base of twining fish was exhibited, she received orders to make four dozen of them. Preston also created unusual trophies, metal desk sets, boxes, electric shades, and decorative items. Exhibitions, including the annual arts and crafts shows at the AIC from 1902 to 1917, vaulted her exquisite, finely hammered jewelry in silver, copper, and gold, frequently adorned with enamel, pearls, opals, abalone pearl, and turquoise. In 1917, she showed platinum and diamond jewelry.

Preston displayed her lotus design candlesticks at the CACS exhibit in 1900, and bronze candlesticks at the AIC in 1902 and 1904. She was the designer and maker of the items, in contrast to Jarvie, who had his candlesticks casted by local foundries.

An Oak Park native, Preston shared her FAB studio with a variety of artisans, including Hannah C. Beye (1902–1903), Ella Brison (1903–c.1910), and Dorothy Rouse (1917–1918). In 1906–1908, she taught special courses in metalwork and jewelry at the Minneapolis School of Fine Arts. From 1914, Preston advertised her studio as "The Gift Shop." She exhibited her work extensively in Chicago, Oak Park, Boston, and throughout the Midwest, and she won several prestigious awards. She served on the board of directors for the Artists' Guild and on its metalwork jury with Robert Jarvie; she also was a founding member of the Cordon Club for women of the arts.

In 1918, Preston gave up her studio and volunteered for the war effort near the front line in Paris. She and her friend Grace Gassette taught vocational crafts and made prosthetic devices for wounded soldiers; she wrote a long letter of her initial impressions of Paris that was published in her hometown paper. After the war, she studied at the Sorbonne and worked in Paris until she returned to the United States in 1934. Records show that she lived in New York through 1942. [3]

Hand-wrought silver mother-of-pearl brooch with original box, unsigned. Courtesy of Boice Lydell, photo by author.

Marks for Jessie M. Preston. She also used an MP over a sideways letter "J". Courtesy of the Charles S. Hayes family, photos by Scott Bourdon Studios.

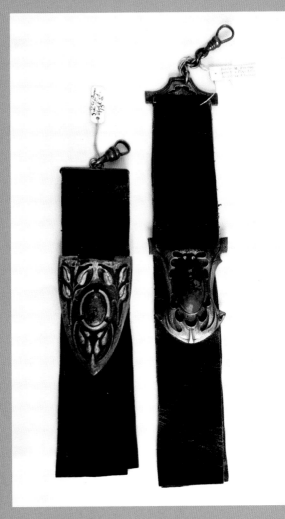

Preston blue labradorite and brown opal fobs showing intricate hammering and carving. Both fobs are unsigned but have the original sales tags attached, marked Jessie M. Preston 1028 The Fine Arts Building Chicago. Collection of Meredith Wise Mendes and Michael Levitin, photo by author.

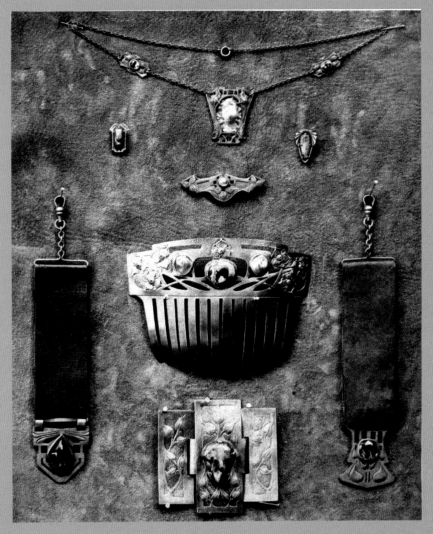

Exhibition jewelry display by Jessie M. Preston from *The Sketch Book* (December 1906). Author's collection.

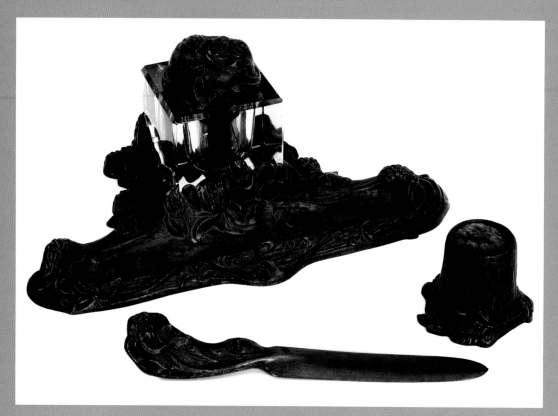

Jessie Preston desk set, three pieces include an
inkwell, letter opener and pen wipe, in bronze,
deep organic design, all pieces signed. Inkwell:
5" high. Courtesy of John Toomey Gallery.

Jessie M. Preston bronze
candelabrum in a thistle pattern,
marked J Preston Chicago. 13 1/2" x
10" Previously exhibited in *Women
Designers in the USA 1900–2000*
(Kirkham 2002). Courtesy of the
Charles S. Hayes family, photo by
Scott Bourdon Studios.

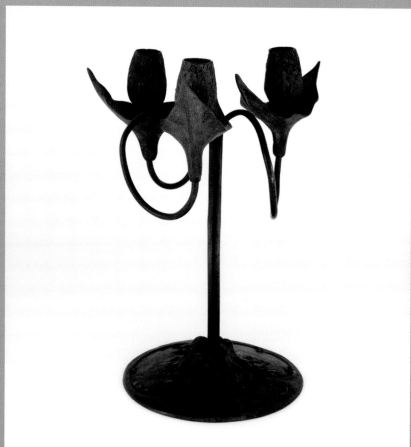

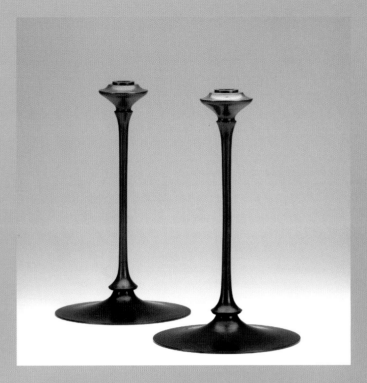

Jessie Preston, pair of bronze candlesticks, marked JMP and a letter A in a triangle. 13" high x 8" wide. Courtesy of Rago Arts and Auction Center, Lambertville, NJ.

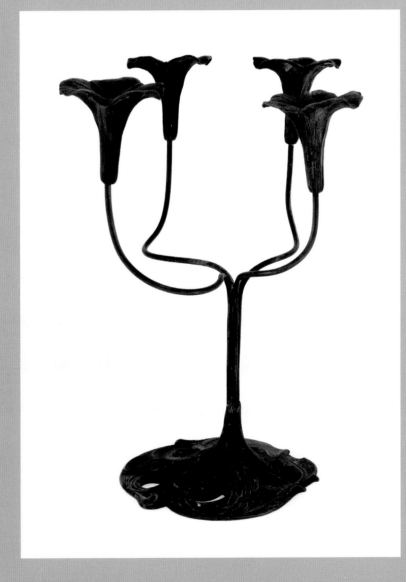

Jessie M. Preston bronze candelabrum. Courtesy of the Charles S. Hayes family, photo by Scott Bourdon Studios.

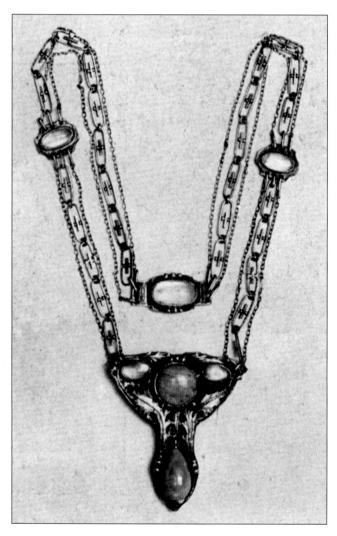

Christia M. Reade in her Fine Arts Building studio, working on a repoussé bowl. From Bennett (1904). Courtesy of the Art Institute of Chicago.

Reade silver, coral and moonstone necklace. From the *Chicago Artists' Guild* (1917). Courtesy of the Chicago Public Library.

Christia Maria Reade (1868–1939)

Reade was one of the founding artists of the Chicago Arts & Crafts Movement and a pioneer in its hand-wrought metalwork and jewelry. In 1902, she took a studio and was a creative force in the building until 1929.

Born in west suburban Lombard, Illinois, to a prominent family, Reade studied at the AIC in the late 1880s. She exhibited designs for stained-glass windows in the 1890 Art Student League exhibit and caught the admiration of Louis Millet. The following year, she joined his firm, Healy & Millet, the leading design studio in the city. At Millet's encouragement, Reade studied abroad for two years, returning to Chicago in 1894. She was one of the few women who exhibited in the Chicago Architectural Club annual exhibitions. From her studio on Wabash Avenue, she designed many stained-glass windows, including the Judge Drummond Memorial Window in the Trinity Episcopal Church in Wheaton, Illinois.

In 1897, Reade moved into the Marshall Field & Co. Annex building and co-founded a collaboration of artisans called the Krayle Company and Workshops; she served as the primary metalworker. Reade soon became well known for her jewelry.

Reade fashioned exquisite copper, silver, brass, and sometimes gold brooches, rings, pendants, clasps, and belt buckles, as well as entire belts, including an extravagant silver belt set with amethysts that resembled Louis Millet's bas-relief ornamentation found in many Louis Sullivan buildings. She exhibited her belts and jewelry in the Chicago Arts and Crafts Society exhibits from 1898 and jewelry, furniture, and copper wares in the annual arts and crafts shows at the AIC from 1902 to 1914.

Reade was recognized by several contemporary reporters as one of the finest artisans, metalworkers and jewelers of the period. Reade shared her studio with various jewelers and metalworkers over the years, including designer Johanna M. von Oven (1906), leather worker Augusta McCarn (1912) and designer Hurst F. Garrett (1913), as well as several painters. Isadore V. Friedman worked for her, and likely other silversmiths did as well.

From 1913 to 1917, Chicago metalsmith George H. Trautmann shared her studio, and the pair created innovative designs for lamps and fixtures that won a Municipal Art League prize at the AIC in 1914. Reade was active in the Artists' Guild and many other arts organizations, including associations in Oak Park and Lombard, Illinois. She maintained her FAB studio through 1929 and lived in Lombard until her death in 1939.

The TC Shop (1910–1918; 1918–1931)

Principals
Clemencia C. Cosio (1885–1978)
Emery Walter Todd (1885–1949)

In the fall of 1910, Emery W. Todd and Clemencia C. Cosio co-founded the TC Shop in the FAB as a hand-wrought jewelry studio. Cosio, a graduate of the decorative design program at the AIC, was principally the designer but also fashioned some jewelry. Todd was a graduate of the Lewis Institute who furthered his studies at the Kalo School, c.1908–1909. He exhibited original copper and silver jewelry and small silver items under his own name in the 1909 annual show at the AIC.

In 1910, the TC Shop debuted silver and pearl rings and a brooch at the annual AIC show, and showed a much larger collection of hand-wrought jewelry three years later. By 1916, the partnership faltered, and Todd concentrated on hollowware, winning an Artists Guild prize that year; his shift into metalwork may indicate that he returned to the Kalo School or studied with a Chicago silversmith, based on similarities between his work and that of the Kalo Shop. In 1916 Cosio showed only monograms at the annual AIC show.

After Todd left the partnership, Cosio continued the TC Shop by hiring many different jewelers and silversmiths to execute her designs, including Novick, Friedman, Breese, Hanck, and Gustafson. In 1918, Todd moved out of the FAB studio they shared and was no longer identified with the TC Shop. In 1920, Cosio married Nixon Hall and maintained her studio in the FAB until 1931, but by the late 1920s, it had evolved into a giftware company. In the 1930s, the Halls moved to New York and operated Clemencia & Nixon Hall, giftwares, which was active through 1959. Clemencia died in Maryland in 1978.

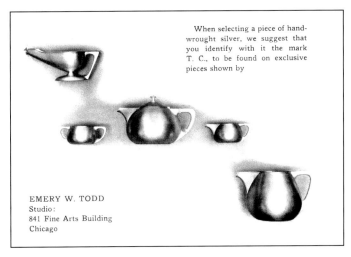

When selecting a piece of hand-wrought silver, we suggest that you identify with it the mark T. C., to be found on exclusive pieces shown by

EMERY W. TODD
Studio:
841 Fine Arts Building
Chicago

Advertisement for the TC Shop, *Chicago Artists' Guild* (1917). Courtesy of Chicagosilver.com.

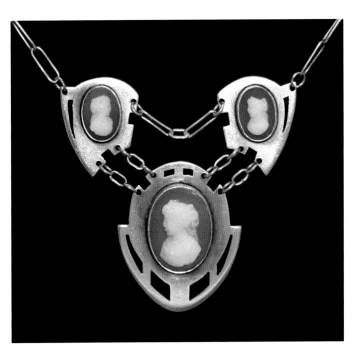

TC Shop sterling silver and cameo necklace with paper clip chain. Courtesy of Chicagosilver.com.

TC Shop marks, author's collection and photos.

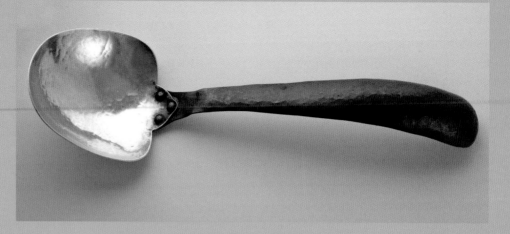

TC Shop hammered copper and silver spoon in the style of F. Novick. Courtesy of Chicagosilver.com.

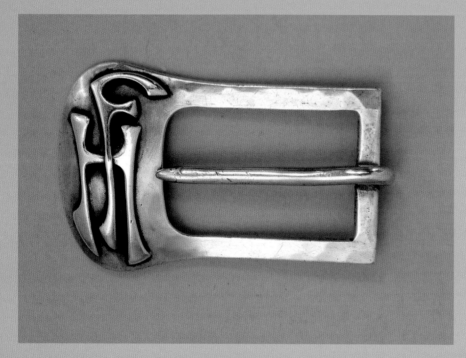

TC Shop monogram belt buckle. This style was developed at the Kalo Shop and was made by many of the Kalo entrepreneurs. Author's collection, photo by Rich Wood.

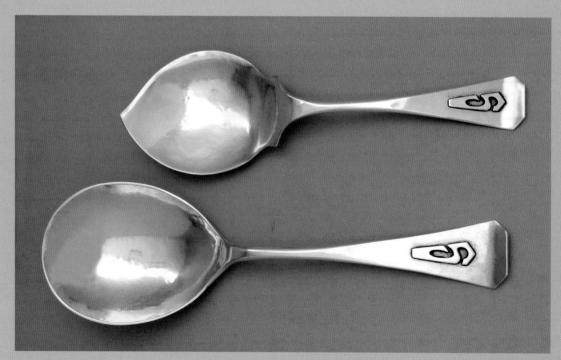

TC Shop sterling silver serving spoons with applied "S" monogram. Author's collection, photo by Rich Wood.

Todd's Shop, Todd's Jewelry Store
(c.1922–1930)

Principals
Emery Walter Todd (1885–1949)
Nelle K. Browning (1877–1950)

Todd left the TC Shop and worked for Mandell Brothers during the war. Around 1922, he launched a new jewelry and silver studio with the assistance of Nelle K. Browning. From 1927 to about 1930, he taught jewelry at the AIC. He died of a heart attack while on a trip to Florida.

Todd's Shop hallmark. Author's collection and photo.

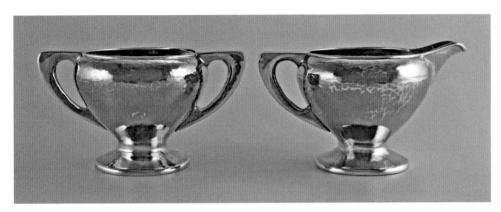

Sterling silver creamer and sugar signed Todd Handwrought Sterling. Courtesy of Chicagosilver.com.

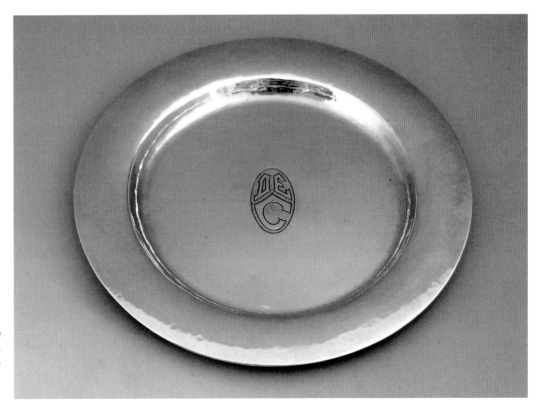

Todd sterling silver plate with engraved monogram. Author's collection and photo.

George Henry Trautmann (1873–1955)

Trautmann was a Chicago metalsmith best known for his hand-wrought copper lamps and sconces. Born in Wisconsin, he received a degree in mechanical engineering from the University of Wisconsin in 1896 before moving to Chicago. Tinkering with copper in his home workshop on Ravenswood and likely through private lessons, Trautmann became so proficient that he was selected to exhibit his copper wares in the 1909, 1910, and 1912 annual AIC shows. He teamed up with noted designer and metalworker Christia Reade and shared her studio in the FAB from 1913 to 1917. The creative collaboration led to a Municipal Art League Prize in 1914, and Trautmann went on to win an honorable mention at the Panama Pacific Exposition in San Francisco, as well as top awards from the Chicago Artists' Guild. His work included copper lamps with mica shades, candlesticks, copper and brass sconces, and copper bowls. In 1917, Trautmann became the Captain of Ordnance in the Officers' Reserve Corp, stationed in Lebanon, Ohio. In 1918, he married fellow FAB artisan Ella S. Brison. The couple moved to Wisconsin, where he worked as an engineer. They retired to Los Angeles where George died in 1955 and Ella in 1970.

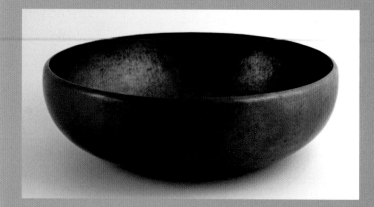

Trautmann hammered copper bowl.
Courtesy of Chicagosilver.com.

George H. Trautmann hallmark. He also used the letters GTH in a circle. Courtesy of Chicagosilver.com.

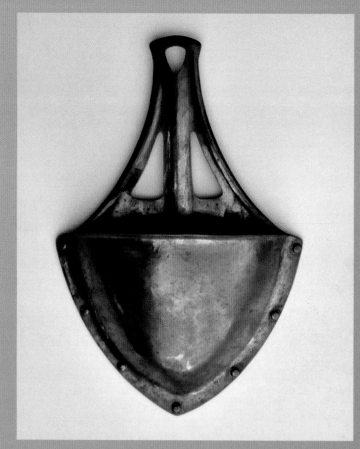

Trautmann copper wall pocket, engraved G.H. Trautmann Lamps 1039 Fine Arts Blg. Courtesy of John Toomey Gallery.

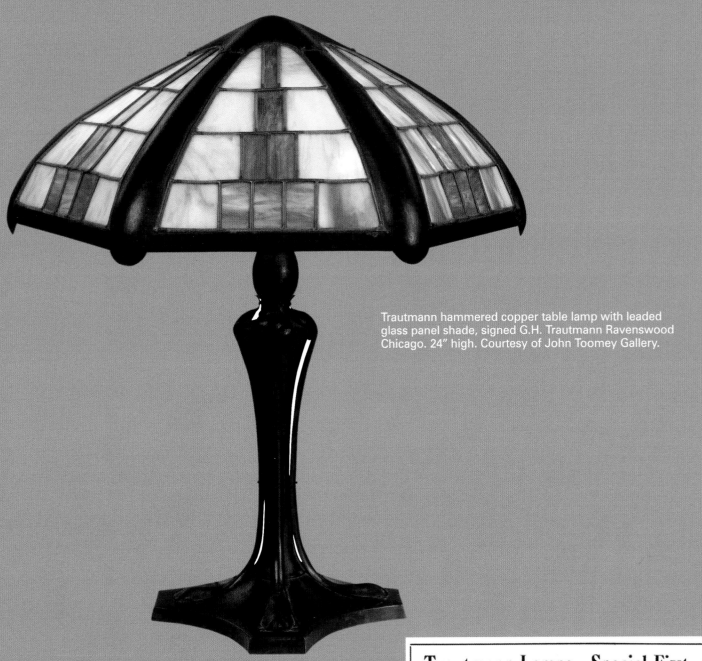

Trautmann hammered copper table lamp with leaded glass panel shade, signed G.H. Trautmann Ravenswood Chicago. 24" high. Courtesy of John Toomey Gallery.

Trautmann advertisement from the *Chicago Artists' Guild* (1914). Author's collection.

Trautmann Lamps--Special Fixtures

Exclusive designs in hand wrought lamps and lighting effects *cost you no more* than the best commercially produced fixtures.

This is possible when dealing direct with maker.

G. H. Trautmann
Business Address
4879 Ravenswood Ave.
Phone, Edgewater 6690

Exhibition Studio: 1039 Fine Arts Bldg., 410 S. Michigan Bd.

Albert Wehde (1868–1941)

German-born Wehde was a world traveler and a U.S. citizen when he came to Chicago in 1900 to pursue a jewelry career. He lived in the Tree Studio complex, studied engraving, and worked for various jewelers, as well as studying decorative design and modeling at the AIC. In 1909 Wehde was greatly disappointed when his exotic Mayan motif jewelry was rejected by the jury for the annual arts and crafts exhibition at the AIC. He resubmitted the works the following year, and new jurors Clara B. Welles, William J. Meyers, and Ellen Iglehart saw them in a better light, as they were included in the show. Buoyed by his success as a jeweler, Wehde joined Russell Freeman's studio in the FAB. His prominence as an arts and crafts jeweler continued to grow; the American Federation of Arts asked him to include his jewelry in a national traveling exhibition. That, in turn, led to Irene Sargent, one of the most respected journalists in the art world at the time, to feature Wehde and his work in *The Keystone*, a large circulation national magazine for the jewelry trade. Wehde later wrote in his autobiography that he was elated. From 1910, his work was selected in every annual AIC show through 1915 and he rented his own studio in the FAB from 1912. His exhibited work included large collections of silver and gold jewelry set with gemstones, a steel and gold ring inlaid with diamonds, a silver salad set with carved designs, silver and copper bowls, and a silver vanity box with inlaid enamel. A reporter described one of his jewelry creations:

> *A pendant, now owned by William Wrigley Jr. and exhibited at the Art Institute last winter, was designed in carved gold, framing a turquoise carved with a Maya God. The historic Maya motif of decoration in the gold was set with cat's-eyes.*[4]

In 1914, Wehde won the coveted Municipal Art League Prize for his jewelry.

Wehde's career took a turn for the worse during World War I. An American citizen with strong sentiments for his former homeland, he turned the daily operations of his studio over to his sister in 1915 so that he could assist in a plan to promote India's independence from British rule. He was charged with fomenting revolution in violation of the U.S. Neutrality Act, and in 1917 he was convicted. Viewed widely as a political prisoner, Wehde fought his conviction to the U.S. Supreme Court, but the court refused to hear the case in 1921, and he began serving his sentence at the Federal Penitentiary at Leavenworth. Fortunately, President Harding commuted his sentence and he was released in 1922, but not before he was allowed to do research at the prison and used his precise molding and engraving skills to show how fingerprints could be forged. Wehde returned to Chicago and published three books: *Since Leaving Home* (1923), *Fingerprints Can Be Forged* (with John Beffel, 1924), and *Chasing and Repoussé* (1924). He also focused on his jewelry and metalwork, creating distinctive and innovative designs. Wehde wrote of his return:

> *There was a job waiting for me when I came back… My work bench is set up facing a window on the thirteenth floor of a skyscraper. Here I busy myself through the days, quite as I did during the last years before I started on my jaunt to the Orient, creating objects of beauty as I see and feel beauty. Platinum, gold and silver—what a world of possibilities is in them! They can be made to sing of far countries, they form links with fantastic regions where life moves along under eerie light of which the western hemisphere knows naught.*

Wehde made exquisite metalwork and jewelry in Chicago through the 1930s. He retired to Florida and died there after an operation in 1941.

Albert Wehde hallmarks. Author's collection and courtesy of Chicagosilver.com.

Wehde brooch from *Chasing and Repoussé* (1924). Author's collection.

Wehde design drawings from *Since Leaving Home* (1923). Author's collection.

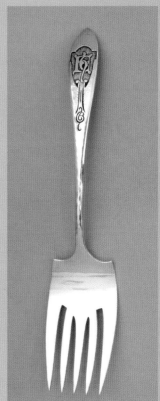

Sterling silver fork made by Towle, carved and etched by Wehde. Fork signed with Towle silver marks and Wehde. Author's collection and photo.

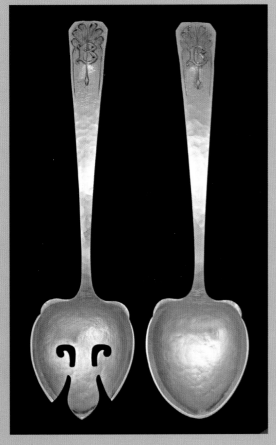

Sterling silver salad servers with engraved design, signed Wehde. Courtesy of Chicagosilver.com.

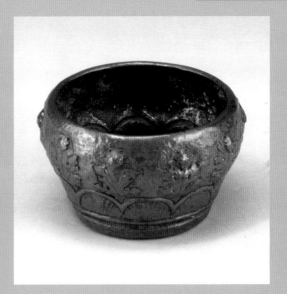

Wehde chased and repoussé copper bowl. Courtesy of Rago Arts and Auction Center, Lambertville, NJ.

Wehde repoussé copper guest book, Fridolin and Emma Pabst chased on front, inscribed
dedication by Wehde dated Dec. 6, 1936. Author's collection and photo.

James Herbert Winn (1866–1940)

Winn, who operated a studio in the FAB from 1905 to 1929, was a leading spirit in Chicago's artist colony by turning out innovative works, becoming active in the civic community, and by training a cadre of influential students who branched out nationwide.

Born in Massachusetts to Irish parents, Winn arrived in Chicago in the 1880s, and soon found his calling as a jeweler. By 1891, he was a partner at Lyman & Winn, and in 1895 he founded James H. Winn & Co., initially focusing on diamond and society jewelry. He studied painting and sculpture at the AIC.

From 1903 to 1907, Winn trained dozens of aspiring jewelers at the Art Craft Institute and he also taught metalwork and jewelry summer school at the Minneapolis Handicraft Guild alongside program director and design instructor Ernest Batchelder. In 1918, he ran the apprentice program for the Chicago Manufacturing Jewelers' Association and, from 1921, he taught jewelry making at the AIC. His protégés included Donald Donaldson, Wilhelmina Coultas, Edith Spencer Lloyd, Eda Lord Dixon, and many more. Winn was an active member of the Chicago Arts and Crafts Society, the Boston Arts and Crafts Society, the Cliff Dwellers' Club, the American Federation of the Arts, the Chicago Artists' Guild, and the Chicago Jewelry Manufacturing Association.

From 1904 to 1920, Winn's prodigious collection of jewels was selected for exhibition in the annual arts and crafts shows at the AIC, and he also served on some of the juries. His work included finely hammered silver, gold, and copper brooches set with gemstones, as well as fobs, rings, pendants, scarf pins, and cuff links. Winn also exhibited at the BSAC, in Minneapolis, and in many other locales throughout the country.

In 1929, Winn moved to Pasadena, California, and opened a jewelry shop where he still worked until he died of a stroke in 1940.

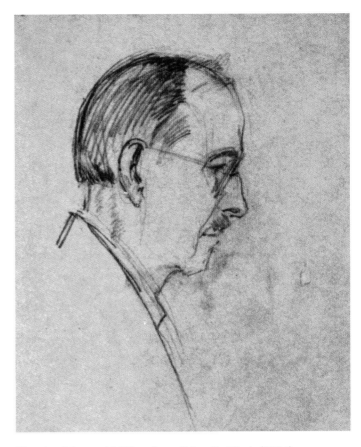

Sketch of James H. Winn from *Friendly Libels* (1924). Author's collection.

Hallmark for James H. Winn. Courtesy of Boice Lydell.

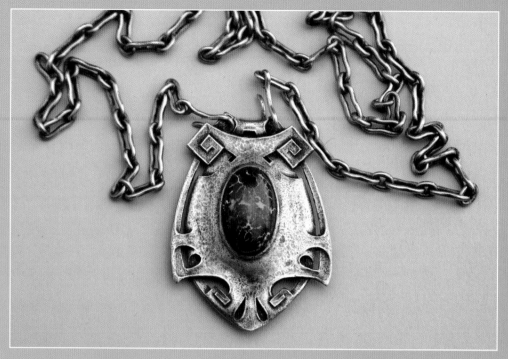

Winn hammered and carved gold memorial locket with paper clip chain, locket engraved *May 14-June 30, 1905*, signed Winn/1905. Courtesy of Boice Lydell.

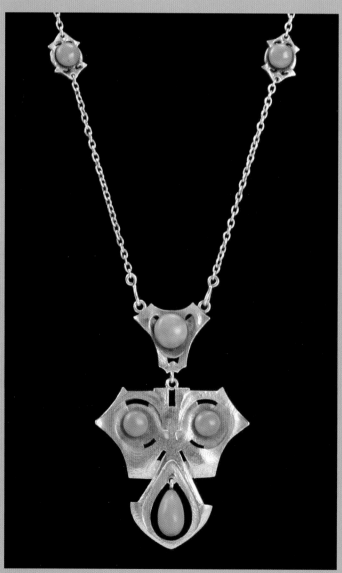

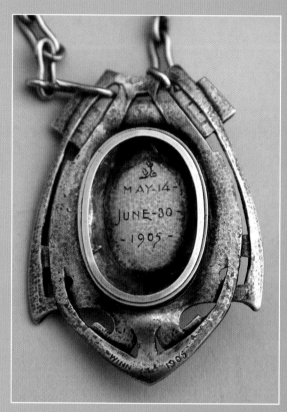

Winn carved gold necklace with coral. Courtesy of Chicagosilver.com.

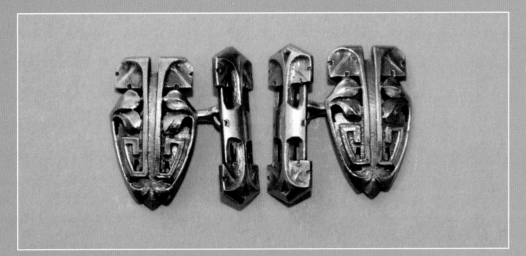

Winn 14K carved gold cuff links in a geometric design. Courtesy of Boice Lydell.

Winn 14K carved gold cuff links with lapis lazuli. Courtesy of Boice Lydell.

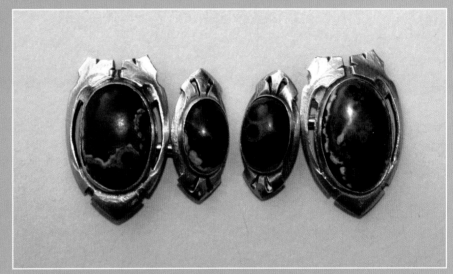

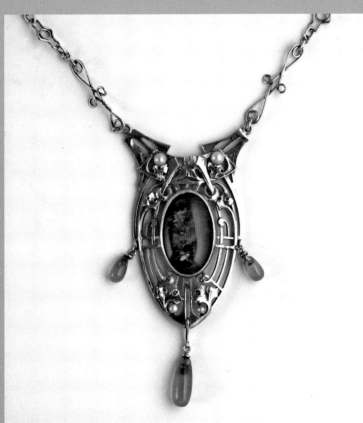

Winn hammered and carved gold necklace with opal, pearl, and green chalcedony. Courtesy of Chicagosilver.com.

Artisans with Unknown Marks

Louise C. Anderson (1858–1925)

Anderson was a prominent Chicago jeweler, metalworker and crafts worker who was a leading force in the early years of the Chicago Arts & Crafts Movement. She and her sister, Emma Kittredge, exhibited painted china at the World's Fair of 1893. Anderson was a founding member of the CACS and exhibited in its annual shows. She and her niece, Jeanette Kittredge, a noted wood carver, exhibited in many local and national shows, featuring burnt leather, hammered copper and brass, jewelry, silver, and metalwork. Anderson was one of the instructors for a metal work class at the Industrial Arts School in 1899; she also completed William J. Meyer's metalwork class at the AIC in 1902. A 1907 ad for her studio, the Work Shop, touted antique furniture, hand-wrought jewelry, lamp shades, rare porcelains, candle shades, stencils, and leather work.

Anderson had studios in the Auditorium Building (1891–c.1897), Tree Studio Building (1897–1899), 187 Rush Street with Blanche Ostertag (1899–1901), 738 Fine Arts Building (1906–1907), the Work Shop at 10 E. Van Buren (with Mary Hale Pope, 1907–c.1912) and a home workshop at 9 E. Scott (1913–1916). She was active in Chicago art circles until her death in 1925. Examples of her work have not been identified.

Katherine S. Cunningham (c.1875-)

Cunningham graduated from the AIC with Hannah Beye and Helen McNeal, and opened a design studio in Chicago. The daughter of prominent Chicago attorney and judge, William B. Cunningham, and his wife Kate Sarah, she arrived in the city with her family by 1880 from China Grove, Mississippi. In 1902, she exhibited monograms in the annual AIC show and completed William J. Meyer's metalwork class. She subsequently designed jewelry from her home studio, and was retained as the chief designer for the 1912 Lebolt & Co exhibit at the annual AIC show, designing silver for such makers as J. Edward O'Marah, David Mulholland, and C.H. Didrich. By 1916, she joined Esther Blanke in her Steinway Hall studio, along with architects E. Norman Brydges, Lawrence Buck, and Park Ridge sculptor John Paulding. Cunningham was listed under silversmiths in the city directory at that location the following year. In 1920, she was listed as a jewelry designer and, in 1930, as an interior decorator. A few examples of arts and crafts style jewelry stamped CUNNINGHAM might have been made by her.

Magda M. Heuermann (1858–1962)

Heuermann was a celebrated miniature painter who studied at the AIC and in Germany under the Munich secessionists. Born in Chicago, Heuermann moved to Oak Park in the 1920s, and she maintained a studio in the FAB from 1900 to 1921; from 1900 to 1902, she and Hannah Beye shared Jessie Preston's studio; in 1916–19, Wilhelmina Coultas shared her studio. Heuermann and her sisters were active in the Artists' Guild, and Heuermann crafted some metalwork and jewelry, as noted in 1910: "Magda Heuermann, a miniature painter, who also makes individual jewelry from which selections can be chosen to match any era or fabric. Mountings in gold and precious stones for miniatures which can be worn as lockets and pendants are a specialty with this artist." [5] She designed a ring that she exhibited in the 1903 annual show at the AIC, which was made by a C. Rothmuller. In 1904, she exhibited a bag with a silver top in the St. Louis World's Fair exhibition. A photograph of a lovely, five-panel necklace she made appears in her papers at the Smithsonian. Her signatures on paintings include Magda Heuermann written vertically, a block style MH, and a stylized M over an H, although her jewelry marks are unknown.

Margaret Ellen Iglehart (1858–1933)

Iglehart was an early Chicago artist who initially worked in ceramics before focusing on jewelry and metalwork. She maintained a studio in the Auditorium Building from 1894–c.1918. From 1909 to 1921, she exhibited in several of the AIC annual shows, featuring silver jewelry set with gem stones and gold jewelry set with Australian opals, black opals, and aquamarine. A lapis and silver necklace she showed in 1909 was mentioned in a local newspaper. By the 1920s, she also taught art in the public schools.

Pratt Studio

Principals
Emma Jeannette Pratt (1882–after 1949)
Mary Calista Pratt (1871–1948)

In 1906, Jeannette and Calista Pratt established a studio in the FAB, focusing on hand-wrought gold and silver jewelry. The Wisconsin natives participated in many exhibitions throughout the region, including the annual arts and crafts shows at the AIC in 1908–1909; Jeannette also was a juror for several of the exhibitions. Their work included silver and translucent amber necklaces, a gold, pearl, diamond, and coral pendant, an opal cameo brooch set in gold, a silver and opal brooch, lotus and thistle design jewelry, and various scarf pins and rings. An illustrated article in the *Reform Advocate* showed the sisters in their FAB studio and a platinum necklace set with 0.5–1.5 carat diamonds. Most of their work featured precious stones.[6]

A graduate of the Pratt Institute, Jeannette operated her jewelry design business in the FAB at least through 1942, making Pratt Studio one of the longest lasting tenets of the building.

Albert Z. Seror (1884–1964)

Seror, an Algerian jeweler and metalworker, arrived in Chicago in 1908 to study at the AIC. That year he debuted his creative jewelry at the annual arts and crafts show, featuring scarab neck slides set in silver, gold and silver rings, a labradorite and silver brooch, and a silver spoon. He also was the maker of a gold, silver, and pearl fob designed by Arthur Gunther, a fellow AIC graduate. Seror was also associated with artisan Charles A. Herbert, who served as a naturalization witness for him. In 1912, Seror moved to the FAB from the Auditorium Building. He exhibited in the 1913 annual AIC show, displaying a gold Egyptian bag, a silver bag, a gold comb in a peacock design, a silver watch, a gold and diamond tiara, and gem set jewelry. His work was mentioned as among the best in a *Chicago Tribune* review of the show.

Ever creative, Seror and his family were vaudeville actors as well, who traveled from New York to California when on tour. From 1925 to 1931, Seror patented a series of designs for strikingly original and whimsical stuffed animal dolls with exaggerated features. In later years, he and his wife Sadie operated the Bazaar Oriental Antique Shop on N. Clark in Chicago. Albert died in 1964.

The Swastica Shop (c.1902–1911)

Principals
Mary E. Ludlow (1871-)
Katherine L. Mills

Known workers
Bessie Bennett, c.1902–1907
Edith Deming, 1906–c.1911
Mary E. Ludlow, c.1902–1911
Katherine L. Mills, c.1902–1911
Florence Ward, c.1903
Hazel Wilcox, 1906

The Swastica Shop, named after an ancient symbol for good luck, was a noted arts and crafts design studio that exhibited frequently throughout the Midwest. Its work was included in the 1904 St. Louis World's Fair Exposition. Founded by Ludlow and Mills in the Marshall Field Annex building, several Chicago artisans made wares for the shop, including jeweler and metalworker Bessie Bennett. The shop moved into the FAB in 1905 and the McClurg Building in 1911. The studio variously featured artistic metal, jewelry, leather and wood work, as well as its classic shades for lamps and candles.

Leatherworks Known to Make Metalwork & Jewelry

The Wilro Shop (1902–1910)

Principals
Minnie Dolese(1864–1939)
Rose Dolese (1866–1932)

In 1900, the Dolese sisters graduated with degrees in decorative designing from the AIC, and Rose became a founding member of the Kalo Shop, focusing on hand decorated leather items; her sister Minnie joined a year later. In 1902, they founded the Wilro Shop in the FAB. Their studio was known primarily for strikingly original illuminated leather, and also copper and brass metalwork, jewelry, and hand woven fabrics made by Christina Nystrom. They exhibited leather items in the 1904 St. Louis World's Fair exposition and in the annual arts and crafts shows at the AIC from 1902–1905 and 1907–1909. In 1907, they won a silver medal for an illuminated leather book shown at the AIC. In 1910, they closed their FAB studio and worked from their home in Evanston through the 1920s.

Wilro Shop hallmarks. Author's collection and photo.

IV

The Kalo Shop

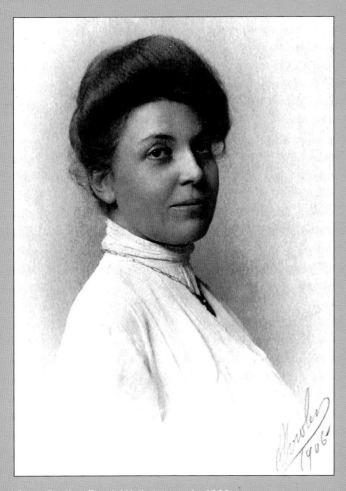

Clara Pauline Barck Welles portrait, 1906.
Courtesy of Stanley Hess.

The Kalo Shop (1900–1970)
Chicago, Illinois

Kalo Shop locations: Chicago and Park Ridge

175 Dearborn, 1900–1902
916 Fine Arts Building, 1903–1907
8 Jackson Blvd., 1907
Park Ridge, IL, workshops and school, 1907–1914
182 Michigan Avenue (308 S. Michigan Avenue), 1908–1913
32 N. Michigan Avenue, 1914–1919
221 E. Ontario, 1919–1920
416 S. Michigan, 1920–1924
152 E. Ontario, 1924–1936
222 S. Michigan, 1936–1970
226 S. Wabash, workshops, 1936–1970

Kalo Shop, New York Store, 1912–1916

In 1912, at the height of the arts and crafts metalwork movement, Clara Welles launched a branch of the Kalo Shop in New York, managed by her sister Helena Barck. In December 1911, the Kalo Shop signed a sub-lease on an upscale Manhattan studio at 718 Fifth Avenue – reported in the *New York Daily Tribune* as probably the highest rent ever paid for a similar property. In 1915, the Kalo Shop moved to 130 W. 57th Street, before shutting down at the end of 1916. Sales of Kalo silver continued in New York at the Milch Galleries and later through Anne Doughty's shop at least through 1939. Kalo works that are stamped with the Chicago and New York logo were made between 1912 and 1916. [13]

For a list of Kalo Shop workers, see Appendix 1.

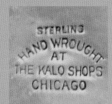

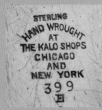
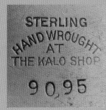

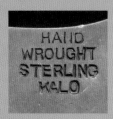

Most common Kalo Shop jewelry and metalwork hallmarks. Kalo was used from c.1902; Kalo 14k, used c.1902–1970, Park Ridge, used 1908–1912; Kalo Shops with Chicago, used in 1912; Chicago and New York was used 1912–1916; Hand Wrought at the Kalo Shop was used 1917–1970 and a variant on the mark was used for jewelry, c.1940s–1970. Marks from author's collection and courtesy of Chicagosilver. com.

Kalo Shop logo. From *Chicago Tribune* (Jan. 13, 1901). Author's collection.

From 1900 the Kalo Shop was synonymous with innovation and entrepreneurship in arts and crafts design, jewelry and metalwork. Founded in Chicago by Clara Pauline Barck and a small band of women designers—all of whom were graduates of Louis J. Millet's decorative design course at the Art Institute, the Kalo Shop quickly became recognized as a leader in the emerging art industries sweeping America. No single studio embodied the breadth of the Arts & Crafts Movement or had such a great impact on the spirit of a major city than the Kalo Shop. Its persistent quality, original designs, progressive politics and emphasis on entrepreneurship—as well as the crucial role women played in its success—made the Kalo Shop unique. Named after the Greek word "to make beautiful," the shop epitomized the philosophy of the British Arts & Crafts Movement coupled with the intensity of Chicago commerce: women entrepreneurs like Barck believed they could build profitable businesses, create jobs, promote equality for women and immigrants, and improve the conditions of working people through the new and exciting industry of hand-wrought art and handicrafts.

The Kalo Shop, co-founded by Barck, Bertha Hall, Rose Dolese, Grace Gerow, Ruth Raymond, and Bessie McNeal, started as an avant-garde design studio that transformed mundane objects into artistic feats.[1] A *Chicago Post* reporter noted several weeks after the shop opened: "They have the largest kind of ambitions for future interior decorating and architectural work, but just now is the day of small things with them. They are not ashamed to say that one of their successes has been with that humble article, the shopping bag, done in a new way, with a genuine Arabian pattern cut out in brown leather over yellow." The shopping bag became an overnight success, and the Kalo Shop also injected creativity and innovation into hand-crafted leather accessories, lamp shades, tiles, furniture, bookplates, burned wood items, weaving, embroideries, purses, handbags, and jewelry. From its humble beginnings, the Kalo Shop rapidly moved to the vanguard of arts and crafts design studios throughout the nation. Their motto, as taught by Millet, was to create objects "beautiful, useful, and enduring."

Many women came and left the partnership, but Barck, who was elected the manager from the beginning, persisted in building a collaborative network of creative crafts workers with new artisans, especially in jewelry and metalworking.

In December 1903, at the annual AIC show, Mabel Conde Dickson exhibited the earliest known jewelry made at the Kalo Shop, which consisted of an oxidized silver fob and a green gold-on-copper hat pin set with a turquoise scarab. Four months later, Hannah C. Beye exhibited a silver buckle, watch fob, chain, pin, and ring. In metalwork, Agnes Dyer Cox showed candlestick designs in 1902, and, in 1905, Metta F. Morse and Barck (who by that time had married and used her married name Clara B. Welles) exhibited brass and copper candlesticks in Detroit.

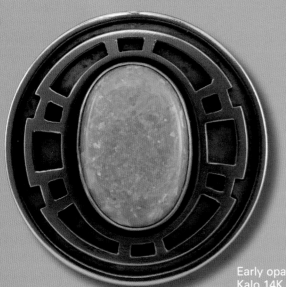

Early opal and gold brooch with geometric design, marked Kalo 14K. Courtesy of Didier Ltd. Photo by Rich Wood

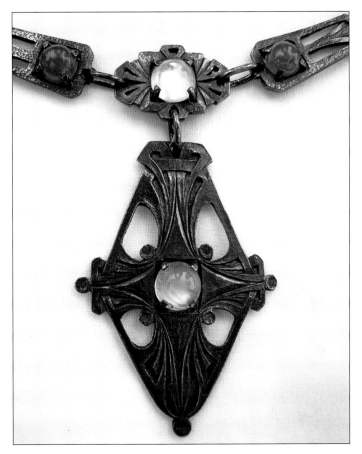

Hannah Christabel Beye (Mrs. James L. Fyfe) (1879–1965)

Born in Chicago and raised in Oak Park, Illinois, Beye graduated from the decorative design program at the AIC and became an accomplished jeweler, metalworker, designer, and instructor. From 1902–1903, she worked out of Jessie Preston's studio and the Oak Park natives frequently exhibited at the same shows. In 1904, Beye merged her jewelry practice into the Kalo Shop. She participated in many exhibitions throughout the Midwest and helped establish the Kalo Shop as a leader in innovative jewelry designs. A burnished silver belt made while at the Kalo Shop received special attention in the press. In 1907, she taught metal work at the Academy of Fine Arts in Chicago. Later that year, she married architect James L. Fyfe and left the Kalo Shop. She was a founder of the Oak Park Art League and exhibited her jewelry and metalwork at the Oak Park Guild of Applied Arts and the Fine Arts Society at least through 1924, operating out of her home workshop. Her works included intricately carved metal, enamel, pierced and hammered designs.

Beye Fyfe was active in women's rights issues, founded what became the League of Women Voters in Oak Park, and was instrumental in the fight to allow women to serve on juries. She made pencil sketches and book plates throughout her life and at the age of 82, she illustrated a book, *Little Old Oak Park.* Her son, William Beye Fyfe, became a well-known architect and was one of Frank Lloyd Wright's first apprentices at Taliesin in Spring Green, Wisconsin. Beye Fyfe died while visiting in Evanston in 1965.

Photo of Hannah C. Beye, an early jeweler for the Kalo Shop. Courtesy the Fyfe family.

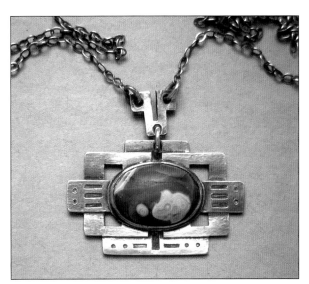

Sterling necklaces, one with turquoise and one with moonstone, by Hannah C. Beye at the Kalo Shop, c.1904. Both are unsigned. Courtesy of the Fyfe family, photos by author.

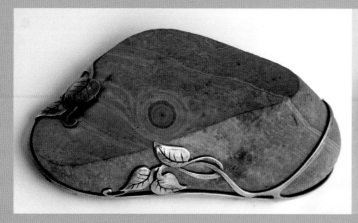
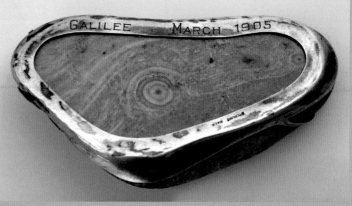

Kalo Shop paperweight, set in sterling silver and engraved *March 1905*. This is the earliest known piece of dated Kalo silver. Courtesy of Chicagosilver.com.

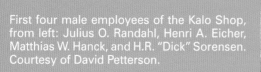

The Kalo Arts Crafts Community House in Park Ridge, IL, 1907–1914. Author's collection.

First four male employees of the Kalo Shop, from left: Julius O. Randahl, Henri A. Eicher, Matthias W. Hanck, and H.R. "Dick" Sorensen. Courtesy of David Petterson.

Men and women artisans who studied at the Kalo School and made items in the worksshops, posed in front of the main house. Courtesy of Stephen H. and Holly Randahl.

Early brass tray and copper blotter corners, all marked Kalo. Courtesy of Chicagosilver.com.

Kalo copper fork, marked. Courtesy of Chicagosilver.com.

Repoussé copper box with GSW chased on the cover for George S. Welles, marked Kalo under the lid. Someone later wrote lightly on the bottom: *Kalo Shop, Made 1906, Mr. George S. Welles, Husband of Clara Barck Welles.* The piece was made by Clara Welles for her husband. Courtesy Chicagosilver.com.

Kalo Park Ridge copper tray with stones. Courtesy of Chicagosilver.com.

Sterling silver trumpet candlestick marked Kalo Sterling 8552. Courtesy of Chicagosilver.com.

Many of the artisans of the era sold their wares from their studios, but they also relied heavily on sales from exhibitions across the country, which left a lasting impression on local communities about what entrepreneurial women and men might accomplish from the power of arts and crafts in the "modern age." In 1904, Kalo Shop artisans, including Barck and Grace Gerow, exhibited leather goods at the St. Louis World's Fair, and Gerow won a bronze medal for her work, as did former Kalo workers Rose and Minnie Dolese.

While working at the Kalo Shop, Barck met George S. Welles through Frederick Richardson, a revered drawing instructor at the AIC and George's son-in-law. Welles was an ultra-charming ladies' man and an entrepreneur with a dicey reputation. Divorced from his first wife, Welles was fully committed to the life of a gentleman but possessed little means of paying for it beyond securing investment capital for various odd inventions. He had been sued, unsuccessfully, by a myriad of investors by the time he and Clara married in February 1905. In September 1905, Clara secured investment capital from several women, including restaurant owner Claudia Kellogg, and incorporated the Kalo Shop, thus shielding her and the shop from any lawsuits related to her husband. George's sole equity in the company consisted of one lone share of stock that was transferred to him in 1908. [2]

Clara Welles dreamed of establishing an arts and crafts school and workshop in harmony with nature, and she finally had the opportunity after moving to suburban Park Ridge, Illinois, with her husband. [3] In September 1906, Clara's sister, Helena "Phoebe" Barck, bought the large, rambling farm house at 322 Grant Place with investor funds. The home had been built by George Welles for his first wife, Ella Robb, but it had been sold in their divorce. Helena Barck transferred the house to the Kalo Shop for stock, giving birth to the Kalo Arts Crafts Community House.

Park Ridge already enjoyed a solid reputation as an artists' colony. Many AIC instructors as well as sculptors, painters, musicians, illustrators, and like-minded supporters lived in the picturesque and verdant town from the turn of the century, including Richardson. With the foundation of the Kalo Arts Crafts Community House, the town soon was alive with artists and crafts workers. The Kalo Shop sold an extensive line of crafts made in Park Ridge, including jewelry, copper, and brass decorative objects, baskets, pottery, woven fabrics, leather goods, drawings, bookplates, and the like.

In 1907, the Kalo Shop expanded more into artistic silver and metalwork by recruiting Julius O. Randahl, its first professional silversmith. Randahl had worked on the wholesale colonial silver line at Marshall Field & Co., and he executed Welles's designs in hammered silver that would soon become the hallmark of the Kalo Shop. Demand for finely crafted silver wares grew rapidly, and Welles recruited master silversmith Henri A. Eicher in January 1908, as well as jewelers Matthias Hanck and Dick Sorensen later that spring. These professional silversmiths and jewelers complemented the abundant output of crafts, metalwork, and jewelry from women crafts workers and designers. Women artisans housed in the "big house" already had made the Kalo Shop famous through their weavings and jewelry by the time the shop expanded into hammered copper and silver, and Randahl likely instructed a new cadre of women metalsmiths. A January 1908 article in the *Los Angeles Times* touted silver made by the Kalo Girls, and April articles in the *Decatur Review* and *Chicago Post* highlighted gold and silver jewelry as well as bowls, spoons and ladles. [4]

The School of the Kalo Workshop launched in 1908[5] with classes in jewelry making taught by Hanck; the initial program attracted 20 young women, many of whom excelled at the craft and later worked for the Kalo Shop or companies throughout the Midwest. The Kalo Arts Crafts Community House and School in Park Ridge became a haven for aspiring and experienced artisans and grew to more than 50 people by 1911. Welles organized the artisan workers into three functional units: a silversmithy, men's jewelry, and the long-standing jewelry and crafts work made by women workers; each unit had a shop manager or foreman.[6] Of the known leaders, Eicher managed the silversmithy from 1908 to 1916, followed by C.H. Didrich, and then Peter Berg; women's jewelry was managed by Mildred Bevis and then Esther Meacham; and men's jewelry was managed by Kristoffer Haga, c.1913–1914.

Mildred Belle Bevis (Mrs. Marshall Hanks)
(1883–1980)

In 1909, Mildred Belle Bevis arrived at the Kalo School in Park Ridge, having trained at the California School of Design and the Washington School of Fine Arts in St. Louis. After studying under Matthias Hanck at the Kalo School, she became an instructor in 1910. At least from 1909–1911, her name appears in Kalo customer order books and her notebook of designs at the AIC shows a variety of arts and crafts jewelry in pierced and floral designs as well as small trays, creamer and sugar, and a water pitcher. Her friends and jewelry students at the Kalo School included Esther Meacham, Dorothy and Myrtle Wood, Julie Mayer, Gertrude Atwell, and Edna Coe. In September 1913, Bevis left the Kalo Shop and married Marshall Wilfred Hanks, retiring from the business.

Sugar bowl and cream jug, bowl, tray, c. 1910–1913. Bevis, Mildred B., designer. Mildred B. Bevis notebook of designs for the Kalo Shop, Ryerson and Burnham Archives, The Art Institute of Chicago. Courtesy of The Art Institute of Chicago.

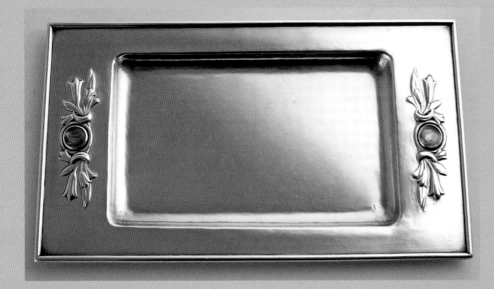

Kalo sterling silver tray with pearl.
Courtesy of Chicagosilver.com.

Kalo sterling paper knife with pearl.
Courtesy of Chicagosilver.com.

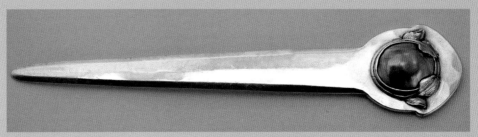

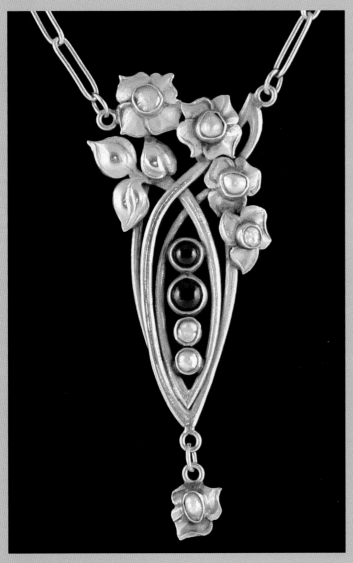

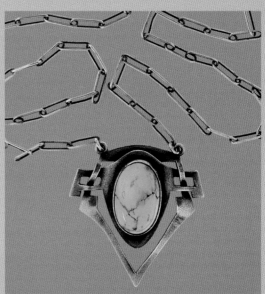

Turquoise and sterling silver Kalo pendant,
courtesy of Rago Arts and Auction Center,
Lambertville, NJ. and Kalo sterling and abalone
belt or scarf pin, author's collection and photo.

Kalo gold, garnet, and pearl necklace in a floral
spray design. Courtesy of Chicagosilver.com.

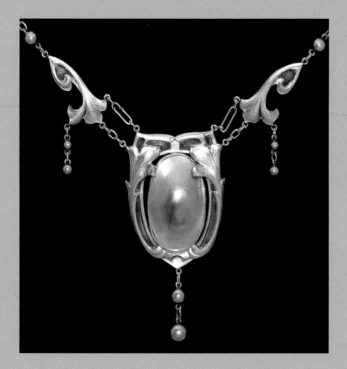

Kalo brooch with pearl. Courtesy of Curators Collection, photo by Rich Wood.

Kalo finely hammered and carved silver necklace with pearl. Courtesy of Chicagosilver.com.

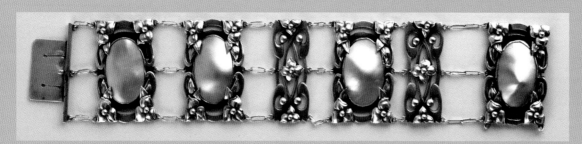

Kalo sterling silver panel bracelet with pearl. Courtesy of Chicagosilver.com.

Kalo 14K rose gold and turquoise brooch. Courtesy of Curators Collection, photo by Rich Wood.

Kalo scarab, citrine, and moss agate rings, all marked Kalo. Courtesy of Curators Collection, photos by Rich Wood.

Kalo 14K gold and citrine pendant. Courtesy of Curators Collection, photo by Rich Wood.

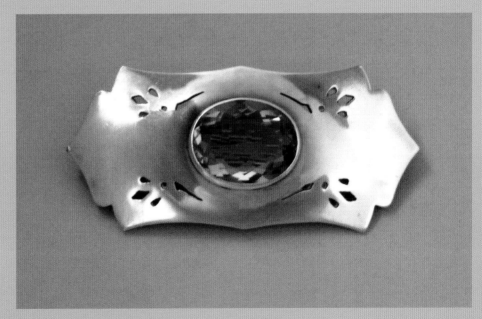

Kalo sterling silver brooch with topaz. 2.5" long. Author's collection and photo.

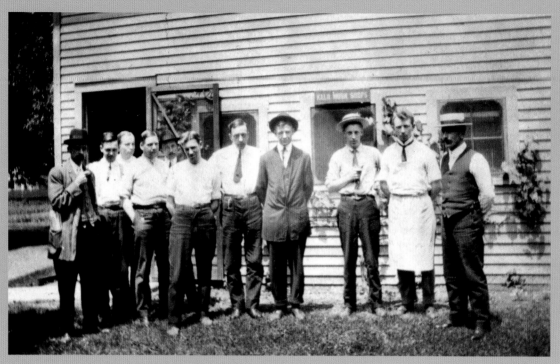

Kalo silversmiths in front of the Park Ridge workshop, c.1914. Left to right: Edward H. Breese, Peter L. Berg, unknown, Julius O. Randahl, unknown, unknown, B.B. Andersen, unknown, Sven W. Anderson, unknown, and Henri A, Eicher. Courtesy of David Petterson.

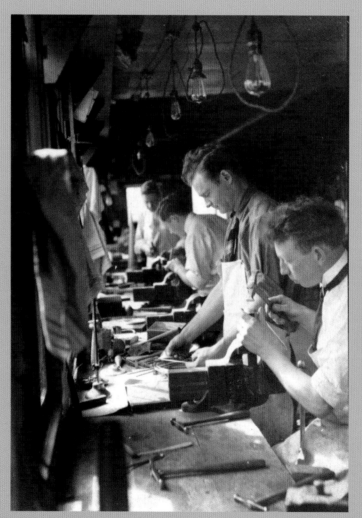

Interior of a Park Ridge workshop. From the front: an unidentified Kalo silversmith, Walter Mulholland, and two others. The facility was the Mulholland workshop or the Kalo School. Courtesy of the Mulholland family.

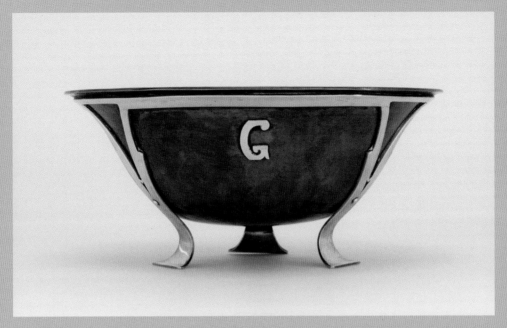

Copper bowl with sterling silver frame with applied "G" monogram, marked with the Park Ridge logo. Courtesy of the Charles S. Hayes family, photo by Scott Bourdon Studios.

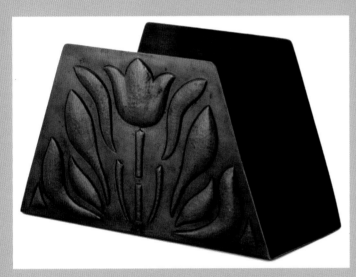

Kalo copper letter holder, engraved HHEF and marked with the Park Ridge logo. Courtesy of Chicagosilver.com.

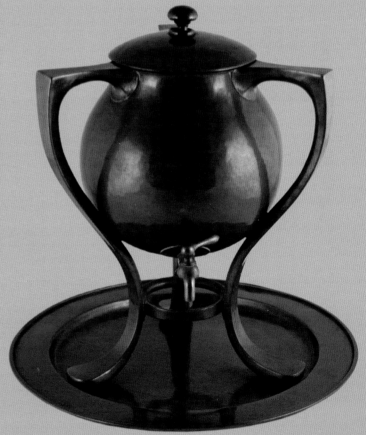

Kalo Park Ridge copper samovar, marked with the Park Ridge logo. 15.5" high. Courtesy Chicagosilver.com.

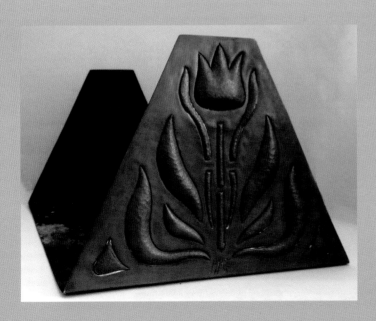

Matching copper book shelf, engraved HHEF with Kalo Park Ridge logo. Courtesy of the Charles S. Hayes family, photo by Scott Bourdon Studios.

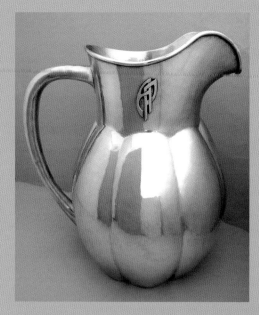

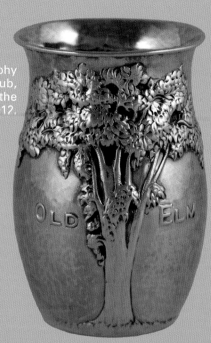

Kalo sterling silver repoussé trophy cup for the Old Elm Country Club, Highland Park, IL, marked with the Chicago and New York logo, c. 1912. Courtesy Chicagosilver.com.

Kalo sterling silver water pitcher with applied AP monogram for Adeline Phillipson, the original owner. Marked Hand Beaten at Kalo Shops Park Ridge Ills. Sterling. 9.375" high. Author's collection and photo.

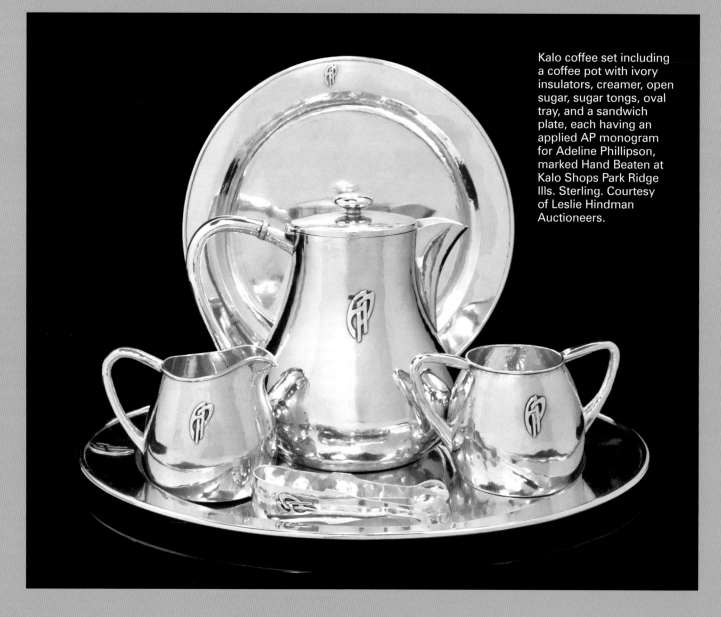

Kalo coffee set including a coffee pot with ivory insulators, creamer, open sugar, sugar tongs, oval tray, and a sandwich plate, each having an applied AP monogram for Adeline Phillipson, marked Hand Beaten at Kalo Shops Park Ridge Ills. Sterling. Courtesy of Leslie Hindman Auctioneers.

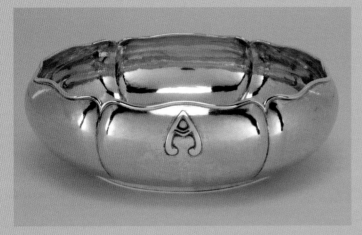

Fluted Kalo bowl with applied "A" monogram, marked with the Chicago and New York logo. Courtesy of the Charles S. Hayes family, photo by Scott Bourdon Studios.

Sterling silver pitcher spoons with applied monograms, a design developed at the Kalo Shop. Top spoon signed Mulholland, others marked Kalo H201.

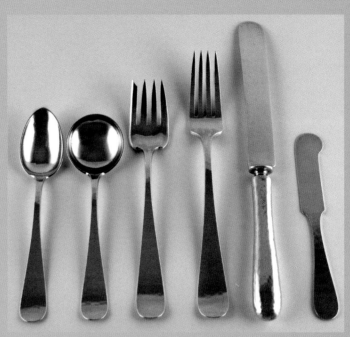

Place setting of Kalo sterling silver flatware. Courtesy of Chicagosilver.com.

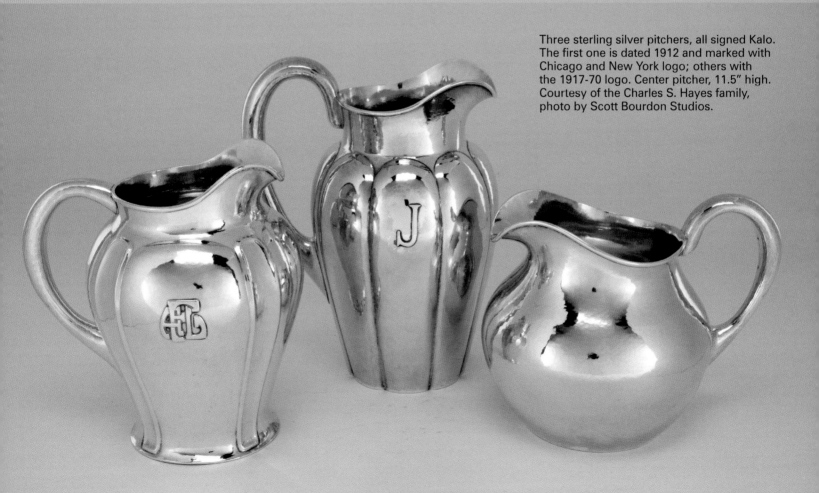

Three sterling silver pitchers, all signed Kalo. The first one is dated 1912 and marked with Chicago and New York logo; others with the 1917-70 logo. Center pitcher, 11.5" high. Courtesy of the Charles S. Hayes family, photo by Scott Bourdon Studios.

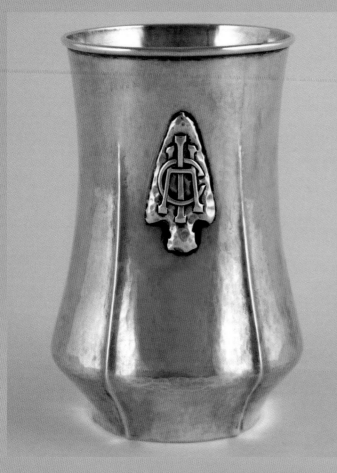

Kalo sterling silver trophy cup with applied arrowhead and IHC, dated 1917. Courtesy of Chicagosilver.com.

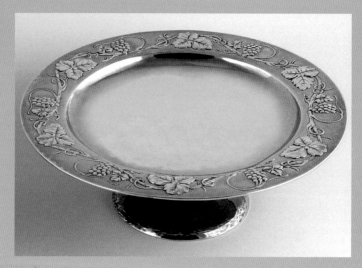

Kalo repoussé compote in a grapevine and leaf motif. Engraved on the bottom, *1895 Adele Enloe Wilkinson George Lawrence Wilkinson 1920*. Signed Sterling Hand Wrought at Kalo Shop K575SS. Courtesy of Chicagosilver.com.

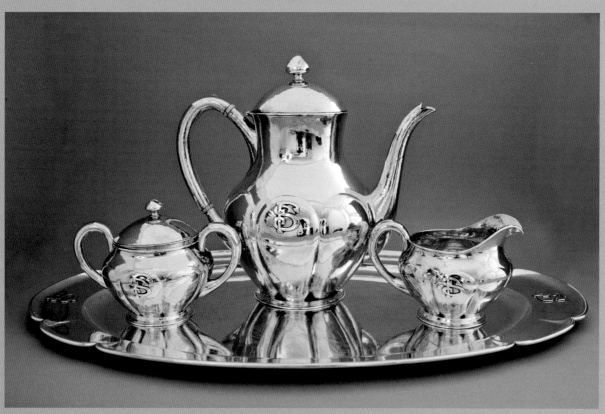

Kalo sterling silver coffee service with tray, marked with Chicago and New York logo, dated 1916. Courtesy of the Charles S. Hayes family, photo by Rich Wood.

Rooster decoration on a sterling silver child's porringer that Clara B. Welles gave to B.B. and Florence Andersen on the birth of their son. Porringer engraved *Bjarne Seth* and *July 3, 1928*. Courtesy of the Andersen family, photo by Bruce Brewer.

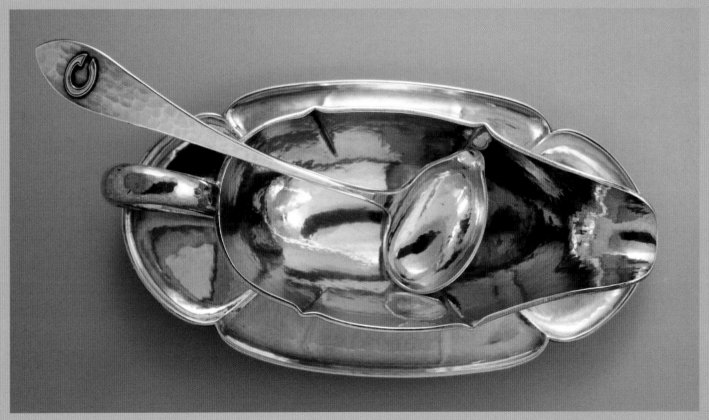

Kalo sterling silver gravy boat, tray, and ladle, designed for John W. Campbell of The Apartment in New York. Ladle marked Kalo and engraved *J.W.C. 1915*. Gravy boat marked with the Chicago and New York logo and engraved *Designed and handwrought for John W. Campbell 1916*. Tray marked with the later Kalo logo and engraved *Designed and handwrought for Rosalind D. Campbell 1921*. Courtesy of the Charles S. Hayes family, photo by Scott Bourdon Studios.

The creative output of the Kalo Shop came from the diversity and imagination of the individual designers and crafts workers, but Welles oversaw the workshops and insisted on universal quality. She also was the consummate designer, and she would interview customers at length to get a personal insight into their lives before she would design an original piece of silver or jewelry. Some items might include the leaves of a favorite tree or vine from a childhood estate; most reflected special memories or places; all would be unique and customers would return countless times for special-occasion silver. The silversmithy and jewelry divisions grew rapidly, and the Kalo Shop attracted some of the finest professionals in the country. In 1912 silversmiths David and Walter Mulholland arrived in Park Ridge to teach at the school and work for the Kalo Shop; by the fall, they had launched their own studio. Former Kalo silversmith J. Edward O'Marah, who was the foreman of the Lebolt & Co. silver workshop, enlisted David Mulholland and other Park Ridge silversmiths to craft exceptional silver for Lebolt's planned entry in the 1912 annual AIC show; Katherine Cunningham, a 1901 AIC graduate, was the designer for the items. The Mulhollands also organized a second exhibit for the 1912 show under their own names, featuring a silver chalice with a gold panel. The piece was designed by David and made by Walter and another relative, Daniel E. Mulholland, and won an honorable mention. In 1913, the Mulhollands exhibited a single gold and pearl fob in the annual AIC show, vaunting their skill in jewelry to complement their metalwork.

The Kalo Shop continued to recruit silversmiths, including B.B. Andersen and C.H. Didrich from Norway and Edward Breese from England, as well as a myriad of designers, jewelers, and crafts workers who created many original designs that became distinctive motifs in the American Arts & Crafts Movement. The Kalo School attracted many admirable students as well; Welles noted that Grant Wood was one of her students before he joined the men's jewelry division.[7] Welles was also committed to maintaining ideal work conditions, with plenty of light, fresh air, reasonable hours, and an artistic social environment than promoted innovation. Unlike most traditional businesses at the time, Welles believed in collaboration, harmony, and cooperation, and she encouraged entrepreneurship at every opportunity. Many of the Kalo Shop employees started their own companies—often in the evening after a full day at work until they became self-sufficient—with the blessing and support of Welles. Hanck and Randahl founded the Julmat in 1910.

Welles was proud of such ventures and noted to a reporter at the *Christian Science Monitor* years later that almost all of her workers only left the Kalo Shop to start their own businesses.[8] Her unique and highly significant corporate philosophy was responsible in large part for transforming Chicago and the region into the leader of hand-wrought silver and metalwork during the American Arts & Crafts Movement.

While Welles promoted creativity and entrepreneurship, she was fully committed to the brand of the Kalo Shop and she did not allow any individual workers to sign their works. After 1905, Kalo workers were not mentioned by name in exhibitions either; for example, in the 1921 annual AIC show, where exhibitors, designers, and makers were always noted, Welles simply listed "The Kalo Shop" as maker and designer for sterling silver wares.

Welles was held in high esteem by her workers, including men who likely had never worked for a woman and who might have had difficulty doing so in more traditional lines of employment. Many sources cited the fact that she was regarded as a true American pioneer, as reflected in popular folklore at the time, because she had traveled the Oregon Trail with her parents and five sisters in the 1870s. The Barck women built a life in the barren West and thrived through hard work and democratic values. Kalo workers saw her as a pinnacle of strength and American character, and respected her beyond reproach.

Welles also saw her role as that of a pioneer, particularly for the greater good, and she dedicated herself to women's suffrage with nearly the same resolve as she had towards the Kalo Shop. Welles was an activist in Illinois, culminating in her organization of the Illinois contingent to the enormous *Votes for Women* march in Washington, D.C. in March 1913. Welles designed the women's hats, banners, and outfits; she also led the women in marching drills relentlessly along the route of the Suffragette Train as it made its way to the Capital. When the march got underway, it quickly devolved into a vicious melee by drunken and bigoted men. (Even Helen Keller was nearly trampled.) Welles maintained the order of her division, and Illinois received national recognition for civility, dignity, and honor. The event and its aftermath led to Illinois becoming the first state east of the Mississippi to grant women the right vote in June 1913.[9]

Women's suffrage was not much of a priority for George S. Welles, who preferred the life of leisure. Cracks surfaced in the marriage as Clara became more involved in *Votes for Women*, and, in December 1912, George

announced that he wanted a divorce. In the subsequent months, they maintained an uneasy reconciliation, with George seeing her on special holidays and maintaining a polite aura at public functions. But by February 1914, he asked Clara to file for a divorce. Clara explained it to family members: "Neither one of us had as much money as the other one thought." George insisted on reclaiming his family abode, which housed the Kalo Arts Crafts Community and School; Clara sold it to him for $1 in May 1914, as part of their divorce agreement and began to consolidate retail and manufacturing operations in Chicago, much to the sadness of the Park Ridge community. In February 1916, George sold the Kalo Arts Crafts Community House for $16,000, which he quickly exhausted. When the divorce was granted in June 1916, Clara asked for no alimony, telling the astonished court that she was a businesswoman with a good income and that her husband had no business whatsoever, and never had much of a business. Two months later, George died of a heart attack on the Park Ridge golf course. Clara inherited a small cottage on Prospect Street that George owned, and may have stayed there off and on until she sold it in 1921.

With smaller space and higher expenses in Chicago, Clara Welles focused on jewelry and silver instead of the myriad of craft items that were made in Park Ridge. Although the 1914 transition out of Park Ridge was difficult for the Kalo Shop and the Park Ridge community, it led to a flurry of entrepreneurial activity that helped solidify the Chicago region as an innovator in hand-wrought arts and crafts metalwork and jewelry. Kalo worker Henry Sorensen established the Orno Shop in DeKalb, Illinois; Julius Randahl moved his second company to Chicago and worked at it full time; the Mulhollands moved to Evanston to establish the Mulholland Brothers and a guild to train silversmiths; Esther Meacham founded a jewelry shop in Park Ridge; and Kalo jewelers Kristoffer Haga and Grant Wood co-founded the Volund Crafts Shop in the Eicher barn and workshop after it was vacated by Randahl. In addition, Matthias Hanck's shop and store were evidence that the artist colony would continue to thrive in the city. As each new start-up grew, it added dozens of jobs and expanded the artisan community support network, creating a bustling culture of entrepreneurship that was unparalleled in the art industry. More than 20 hand-wrought silver, metalwork, and jewelry companies and studios grew out of the Kalo Shop, and dozens of former workers went on to teach, organize arts groups, establish vocational programs for wounded veterans, and operate their shops in many areas of the United States, spreading the Kalo influence from Midwestern states to Connecticut and as far west as California.

World War I had a chilling effect on consumer spending, particularly for non-essential items like silver and jewelry. From 1914, many of the shops struggled to find customers, including the Volund Crafts Shop, which shut down within a year. By the time the United States entered the war in 1917, most of the hand-wrought metalwork and jewelry shops ground to a halt as silversmiths left to work in the naval shipyards in San Francisco and around the country; others were drafted into service and many men and women volunteered for the war effort through the American Red Cross or the Y.M.C.A. The Kalo Shop survived with a handful of workers. Eicher started his own company in 1915, recruiting B.B. Andersen and others to work at the shop during their off hours from Kalo. C.H. Didrich briefly became the shop master of the Kalo Shop before he left for San Francisco, surrendering the esteemed position to Peter Berg.

Following the end of the war, the Kalo Shop rehired many of the silversmiths and jewelers, particularly those returning from service such as Yngve Olsson, Kristoffer Haga, and Arthur Scott. In 1923, Welles redesigned a brownstone at 152 E. Ontario, which became her residence and new home of the Kalo Shop; the silver workshops were situated behind the building through a lush courtyard. Named the Clara B. Welles Building, Welles and the architects won an honorable mention in the prestigious Best Building of 1923 competition sponsored by Lake Shore Bank.[10]

Three Kalo bracelets with stones.
Courtesy of Chicagosilver.com.

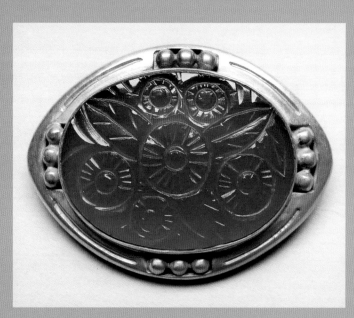

Kalo sterling silver brooch with a carved green chalcedony stone in an Art Deco floral pattern. 1.625" long. Author's collection and photo.

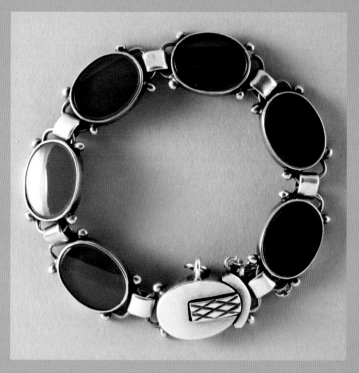

Kalo sterling bracelet with green stones. Courtesy of Curators Collection, photo by Rich Wood.

Kalo cherry bracelet, brooch, and earrings, marked Hand Wrought Kalo Sterling. Courtesy of the Charles S. Hayes family, photo by Scott Bourdon Studios.

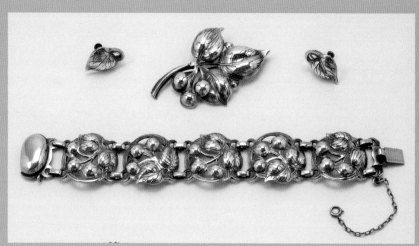

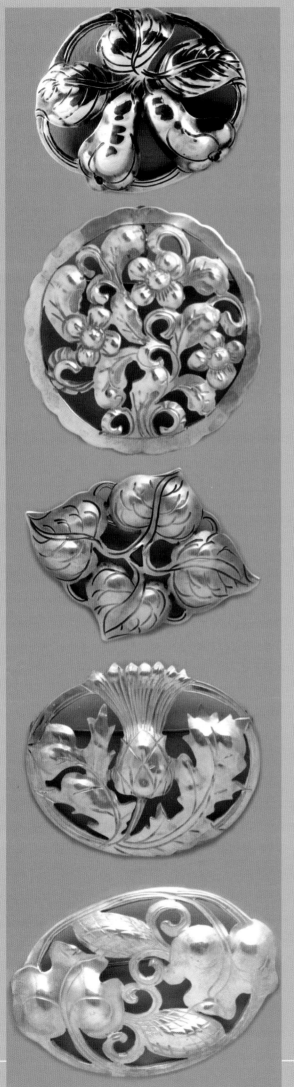

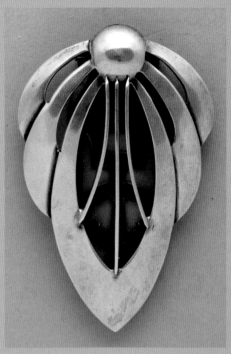

Kalo Art Deco style dress clip. Author's collection, photo by Rich Wood.

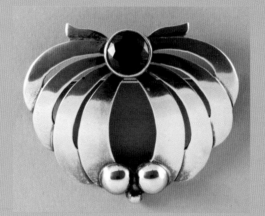

Kalo brooch with blue stone. Courtesy of Curators Collection, photo by Rich Wood.

Kalo leaf brooch in the style of Albino Manca, a New York sculptor and designer who maintained a large and distinctive national jewelry business in the early 1940s-1960s. Several Manca styles were made by the Kalo Shop, suggesting a collaboration or that some of the Manca jewelry workers later worked for Kalo. Author's collection and photo.

Five sterling silver Kalo brooches in repoussé designs. Courtesy of author's and Curators Collections. Photos by Rich Wood.

Kalo tulip brooch with blue stone. Courtesy of Curators Collection, photo by Rich Wood.

Iconic sterling silver monogram belt buckle and cufflinks by Kalo. Designed in Park Ridge, this style was popular through the early 1920s. Author's collection, photo by Rich Wood.

In the 1920s, the Kalo Shop designed a variety of modern art deco trophies and jewelry, including some hollowware with Bakelite handles, in addition to traditional patterns. The business flourished, and Welles reported sales of $100,000 and 36 workers before the Great Depression. In 1932, the economy forced Welles to reduce the capital stock in the company from $50,000 to $5,000, and as late as 1939, she reported only four workmen, one apprentice, and $50,000 in annual sales.[11] In spite of the economy, the Kalo Shop continued to participate in exhibitions. In 1937, silver from the Kalo Shop designed by Clara Welles was singled out in the Metropolitan Museum of Art exhibit in New York as "emphatically American," and one critic said it showed "a freshly creative trend," characterized by its classic simplicity without a bit of unnecessary ornament.[12]

In 1939, Welles retired and moved to San Diego with her friend Arthur Frazer, and, in 1959, she gave the Kalo Shop to its four remaining crafts workers: Robert Bower, Yngve Olsson, Daniel Pedersen, and Arne Myhre. They continued to produce silver in traditional Kalo styles as well as new, innovative themes, particularly in jewelry. Most of the later designs were created by Yngve Olsson. In January 1970, after Olsson died, the shop closed, ending a legacy as one of the most progressive, enduring and innovative manufacturers of hand-wrought jewelry, silver and metalwork from the American Arts & Crafts Movement.[13]

In the 1920s, John P. Petterson, Bjarne Meyer, and Joseph Popelka moved to Park Ridge, reestablishing a smaller but vibrant silver and jewelry artisan community that lasted until World War II.

Original house number sign for the former Clara B. Welles Building at 152 E. Ontario, Chicago. Home of the Kalo Shop retail store and workshops from 1924 to 1936. Author's collection, photo by Rich Wood.

The Park Ridge Artists Colony

The Julmat, the Randahl Shop, and Hanck's Art Jewelry Shop were the first companies founded in Park Ridge by silversmiths and jewelers who were associated with the Kalo Shop. A second wave of entrepreneurial activity occurred when the Kalo Shop moved its workshops to Chicago. A small but highly significant enclave of silversmiths and jewelers are discussed here for the first time, as they were omitted from Sharon Darling's *Chicago Metal-Smiths* (1977). Importantly, Asta and Henri Eicher, B.B. Andersen, Kristoffer Haga, Grant Wood, the Volund Crafts Shop, and the Volund Shop are properly identified and recognized for their unique and significant impact on the Chicago Arts & Crafts Movement. [14]

Official Park Ridge post card, 1910. The card and slogan were selected in a special contest to commemorate Park Ridge becoming a city. Designed by Colony Crafts, co-founded by Beulah Mitchell Clute and Dulah Evans Krehbiel. The card includes a hand-written note from Asta Eicher to a relative. Courtesy of Vivian Møller, Denmark.

Bjarne Becker Andersen (r) and Daniel Hamer Pedersen (l), c.1915. Courtesy of the Andersen family.

Bjarne Becker (B.B.) Andersen (1889–1975)

Businesses
 B.B. Andersen (c.1913–1940s)
 Eicher/Andersen Studio, 312 Cedar St., Park Ridge, Illinois, (c.1916–1918)
 The Volund Shop, 4411 N. Sheridan, Chicago, (1919–1926)
 Known workers for the Volund Shop
 B.B. Andersen
 Daniel H. Pedersen

Hallmarks of B.B. Andersen, the Eicher Andersen partnership and the Volund Shop. All except the Eicher Andersen mark are from B.B. Andersen family's flatware and hollowware collection. One of the Volund Hand Wrought stamps is identical to a distinctive mark used on Chicago Silver Co. items. Photos by Bruce Brewer and author.

Andersen salt and pepper shakers, marked Sterling with BAB logo. Author's collection, photo by Rich Wood.

Andersen sterling silver pear-shaped servers, marked with the BAB logo. Original design by Asta Eicher. Author's collection, photo by Rich Wood.

Andersen sterling silver vase, marked with BAB logo. Courtesy of Chicagosilver.com.

Andersen sterling silver coffee pot, creamer and sugar, and tray, all signed with BAB logo.
Courtesy the Charles S. Hayes family, photo by Scott Bourdon Studios.

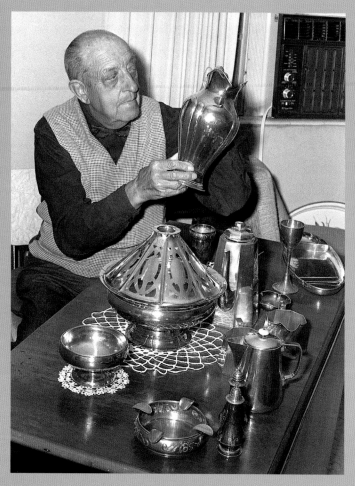

B.B. Andersen looking over his silver in 1970. Courtesy of the *Daytona Beach News*.

Andersen was one of the most ambitious and entrepreneurial of the Kalo silversmiths, frequently working 18 hour days to craft table wares for the Kalo Shop, under his personal mark, for the Eicher shop, and at the Volund Shop, which he founded in Chicago in 1919. Andersen silver is notable for its large size, substantial weight, and skillful execution.

Fluent in German and Norwegian, Andersen came from a family of silversmiths in Oslo, Norway. Attracted to America by extravagant tales of wealth and opulence, Anderson booked first-class passage to New York, paying for it by selling hand-wrought silver to patrons on the ship. In New York, Andersen took a job as a butler with a wealthy family to discover first hand the habits and lifestyles of the rich. He then took a butler job for a family in Hamilton, Ontario, for six months before he was recruited to the

Kalo Shop in 1912. He became close to shop master Henri Eicher and ran his unsuccessful campaign for Park Ridge city council in 1914. In the off-hours from the Kalo Shop, Andersen would craft table wares and special commissions for the Hanck store in Park Ridge. In the fall of 1914, he lived in the Eicher workshop with Daniel Pedersen, Kristoffer Haga, and Grant Wood; Haga and Wood made jewelry at the shop during the day under the name of the Volund Crafts Shop while he and Pedersen commuted to Chicago to work for Kalo. Andersen was close to Haga and his family, and he took his children to visit Haga's mother every week in later years, referring to her fondly as Grandmother Haga. Andersen was also instrumental in recruiting his friend Daniel Pedersen to the Kalo Shop.

In 1915, while continuing to work for the Kalo Shop, Andersen made silver for the newly established Eicher shop. His work was so well regarded that Eicher offered him a half-interest in the business as an inducement to stay, and silver fashioned during the partnership years was marked both Eicher and with Andersen's BAB logo. In 1919, Andersen left the Kalo Shop, despite protests from Clara Welles, to launch the Volund Shop in Chicago. He had already left his partnership with Eicher and he wanted to establish his own business as he was about to marry Florence Ketter, daughter of Kalo Shop worker William Ketter.

Andersen, utilizing a team of silversmiths that included Daniel Pedersen and others, built the Volund Shop into a profitable hand-wrought silver enterprise in the early years. As customer tastes began to change in the 1920s, Andersen soon found it to be more lucrative to sell women's beaded handbags and fashion items from his storefront shop. He was so successful that he his sobriquet became "the bag man." In 1926, Andersen gave up the Volund Shop entirely and was listed as a jeweler from 1927 to 1929. By 1930, he launched a highly successful multi-million dollar commercial real estate development business. Andersen prospered during the Great Depression and supported his extended family. His wife died in 1936, and he remarried Wanda Jennings in 1941. He spoke fondly about the Kalo Shop and Clara Welles throughout his life, and Welles had silver and jewelry made for his wife and children for all special occasions. Andersen continued to make limited silver, especially for family and friends, under his BAB logo.[15]

Brooch with applied flower, marked Hand Wrought At Volund Shop Sterling. Author's collection, photo by Rich Wood.

Volund Shop box with gold intaglio onyx ring. Ring marked 585 and likely European. Courtesy of the Andersen family, photo by Bruce Brewer.

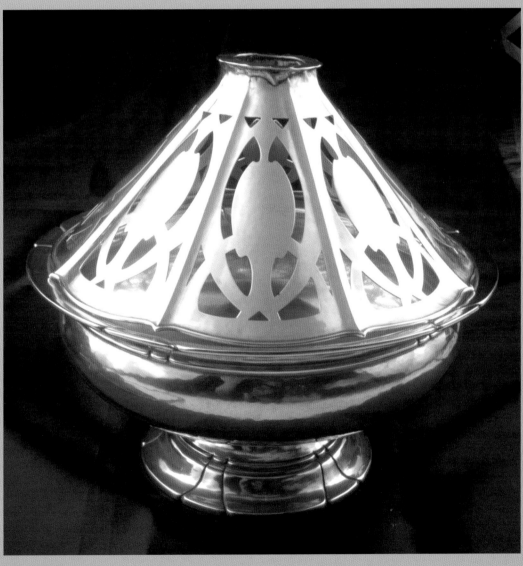

Sterling silver centerpiece bowl with decorative flower frog. Bowl made by Pedersen and marked Hand Wrought * D P *. Frog made by Andersen, unmarked. Courtesy of the Andersen family, photo by Bruce Brewer.

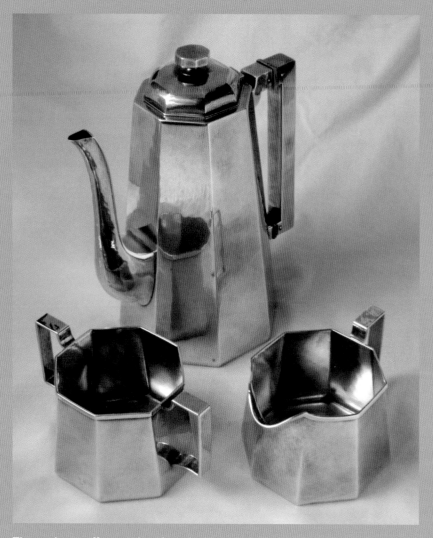

Volund Shop child's cup engraved *Robert* and *July 28, 1922*, marked Hand Wrought At Volund Shop Sterling. 3" high. Author's collection, photo by Rich Wood.

Three-piece coffee service signed with Andersen's BAB logo, c.1919. Courtesy of the Andersen family, photo by Bruce Brewer.

Silver over copper hammered bowl with applied monogram, signed Hand Wrought At Volund Shop. Author's collection, photo by Rich Wood.

Massive meat fork marked Volund Hand Made Sterling. 11.125" long. Author's collection, photo by Rich Wood.

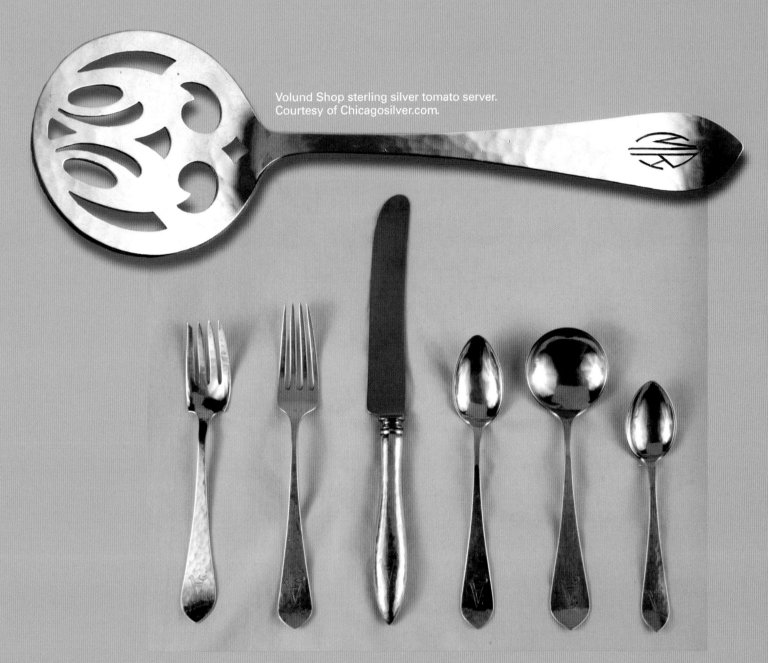

Volund Shop sterling silver tomato server. Courtesy of Chicagosilver.com.

Volund Shop sterling silver flatware place setting, made by B.B. Andersen for his wife Florence, engraved with an "A" monogram. Courtesy of the Andersen family, photo by Bruce Brewer.

Henri Anton Eicher (1876–1923)
Asta Bothilde "Buick" Larsen Christensen Eicher (1881–1931)

Businesses

H.A. Eicher, 312 Cedar St., Park Ridge, IL
(1915–c.1917, c.1919–1931)

Eicher/Andersen Studio, Park Ridge, IL
(c.1916–1918)

In January 1908 Henri Eicher moved to Park Ridge and served as the first silversmith manager or "foreman" of the Kalo Shop. From around 1909, he established a studio workshop in his garage and barn, which functioned like a modern day incubator for start-ups. The studio was used by Kalo silversmiths in their off-hours, including the Randahl Shop, the Volund Crafts Shop, the Eicher shop and the Eicher/Andersen partnership. Julius Randahl would remark to Robert Bower years later that Henri Eicher was the finest silversmith he ever met. [16]

Eicher, his future artisan wife Asta, and her mother immigrated to New York in 1907 from Copenhagen, where the Swiss-born Eicher had worked as a silversmith. Asta was recently divorced when she started her new life with Henri; they were together but could not legally marry until one year from her divorce, which finally happened in April 1908. Asta was pregnant with twins at the time, but both of her girls died within a month after she gave birth that summer. Asta—a painter, designer, crafter, and musician—busied herself in the midst of the Park Ridge artists' colony by participating in a broad variety of arts and crafts, including textiles, oil painting, and china painting. [17]

In 1915, Eicher left the Kalo Shop to establish his own business. B.B. Andersen and four to six other silversmiths worked for him during their off-hours, and Asta designed all of the silver made at the shop. Eicher retained a wholesale manufacturer's agent in Chicago to sell the firm's silver from coast-to-coast. The business was very successful and afforded the Eichers with an upscale lifestyle, including autos, a chauffeur, and servants. After many attempts at starting a family, Asta had three children, to whom she was relentlessly devoted.

By 1919, Henri developed mental illness, probably schizophrenia. He remained reasonably productive until he was institutionalized in a Milwaukee sanitarium in the 1920s. Asta retained the shop's silversmiths and ran the business while Henri underwent treatment. In 1923, having

exhausted their substantial savings, Asta brought Henri home. He died in August, officially from stomach cancer, but possibly suicide.

For several years, Asta continued to operate the studio; she eventually shed the workers, and was paid a commission by the Kalo Shop—and perhaps B.B. Andersen—to execute her designs in hand-wrought silver. Asta's design work included pear-shaped servers, special silver for a Chicago hotel and a silver picture frame for a wealthy Chicagoan who was so pleased with it that he gave her $300.

After the stock market crash, Asta struggled to make ends meet and fell behind in her bills, including two mortgages; this despite loans from Clara Welles. In 1931, Asta became entangled with a ruthless confidence man who posed as a wealthy suitor. He promised to marry her and provide a bright and carefree future for her children. Instead, he murdered the entire family. The sensational case was so horrific that none of the silversmith families ever discussed it until the 1970s when Robert Bower—the business manager of the Kalo Shop—remarked that it was a terrible end for members of the Kalo family.

Henri A. Eicher hallmarks used prior to and after the partnership with Andersen. Author's collection, photos by Rich Wood.

Eicher sterling silver oval bowl with applied monogram, marked Hand Wrought Eicher Park Ridge ILL. 10" long. Author's collection and photo.

H.A. Eicher sterling silver octagon salt dishes and pepper shakers, designed by Asta Eicher and executed at the shop. Author's collection, photo by Scott Bourdon Studios.

Eicher Andersen sterling silver paper knife with applied bee, designed by Asta Eicher. Courtesy of Chicagosilver. com.

Pear-shaped servers in sterling silver with applied monograms, marked Sterling Eicher. Designed by Asta Eicher and executed at the shop. Author's collection, photo by Rich Wood.

H.A. Eicher sterling silver water pitcher, designed by Asta Eicher and executed at the shop. Author's collection, photo by Scott Bourdon Studios.

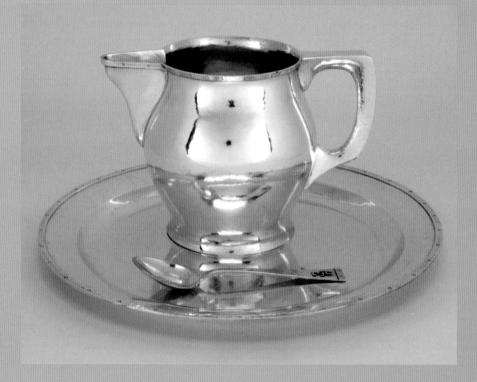

Eicher Andersen sterling silver tray, Andersen pitcher and spoon marked with BAB logo, all with hammered strap work. Tray 14" diameter. Courtesy of the Charles S. Hayes family, others author's collection. Photo by Scott Bourdon Studios.

The Volund Crafts Shop, Park Ridge (1914–1915)
Kristoffer Haga (1887–1932)
Grant D. Wood (1891–1942)

In June 1914, Kristoffer Haga and Grant Wood founded the Volund Crafts Shop in the Eicher barn and studio, which was being vacated by the Randahl Shop. Haga furnished the funds for the new enterprise and Wood was the principal designer. Wood devised the Volund Crafts Shop name, taking it from the god of the silversmiths in Norwegian folklore. In the fall of 1914, they unveiled their works in the annual arts and crafts show at the AIC under the name of the Volund Crafts Shop. Designed by Wood and executed by Haga and Wood, the items included a cameo and pearl pendant set in gold; copper panels lent by Kate Loomis; a gold and pearl pendant; a beetle brooch in silver; and a silver repoussé jewel casket with a girl swimmer chased on the cover, holding a baroque pearl in her hand. The casket most likely was the one that Daniel Pedersen mentioned to Robert Bower years later, noting that it was a remarkable piece.

Haga and Wood lived in the Eicher barn and studio with Daniel Pedersen and B.B. Andersen, who worked at the Kalo Shop during the day and also made silver in the studio in the evenings. Each of the men paid $4 a week for room and board, which included hearty meals. The barn had no bathroom or running water, and the men would go outside, even in the blistering winter. In the summer, Wood would frequently shower by running around in rainstorms without his clothes. The inexpensive and minimalist housing allowed the men to work relentlessly and save as much as they could, except for Wood, who spent all of his money as quickly as he made it. According to Garwood (1944), Andersen and Pedersen cared little for Wood and they belittled his chasing skills, but thought highly of Haga.

The Volund Crafts Shop succeeded initially. Haga and Wood may have sold their jewelry at one of the Park Ridge studios and jewelry stores, as well as through Chicago shops and individual clients. By 1915, Haga was a member of the Chicago Artists' Guild, and the partners would have sold items through the cooperative shop in the Fine Arts Building. That summer, Haga and Wood took a trip to Iowa and collected river pearls to use in their jewelry and craft items, anticipating a strong demand for Christmas. Instead, they had a disastrous holiday season. Wood ran out of money and walked the streets in search of work during a harsh winter. In January 1916, he re-enrolled at the Art Institute to take a painting class before dropping out 11 days later, as he had no money for food or living expenses. He said of his experience: "I was a little discouraged. It was the only time in my life that I couldn't find a job of some sort. On a wild chance I wrote to a friend in Cedar Rapids and he sent me a small check. I came back home again, a ragged failure—and my mother was glad to see me."[18]

Wood focused on his painting, and triumphantly returned to Chicago in 1930, winning the Norman Wait Harris Prize at the AIC for his painting titled *American Gothic*. Wood became an overnight sensation and a famous painter. When he finally married in 1935, he returned to the Kalo Shop on Michigan Avenue to have his fiancée's ring made from his design. Wood died of cancer two hours before his 51st birthday.

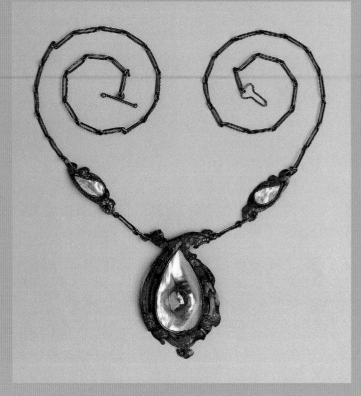

Grant Wood, Necklace, 1915. Copper and mother-of-pearl, 12 x 1.75 x 0.75 inches. Cedar Rapids Museum of Art, Gift of John B. Turner II. 82.1.5

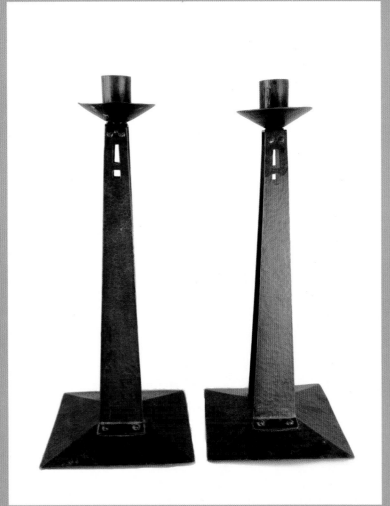

Hammered copper candlesticks by Grant Wood, marked Volund and Hand Made. Acquired from an Eastern Iowa estate. Original patina. Author's collection, photo by Rich Wood.

Haga Studio

KristofferHaga was a talented jeweler who worked for several arts and crafts shops before launching the Volund Crafts Shop with Grant Wood. After the shop collapsed in the fall of 1915, Haga maintained his studio at the Eicher workshops in Park Ridge and sold his jewelry through the cooperative shop in the Fine Arts Building. In the summers, he lived on land in Medford, Wisconsin, he purchased in 1915. [19]

Haga had apprenticed as a goldsmith in his native Norway before joining his mother and siblings in Chicago in March 1909. He almost immediately joined the Tre-O Shop in Evanston and was one of the jewelry makers for the company in the 1909–1910 annual arts and crafts shows at the AIC. By 1913 Haga joined the Kalo Shop in Park Ridge as the jewelry foreman for the men workers. The following year, when the Kalo Workshops began to relocate to Chicago, Haga and Grant Wood founded the Volund Crafts Shop, but the partnership broke up in the fall of 1915. Haga was listed under his own name in the 1915–1916 Artists' Guild publication.

Haga enlisted during World War I and served from 1918–1919. After the war, Haga rejoined the Kalo Shop, and also may have worked for Andersen, who established the Volund Shop in 1919. By 1923, Haga returned to Wisconsin and was in and out of the hospital for tuberculosis, eventually succumbing in 1932.

The Julmat, Park Ridge (1910–1911)
Julius Olaf Randahl (1880–1972)
Matthias William Hanck (1883–1955)

The Julmat was the first silver and jewelry company to spin out from the Kalo Shop in Park Ridge. From 1910 to 1911, Randahl and Hanck made a variety of jewelry and hollowware items, and, as soon as pieces were completed, Randahl would sell them to retail establishments in Chicago and Milwaukee. The Julmat was located at the corner of Main and Centre (Touhy) Streets, several blocks from the Kalo workshops, where Randahl continued to work during regular business hours. In the fall of 1911, the partnership faltered, as Hanck wanted to focus only on jewelry and Randahl wanted to focus on table wares. Randahl banded with a group of Kalo silversmiths to launch the Randahl Shop out of the Eicher workshop on Cedar Street. By the beginning of 1912, Hanck and his wife Elizabeth founded Hanck's Art Jewelry Shop on Garden Street in Park Ridge.

Hallmarks of The Julmat. Courtesy of Stephen H. and Holly Randahl and Chicagosilver.com.

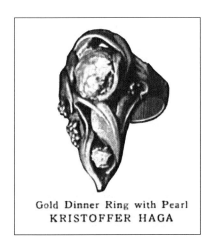

Gold Dinner Ring with Pearl
KRISTOFFER HAGA

Kristoffer Haga Studio, Park Ridge, ring shown in the *Chicago Artists' Guild* (1915). Author's collection.

Cameo brooch in gold marked Julmat
14K. Courtesy of Chicagosilver.com.

Sterling silver tongs by the Julmat, c.1911.
Courtesy of Chicagosilver.com.

Sterling silver and pearl brooch, cufflinks, and belt pin, all signed
Julmat, c.1910. Courtesy of Stephen H. and Holly Randahl, photo
by author.

Sterling silver and coral watch fob made by Julius O. Randahl at the Julmat, c.1910. Front and back views. Courtesy of Stephen H. and Holly Randahl, photos by author.

Branding stamps for the Julmat and JOR used by Julius O. Randahl. Courtesy of Stephen H. and Holly Randahl, photos by author.

Hanck's Art Jewelry Shop (1911–1940s)
Matthias William Hanck (1883–1955)

Locations
206 Garden St., Park Ridge, 1911–1915
1 Main Street, Park Ridge, 1915–1920
142 S. Prospect Ave., Park Ridge (originally
 numbered 40 S. Prospect), 1920–1936
2425 N. Marshfield Ave., Chicago 1936–1940s

Known workers
Edward H. Breese, c.1915–1920
Edwin E. Guenther, c.1914–1916
Elizabeth Hanck, designer and sales manager,
 1912–1936
Peter Hanck, jewelry maker, c.1914–1930s
John Hanck, jewelry maker, c. 1914–1930s
Carl F. Hanck, jewelry maker, c.1920–1930s
Irene Hall Hanck, jewelry maker, c.1922–1930s

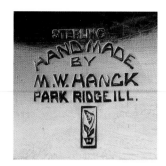
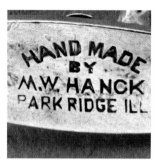

Matthias W. Hanck hallmarks. Author's collection and photos.

Telephone Park Ridge 881

MATTHIAS WM. HANCK

Maker of

Hand Wrought Jewelry and Silverware

I carry in stock many distinctive and individual pieces of hand-wrought jewelry, such as cannot be found in other shops, which make very satisfactory and appreciative gifts. I also make hand-wrought silver pieces, suitable gifts for weddings and other occasions.

SHOP
206 Garden St.

STORE
1 Main St.

Advertisement for Hanck's jewelry store and workshop. From Beaudette (1916). Author's collection.

Matthias Hanck trained dozens of women to make arts and crafts jewelry at the School of the Kalo Workshops, influencing a generation of crafts workers and promoting a style that is readily identified with the Chicago movement. Hanck's Art Jewelry Shop in Park Ridge was an important vehicle for selling a broad range of handmade silver, metalwork, and jewelry items made in his studio and from the network of community artisans.

The son of German immigrants, Hanck completed a seven-year apprenticeship in Chicago with R.M. Johnson & Sons, makers of Masonic jewelry. He also studied chemistry and metals in the evenings at the Lewis Institute and he took decorative design classes at the AIC. In 1908, Hanck taught at the School of the Kalo Workshops and made jewelry for the Kalo Shop. After three years, he grew weary of teaching and commuting from Chicago. Late in 1910, he moved to Park Ridge and co-founded The Julmat with Julius Randahl. The name was derived by using the first three letters of their first names. Randahl continued to work at Kalo during the day and devoted his evenings to their new venture. In 1911, the partnership waned, as Hanck wanted to focus on jewelry while Randahl wanted to focus on hollowware and silverware. Late that year, they split to form their own companies. Hanck and his wife Elizabeth established Hanck's Art Jewelry Store by the beginning of 1912, operating out of a little workshop behind their home.

Hanck's early customers came from Park Ridge, Chicago, and the North Shore, and the growing business allowed them to hire Hanck's brothers Peter, John, and Carl—who were also professional jewelers—and a sister-in-law, Irene Hall Hanck. In 1913, Hanck exhibited his jewelry in the annual arts and crafts show at the AIC, showing silver belt buckles with chased poppy designs, a brooch in silver and pearl, a gold and pearl bar pin with a carnation design, a silver bar pin with malachite and enamel, and a silver initial E in a morning glory design. Intricate three-dimensional floral designs, often carved, chased, and engraved, were hallmarks of Hanck jewelry.

In 1915, the Hancks opened a jewelry store at 1 Main Street in Park Ridge, and around that time entered into a partnership to make jewelry for Clemencia C. Cosio of the TC Shop. They also employed former Kalo silversmith Edward Breese, who made exquisite hollowware and silverware. Elizabeth ran the Main Street store, offering design ideas and sketches for customer orders. The Hancks also sold silver in their shop made by B.B. Andersen, H.A. Eicher, and other local silversmiths.

Between World War I and the Great Depression, the Hancks focused increasingly on ecclesiastical silver that afforded a higher margin and guaranteed payment; Breese, Andersen and possibly Eicher likely executed Hanck's designs for these pieces. After 1929, the Hancks shed their store and employees, and Matthias worked alone on filling orders, including a replica of the Kentucky Derby Trophy. From the late 1930s until his retirement in 1955, Hanck worked for Kenneth Parker in the experimental department of the Parker Pen Company, designing new products and features. His daughter later claimed that his proudest achievement was when General Dwight D. Eisenhower used a Parker pen designed by Hanck to sign the papers bringing an end to World War II.

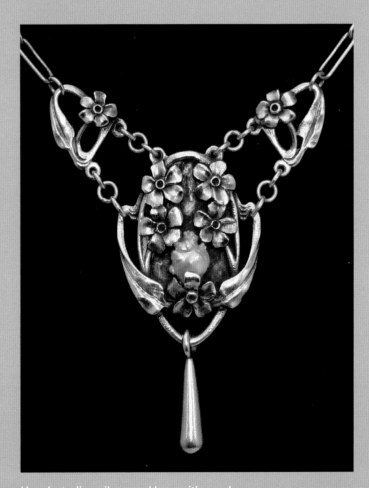

Hanck sterling silver necklace with pearl.
Courtesy of Chicagosilver.com.

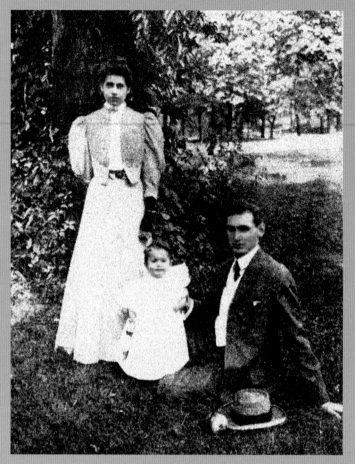

Photo of Mathias and Elizabeth Hanck with baby.
From Beaudette (1916). Author's collection.

Two sterling silver napkin rings with applied
monograms. Author's collection, photo by Rich
Wood.

Hanck sterling silver and pearl brooches and pin, all signed. Courtesy
of Curators Collection and author's collection, photos by Rich Wood
and the author. Top right brooch is 1 3/8 inches long. (Top right)

Chalice and paten made by Hanck's Art Jewelry Shop. The back of the paton is engraved *In Memoriam/Harriet Duclos Vosburgh/1810–1897/Church of the Atonement/Chicago/Easter 1916*. Both pieces marked with Hanck's Park Ridge logo and flower pot. Courtesy of the Episcopal Church of the Atonement.

Bjarne Meyer (1896–1949)

Business
Bjarne Meyer Hand Made Jewelry (c.1928–1945),
510 S. Lincoln Avenue, Park Ridge, IL

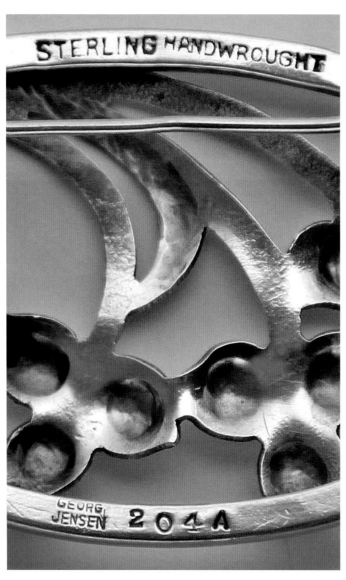

Bjarne hallmarks and his marks on jewelry made for the Gorham Company and Georg Jensen USA. Courtesy of Chicagosilver and author's collection. Meyer also made hollowware and silverware, although examples have not been identified.

Meyer was an accomplished silversmith and jeweler who was best known for his highly distinctive, hand-wrought silver jewelry after he moved to Park Ridge around 1928.

Born Bjarne Andersen in Norway, Meyer immigrated to the United States in 1912 to join his parents in New Jersey, who had already changed their last name from Andersen to Meyer. In 1919, after completing service in World War I, he married Nora A. Dalby in Chicago and worked as a silversmith for Lebolt & Co. In 1921 and 1923, he made candlesticks, compotes, and a variety of silverware with John Petterson for the annual arts and crafts shows at the AIC. By 1928, Meyer moved to Park Ridge and opened a jewelry studio from his home workshop; he lived a short distance from Petterson and fellow jeweler Joseph Popelka.

Meyer primarily catered to the wholesale market, including a line of jewelry for the Gorham Company. In the 1940s, he was one of the leading jewelers who fashioned unique sterling silver jewelry for Frederick Lunning's Georg Jensen U.S.A. [20]

Meyer's work was characterized by intricate, repoussé, three-dimensional floral designs and some of his later work featured streamlined hammered geometric patterns. In 1945, Meyer sold his home in Park Ridge and moved to Yonkers, New York, where he operated a studio until his death from a brain tumor in 1949.

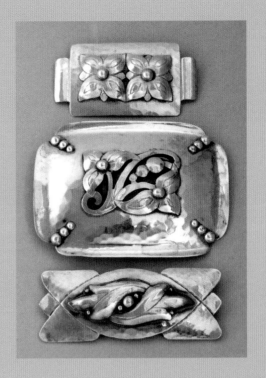

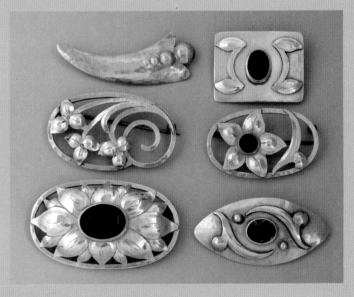

Bjarne Meyer sterling silver jewelry. All marked Handwrought By Bjarne except bracelet, which is only marked Handwrought. Author's collection and photos. (below and right)

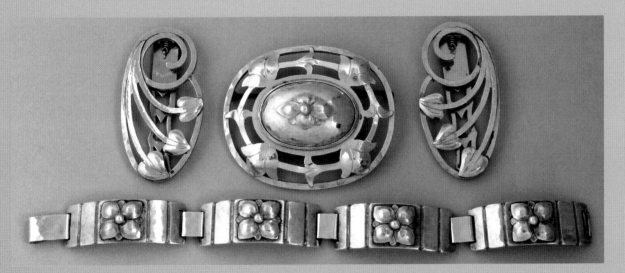

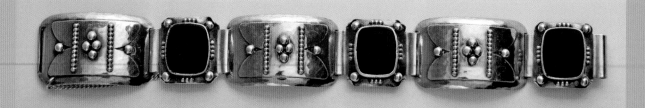

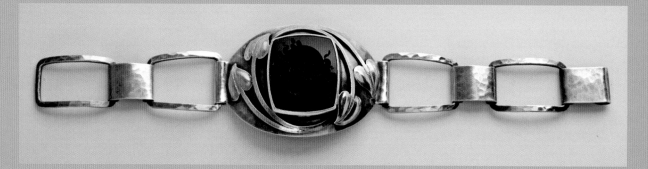

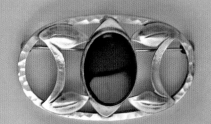

Bjarne Meyer sterling silver bracelets with intaglio onyx stones and three brooches, all signed Handwrought By Bjarne. Courtesy of Chicagosilver.com. (above and left)

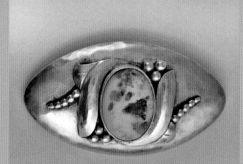

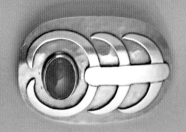

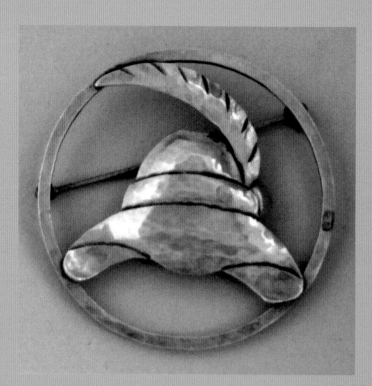

Sterling hat brooch made by Bjarne Meyer and signed Gorham. Author's collection and photo.

Enoch William Olsson (1898–1969)

Olsson trained as a silversmith in his native Denmark, immigrating to Chicago in January 1917 to join his brother Yngve. Olsson moved to Park Ridge and worked for Wendell & Co., a fine jewelry and silversmith firm in Chicago that traced its roots back to 1862. He also may have worked for Henri Eicher or another of the Park Ridge silversmiths; he lived in the city from 1918 to 1923. Gregarious and creative, Enoch once painted his automobile light green to protest that automobiles were only available in black. Enoch frequently collaborated with Yngve in their basement workshops, making silver jewelry, hollowware, and a broad variety of hand-wrought copper and brass lamps. After 1933, he worked for New Metal Craft, a Chicago lamp manufacturer. From the late 1930s, he made tiny sterling silver replicas of candelabra, lighting fixtures, coffee and tea services, silversmith tools and a wide variety of decorative items for the famous Thorne Miniature Rooms at the Art Institute of Chicago, under the general direction of Eugene Kupjack. Many years later he joined the Howard Foundry Co. in Chicago as a pattern maker, where he worked until his death from lung cancer.

Drawing for a bracelet by Yngve Olsson for his brother Enoch. Courtesy of Burt Olsson.

Enoch William Olsson hallmark. Author's collection, photo by Rich Wood.

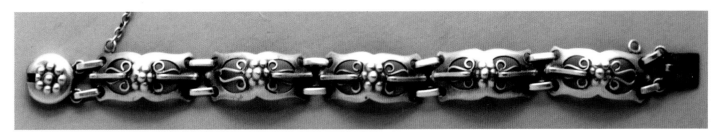

Sterling silver bracelet by Enoch Olsson. Author's collection, photo by Rich Wood.

Louisa Stagg (1871–1969)

Business

The Avenue Shop (c.1914–1931)
28 N. Prospect St., Park Ridge, IL

Born in Canada, Louisa Stagg arrived in Park Ridge with her family in the 1870s, where her father prospered as a grocery store owner. Preferring the name Louise, she worked in the family business before joining Marshall Field & Co. in Chicago, where she became a successful buyer. In c.1914, she opened The Avenue Shop, a popular art goods and hand-wrought jewelry store at 28 N. Prospect Street in Park Ridge. Stagg's store was an important retail facility for many of the local silversmiths and jewelers, including Kalo workers who continued to live in Park Ridge after the workshops moved to Chicago. Stagg also may have studied at the Kalo School and made jewelry herself. The Avenue Shop thrived until the 1930s, when Stagg sold the store and retired.

Infants' Apparel
Muslin Underwear
Gloves
Baskets
Hand-Wrought Art
Jewelry

Exclusive and Select
Gifts at

LOUISE STAGG

Telephone 483

28 N. Prospect Ave.

Advertisement for The Avenue Shop, 1916. Author's collection.

Kalo Arts and Crafts Entrepreneurs

Peter Lauritz Berg (1885–1959)

Berg was a consummate Kalo silversmith who worked at the shop from 1909 until the 1930s, when he had a business dispute of some sort with Clara Welles and left the company. His Kalo career included serving as the silversmithy manager from c.1918–1930s, and he designed and executed a broad range of artistic silver. His notebook of design sketches illustrates a delightful variety of bowls, trophies, jugs, vases, coffee pots, hair brushes, and fluted pitchers. Berg was adept at fashioning large, complicated silver trays, coffee and tea sets, as well as flatware and small table wares. His sketchbook notations include estimated production times: 12 hours for a 6 1/2" compote, 13 hours for a 10 5/8" bowl, 22 hours for a 7 1/4" trophy cup, and 60 hours for a three-piece fluted tea set. Some of Berg's silver, signed with his personal mark, featured intricate repoussé work.

Born in Norway, Berg immigrated to Chicago in June 1909, and joined the Kalo Shop in Park Ridge, while boarding with Randahl in nearby Des Plaines. In addition to Kalo, Berg worked for the Randahl Shop from its inception in 1911 and variously throughout his life. By 1936, Berg had left the Kalo Shop and joined the Randahl Shop, as well as continuing a home workshop in Chicago for most of the remainder of his life. Berg had a steady stream of loyal customers, including some who bought silver from him for decades.

Berg's first wife, Minnie, died in 1935 and he remarried to Clarissa Roe, who died in 1953. He passed away in 1959 while living in Arlington Heights, Illinois.

Peter L. Berg hallmarks. Courtesy of the Charles S. Hayes family and author's collection, photos by Scott Bourdon Studios.

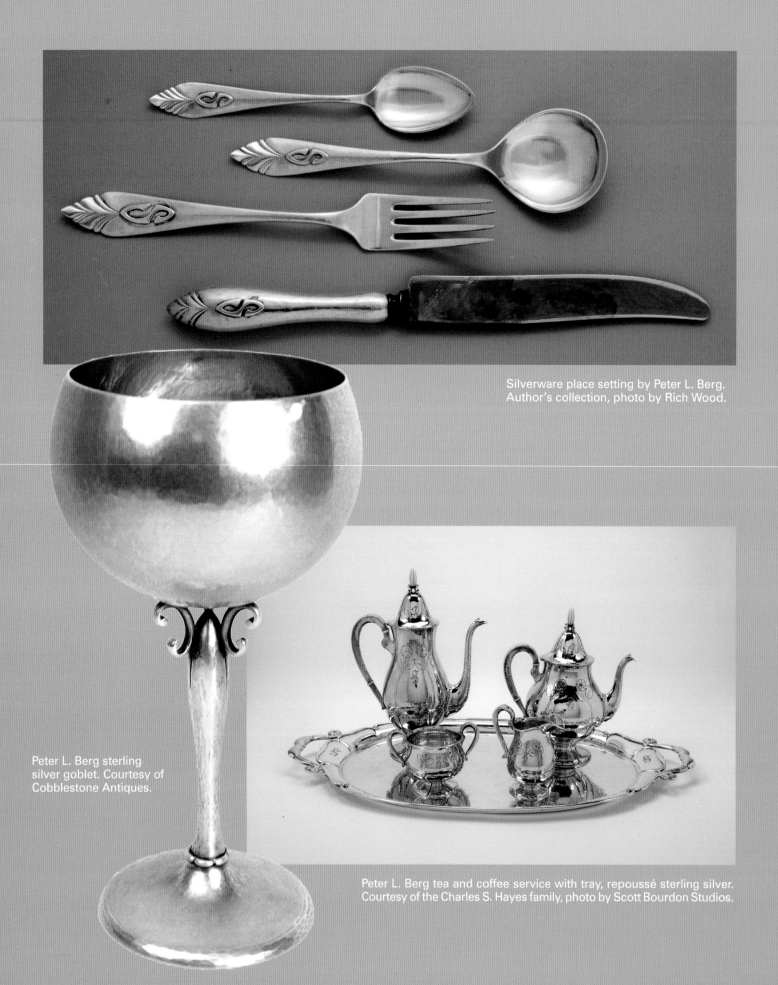

Silverware place setting by Peter L. Berg.
Author's collection, photo by Rich Wood.

Peter L. Berg sterling
silver goblet. Courtesy of
Cobblestone Antiques.

Peter L. Berg tea and coffee service with tray, repoussé sterling silver.
Courtesy of the Charles S. Hayes family, photo by Scott Bourdon Studios.

Edward Harry Breese (1872–1941; active, 1913–1940)

Breese was a talented Birmingham-born silversmith working in Sheffield, England, when he immigrated to the United States in 1907 to "seek his fortune." He was treated so poorly upon his arrival in New York that he had his wife and sons sail to Boston, where they joined him two months later. Initially settling in Providence, Rhode Island, Breese soon joined Tiffany & Co at its factory in Newark and met Norwegian silversmiths C.H. Didrich and John P. Petterson.

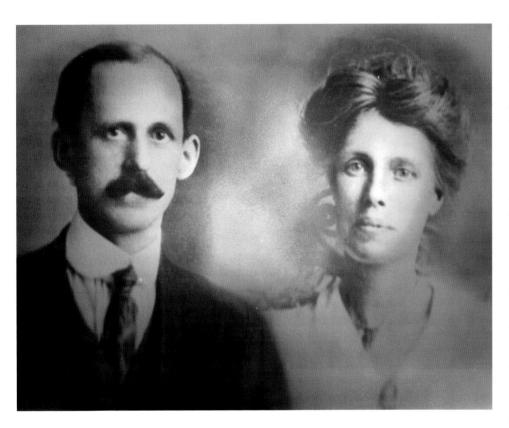

In 1911, Breese moved to Tiffany Studios in Jersey City and, in October 1913, he was recruited to the Kalo workshops to work under the direction of shop master Henri A. Eicher. He lived in Park Ridge for a year with his family before moving to Arlington Heights, about 13 miles north of Park Ridge.

Breese worked at the Kalo Shop (1913–c.1916), at his home workshops with his sons Willis and Eric in Arlington Heights (1914–1940), for Matthias Hanck (c.1915–1920), and launched his own company in Chicago in 1921. From 1921 to 1925, the Breese studio was located in the Singer Building, 120 S. State in the Chicago Loop. In c.1924, Breese installed expensive, modern silversmithy equipment in his shop that would allow him to make stylish, machine-assisted silver items similar to those of the Randahl Shop, but almost immediately a spectacular fire destroyed his studio and the entire six-floor building. Financially devastated, Breese briefly operated at 126 S. Clinton Street in Chicago after the fire. In 1926 he relocated his workshop to Arlington Heights.

Breese was a hollowware artisan who crafted distinctive pitchers, chalices, bowls, trays, candlesticks, and table wares. He retained wholesale silver manufacturing agents who sold his silver throughout Illinois and the Midwest, and his wife Amelia would often take the train from Chicago to New Orleans to deliver a steady stream of orders. He also made special order pieces for a variety of Chicago jewelers and silversmiths, and likely sold silver in Hanck's Art Jewelry Shop and The Avenue Shop. A trusting customer once left many pounds of sheet gold on Breese's back porch to make a large tea service. Breese completed the job, even though he had not previously worked in gold. From the 1920s, he delved into jewelry, fashioning hammered silver bracelets, belt buckles, and similar items. Breese and his family moved to St. Louis in 1940 and he died the following year.

Edward and Amelia Breese. Courtesy of the Breese family.

Edward Harry Breese hallmark. Author's collection, photo by Rich Wood.

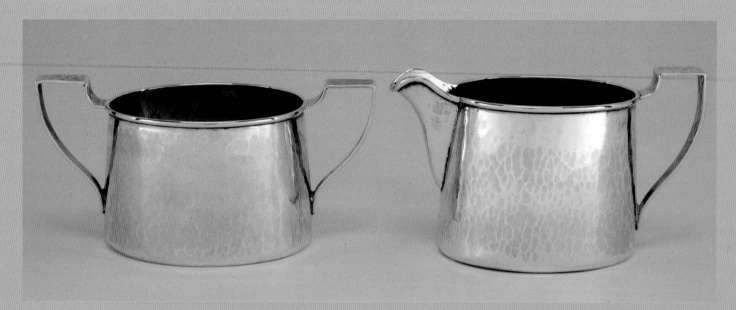

Breese sterling silver creamer and sugar. Courtesy of the Charles S. Hayes family, photo by Scott Bourdon Studios.

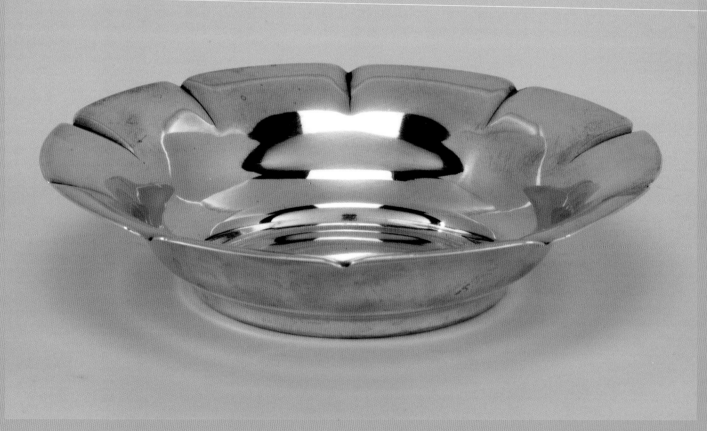

Breese lobed bowl with smooth surface, c.1920s. Author's collection, photo by Scott Bourdon Studios.

Breese sterling silver specialty fork.
Author's collection, photo by Rich Wood.

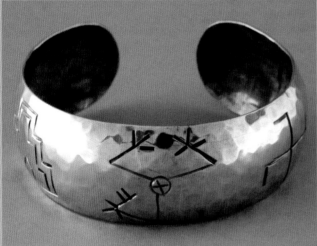

Breese bracelet engraved with Indian symbols.
Author's collection, photo by Rich Wood.

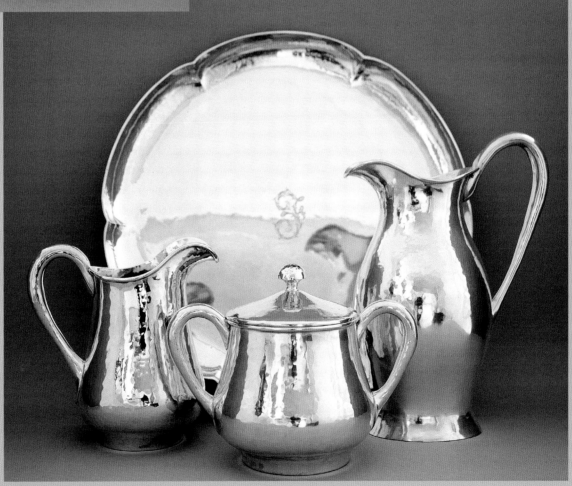

Breese sterling
silver platter, pitcher,
creamer, and sugar,
all marked. Pitcher
8.5" high. Author's
collection, photo by
Rich Wood.

Carl Henry Didrich (1878–1940)

Didrich honed his skills at Tiffany & Co. before he made silver and metalwork for the leading Chicago firms and served as the foreman of the Kalo Shop. He also operated a prosperous studio, selling to retail and wholesale clients, and taught many students, including Mabel Frame and Lucien Shellabarger, both of whom became well-known and respected metalwork artisans. [21]

Didrich was best known for his fluted tulip candlesticks in silver and pewter, fluted bowls in copper, silver, and pewter, and his substantial silver serving pieces that characteristically have a concave surface along the upper half of the back of the handle. His innovative table wares in pewter helped make artistic metalwork more desirable and affordable to a broad audience.

In 1904, Didrich arrived in the U.S. from Norway and by 1906 worked for Tiffany & Co. in New Jersey. From 1909 to 1910, Didrich and silversmith John P. Petterson shared a flat with their families in Newark, the site of the old Tiffany factory. In 1912, he taught and worked for the Kalo Shop and made silver items for the Lebolt & Co. fall exhibit. From 1913 to c.1916, he worked for Reed and Barton, returning to Chicago in 1916 to become the foreman of the Kalo Shop. In 1918, the war took him to the naval shipyards in San Francisco and he briefly worked as a silversmith for one of the local shops. In 1920, he returned to the Kalo Shop, changing his name from Didrichsen to Didrich when he became a United States citizen. By the mid–1920s he operated a thriving studio and exhibited his silver in Milwaukee and at the AIC. His wholesale clients included Grable's of Oak Park, Duncan Studios of Winnetka, the Cellini Shop in Evanston, Hyman & Co. of Chicago, and many retail establishments nationwide. From the late 1920s to the 1930s, he also worked for the Randahl Shop, in addition to his studio. Some of his pewter tulip candlesticks are marked with Randahl's JOR mark or with the names of his wholesale clients. Didrich remarried after his first wife passed away in 1918. Like many of the Kalo silversmiths who worked in Park Ridge, he developed stomach cancer and died at age 62.

Photo of C.H. Didrich (r) and J.P. Petterson with their families. Courtesy of David Petterson.

Carl Henry Didrich hallmarks. Author's collection, photos by author and Rich Wood.

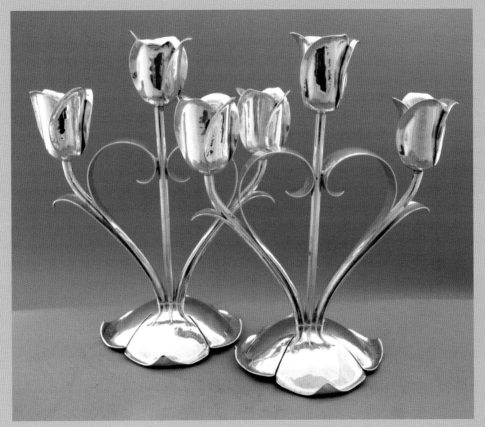

Didrich tulip candlesticks, marked CHD Hand Wrought Sterling 344 S. Author's collection, photo by Rich Wood.

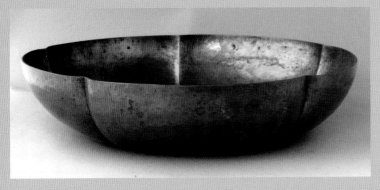

Hammered copper bowl, marked CHD Hand Wrought Copper 251 C. Author's collection and photo.

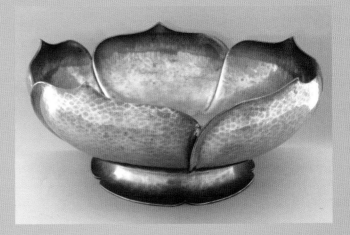

Didrich pewter oval and round center bowls with scalloped edges, marked with the CHD logo. Author's collection, photos by Rich Wood.

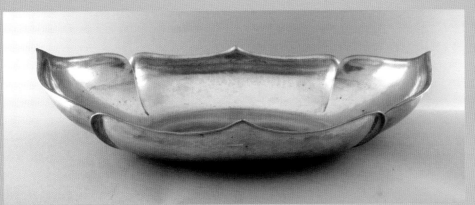

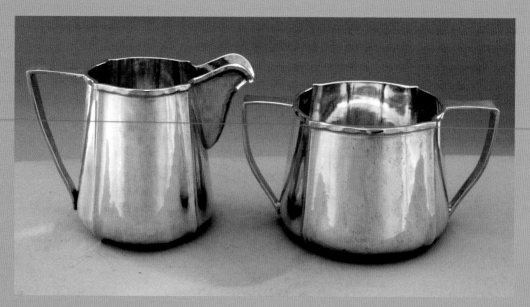

Didrich sterling silver creamer and sugar. Creamer marked C.H. Didrich, sugar marked Sterling. Author's collection, photo by Rich Wood.

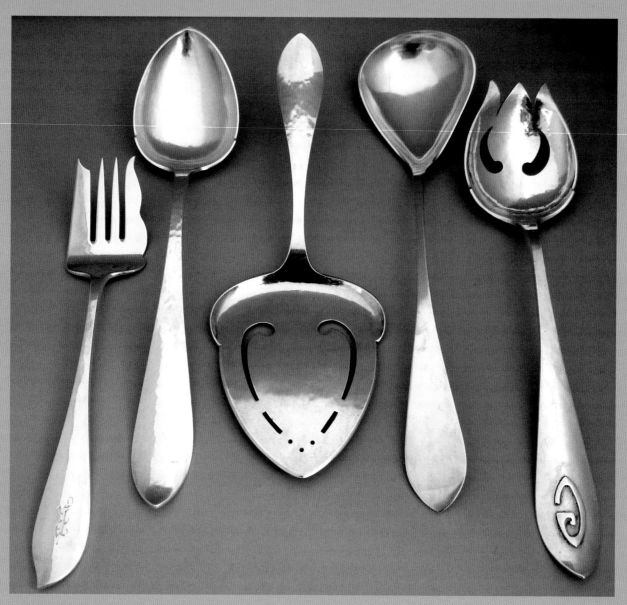

Four serving spoons and a pie server by Didrich, all marked. Author's collection, photos by Rich Wood.

Yngve Harald Olsson (1896–1970)

Olsson was a dedicated and creative silversmith who worked for the Kalo Shop for more than fifty years until his death in 1970. Longtime Kalo manager Robert Bower credited Olsson with the longevity of the business and considered him one of his closest friends. "Oley," as he was called by his colleagues, was an expert silversmith, chaser, and designer, who introduced many new jewelry designs into the Kalo portfolio, including three-dimensional sculpted pieces, colorful geometric enamels, acorn, leaf, and pineapple motifs, and whimsical creations featuring Kukla, Fran, and Ollie, the popular TV puppet characters from the 1950s. In 1959, he became a co-owner of the Kalo Shop, when Welles gave the capital stock, bonds, and assets of the business to her four most loyal employees.

In 1915, Olsson immigrated to the United States from his native Denmark to join his aunt Bertha K. Olsen, who lived in Chicago. He soon worked for the Kalo Shop on Michigan Avenue as a jeweler and silversmith. In April 1918, he enlisted in World War I and was stationed in Siberia. After the war, he returned to the Kalo Shop for the remainder of his career.

In addition to Kalo, Olsson operated a home business at 2118 N. Kenneth in Chicago in the 1920s and 1930s. He frequently crafted metalwork with his brother Enoch, who was also a gifted silversmith. He married Marie Annette Larsen and they had two sons, Daniel and Burton. Olsson died of heart failure in January 1970, five months after his brother Enoch passed away.

Photo of Yngve and Marie Olsson. Courtesy of Burt Olsson.

Yngve Olsson hallmarks. Courtesy of Chicagosilver.com and Burt Olsson.

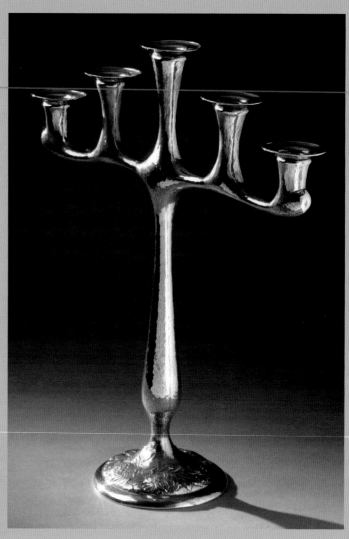

Yngve Olsson business card with design sketches.
Courtesy of Burt Olsson.

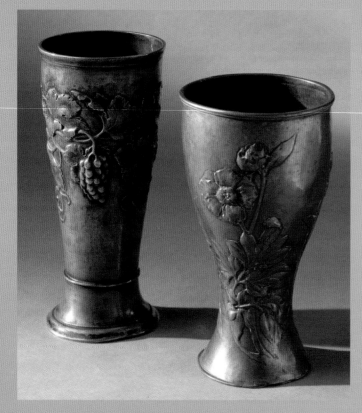

Olsson brass candelabra with chased floral design at base.
Courtesy of Burt Olsson, photo by Russell Olsson.

Olsson repoussé copper vases. Courtesy
of Burt Olsson, photo by Russell Olsson.

Olsson sterling silver condiment spoon, marked.
Author's collection, photo by Rich Wood.

Colored sketch for enamel necklace drawn by Yngve Olsson. Courtesy of Burt Olsson, photo by Russell Olsson.

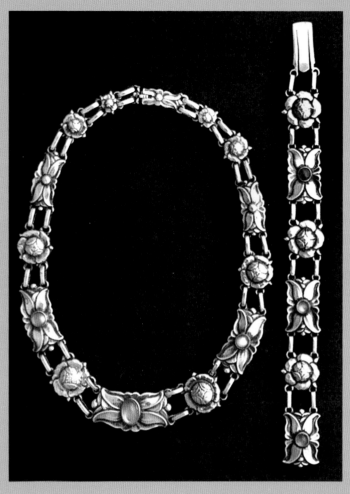

Olsson sterling silver bracelet and necklace with moonstones. Courtesy of Burt Olsson, photo by Russell Olsson.

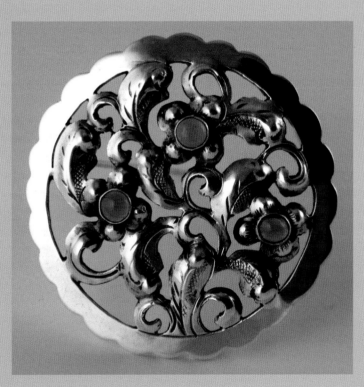

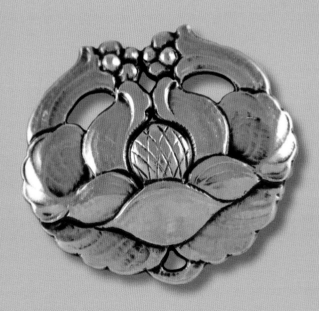

Yngve Olsson sterling silver brooches, one with stones, both signed. Courtesy of Chicagosilver.com. (above and right)

The Randahl Shop
Julius Olaf Randahl (1880–1972)

Businesses

The Randahl Shop,1911–1965
Park Ridge and Chicago
Randahl Jewelers,1963–c.1985
(acquired the Cellini Shop and Von Buelow's)

Work Chronology

Marshall Field & Co., 1905–1907
The Kalo Shop, 1907–1914
The Julmat, 1910–1911
The Randahl Shop, Park Ridge, 1911–1914;
Chicago 1914–1942; Skokie and Park Ridge
c.1943–1965

Known workers

Peter L. Berg, 1911–1960s
Carl Henry Didrich, c.1920s–1930s
Henri Anton Eicher, 1911–1914
Isadore V. Friedman, 1911–1950s
Gunnard Alex Peterson, c.1927–1940s (also
made items marked 'Sterling by Gunnard')
Harry Einar Peterson, c.1921–1940s
Julius "Bud" Randahl, 1939–c.1965
Scott Randahl, 1946–c.1963

Interior of the original Randahl Workshop, Park Ridge, IL, c.1911. From left: Isadore V. Friedman, Julius O. Randahl, unidentified, Henri A. Eicher, and Peter Berg. Courtesy of David Petterson.

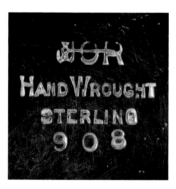
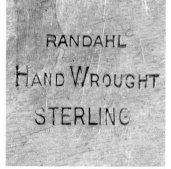
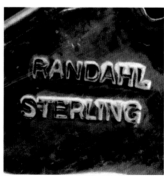

Randahl Shop hallmarks. Author's collection. Photos by Rich Wood.

Randahl played a pivotal role in establishing and maintaining the arts and crafts metalwork and jewelry industries in Chicago by building one of the longest lasting and most successful shops in the region. He made his first visit to the United States in 1896, to visit his sister in Brooklyn, hoping to discover a career where he might flourish in America. Deciding to become a silversmith, he apprenticed in his native Sweden and returned to New York in February 1902. Randahl worked for several silver companies before he was recruited in 1905 to join the ambitious Marshall Field & Co. silver workshops in Chicago. In 1907, Randahl caught the attention of Clara B. Welles from the Kalo Shop, who hired him as her first professional silversmith in Park Ridge.

In 1910, Randahl co-founded the Julmat with Kalo jeweler Matthias W. Hanck, but the short-lived partnership ended in 1911. He then established the Randahl Shop in the Eicher barn and workshop at 312 Cedar Street. Randahl used funds that he borrowed from his fiancée, Cornelia Scott, whom he married the following year. His initial employees were Kalo silversmiths Henri Eicher, Isadore Friedman, Peter Berg, and one other man. In Park Ridge, the Randahl Shop made silver for wholesale customers, including Von Buelow's, C.D. Peacock, and Marshall Field & Co., in addition to special order work for individual clients.

In 1914, Randahl moved the business to Chicago and worked at it full-time. Following the tradition of many Chicago silversmiths, he exhibited at the annual arts and crafts show at the AIC that year, showing two bowls, an

oval salad dish, two salad spoons and forks, a berry spoon, and a child's cup. He also was active in the Artists' Guild at the FAB, and the Hull-House Shops, and as a member of the Boston Society of Arts and Crafts. The business prospered until World War I forced Randahl to close the shop and take a position with a naval shipyard in Portland. He reopened the shop after the war, and employed fifteen to twenty workers. In the 1920s, he employed C.H. Didrich, who introduced his novel hand-wrought tulip candlestick designs into the Randahl repertoire, as well as the use of pewter for bowls, trays, and candlesticks. The Randahl Shop and Didrich provided silver to the Cellini Shop in Evanston after the Mulholland Brothers moved to Aurora, and the Randahl Shop maintained a steady stream of wholesale customers that the shop had cultivated for years.

Randahl produced only hand-wrought silver through the mid–1920s. He then began to experiment with machine-made and machine-assisted designs that were more streamlined, resembling the Art Deco period rather than traditional Arts & Crafts. He developed some remarkably innovative designs, including a popular square and fluted bowl with rounded corners. He continued to offer both machine-made and hand-wrought items throughout the history of the Randahl Company, and from the 1940s, he would add hand-wrought handles and special details to machine-made objects. In 1937, Randahl was selected to show his hand-wrought work at the Exhibition of Contemporary and Handwrought Silver at the Brooklyn Museum and the Exposition Internationale des Arts et des Techniques in Paris, where he won a silver medal for a pair of candlesticks and center bowl. In 1939, when Randahl's son Bud became active in the business, he stopped using his JOR hallmark and used the Randahl mark instead.

During World War II, Randahl and his wife Cornelia took out a mortgage on their home so they could continue to employ silversmiths in the shop for three to four days per week, which helped the Chicago silver industry to survive one of the most challenging times in its history. Hardworking and kindhearted, he offered steady work to silversmiths like C.H. Didrich, Peter Berg, Isadore Friedman, and many others throughout their lives. In 1965, he sold the silver manufacturing business to Reed & Barton. In retirement, he taught handicapped children to make silver and copper wares in Park Ridge, where he lived until he died of stomach cancer at the age of 92.

In the 1960s, Randahl's sons, Scott and Julius "Bud," bought Von Buelow's in Park Ridge and the Cellini Shop in Evanston to form Randahl Jewelers, which existed well into the 1980s.

the Charles S. Hayes family, photo by Scott Bourdon Studios.

Randahl jewelry showing Scandinavian influences. Courtesy of Curators Collection, photos by Rich Wood.

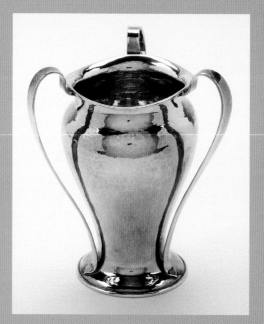

Randahl loving cup marked Hand Wrought JOR. 5.75 inches high. Courtesy the Charles S. Hayes family, photo by Scott Bourdon Studios.

Sterling silver owl brooch signed Randahl. Courtesy of Stephen H. and Holly Randahl, photo by author.

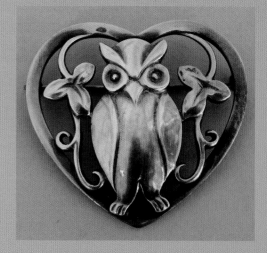

Five sterling silver brooches by Randahl, including one with green stone. Courtesy of Chicagosilver.com.

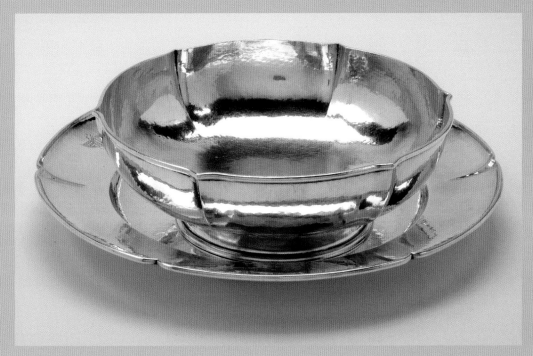

Randahl hand-wrought sterling silver bowl and tray marked with JOR logo.
Courtesy of the Charles S. Hayes family, photo by Scott Bourdon Studios.

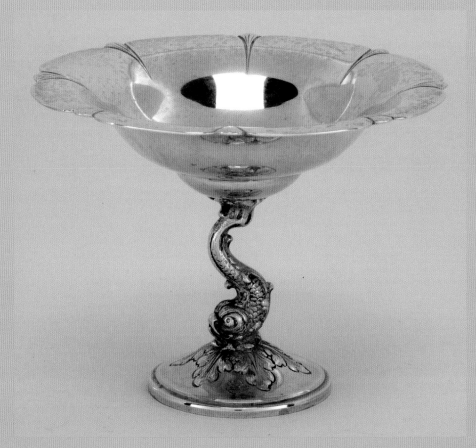

Randahl sterling silver dolphin pedestal dish, one of a pair, showing a
combination of hand-wrought detailing on machine made silver, marked JOR
Sterling. Author's collection and photo.

Randahl sterling silver trophy cup for the
Exmoor Country Club, signed Randahl
Hand Wrought Sterling C.D. Peacock. 4.75
inches high. Author's collection, photo by
Scott Bourdon Studios.

Randahl tulip candlestick, one of a pair, designed by
C.H. Didrich. Marked C.D. Peacock Hand Wrought
Pewter JOR. Author's collection, photo by Rich Wood.

Randahl three-lobed bowl with repoussé floral design
marked JOR Hand Wrought Pewter.

Randahl sterling silver water pitcher with
repoussé handle, marked Randal Sterling 108.
9.5" high. Author's collection and photo.

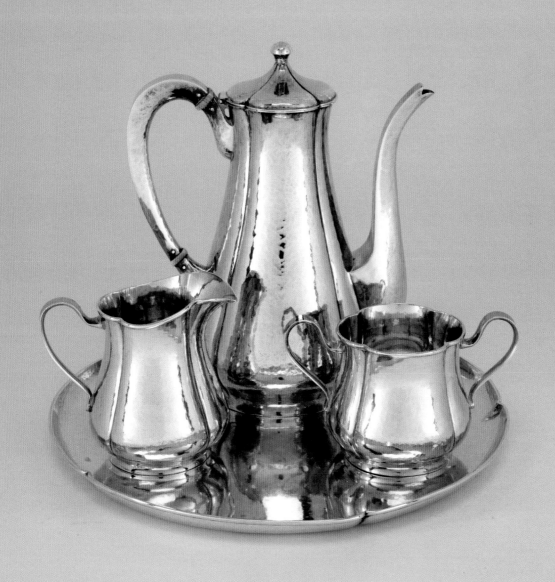

Randahl sterling silver coffee pot, creamer, sugar, and tray, all marked JOR Hand Wrought.
Courtesy of the Charles S. Hayes family, photo Scott Bourdon Studios.

The Orno Shop
Henry Richard "Dick" Sorensen (1890–1981)

Business

The Orno Shop (1913–c.1925)
127 E. Lincoln Highway, DeKalb, IL

Sorensen was an early jeweler for the Kalo Shop who went on to open his own business, teach, and publish on handmade jewelry. A Chicago native, he came to Park Ridge in 1908 to study and work at the Kalo Shop alongside Matthias Hanck; later he taught at the Kalo School. In 1912, he married Aldana Drury, a local public school teacher, and the following year they moved to DeKalb, where Sorensen founded the Orno Shop. The store sold jewelry, silver, and a variety of arts and crafts goods, including Roycroft copper from New York. Sorensen also taught manual training in the DeKalb High School and the Northern Illinois State Normal School (now Northern Illinois University).

Sorensen frequently wrote on jewelry for manual arts training publications and, in 1916, he and S.J. Vaughn published *Hand-Wrought Jewelry*, a popular book that sold to a national audience.

Carved geometric designs, cut-out patterns, and tiny applied flowers characterize the known jewelry from the Orno Shop, which is also similar to Hanck, Brooks, and early Kalo Shop jewelry.

In the 1920s, Sorensen became a real estate salesman and worked in Chicago for various brokers until the end of World War II, when he and his wife retired to Stamford, Connecticut. An avid singer, Sorensen opened a record store with his son-in-law, and remained active until his death from esophageal cancer at the age of 90.

Sterling silver acid-etched brooch, marked Orno. Courtesy of Chicagosilver.com.

Orno Shop sterling silver brooch with turquoise. Courtesy of Curators Collection, photo by Rich Wood.

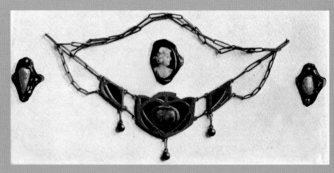

Jewelry from the Orno Shop shown in *Hand-Wrought Jewelry* (1916). Author's collection.

Orno Shop mark. Courtesy of Amanda J. DeSilver, photo by Frank Blau Photography.

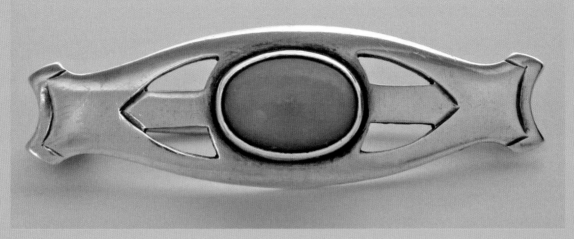

Green stone and sterling brooch marked Orno. 1 ½" long. Courtesy of Chicagosilver.com.

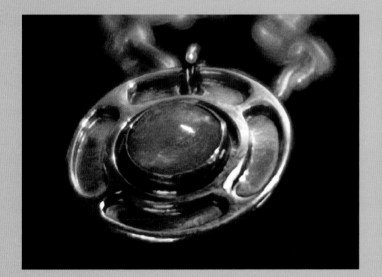

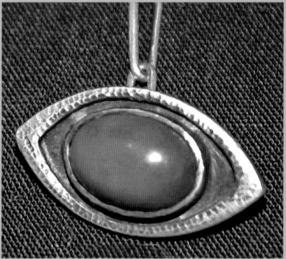

Orno Shop sterling silver fobs and an opal pendant.
Courtesy of Amanda J. DeSilver, photos by Frank Blau
Photography and Amanda Silver.

Kalo Entrepreneurs: Individual Marks

Bjarne Olaf Axness (born Oksnes) (1887–1943)

In April 1909, after completing his apprenticeship as a goldsmith in his native Norway, Axness arrived in Chicago with his brother. He soon joined the Kalo Shop and was close with the other Norwegian silversmiths, including Myhre and Didrich. In 1915, he married Hilda Carlson; they had four children. In 1925, he, along with other Kalo silversmiths, signed a commemorative tray given to Clara B. Welles on the 25th anniversary of the shop. He worked for Kalo until his death in 1943 from nephritis.

Hallmark attributed to Bjarne Axness. Courtesy of Chicagosilver.com.

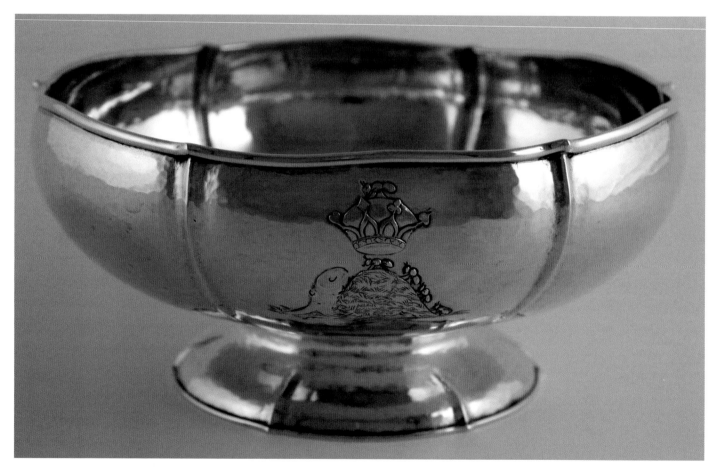

Sterling silver "King of the Ant Hill" repoussé bowl with applied "A" monogram and engraved *1907 May 29 1932*, signed Hand Wrought Sterling B.A. Courtesy of Chicagosilver.com.

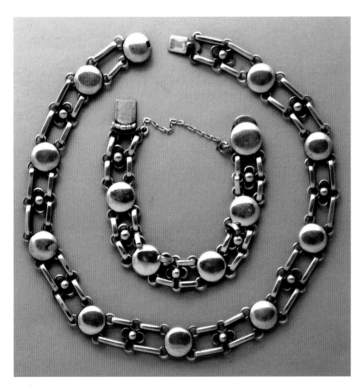

Robert R. Bower hallmark.
Author's collection.

Robert R. Bower (1902–1993)

Bower grew up in Joliet, Illinois, and lived across the street from Kalo designer Anna Doughty. He took jewelry making lessons from her and became proficient, prompting Doughty to suggest that he work for the Kalo Shop in Chicago. In 1921, Bower was hired and, under the tutelage of Peter Berg, made items such as hand-wrought, sterling napkin rings and baby cups. The Norwegian silversmiths poked fun at him and called him "the kid," but Bower became extremely close to Olsson, Myhre, and Pedersen. After the Kalo Shop moved its retail and workshop operations to the Clara B. Welles Building at 152 E. Ontario, Bower played an increasing role in managing the shop during Welles's frequent travels. From 1939, Bower managed all operations for the company and he became a part owner in 1959. Bower remained at the Kalo Shop until it closed in 1970. Bower's jewelry is substantial and finely crafted in a variety of styles.

Sterling silver chased brooch signed RRB Sterling. Author's collection, photo by Rich Wood.

Sterling silver disk necklace and bracelet. Necklace signed RRB Sterling, bracelet signed Hand Wrought Sterling. Author's collection, photo by Rich Wood.

Chased sterling silver bracelet with red carnelian, signed RRB Sterling. Courtesy of Chicagosilver.com.

Arne Margido Myhre (1888–1981)

In February 1909, goldsmiths Myhre and Karl Moe arrived in Chicago with the assistance of Myhre's cousin, Harold Carlsen, who worked for Leonide Lavaron in the Fine Arts Building. Myhre soon joined the Kalo Shop and worked in Park Ridge and Chicago. In 1925, he signed the commemorative tray given to Clara B. Welles. In 1959 Welles gave the Kalo Shop to him and three others. Myhre's known work includes candlesticks, bowls, and coffee sets. He died at the age of 93 in Florida.

Arne M. Myhre hallmark. Author's collection and photo.

Myhre tall sterling candlesticks, marked. This style was made by the Kalo Shop, Edward Breese, and likely many other Kalo artisans, c.1920s. Author's collection, photo by Scott Bourdon Studios.

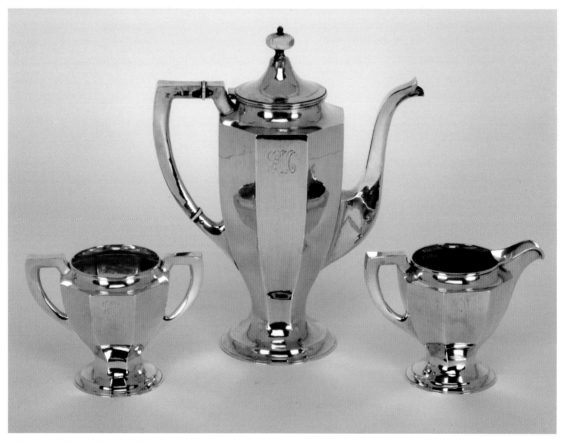

Myhre sterling silver coffee pot, creamer, and sugar, all marked. Author's collection, photo by Scott Bourdon Studios.

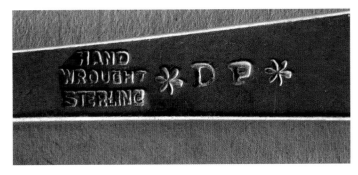

Daniel Hamer Pedersen (1893–1968)

In 1914, Pedersen arrived in Chicago from his native Norway at the suggestion of his friend and Kalo silversmith B.B. Andersen. Pedersen joined the Kalo Shop and lived in the Eicher barn/studio with Andersen, Haga, and Wood, commuting to the Kalo Shop in Chicago. Under his signature, he made striking hollowware items of impeccable quality and also a fair amount of jewelry in hammered and engraved designs; he also made silver for the Volund Shop. In 1959, Clara B. Welles gave the Kalo Shop to him and three others. From the 1950s, he taught silversmithing at the AIC, and Chicagoan William Frederick was one of his successful students. Pedersen had a keen appreciation for the silversmith's art and could identify the maker of a silver item by the individuality of their hammer marks.

After Pedersen's wife Helen died in c.1967, he moved to Scottsdale, Arizona, where he intended to start his own studio. He suffered a stroke and died there in 1968.

Daniel H. Pedersen hallmarks. Courtesy of the Andersen family. Photos by Bruce Brewer and the author.

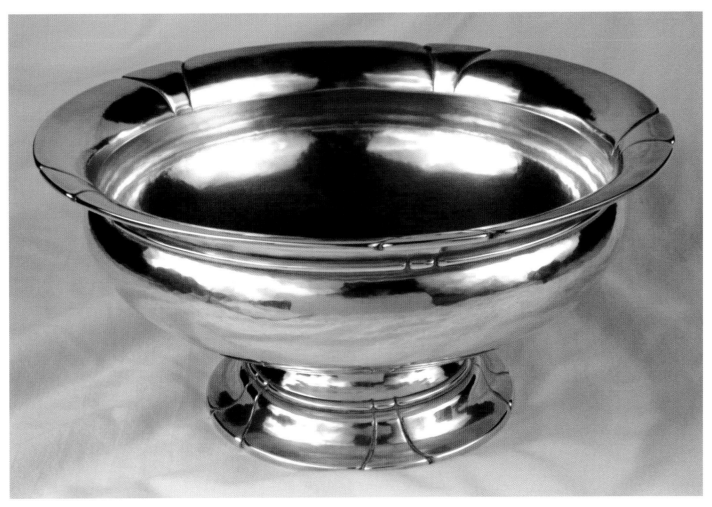

Pedersen sterling silver center bowl, made for B.B. Andersen. Courtesy of the Andersen family. Photo by Bruce Brewer.

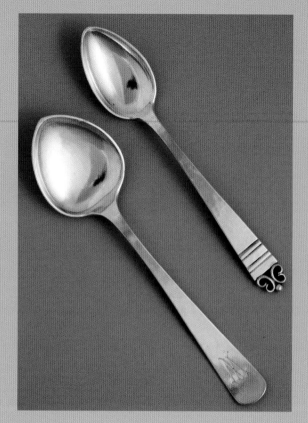

Pedersen sterling silver tea spoon and serving spoon, both signed. Author's collection, photo by Rich Wood.

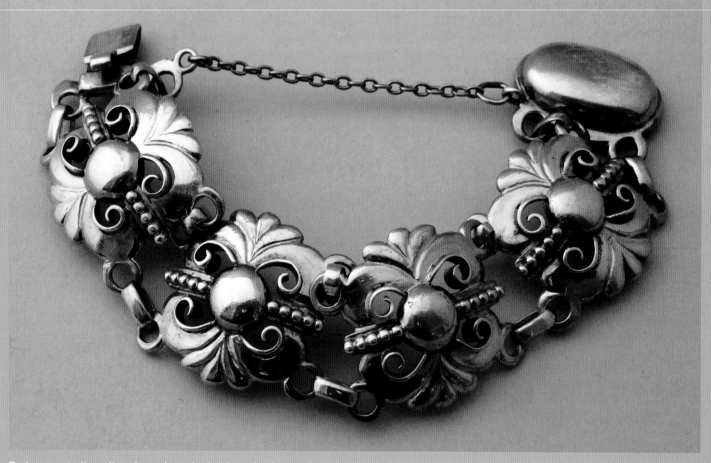

Pedersen sterling silver bracelets. Author's collection and photos. (Above and opposite page)

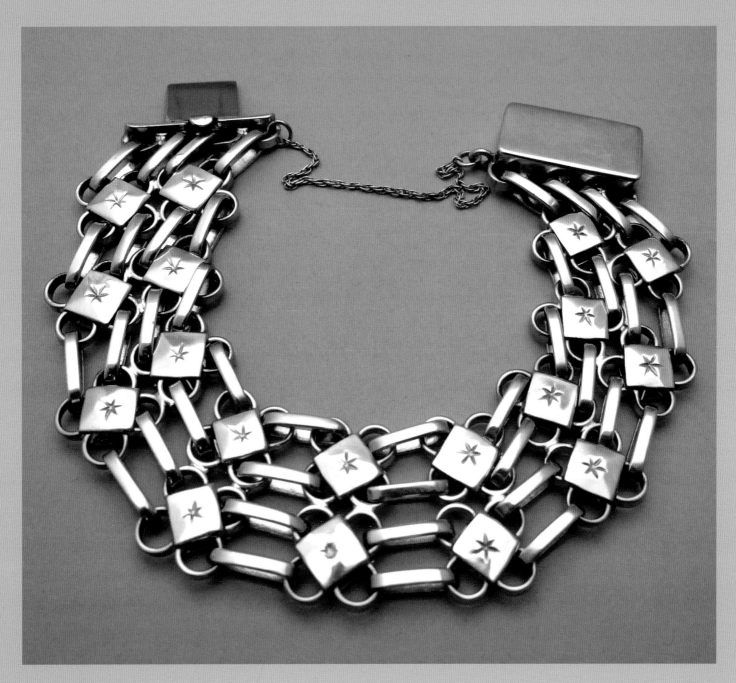

Kalo Artisans, Marks Not Identified

Sven Wilhelm Anderson (1880–1964)

Anderson arrived in Chicago from his native Sweden in October 1910, and joined the ranks of the Kalo Shop as a silversmith. After 1916, he may have worked for H.A. Eicher, and he worked for the Randahl Shop from c. 1921. From at least 1942 to 1949, he served as the main silversmith for J.P. Petterson. In 1948, he and Petterson were highlighted in a *Sun-Times* photo underscoring the shortage of craftsmen in America. After Petterson died, he made flatware for his son John C. Petterson until his death in 1964.

Edna Coe (Mrs. Joseph Lowe McNab) (1881–1956)

Born in Chicago and raised in Evanston, Coe graduated from the decorative design course taught by Louis Millet with co-students Hannah Beye and Helen McNeal. In 1908, she studied at the Kalo School in Park Ridge, and then worked designing and making jewelry for the Kalo Shop. She is listed Kalo order books from 1909, and she worked closely with Mildred Bevis through 1913. In 1914 she married attorney Joseph McNab and lived in Plano, Illinois. She died in Florida.

John Holmes Cook (1887–1966)

Born into a working class family in San Francisco, Cook apprenticed as a silversmith at Shreve and Company from the age of 16. He moved to Concord, New Hampshire, where he worked for one of the local silversmith companies. By 1917, he moved to Chicago to work for the Kalo Shop. After serving in World War I, he returned to the Kalo Shop and his name is among the signatures on a 1925 anniversary tray given to Clara B. Welles. He was unemployed but living in Chicago during World War II and died in the city in 1966.

Anna Pond Doughty (1881–)

Doughty grew up across the street from Robert Bower in Joliet. Initially a librarian, she received a degree in graphic arts from Illinois State University and worked as a jeweler and designer for the Kalo Shop from c.1916. She also taught Bower how to make jewelry out of her basement workshop in Joliet. In 1920, she co-founded the Hines Doughty Co., which managed the retail operations of the Kalo Shop at 416 Michigan Avenue in Chicago.

In 1922, Doughty moved to New York City and established several companies in design and jewelry manufacturing that also retailed Kalo silver through the 1930s. Some of the items Doughty ordered from Kalo included copper bowls with silver monograms, belt buckles, a powder box with a bakelite knob, a shoe horn, and a brush.

Edwin Emil Guenther (1893–1925)

A Park Ridge native, Guenther apprenticed as a silversmith and jeweler at the School of the Kalo Workshop as a teenager. After Kalo relocated to Chicago, Guenther worked for Matthias Hanck (c. 1914–1916), and he joined Lebolt & Co. by 1917 where he remained until his death.

Raymundo Gomez

Gomez was "the last good silversmith" who worked for Kalo, according to Robert Bower. He apprenticed at the shop for about eight years. Gomez was listed in the Kalo order books in 1966, and the *Chicago History Museum* has a Kalo belt made by Gomez in 1969.

Ole J. Horway (1884–1938)

In 1912, Horway emigrated to Chicago from his native Norway and lived with his aunt and uncle. A silversmith, he worked for the Kalo Shop by 1917 and worked at Lebolt & Co. in 1928. [22]

Einar Johansen (1882–1934)

Johansen was a jeweler for David Andersen in Oslo before he came to New York in 1912 with three fellow jewelers. In 1920, he lived in Chicago with his sister and her husband, and worked as a jewelry engraver, probably for the Kalo Shop. In 1925, he signed a commemorative tray given to Clara B. Welles. He died in Chicago in 1934.

Walter B. Kichura (1918–2003)

Kichura was a Kalo jeweler from 1936. He served in World War II, and returned to Kalo after the war, working part-time in addition to serving as a part-time lieutenant in the fire department. Robert Bower, the last manager of the Kalo Shop, said he was a wonderful, expert jeweler who could also make flatware—knives, forks, and spoons. Commenting on his abilities, Bower said that, "If Walter made it, it was perfect."

Iwan Loukacheff (1903–1989)

Loukacheff worked for the Kalo Shop at least from 1959–1966.

Julie Mayer [also Julia] (1889–after 1948)

In 1910, German-born Mayer was sponsored to come to the United States by George and Clara Welles. She studied at the Kalo School and was close to Mildred Bevis and Esther Meacham. She made jewelry for the Kalo Shop and probably Meacham's shop while living with sculptor John Paulding and his wife Jane in Park Ridge. Around 1917, she began designing and making jewelry for Clara Flinn at the Tre-O Shop in Evanston. By 1922, she had moved to Evanston and later transitioned with Flinn as an interior designer at C.D. MacPherson. Mayer managed the firm and served as president after Flinn died in 1945. She was listed in Evanston directories through 1948.

Esther Lydia Meacham (Mrs. Harold W. Ward) (1893–1966)

Business
Meacham Studio (c.1914–1918)
131 Vine Street, Park Ridge, IL

Meacham was a Park Ridge native and one of the dozens of aspiring women artists who studied at the Kalo Arts Crafts Community House and the School of the Kalo Workshops. She excelled at making jewelry and soon became a teacher at the facility. From c.1914 to 1918, she operated her own business, selling hand-wrought jewelry and offering classes at 131 Vine Street in Park Ridge. In 1918, she married Harold W. Ward and gave up her career to raise her family. She died in Florida in 1966.

Joseph Edward O'Marah (1879–1956)

O'Marah was a silversmith who worked for the Frank W. Smith Co. and Towle Silversmiths in Massachusetts before he joined the Kalo Shop in 1908. By the summer of 1911, he was the foreman of the Lebolt silver workshops, and he organized the 1912 Lebolt exhibit at the annual arts and crafts show at the AIC. He and his team built the Lebolt & Co. silver shop into a leading force in the Chicago Arts & Crafts Movement. He remained at Lebolt until he retired in the 1940s.

Arthur Winfield Scott (also William) (1895–after 1942)

Park Ridge native Scott attended the Kalo School and worked as a jeweler for the Kalo Shop from c. 1910 to 1918, and his name appears in early jewelry order books. He served in World War I, returning to the Kalo Shop in 1920. By 1930, he worked as a writer and editor of books and magazines.

Henry A. Strater (1869–1927)

In 1910, Strater, an experienced silversmith from Rhode Island, worked for the Kalo Shop in Park Ridge. By 1920 he had returned to his native Rhode Island and he worked there until his death in 1927.

Emery Walter Todd (1885–1949)

Todd, a co-founder of the TC Shop in the FAB in 1910, studied at the Kalo Shop, probably from 1908 to 1910.

Victor Weinz (1875–1933)

In 1886, Weinz and his family immigrated to Chicago from his native Germany and he apprenticed as a jeweler by 1900. By early 1910, he worked for the Kalo Shop in Park Ridge and was the maker of a large cross illustrated in the shop's order books. In 1913, he was a maker for the studio of Leonide C. Lavaron in the FAB. He worked in Chicago until he moved to California in 1920. He variously worked as a jeweler and rancher until he died in an automobile accident in 1933.

Clarence Willie (1894-)

Willie lived in Park Ridge and was listed as a silversmith in the 1910 census; he likely attended the Kalo School. He worked as an auto mechanic in 1920 and for the *Chicago Tribune* in 1942.

William Wood (1866-)

In 1910, Wood was a jeweler at the Kalo Shop in Park Ridge.

Peter M. Young (c. 1869–1924)

A Wisconsin native, Young worked for the Kalo Shop from c.1910 to 1914. He co-founded Young & Joetten in Chicago in 1914, which he operated through 1916. By 1920, moved to Providence, Rhode Island and operated his own jewelry business until his death.

Edmund C. Zerrien (1890–1963)

A Park Ridge native who lived adjacent to the Kalo Arts Crafts Community House, Zerrien studied at the Kalo School and became a goldsmith by 1910. He subsequently became a skilled-trades worker. He died in Florida in 1963.

Kalo workers playing croquet in the yard at the Kalo Arts Crafts Community House. George Welles is smoking the pipe in front. Courtesy of David Petterson.

Clara B. Welles in San Diego, CA, August 1948. Courtesy of Stanley Hess.

V

Chicagoland Business Districts

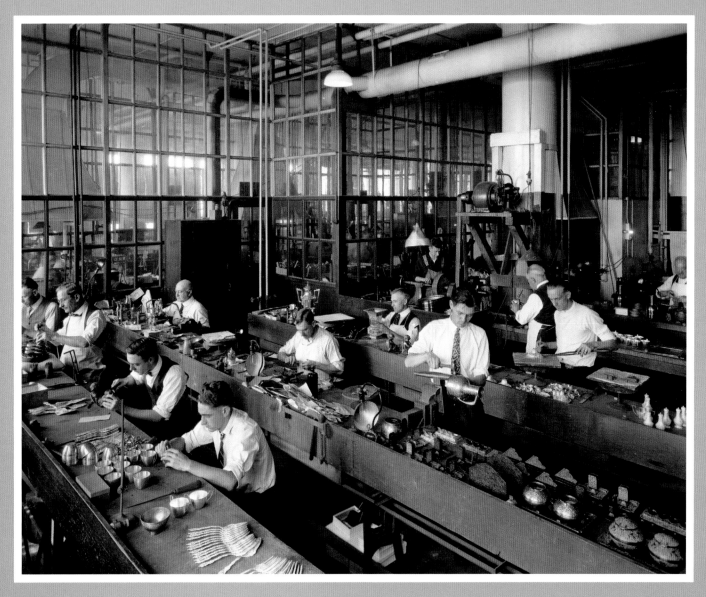

Marshall Field & Co. jewelry and silver workrooms, c.1920. Courtesy of Marshall Field & Co. Archives.

Marshall Field and Company

Marshall Field and Company,
Craft Shop and Workrooms
> Jewelry and Silver Workrooms, wholesale and retail, c.1903–1940s
> Craft Shop, Art Metal Craft and related lines, retail, 1907–1917
> Hand-hammered Colonial silver, retail, 1907–c.1925
> Dufour, George Holmes (1873–1937)

Known workers
> Ovide J. Bedard, silversmith and silver plate foreman, 1910–1930s
> Ernest Benziger, silversmith, 1918–1940s
> Herman A. Brandt, jeweler, 1908
> Willis Breese, silver worker, 1928
> William Conrad, jeweler, c.1910–1920s
> George H. Dufour, manager, silversmith, jeweler, 1901–1937
> Isadore V. Friedman, silversmith, metalworker, jeweler, c.1905–1907
> Ernest J. Gerlach, jeweler, prior to 1912
> Walter B. Gerlach, jeweler, 1917
> Karl Henry Koch, designer, jeweler, 1907–1910
> Victor E. Lindgren, silversmith, 1916
> Fred C. Minuth, jeweler, 1909
> Arthur A. Neale, silversmith, c.1908–1925
> Henry Olin, jeweler, 1916
> Richard W. Orpwood, silversmith, 1910–c.1931
> Julius O. Randahl, silversmith, 1905–1907
> George C. Rosenbaum, jeweler, 1923–1940s
> Elmer G. Smith, silversmith, 1907
> Peter Stepanienko, silversmith, 1910–1940s
> Michael Charles Thurnes, jeweler, 1918–1940s

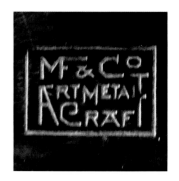
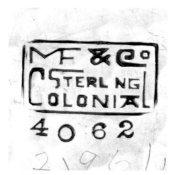
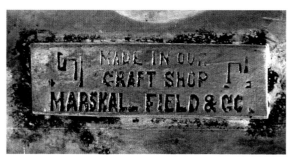
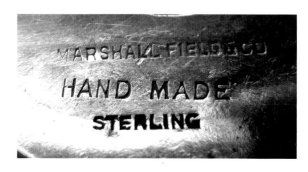

Marks for Marshall Field and Co. Craft Shop, Colonial silver and Wrought-Right silver plate. Author's collection.

Shortly after the turn of the century, Marshall Field & Co. emerged as a major commercial manufacturer of wholesale and retail arts and crafts jewelry, silver, and metalwork. Its innovative workshops provided training for dozens of workers who went on to start their own companies or work for the leading artisans of the period. Founded by Potter Palmer in 1852 and renamed Marshall Field & Co. in 1881, the store manufactured, imported, bought, and sold a plethora of luxury goods for the flagship retail store on State Street while maintaining a vigorous and highly profitable wholesale business through the 1920s. The store was important in promoting the Arts & Crafts Movement in Chicago because it bought merchandise from local artisans, sold wares on consignment, sponsored art exhibits in its store, and openly embraced the metalwork and jewelry industries taking hold in the city.

In 1901, Marshall Field's hired George H. Dufour, a jeweler and silversmith, to establish jewelry and silver workrooms, which would also manufacture decorative household objects. Dufour modeled the facilities after Tiffany & Co. and opened the workrooms and a wholesale silver business around 1903. These comprehensive workrooms allowed Marshall Field & Co. to qualify as the first department store in the country to sell Gorham silver.

Marshall Field & Co. quickly embraced and fueled the burgeoning arts and crafts industries by introducing the latest designs in its stores and for the wholesale trade. One ad from 1904 touted, "Verdigris green, an artistic coloring in jewelry, silverware, lamps, and electroliers, is now executed in our jewelry workroom."[1] In December 1907, Dufour launched the Marshall Field & Co Craft Shop, which manufactured acid-etched and hammered jewelry in copper, brass, and silver, as well as a broad array of decorative objects for its retail store including trays, boxes, desk sets, inkwells, photo frames, calendar sets, letter holders, and candlesticks. Objects were stamped with the MF & Co Art Metal Craft logo or, less often, style names such as Viking Craft and others. The Craft Shop also made custom designs for customers. Also in December 1907, Field's announced a new retail line of hand-hammered Colonial silver in the arts and crafts style, which included bowls, plates, tea and coffee sets, water pitchers, chocolate sets, trays, flatware, serving pieces and tea caddies, children's silver—all "finished to show the hammer marks." A reporter for the *Illustrated Review* in 1908 noted that the Craft Shop, a place where "Ruskin or William Morris might have joyed in," made Colonial silver and a broad range of artistic metal craft items and jewelry that crystallized "the personal impulse of the craftsman."

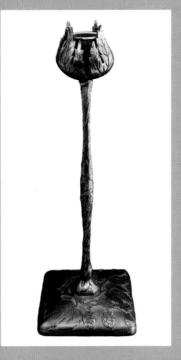

Marshall Field & Co. Art Metal Craft Virginia Creeper vine pattern decorative items. Candlestick courtesy of Boice Lydell, desk set courtesy of the Charles S. Hayes family, letter rack courtesy of author's collection. Photos by author and Scott Bourdon Studios.

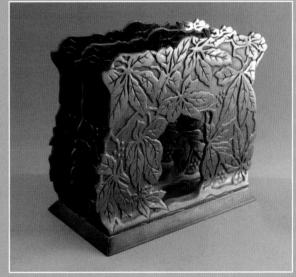

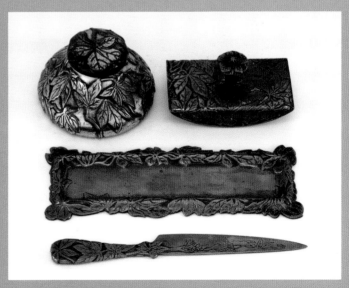

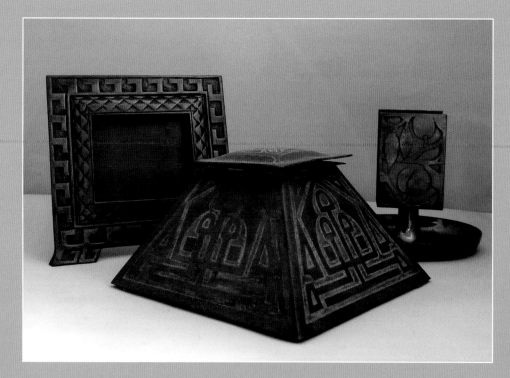

Marshall Field & Co. Craft Shop. Copper etched match holder marked MF & Co Art Metal Craft. Frame and inkwell marked Made by Marshall Field & Co. Author's collection, photos by Rich Wood.

Marshall Field & Co. Craft Shop. Three acid-etched brooches in sterling silver and brass, one with coral-colored glass stones. All marked Made in Our Craft Shop Marshall Field & Co. Author's collection and photo.

Sterling silver hammered bracelet with applied monogram, marked with MF & Co Colonial logo. Author's collection, photo by Rich Wood.

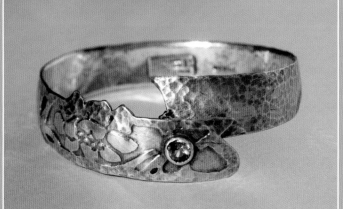

Sterling silver and amethyst bracelet courtesy of Boice Lydell.

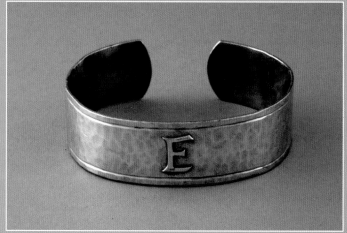

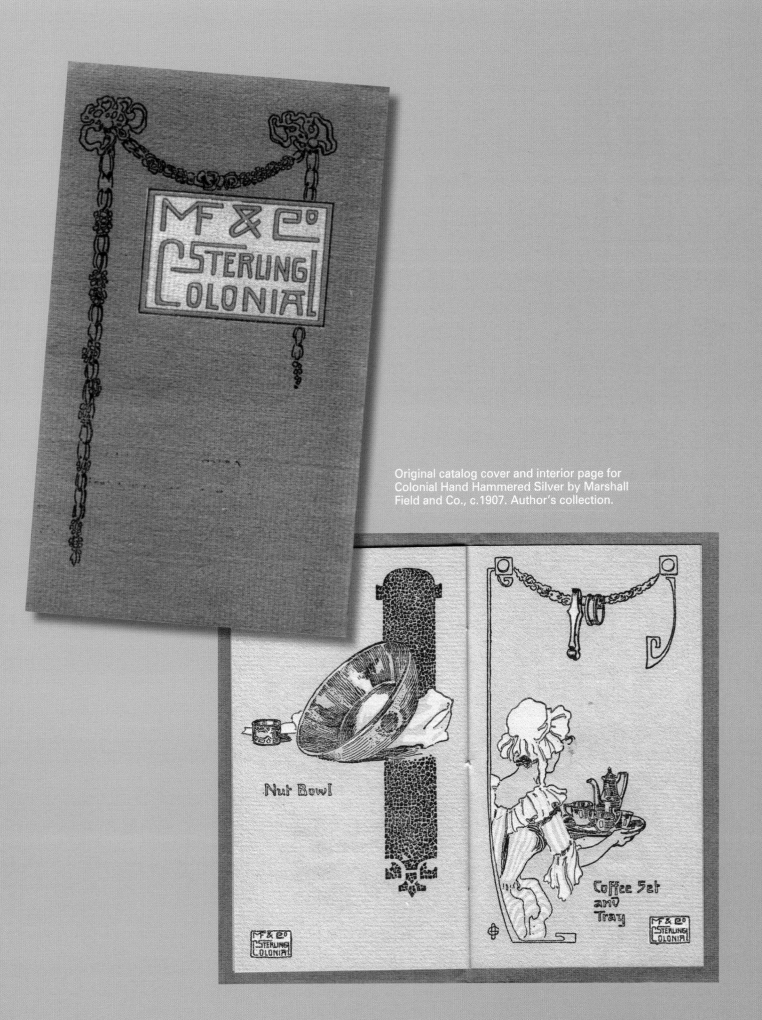

Original catalog cover and interior page for Colonial Hand Hammered Silver by Marshall Field and Co., c.1907. Author's collection.

Nut Bowl

Coffee Set and Tray

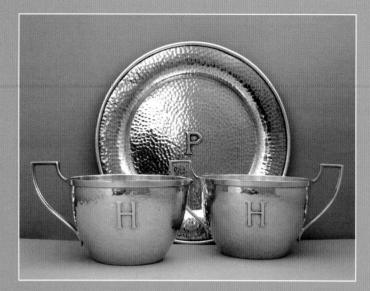

Colonial sterling silver plate, creamer, and sugar with applied monograms, all marked. Author's collection and photo.

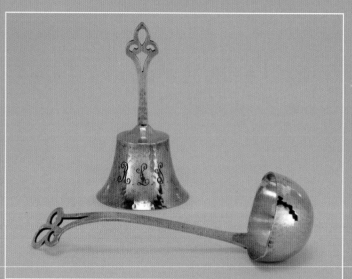

Marshall Field & Co. sterling silver bell and ladle. Both marked MF&Co Gothic Sterling, a variant on the Colonial line. Author's collection, photos by Rich Wood.

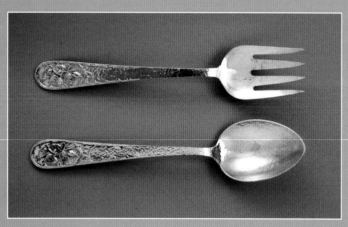

Marshall Field & Co. acid-etched serving spoon and fork, c.1920. 10.25 inches long. Author's collection, photo by Rich Wood.

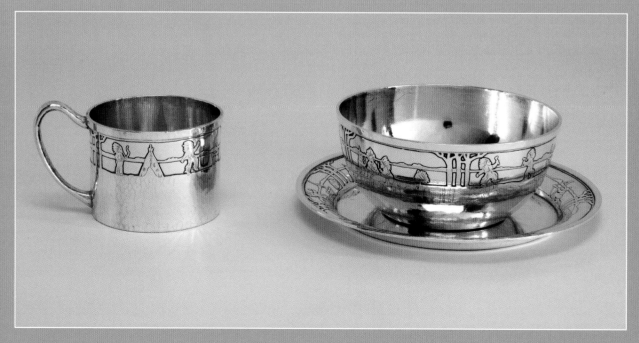

Child's porringer, under plate, and cup in acid-etched Indian motif, all marked MF & Co Sterling Colonial. Courtesy of the Charles S. Hayes family, photo by Scott Bourdon Studios.

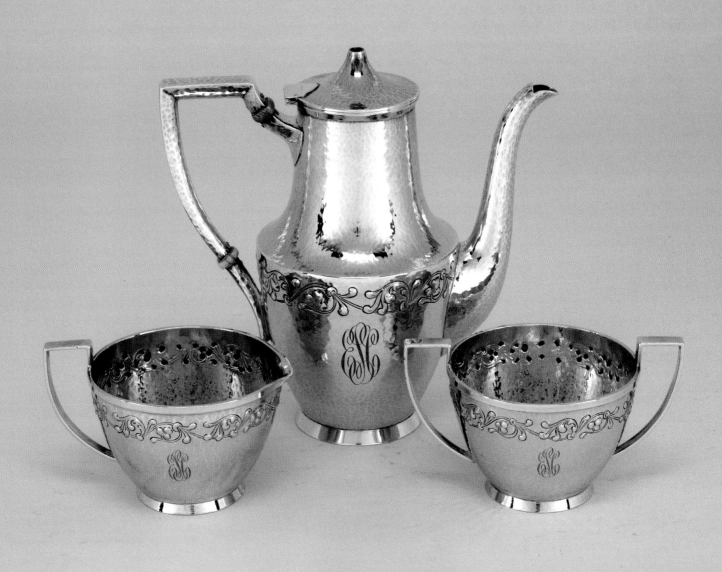

Colonial hand-hammered sterling silver coffee pot, creamer, and sugar with repoussé detailing.
Courtesy of the Charles S. Hayes family, photo by Scott Bourdon Studios.

Marshall Field and Co., Wholesale Division
(c.1903–1920s)

Field's started with a wholesale line of just about everything it sold in its stores, including arts and crafts silver and jewelry. From c.1903, hand-hammered Colonial silver marked with a distinctive 925/000 represented Field's wholesale line, and pieces often carried the names of the retail stores as well. [2]

The 925/000 silver mark attributed to the Marshall Field & Co. wholesale division. Author's collection and photo.

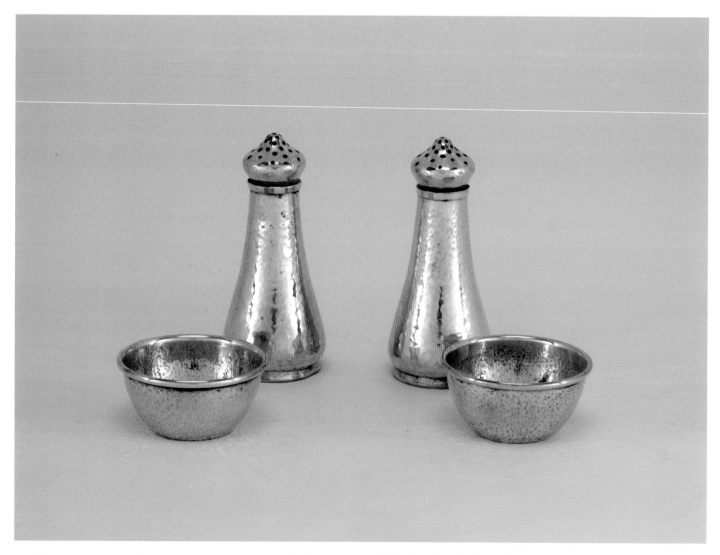

Sterling silver pepper shakers and salt dishes. The salt dishes are marked with the Marshall Field & Co. Colonial logo and the pepper shakers with the 925/000 logo. Author's collection, photos by Rich Wood.

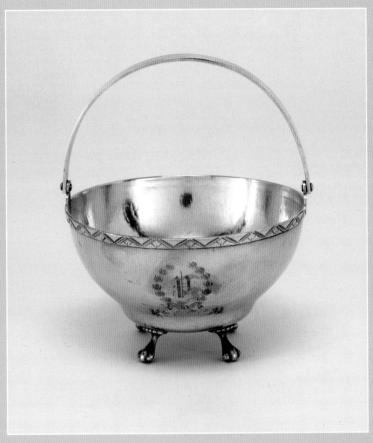

Sterling silver footed basket, marked 925/000 for Marshall Field &
Co. wholesale division. Author's collection, photo by Rich Wood.

Sterling silver pendant with paperclip chain and scarab
bracelet set with green chrysoprase. Both signed 925/000; the
pendant is also marked 478 A. Author's collection and photos.

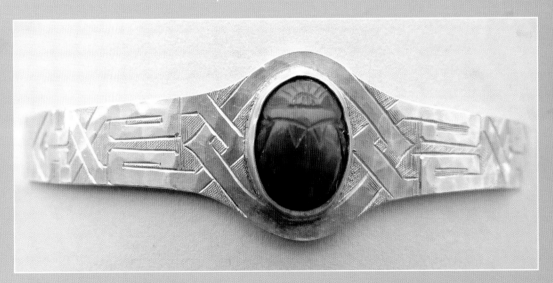

In 1917, Field's shut down the Craft Shop, although Dufour continuod to manufacture and market hand-hammered silver in the Colonial style through c.1925. Equally popular, Field's silver workshops introduced fancy Dutch style serving pieces, bowls, themed boxes, and acid-etched sterling silver serving pieces with an organic leaf design that were made through the 1940s.

ZODIAC 5 O'CLOCK TEA SPOON

Plain Bowl

93538.	Dozen **21.00**
Dec. 21st to Jan. 20th	
93539.	Dozen **21.00**
Jan. 20th to Feb. 19th	
93540.	Dozen **21.00**
Feb. 19th to March 21st	
93541.	Dozen **21.00**
March 21st to Apr. 19th	
93542.	Dozen **21.00**
April 19th to May 20th	
93543.	Dozen **21.00**
May 20th to June 21st	
93544.	Dozen **21.00**
June 21st to July 22nd	
93545.	Dozen **21.00**
July 22nd to Aug. 22nd	
93546.	Dozen **21.00**
Aug. 22nd to Sept. 23rd	
93547.	Dozen **21.00**
Sept. 23rd to Oct. 23rd	
93548.	Dozen **21.00**
Oct. 23rd to Nov. 22nd	
93549.	Dozen **21.00**
Nov. 22nd to Dec. 21st	

93538.

Zodiac Spoon, marks, and ad from 1909 wholesale catalog. Marshal Field & Co.'s wholesale division sold items made in its workrooms as well as assembling goods from around the world. This Zodiac spoon, popular with modern-day collectors, was sold by the wholesale division, but it is currently unknown if it was made at the company for the wholesale market or purchased from another studio. Author's collection.

Kenilworth Gift Shop brochure for a "store within a store" gift wares display that was marketed by Marshall Field & Co. wholesale division to stores all across the country. An accompanying letter, dated 1918, explained that Field's would provide three different catalogs for the retailer to mail to its customers after the gift shop was established. Brochures were customized for each retailer and did not mention Marshall Field & Co. Author's collection.

Department Stores, Manufacturing Jewelers, Retail Jewelers, and Silversmiths

In addition to Marshall Field and Company, a host of other Chicago department stores, manufacturing jewelers, retail jewelers and silversmiths offered exquisite hand-wrought jewelry and silver to their customers. Many produced jewelry in their workshops, but silver tableware and hollowware typically was outsourced to the large pool of local silversmiths—some of the finest in the country—instead of investing in a substantial onsite workshop with full-time employees. This network strategy resulted in abundant and stable work for Chicago artisans who often catered to the wholesale market.

In October 1910, Lebolt & Co., originally a manufacturing jeweler, delved into the hand-wrought silver market by establishing its own workshop. Lebolt recruited J. Edward O'Marah from the Kalo Shop to head up its initiative, and Lebolt rapidly became one of the country's leading producers. Around 1913, Hyman & Co., a manufacturing jeweler with a long-standing pedigree in the Chicago jewelry business, launched a hand-wrought silver business that appears to have been staffed by the local network of wholesale silversmiths. By 1915, Lewy Brothers introduced hand-wrought special order silver produced by the Mulholland Brothers; the two companies jointly exhibited a championship trophy at the annual AIC show that year. John Petterson and the Chicago Silver Company also made silver items for Lewy Bros.

Chicago's oldest jewelry establishment, C.D. Peacock, frequently sold hand-wrought silver produced by J.O. Randahl. Other firms, including Frank S. Boyden, Boyden Minuth, P.N. Lackritz, W.D. Smith Silver Company, Spaulding & Co., and Tatman's, relied on the expertise of Chicago silversmiths to produce its hand-wrought silver. In the 1920s, F.E. Foster & Co., a famous shoe merchant, featured stylish hammered copper and silver shoe buckles made by the Kalo Shop (marked Foster).

Manufacturing jewelers that produced arts and crafts jewelry in silver, gold, or platinum included Juergens & Andersen, which hired avant-garde metal artisans such as Bessie Bennett and Essie Myers to design and make items. Other known arts and crafts style makers included Brandt Jewelers, Ferdinand Holz, Lebolt & Co., Mandel Bros., J. Milhening, and Wendell & Co.

Fraternal jewelers also helped popularize the arts and crafts industries in Chicago, and several featured hand-wrought silver bracelets, pins, pendants, brooches, and rings with organizational insignia, applied initials in the Chicago style, and cutout monogram jewelry. Notable firms included Brochon, Chicago Art Metal Works, Chicago Monogram Works, R.M. Johnson & Son, Spies Bros., and Clarence Wadley.

Frank S. Boyden and Company
Boyden-Minuth

Businesses
Boyden, Frank S. & Co. (1897–1918)
Clark & Madison, Chicago
Boyden-Minuth (1918–1980s)
#1312, 29 E. Madison, Chicago

Principals
Frank S. Boyden (1862–1944)
Fred Charles Minuth (1884–1966)

Frank S. Boyden & Co. and Boyden-Minuth were known among Chicago's fine manufacturing and retail stores that featured gold and platinum jewelry. In 1908, Boyden, a creative and original designer, received a patent on a brooch depicting a bird carrying a diamond. The Boyden companies also were noted for their specialty sterling silver items and golf trophies that were designed by Boyden and fashioned through a partnership with Eivind Borsum from c.1915 to 1918, and subsequently by John P. Petterson, Emery Todd, and others for many years. The company employed manufacturing jewelers and a silver plater, Peter Gerharz.

Sterling silver golf trophy designed by Frank Boyden, signed Boyden Minuth with its logo. Courtesy of Chicagosilver.com.

F.S. Boyden and Boyden Minuth hallmarks. Silver was designed at the company and executed by a variety of Chicago's leading silversmiths. Courtesy of author's collection and Chicagosilver.com.

Boyden Minuth sterling silver Windsor Trophy vase, marked with logo and Hand Made. Attributed to J.P. Petterson. Courtesy of Chicagosilver.com.

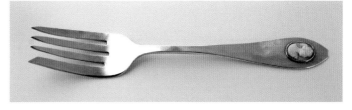

F. Boyden sterling silver fork inset with a cameo, signed Boyden Chicago Handmade. Courtesy of Chicagosilver.com.

Hyman and Co. (1909–1923)

Principal
Harry S. Hyman (1864–1941)

Locations
33 N. State St., 1909–1919
64-66 E. Washington St., 1919–1923

Hyman & Co. traced its roots back to 1859, when Charles Wendell and Sigmund Hyman, Chicago retail jewelers, catered to the rising prosperity of local residents. In 1909, following a succession of retail establishments with his brother Edward and Morris Berg, Harry S. Hyman organized Hyman & Co. as a manufacturing jewelry shop at 33 N. State Street, in the heart of the Chicago shopping district. By 1913, the company offered a variety of hand-wrought sterling hollowware items that appears to have been outsourced to the local network of silversmiths—primarily to John P. Petterson, but also to Julius O. Randahl, C.H. Didrich, and possibly the Mulholland Brothers. The items were usually signed "Hand Made" or sometimes "Handwrought" and some pieces included Randahl's JOR mark in addition to the Hyman & Co. A 1919 Hyman & Co. catalog illustrated water pitchers, gravy boats, trays, creamers and sugars, baskets, candlesticks, a coffee set, sugar cube holders, flatware serving pieces, bowls, and napkin rings.

In 1915, Hyman & Co. reorganized under bankruptcy protection, and stayed in business until 1923, when Hyman announced he was retiring; company assets were sold at auction. Hyman died in Chicago in 1941.

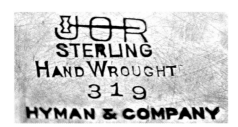

Hyman and Company hallmark and Randahl Hyman hallmark. Courtesy of Chicagosilver.com and author's collection.

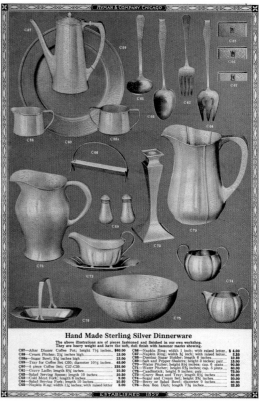

Hyman & Company catalog, 1916. Courtesy of Chicagosilver.com.

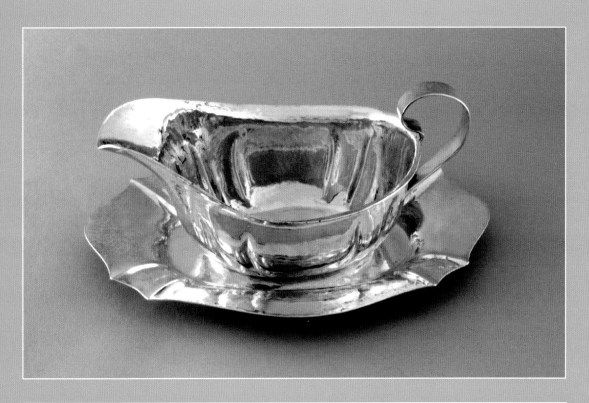

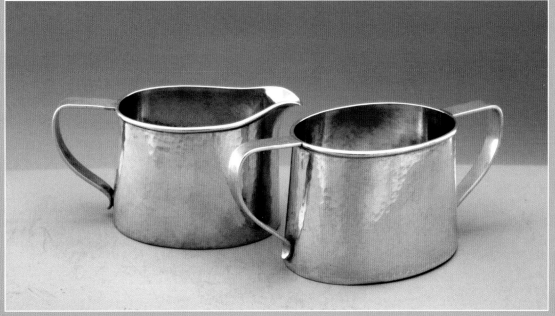

Sterling silver gravy boat
and tray, creamer and sugar,
and three napkin rings
signed Hyman & Company.
Author's collection, photos
by Rich Wood.

Juergens & Andersen (1854–1980s)

Location
100–108 N. State St., Chicago,

Known workers
Elizabeth Wilmarth Belknap, designer, 1902
Bessie Bennett, designer and maker, 1902–1908
Mabel Conde Dickson, designer and maker, 1904
Henry Olin, jeweler, 1917
Essie H. Myers, designer and maker, 1905–1912

A family-owned manufacturing jewelry business for more than 130 years, Juergens & Andersen originally made jewelry and coin silver items before the Great Chicago Fire, and, after 1871, migrated to fine jewelry manufacturing, particularly using platinum, diamonds, and pearls. From the turn of the century, the company employed AIC-trained women designers, including former Kalo jeweler Mabel Conde Dickson. Work by the women was featured in the annual AIC shows, where the company exhibited silver and gold brooches, scarf pins, necklaces, pendants, combs, rings, fobs, and cuff links set with labradorite, opals, malachite, turquoise, lapis lazuli, amethyst, rose quartz, and emeralds, as well as some copper jewelry and silver with enamel. In the 1920s, Juergens & Andersen gave up its street-level retail store and concentrated on wholesale jewelry manufacturing, including its popular add-a-pearl line.

Early Juergens and Andersen hallmark on silver and later jewelry mark. Author's collection.

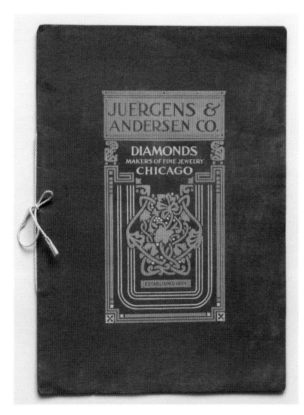

Essie Myers silver and rose gold watch fobs that were made while she worked for Juergens and Andersen. From *Palette and Bench* (March 1909). Courtesy of Boice Lydell.

Lewy Brothers (1898-1925)

Principal
Marks Lewy

Marks Lewy was an experienced jeweler and diamond merchant when he incorporated Lewy Brothers with his brother Jay B. and nephews Ervin G. and Max D. in 1898. In 1912, Ervin G. died on the Titanic when returning from Europe from a diamond-buying trip. Lewy Brothers relied on Chicago's leading silversmiths, including Mulholland Brothers, to fashion hand wrought silver that was sold under the Lewy hallmark and also may have outsourced custom jewelry creations like this gold cameo brooch. The company filed for bankruptcy and went out of business in 1925.

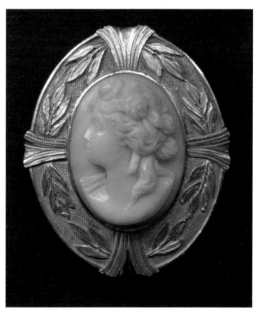

Intricately carved gold cameo brooch signed Lewy 14K. 1 5/8" by 1 3/8". Author's collection and photo. This brooch is a fine Arts and Crafts Movement example of carved gold similar to some of the known work by Chicago artisans James Winn, Hannah Beye, Emil Kronquist or Albert Wehde. A revival of cameo jewelry became a raging world-wide fad from 1911 to World War I, featuring hand-carved, deep pink coral and Wedgwood blue china medallions set in silver or gold.

Juergens & Andersen Co. catalog cover, c.1910. Author's collection.

J. Milhening (1870–c.1970s)

Principals
> Joseph Milhening (1839–1939)
> Frank Milhening (1876–1964)

Known workers
> Ernest G. Bager (1870–1939), jewelry foreman, 1890s–1930s
>
> Charles Sebastian Bichele (1886–1944), designer, c.1908–1944
>
> Mary "Mimi" Jayne Gospodaric (1899–1966), assistant designer, 1930s

J. Milhenning hallmark. Courtesy of Boice Lydell, photo by author.

J. Milhening was one of the leading Chicago manufacturing jewelers that produced gold arts and crafts jewelry in the early 20th century. Born in Scotland, Joseph Milhening established a business in 1870, which was destroyed a year later in the Great Chicago Fire. He reopened and soon became a fixture in Chicago's artistic and civic community. He was a strong supporter of the local Arts & Crafts Movement. In the 1920s and 1930s, his son Frank served as the treasurer of the Association of Arts and Industries, which was instrumental in ushering in the Modernism era through the establishment of the Chicago Bauhaus in 1938.

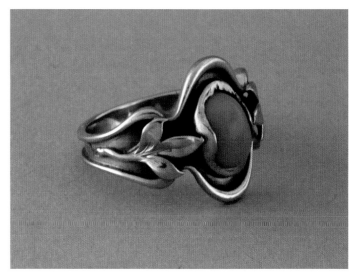

Carved gold ring with coral, marked JM 14K. Author's collection, photo by Rich Wood.

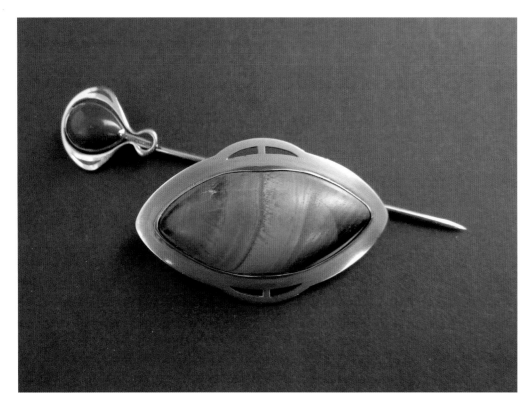

Gold brooch set with malachite and stickpin set with lapis lazuli, both marked JM 14K. Courtesy of Boice Lydell.

W.D. Smith Silver Company (1913–c.1940)

Principal
Winfield Dexter Smith (1881–after 1942)

In 1913 Smith acquired the Bourgeois Bros., a silver plate manufacturing company, and continued the business under the W.D. Smith name until c. 1940. The company offered a limited amount of sterling silver that appears to have been made by the Chicago Silver Co. and the Randahl Shop. In 1923, the company was listed at the same address as the Randahl Shop at 4550 W. Fulton in Chicago. By 1942, Smith had given up the business and worked for the Continental Silver Co. in New York.

W.D. Smith Silver Company hallmark. Courtesy of Chicagosilver.com.

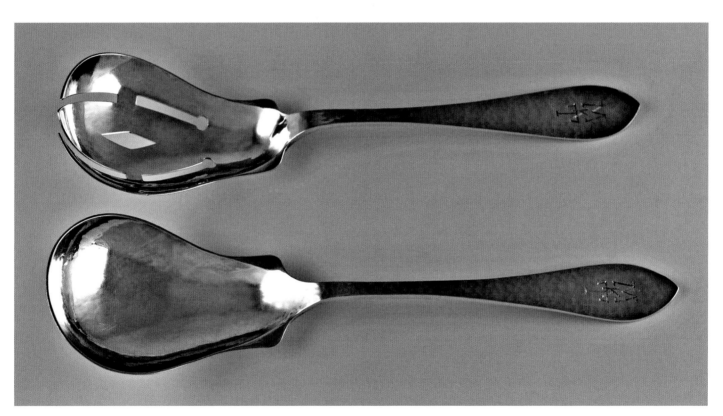

Sterling silver pear-shaped servers marked with the W.D. Smith logo. Courtesy of Chicagosilver.com.

Spaulding and Company (1888–1973)

In 1888, H.A. Spaulding acquired the assets of Matson & Co—one of Chicago's oldest retail silversmiths—and established Spaulding & Co. as a joint-venture with the Gorham Manufacturing Co. In 1895, William Codman and John Codman—sons of William Christmas Codman, the chief designer for the Gorham Manufacturing Co.—moved to Chicago to work for Spaulding & Co. John, a silversmith, stayed one year, while William designed silver and jewelry from 1895 until 1901. In 1899, *The House Beautiful* published an article that featured William Jr.'s jewelry and William Sr.'s silver, including pieces for Gorham's Martelé line. The younger Codman also designed silver, including an important golf trophy for the Midlothian Country Club, according to a 1900 article in *Outing Magazine*. Codman Jr. may have been the designer for a wholesale line of hand-wrought silver that was purchased by wealthy Chicago families and retailed by several different jewelry companies, including a firm with the logo B.S.C. Sotheby's attributed a WC signature on this silver to William Codman (see unidentified marks section).

Spaulding became the Spaulding-Gorham Co. in the 1920s, and reverted to Spaulding & Co. after it was purchased by Gordon Lang in 1943; the company was sold in 1973.

Spaulding & Co. retail hallmark that often appeared with a maker's mark on early silver items. Author's collection and photo.

Sterling silver fork and spoon in the oak leaf pattern, fork signed Spaulding and Co, spoon signed with Knut Gustafson logo. Knut Gustafson received a patent on this design in 1944; pieces were made by Gustafson Craft, Spaulding & Co., and Old Newbury Crafters. Author's collection and photos.

Downtown Chicago postcard showing Spaulding & Co. Author's collection.

Popular sterling silver apple dish made by Knut Gustafson and retailed by Spaulding & Co., c.1940s. The dish is marked only *Spaulding & Co*. Author's collection and photo.

Clarence Warren Wadley (1896–1966)

Clarence W. Wadley hallmark. Author's collection and photo.

Wadley was an African-American engraver who apprenticed at Central Monogram Works in Chicago before he launched his own company in 1925, featuring hand-made jewelry in silver, gold, and platinum. He catered to a sports clientele and made jewelry for baseball legends such as Babe Ruth, Yogi Berra, Jackie Robinson, Nellie Fox, Stan Musial, Ernie Banks, and hundreds more. He transformed silver and gold replicas of team emblems, balls, bats, gloves—anything relating to baseball—into attractive watchcases, cuff links, rings, pendants, and his famous charm bracelet for players' wives. In the off-season, he made monogram jewelry for Chicago's leading department stores and jewelry shops. In 1951, retired baseball great, Clark Griffith, produced a reenactment of the 1924 World Series in honor of the 50th anniversary of the American League and presented President Harry Truman with a diamond-studded gold tie clasp made by Wadley.

Born in Atlanta in 1896, Wadley sold newspapers and worked as a porter before he met a jewelry engraver in Macon during one of his deliveries. Smitten by the craft, in 1917 he moved to Chicago to attend night school at the Chicago Watch Making and Engraving School and later the Winter School of Engraving. A friend took him to the White Sox—Detroit Tigers game on Labor Day, and Wadley met Tiger great Ty Cobb, a native Georgian like himself. Two years later, at Comiskey Park, Wadley presented Cobb with a hand-wrought copper tray with "Ty Cobb" intricately engraved across the front that he had made for his final school project. Cobb was so impressed with the tray that he gave the young entrepreneur an order for a $50 gold ring and took him into the club house where Wadley received a steady stream of orders from fellow baseball players. Wadley attracted the attention of the head engraver at Central Monogram Works and began a six-year apprenticeship. He worked at the firm only a few months when the Chicago race riots broke out, forcing Wadley to sleep in the shop for more than a week because it wasn't safe to go home.

After completing his apprenticeship in 1925, Wadley received an extraordinary $1,250 commission from Philip and William Wrigley Jr., the chewing gum magnate, to make the championship rings for the winning team in the Pacific Coast League. The order allowed Wadley to start his own business in the Chicago Loop and he soon became the most celebrated baseball jewelry designer and maker in the United States. [3] Wadley worked in Chicago through the 1960s.

Chicago Manufacturing Jewelers and Silversmiths

Brochon Engraving Co., c.1908–1946
C.D. Peacock, 1837-present
Mandel Bros., 1855–1960; jewelry workshops 1901–c.1910
Spies Bros., 1878–c.1980s
Wendell & Co., c.1865–c.1980s
Noble, F.H. and Co., c.1872–1940s

Hallmarks for large Chicago manufacturing jewelers and silversmiths, including Brochon Engraving Co., C.D. Peacock, Mandel Brothers (carrot mark), Spies Brothers, and Wendell and Company. Author's collection and photos. (Above and right)

146

Chicago Retail Jewelers and Silversmiths

F.E. Foster and Co., shoe buckles, c.1910s–1940s
Hipp and Coburn 1918–c.1949
Tatman, Inc. 1928–1960
P.N. Lackritz 1898-1940s

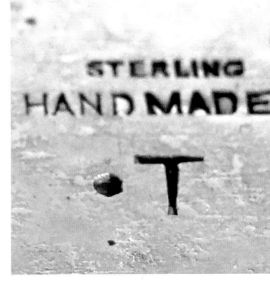

Hallmarks for F.E. Foster shoes and Chicago retail jewelers and silversmiths, including Hipp and Coburn, P.N. Lackritz, Lewy Brothers and Tatman. Author's collection and photos.

Jewelry box from Mandel Bros., c. 1906. In 1901, Mandel & Co. opened a jewelry and silver workroom and in 1906 advertised hand-wrought jewelry made in their own shop. Author's collection and photo.

Mandel Bros. gold and green chrysoprase cuff links and tie pin, marked 10K with carrot logo. Author's collection, photo by Rich Wood.

F.E. Foster had the Kalo Shop make copper and silver buckles for its shoes. Courtesy of Burt Olsson, photos by author.

Chicago World's Fair 1933–1934

The Chicago World's Fair of 1933–1934 was held in honor of the city's founding 100 years earlier. Preparations for the colossal celebration of science and technology helped sustain the local economy during the Great Depression and the nearly 50 million visitors had a significant impact on retail establishments. Chicago jewelers and silversmiths made a variety of commemorative souvenir items to sell at the Fair. John P. Petterson and Isadore V. Friedman demonstrated silversmithing in Colonial Village in 1933 and 1934, respectively. Lebolt & Co. made a broad range of hand-made silver items including bracelets, rings, and fobs; Randahl made napkin rings and other items in both hand-wrought and machine-made styles, and Odd Kraft Studio also made items. Green Duck Co., a novelty manufacturing company in Chicago, was the maker of the official World's Fair souvenir spoon.

Green Duck Co. hallmark and spoon. Green Duck was the maker of the official 1933 World's Fair spoon. Sterling silver bottle opener by Randahl, marked JOR, Lebolt server, and Odd Kraft fob. Courtesy of author's collection and Stephen H. and Holly Randahl.

Arts and Crafts Shops, Studios, Jewelers, and Silversmiths

Ole Nels Aschjem (1874–1948)

Born in Chicago to Norwegian parents, Aschjem was listed as a silversmith in the city from 1896. Hallmarks and styles of his serving pieces are similar to early works by Lebolt and Company, and he may have worked for the company prior to World War I. He likely worked for several arts and crafts silver companies and possibly operated his own business before he died in Chicago in 1948.

Aschjem hallmark and sterling silver serving spoons. Courtesy of Chicagosilver.com. (Above and below)

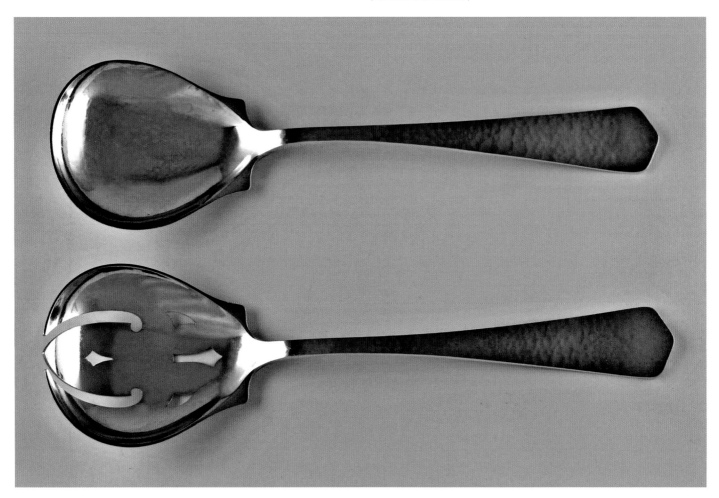

In 1907, Florence Pretz, an illustrator and a manual arts school teacher from Kansas City, Missouri, invented the Billiken, or the "god of things as they ought to be." She illustrated her smiling imp in several articles written by her friend Sara Hamilton Birchall, who had moved to Chicago. Pretz sold some of her sketches and raised enough money to move to Chicago where she accepted a position as a furniture designer for the Craftsman's Guild in Highland Park, organized and run by Edwin Osgood Grover.

Pretz wanted to commercialize Billiken, but had few financial resources. She granted an exclusive license, including sublicensing rights, to Grover and the Craftsman's Guild in exchange for royalties, and Billiken became the mascot of the Guild. In May 1908, Grover launched a successful publicity campaign, including a lavishly illustrated article in the *Chicago Tribune* playing up Billiken's Japanese influence, which was extremely popular at the time, particularly among arts and crafts artisans. Declaring that Chicagoans worshipped the good luck god, the Guild added a marketing twist: one couldn't buy a Billiken, but only could rent it for 99 years for 75 cents. Billiken metal and plaster statues sold by the hundreds from the Guild's Loop store and Marshall Field & Co. Pretz applied for a design patent in June, which was granted in October. In September 1908, the Guild sub-licensed Billiken to a three savvy investors; they incorporated the Billiken Company with $60,000 to manufacture, market and sell Billiken articles. One of the investors, Charles Monash, designed a patented throne for the Billiken, which added much to the popularity of the imp, and they sold by the thousands all across the county. The men quickly sublicensed rights to make jewelry to the Premiere Novelty Manufacturing Co. run by Rudolph Bolle and Henry L. Stern, who incorporated the Billiken Jewelry Company. They made hundreds of Billiken copper and brass acid-etched brooches in the arts and crafts style, some set with stones.

The Billiken Company sublicensed rights to dozens of manufacturers but was not obligated to pay the Guild any additional royalties; Grover in turn had no reason to increase Pretz's payments. She became bitter over her $30 monthly payments when hundreds of thousands of Billiken objects were sold, including statues, jewelry, cards, dolls, and hood ornaments; she made a little over $1,000 by the time the Billiken fad was passé. Still, the Billiken spirit lived on with dozens of social clubs all across the country taking the moniker and inspirational good will, including the annual Bud Billiken Day Parade and Picnic, still held in Chicago.

The Billiken Jewelry Company (1908–c.1910)

Businesses
Craftsman's Guild, Highland Park (c.1901–1909)
The Billiken Company (1908–c.1914)

Inventor
Florence Pretz (Mrs. Robert A. Smalley) (1885–1969)

Billiken hallmark. Author's collection and photo.

Two Billiken brooches with coral colored glass stones. Author's collection and photo.

Billiken postcard and sheet music. Author's collection.

Eivind Julius Borsum (1875–1925)

Borsum was an experienced silversmith and a talented opera singer when he came to Chicago from his native Norway in October 1909. He performed solos for the Norwegian Sangerfest throughout the Midwest and worked at one of the Chicago silversmith companies, but there are no records to indicate which one, or if he studied at the Kalo Shop in Park Ridge. From 1913 to 1914, Borsum opened his own silversmith business in the Chicago Loop. In 1915, he formed a partnership with Frank S. Boyden & Co., and operated out of their workshop. Silver made for Boyden during this period was marked with the Boyden and Borsum marks (this was a similar relationship Randahl had negotiated with manufacturing jeweler C.D. Peacock). In 1917, Borsum moved to San Francisco to work in the navy shipyards. After the war, he opened a silversmith studio in San Francisco where he worked until his death in 1925.

Eivind Borsum hallmarks. Borsum maintained a manufacturing partnership with F.S. Boyden & Co from 1915–17. Courtesy of Chicagosilver.com.

Borsum tray with applied monogram. Courtesy of Chicagosilver.com.

Sterling silver three-piece serving set with applied monograms. Marked Handmade with the EB logo. Author's collection and photo.

Brandt Metal Crafters and Brandt Jewelers
(1909–1928)

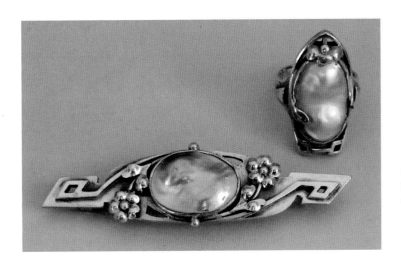

Mark used for Brandt Metal Crafters and Brandt Jewelers. Author's collection and photo.

Principals
Herman August Brandt (1879–1934)
Hugo Ernst Brandt (1880–after 1930)

Location and Business Names
1225 E. 63rd St., Chicago, 1909–1928
H.A. Brandt Mfg. Jewelers, 1909–1911
Brandt Metal Crafters, 1911–1916
Brandt Brothers, 1912–1915
Brandt Brothers & Co., 1914–1915
Brandt Jewelry Company, 1916–1928

Known workers
Gustav Adolph Kratz, 1910–1911

Wisconsin native Herman Brandt apprenticed at Marshall Field & Co. before launching his own jewelry manufacturing business in 1909 in the Woodlawn neighborhood, near the University of Chicago. His brother, Hugo, joined the following year. Taking advantage of the arts and crafts frenzy sweeping the city, they also called themselves Brant Metal Crafters from 1911 to 1916, and made distinctive jewelry in a variety of styles, including artistic geometric designs adorned with floral rosettes, acid-etched brooches, mosaic pieces, and later, marcasite jewelry. Herman roomed with the Allgeyer family, and all three daughters worked in the store. In 1921, Hugo married Ruth Allgeyer. In 1928, the Brandts sold their jewelry business, and pursued real estate speculation in Miami, Florida. Brandt's became a retail jeweler under new ownership, and remained in business through the 1950s.

Gold over sterling silver brooch and ring with freshwater pearls, both signed Brandt Sterling. Author's collection, photo by Rich Wood.

Brass, acid-etched brooch with
its original Brant Jewelers box.
Author's collection and photo.

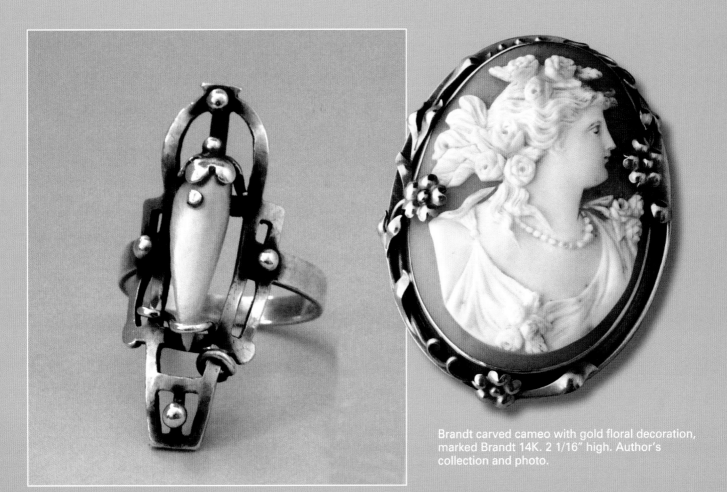

Sterling silver ring with freshwater
pearl by Brandt. 1.25" long.
Author's collection and photo.

Brandt carved cameo with gold floral decoration,
marked Brandt 14K. 2 1/16" high. Author's
collection and photo.

Sterling silver and amethyst
bracelet with geometric design
and applied florets, marked Brandt
Sterling. Author's collection, photo
by Rich Wood.

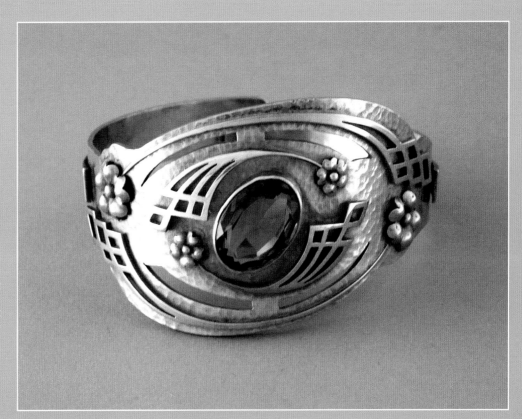

William Norris Brooks
Hand-Wrought Jewelry (1875–1955)

Arts and crafts wholesale jewelry manufacturers in the downtown Chicago business district included Brooks, a hand-wrought silver maker who also made a retail line of natural pearl, onyx, and sterling jewelry. His intricate settings included chased and engraved floral and leaf motifs. Brooks's hammered sterling plaques were used for necklaces and bracelets, and the same designs have been found on several pieces of Art Silver Shop jewelry. His known customers included the Petterson Studios in Chicago. Brooks was in business at 31 N. State Street for 52 years up until the time of his death at 80 years-old. [4]

William N. Brooks hallmark. Author's collection and photo.

Retail $4.50

No. 324—Ring

Hand-wrought
Sterling Silver Jewelry

SET WITH GENUINE PEARLS

Rings, Pendants, Bar-pins, Scarf-pins — original and up-to-date designs. Get acquainted with our goods by sending for a memo. package. The newest and latest in jewelry and silver novelties.

W. N. BROOKS

605 Columbus Memorial Bldg. - 31 No. State St., Chicago

Advertisement for Brooks hand-wrought jewelry. From *Picture and Art Trade and Gift Shop Journal* (Sept. 1, 1916). Author's collection.

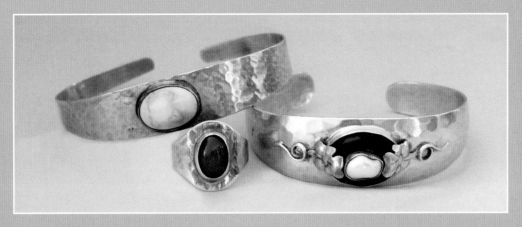

Brooks sterling silver jewelry with green chrysoprase, turquoise, pearl and onyx, all signed with WNB logo. Author's collection and photos.

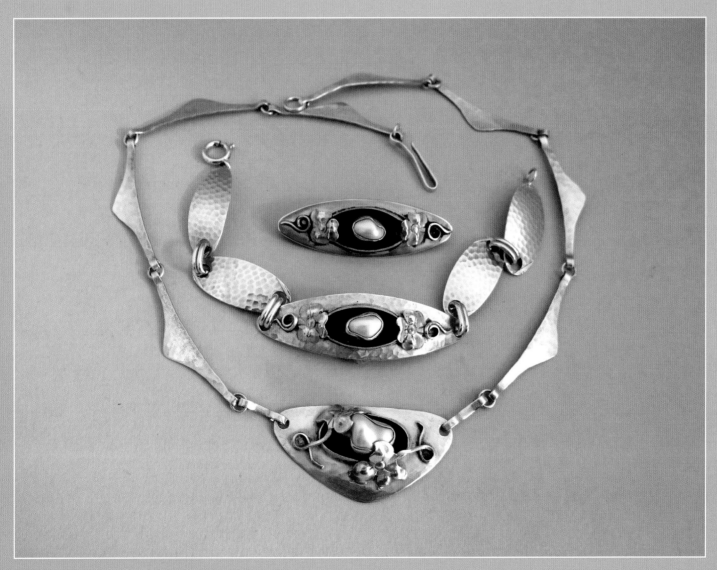

Pearl, onyx, and sterling silver necklace, bracelet and ring marked with WNB logo. Author's collection and photo.

The Carence Crafters (1908–1911)

Locations
> 5th floor, 170 Madison, Chicago, 1908–1909
> 2806 Sheridan Rd., Chicago, 1909–1911

Known workers
> R.D. Camp, business manager, 1908–1909
> Charlotte Pearl Conkright (1884–1976), designer
> 1908–1909
> Harry Morris, sales manager, 1910–1911

The conceits are odd, different, unique, and you'll say, wonderfully artistic. Each piece is an exclusive design which will not be duplicated.
—Newspaper advertisement, 1908

Established to take advantage of the raging interest in arts and crafts jewelry and decorative items, the Carence Crafters was incorporated with $6,000 in Chicago on March 7, 1908, by three investors: R.D. Camp, Carl D. Greene, and John H. Dunham. Camp was the business manager of the shop, located on the fifth floor at 170 Madison Street in the Loop. The company was organized to manufacture, buy, sell, and generally deal in arts and crafts products.

Carence Crafters produced a multitude of copper and brass brooches, pins, necklaces, stickpins, watch fobs, and cufflinks with acid-etched and hammered designs, some set with stones. A special collection of sterling silver jewelry featured three-dimensional braided settings with cabochon set stones. Useful and ornamental hand-made household items included very popular rectangular trays in arts and crafts motifs—some of which were made for special occasions and weddings—as well as candlesticks, sconces, lamps, desk sets, picture frames, boxes, and jardinières. Carence Crafters items were sold through art dealers to a national network of gift shops, department stores, and studios.

Stylistically, many of the acid-etched jewelry items resembled work from the Marshall Field & Co. Craft Shop, the Billiken Company, the Forest Craft Guild, and the Frost Workshops, among others.

In November 1909, the Carence Crafters workshop was bombed incidentally in a gambling gang dispute that involved several of the tenants in the seven-story Madison Street building. The company moved to 2806 Sheridan Road and Harry L. Morris became the sales manager.

Carence Crafters ran into financial problems by the end of the year and the corporation was dissolved in March 1911.

The company did not exhibit in any of the AIC annual arts and crafts shows and none of the Carence Crafters artisans are known, with the exception of Charlotte Pearl Conkright, who was a designer from 1908 to 1909. The diversity of styles and sheer volume of output suggests that several different designers and many crafts workers were involved with the company.

Carence Crafters hallmark. The smaller CC part of the mark was used for jewelry. Courtesy of Curators Collection, photo by Rich Wood.

Carence Crafters letter, dated November 19, 1910. Courtesy of Craig Bowley Inc.

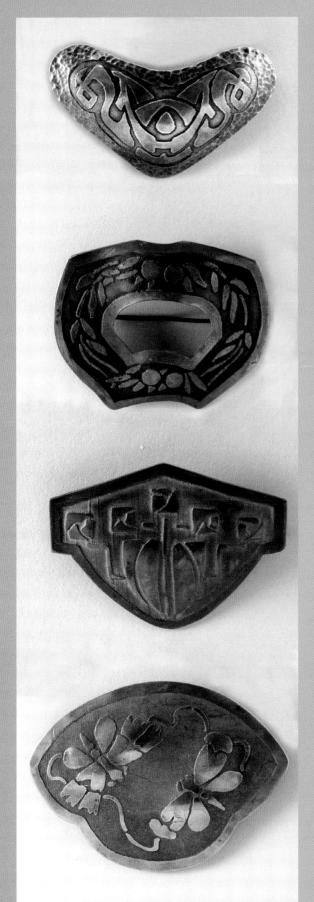

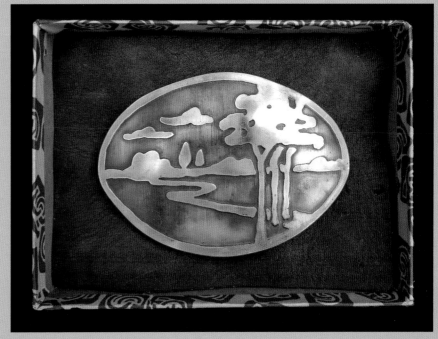

Carence Crafters brooch in original box. Courtesy of Boice Lydell.

Carence Crafters acid-etched brooches, all marked.
Courtesy of Curators Collection, photos by Rich Wood.

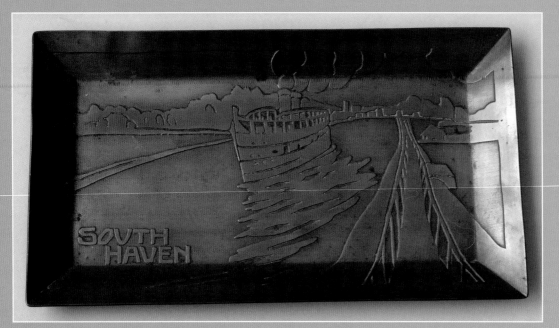

Carence Crafters custom-made tray, Chicago to South Haven steamship line, c.1910. 5 x 9 inches. Author's collection and photo.

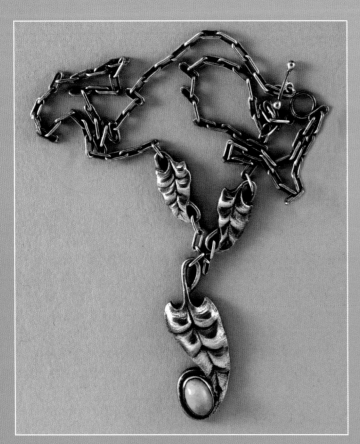

Carence Crafters sterling silver necklace in a finely hammered leaf design with a turquoise-colored stone and paper clip chain. Courtesy of Curators Collection, photo by Rich Wood.

Carence Crafters geometric vase. Courtesy of Boice Lydell.

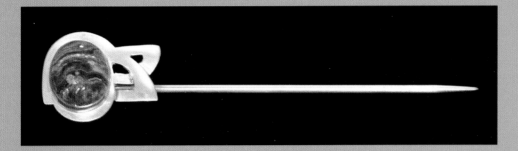

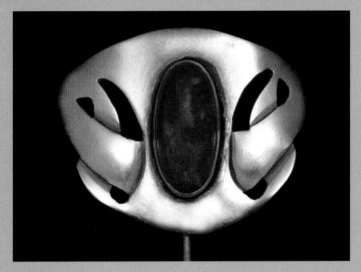

Three sterling silver stickpins with stones by Carence Crafters in a woven design, all marked. Courtesy of Chicagosilver.com.

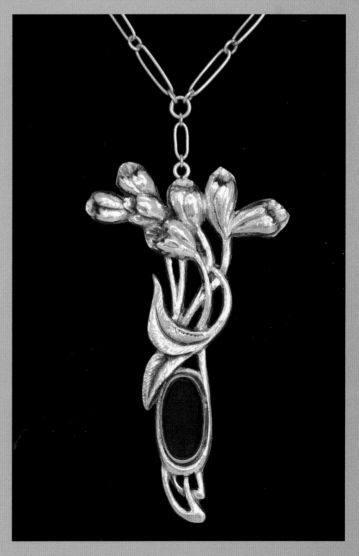

Carence Crafters finely hammered pendant with red stone. Courtesy of Chicagosilver.com.

Chicago Art Silver Shop (1912–1917)
Art Silver Shop (1917–1935)
Art Metal Studios (1927–1980s)

Principals

Ernest Gould (born Goldberger) (1884–1954)
Edmund Bokor (1886–1979)

Known workers

Isadore V. Friedman, dates unknown
Arthur F. Lutwyche, 1930–1942

In 1906, Hungarian silversmith Ernest Goldberger immigrated to the United States and worked for a silver company in North Attleboro, Massachusetts, before arriving in Chicago. In 1912, he founded the Chicago Art Silver Shop, at 17 W. Illinois Street. His lifelong partner, Hungarian Edmund Bokor, had arrived in Chicago the previous summer after working as a metal sculptor in New York City and Chautauqua, New York. Bokor had trained in Budapest under the noted Albert Bachruch and was an expert modeler, designer, and silver chaser, capable of finely executed repoussé designs—created by hammering metal from the reverse side. In Chicago, he caught the attention of Lebolt & Co. foreman J. Edward O'Marah who hired him to work on specialty silver, including repoussé tea sets and wedding silver. Bokor also did repoussé work for Marshall Field & Co. In 1913, Boker left Lebolt and became a partner in the Chicago Art Silver Shop, which moved to a new location at 638 Lincoln Parkway.

Goldberger was adept at making hollowware and complicated silver pieces; Bokor complemented these strengths with his decorative handiwork. Bokor also had a flair for marketing, design, and business management that helped propel the studio into a substantial business. In the fall of 1913, Bokor and Goldberger exhibited in the annual arts and crafts show at the AIC. They featured silver vases, a square dish, a coffee pot, and a gravy boat and tray, all in intricately chased floral and leaf designs, as well as two silver baskets with handles. The Chicago Art Silver Shop was represented in each of the next three annual shows through 1916, although only Bokor was listed as the designer and maker for the pieces, which included table wares and silver jewelry. Bokor joined the Artists' Guild in the Fine Arts Building and the Arts Club of Chicago; he also was listed as a jeweler and silversmith in the *American Art Annual* publications. Before WWI, the Chicago Art Silver

Shop positioned itself as high-end metal sculptors and silversmiths, working in silver and copperware, and the shop offered silver repair services.

In 1917, Goldberger changed his name to Gould and became a U.S. citizen. He lived with Bokor throughout his life but consistently maintained a low profile, particularly in contrast to Bokor. In 1917, they decided to adopt a more universal profile for their company, and dropped "Chicago" from the name, becoming the Art Silver Shop.

In the 1920s, the Art Silver Shop won an award for a tea set at the Arts Club, and the Chicago Republican Women's Club commissioned a picture frame that was given to President and Mrs. Warren Harding. In 1927, amid cooling demand for large silver wares, Bokor and Gould established a second business, Art Metal Studios, to focus on hand-wrought wholesale jewelry. In 1931, they incorporated the Art Silver Shop with $10,000 in capital; it was dissolved in 1935, when they consolidated retail and wholesale operations into Art Metal Studios at 17 N. State. After the deaths of the founders, Art Metal Studios was operated by Bokor's neice Rose Kesten and her husband well into the 1980s.

Marks for the Chicago Art Silver Shop, Art Silver Shop, and Art Metal Studios. Author's collection and photos.

Interior of an Art Silver Shop box
and an Art Metal Studios box.
Author's collection and photos.

Art Metal Studios amethyst bracelet.
Author's collection and photo.

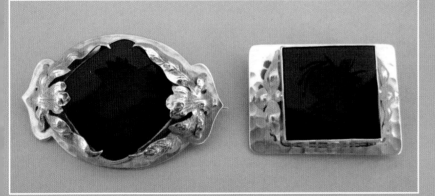

Art Metal Studios intaglio brooches in carnelian and onyx.
Author's collection and photos.

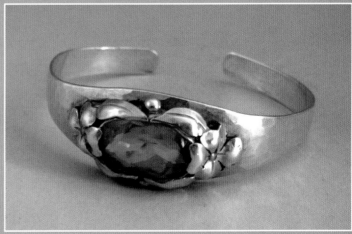

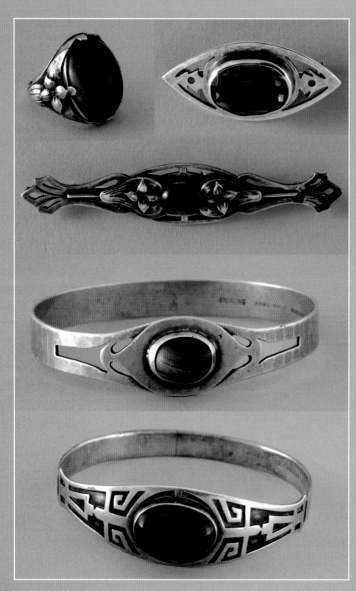

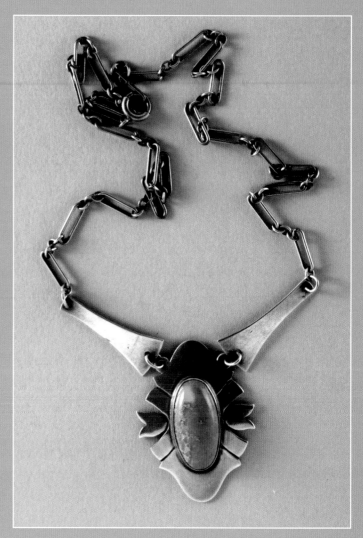

Art Metal Studios necklace with green stone. Courtesy of Curators Collection, photo by Rich Wood.

Art Silver Shop and Art Metal Studios sterling silver jewelry with stones. Courtesy of Curators Collection, photos by Rich Wood.

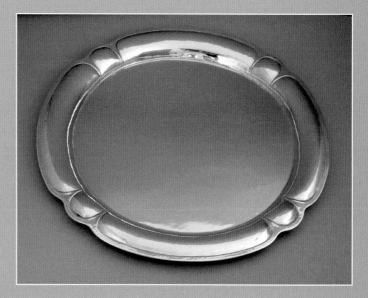

Sterling silver, chased tray signed Chicago Art Silver Shop. Author's collection and photo.

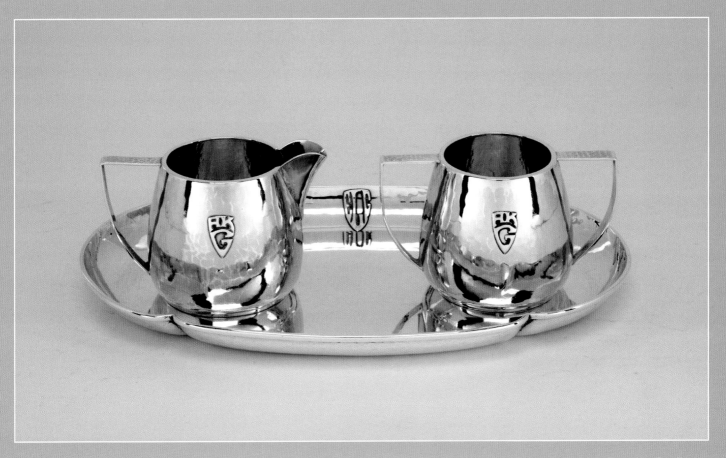

Art Silver Shop sterling silver creamer and sugar with tray. Courtesy of the Charles S. Hayes family, photo by Scott Bourdon Studios.

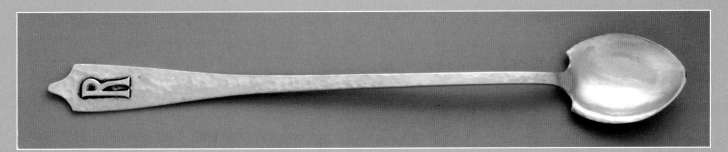

Sterling silver drink spoon with applied monogram, marked Art Silver Shop. Author's collection, photo by Rich Wood.

Art Silver Shop napkin clip with applied monogram. Author's collection and photo.

The Chicago Silver Company (1923–1945, 1945–1956)
Gustafson Craft (1945–1964)

Principal
Gustafson, Knut Leonard (1885–1976)

Locations
Chicago Silver Company
1741 Division, Chicago, IL (1923–1930)
165 N. Wabash, Chicago, IL (1930–1935)
226 S. Wabash, Chicago, IL (1935–1945)

Gustafson Craft
1704 N. Rand, Arlington Heights, IL (1945–1964)

Gustafson was a coppersmith and silversmith who worked for many of the leading Chicago arts and crafts firms before he founded the Chicago Silver Company in 1923. He later founded Gustafson Craft in 1945. Born in Sweden, he apprenticed with C.G. Hallberg in Stockholm before emigrating to the United States in 1909. He first worked for Whiting Manufacturing Co. in Bridgeport, Connecticut, before joining Lebolt & Co. in 1914. The following summer, he was recruited to the Jarvie Shop, but the work was short-lived, and he left after a few months. By early 1916, he worked for Clemencia Cosio at the T.C. Shop after her co-founder, Emery Todd, left the partnership. From c.1920 to 1923, he worked for the Randahl Shop.

In 1923, Gustafson founded the Chicago Silver Company with backing from local investors, and focused on spun hollowware, trophies, flatware, special order work, and hand-wrought silver for Chicago retail establishments including P.N. Lackritz, Marshall Field & Co., Boyden-Minuth, House of Williams, and Spaulding & Co; Milwaukee firms Swankee Karsten, Bundy & Upmeyer, and Neverman Jewelers; and Georg Jensen USA in New York City. In 1945, he sold the company to his partners and founded Gustafson Craft in Arlington Heights, Illinois, catering to his longstanding customers that he had cultivated through the Chicago Silver Company. In 1944 and 1945, he received design patents for his popular Nordic and Oak Leaf flatware patterns. In 1964, a fire destroyed his Arlington Heights workshop, and Gustafson sold the flatware dies to Spaulding & Co. Because Gustafson focused on the wholesale trade, most of the silver made by his companies was marked only by the name of the retail client, including his very popular apple tray in sterling silver made for Spaulding & Co. (See page 144.)

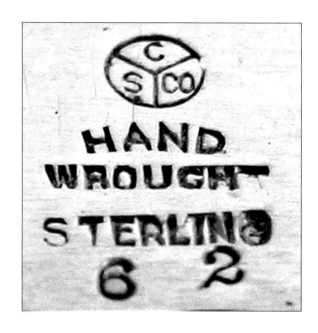

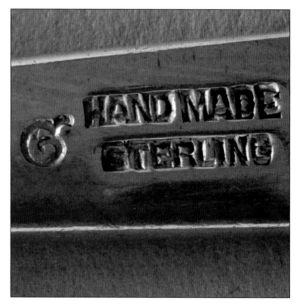

Marks for the Chicago Silver Company (1923–1945) and Gustafson Craft (1945-64). Courtesy of Chicagosilver.com.

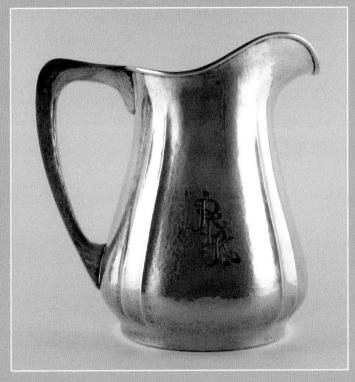

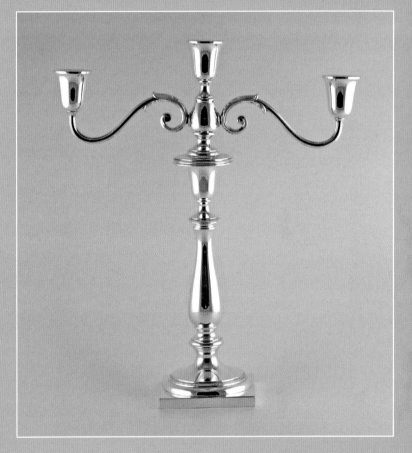

Chicago Silver Company sterling silver water pitcher and candelabrum marked with CSC logo. Courtesy of Chicagosilver.com.

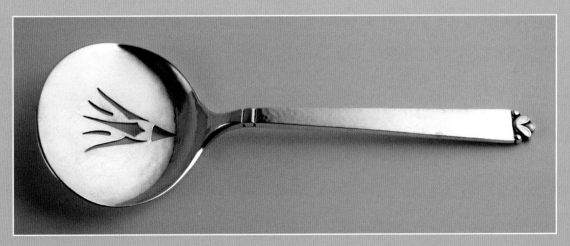

Gustafson Craft sterling silver tomato server in the oak leaf pattern, signed with logo. Courtesy of Chicagosilver.com.

The Jarvie Shop (1900–1918)

Principal

Robert Riddle Jarvie (1865–1941)

Locations

270 S. Homan Ave., 1900
608 W. Congress, 1901–1905
638 Fine Arts Building, 203 Michigan Ave., 1905–1907
194 Michigan in the Victoria Hotel, 1907–1908
57 E. 47th Street, 1908–1910
1340 E. 47th St., 1910–1912
842 Exchange Ave., Stock Yards, 1912–1918

Known workers

Dorothy Deane, leather worker, 1905
Knut Lawrence Gustafson, silversmith, 1915
Theodora Hayes, silver designer, 1913
Hans Jauchen, metal sculptor and silversmith, 1909–1910
John Pontus Petterson, silversmith, 1910–c.1914

The Shop of Robert Jarvie at the Chicago Stockyards. Courtesy of David Petterson.

Jarvie Shop hallmarks. Courtesy of Chicagosilver.com and Boice Lydell.

Jarvie was a designer and a pioneer in arts and crafts work who operated a leading Chicago studio until World War I. Initially a bookkeeper for the Minneapolis Street Railway, Jarvie arrived in Chicago at the time of the 1893 World's Fair to start a new life. He divorced his first wife, who stayed in Minneapolis with their son, and advanced his career as a city transportation clerk. [5] In 1898 he married Lillian Gray and began to experiment with artistic metalwork; he soon found a creative home in the Chicago Arts & Crafts Movement. Although loathe to admit any formal training, he appears to have studied with noted medal sculptor and Krayle Company artisan Henning Ryden. [6] Jarvie's first work was a primitive Dutch lantern, but he quickly became known for designing elegant candlesticks that were cast by a variety of local foundries, including Schueller & Miller, W.B. Anderson, Turner Brass Works, Dawson Brothers, and the Imperial Brass Mfg Co. Jarvie, subsidized by his day job, spent lavishly on advertising, cultivated the media, and participated in dozens of exhibitions throughout the Midwest. From 1900, he and Lillian were active in the Chicago Arts and Crafts Society and he later became secretary of the organization. Known as "The Candlestick Maker," Jarvie became irritated by copies of his unsigned work appearing on the market, and from 1903, he began to use his signature as the mark of a genuine Jarvie candlestick.

Jarvie was identified in the media as a Krayle artisan in 1900–1901, and magazine ads show that he sold his candlesticks through the Swastica Shop (1903), the Kalo

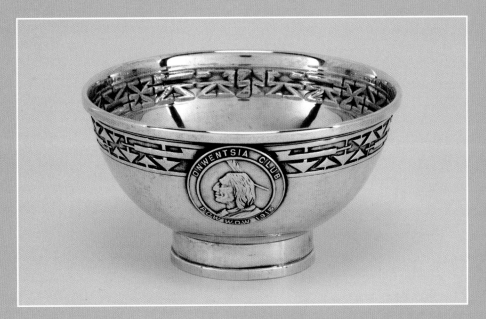

Sterling silver presentation bowl for the Onwentsia Club, Chicago, 1915, marked Jarvie Chicago Sterling 2065. 2.5 inches high. Courtesy of Michael Wright, photo by Scott Bourdon Studios.

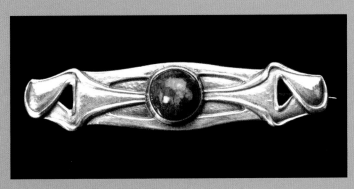

Jarvie Shop hammered sterling silver brooch with an agate cabochon. Signed Jarvie Sterling. 2.25 inches long. Courtesy of Rago Arts and Auction Center, Lambertville, NJ. Collection of Boice Lydell.

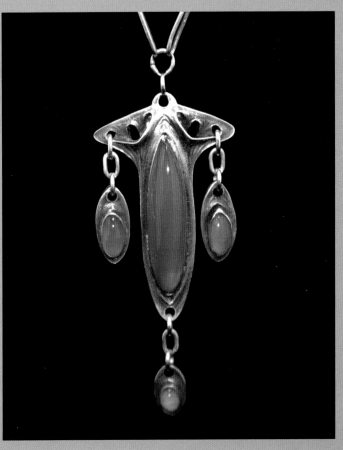

Jarvie Shop pendant with green stone. Courtesy of Chicagosilver.com.

Shop (1903–1904), and The Shop of Robert Jarvie Inc. at 608 W. Congress Street (from 1904). A catalog from the Congress Street studio asserted that all items were made by Robert Jarvie. Illustrated panels showed candlesticks, lanterns, and lamps, a pewter candlestick reproduction, a smoker's lamp reproduced from one made in 1790, and a lampshade for a Teco Pottery base; he noted he could "convert bronze to lamps and make shades to harmonize." From 1902 to 1905, Jarvie exhibited his candlesticks at the AIC annual arts and crafts shows.

In 1905, Jarvie left his job at the city of Chicago and moved the Jarvie Shop to the Fine Arts Building, after tripling the capital investment in his company to $15,000. He sold a broad range of artistic goods made by other artisans in his studio and hired diverse and talented craft workers to expand into the realm of hand-made metal objects. A Jarvie brochure from around 1906 referred to "Jarvie and his craftsmen," and it called special attention to the hand-wrought metal, which included trays, bookends, lanterns, and trophies that could be made in brass, copper, silver, and gold. In 1907, Jarvie took a three-month night design class at the AIC. Late that year he moved out of the Fine Arts Building and into a street-level shop in the Victoria Hotel at what is, today, 332 S. Michigan Avenue. The relocation turned out to be disastrous when the Jarvie Shop was forced to liquidate in a foreclosure sale in July 1908. Jarvie moved to more affordable space at 57 E. 47th Street on the city's South Side and in 1910 he moved to 1340 E. 47th Street.

Jarvie cultivated a close relationship with the city's leading architects, painters, sculptors, artisans, and crafts workers and he was a founding member of the all-male Cliff Dwellers Club in 1909, along with such notables as Daniel Burnham, Louis J. Millet, Louis Sullivan, James H. Winn, and Frank Lloyd Wright.

The Jarvie Shop executed many designs by noted Prairie School architect George Grant Elmslie, including a stunning silver book that was cast, hammered and chased for retiring University of Michigan President James B. Angell in 1909. Elmsie also designed a companion commemorative silver cup that was given to Angell on behalf of his students (pictured in *Michigan Alumnus,* June 1909). Hans Jauchen, a noted metal sculptor and silversmith from Germany, was the manager of the Jarvie art metal workshop from 1909 to 1910, and he or other workers likely executed the pieces. [7] Jarvie, however, told the *Rockford Register-Gazette* that he was the designer

and maker of the Angell cup—and that the Jarvie Shop was selected to design and make the pieces after winning a national competition that bested Gorham and Tiffany—never mentioning George G. Elmslie or the Jarvie Shop's talented cadre of craftsmen. [8]

By 1910, Robert and Lillian Jarvie—an active partner in the business—expanded the Jarvie Shop offerings to focus more on exquisite hand-wrought silver trophies and presentation pieces. Jarvie looked to Tiffany & Co., which was regarded as one of the finest silver manufacturers in the world, and hired art metal master John P. Petterson to work for his shop. Although never mentioned by name, Petterson helped unify Jarvie's innovative designs with extraordinary workmanship, and Jarvie likely employed other professional silversmiths as well. In 1910, Jarvie exhibited a silver punch bowl, brass goods, and jewelry in the AIC annual arts and crafts show, and, in 1911, he unveiled his famous John J. Hattstaedt punch bowl. In both years, Jarvie credited himself only for the designs in most publications, and credited the Jarvie Shop as the maker. In several instances, Jarvie, as well as some reporters and later historians, lost this distinction, and credited Jarvie as the maker of items that actually were designed and executed by others. In the best light, Jarvie followed the Kalo Shop model, which only referred to metalworkers by their shop affiliation rather than by their individual names. In one known exception, Jarvie listed Theodora Hayes as a designer for silver works shown by the Jarvie Shop in the 1913 AIC annual arts and crafts exhibit. The Jarvie Shop also exhibited a leather cushion in 1905, listing Dorothy Deane as the maker; in 1910, the shop listed table linens designed and made by Louise C. Elmslie (sister of the architect George G. Elmslie).

In April 1912, a reporter for *Handicraft* stated that Jarvie had closed his shop on E. 47th Street to "devote his time to other matters," but by September he had reopened in the Old English Cottage building at the Chicago Stockyards. The new venue came with a steady stream of orders for livestock trophies, including 550 cast souvenir metal boxes for the American Meat Packers Association. Sculptors for the Florentine Brotherhood Bronze Foundry Company also shared the cottage, which included such notables as Carlo Romanelli and Josef Mario Korbel. Success was short-lived, however, as Jarvie lamented in a letter that he was financially constrained and had been unable to send silver items on consignment in 1913. In 1915, Jarvie hired skilled metalsmith Knut Gustafson, but the man left after

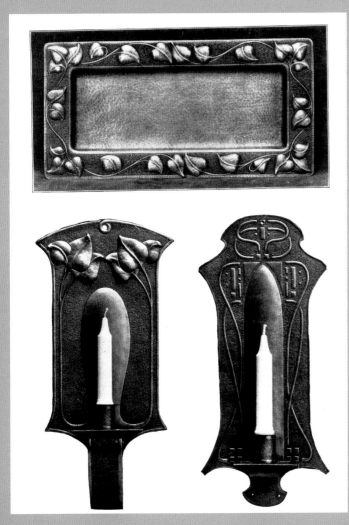

Jarvie Shop hammered copper sconces and a tray. From *The Sketch Book* (Dec. 1906). Author's collection.

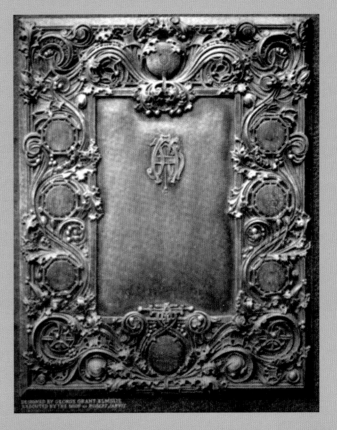

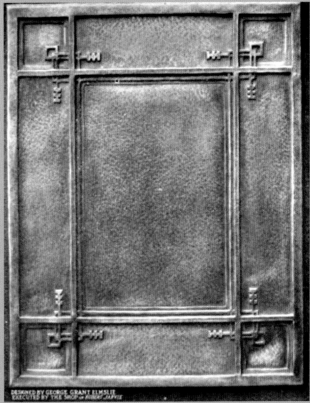

Book designed by Chicago architect George Elmslie for University of Michigan President James B. Angell, executed by the Jarvie Shop. *Michigan Alumnus* (June 1909). Courtesy of the University of Michigan Library.

a few months, telling his family that there "wasn't enough business to keep the men busy." [9]

To improve finances, Lillian took an office job and Jarvie diversified into furniture and rug weaving; he completed a desk and chair with hand-decorated designs for Purcell and Elmslie in 1916. Also that year, he won the Mrs. Julius Rosenwald Prize at the AIC annual arts and crafts show for his finely crafted Aberfoyle wool rugs; he also exhibited rugs at the AIC the following year. A reporter said at the time that he simply invented the technique when experienced weavers threw up their hands and said "It can't be done!" Jarvie, however, more likely benefited from the fact that for decades his Scottish father and extended family worked in the woolen mills in Rockford and Minneapolis.

From 1916 to 1917, Jarvie maintained his community presence and was the treasurer for the newly incorporated Arts Club of Chicago, adjacent to the Fine Arts Building. In 1917, Jarvie was selected to design a 14K gold chalice for Rev. Monsignor Kelley, rector of the church of St. Frances Xavier of Wilmette.

In February 1918, Jarvie abruptly closed his shop and accepted a position as a secretary for the National War Work Council of the YMCA. Selected based on his transportation experience, Jarvie served with the American Expeditionary Force in France and Great Britain. A *Chicago Post* reporter noted, "He has given up the metalwork entirely but is leaving his Aberfoyle rugs at the Old English Cottage. He expects this weaving to go as before in reliable hands. Mr. Jarvie will be gone a year. His friends look forward to his return and the Jarvie Shop beyond question has become the [hallmark] of the arts and crafts movement of this city." [10]

While he was abroad, Lillian volunteered for the war effort at Camp Grant, Illinois. In late 1919, Jarvie returned from Europe and the couple toyed with moving to New York until Lillian secured a position as a secretary at Northwestern University; Jarvie accepted a sales position with C.D. Peacock. The incorporation of The Shop of Robert Jarvie had been cancelled in 1918 for failure to pay taxes; Jarvie finally paid the back taxes and officially dissolved the company in 1926. The Jarvies retired to the Scottish Old Person's Home in 1940; Lillian died in October 1941 and Robert died of a heart attack while visiting the Chicago Board of Trade one month later. After his wife's death, Jarvie had visited his former colleague, John P. Petterson, to place a deposit on a special order, but died before the account was settled.

Hand-colored postcard from the Shop of Robert Jarvie, 1911. Author's collection.

Jarvie Shop cast souvenir box for the American Meat Packers Association, 1912. Courtesy of Chicagosilver.com.

Jarvie Shop sterling silver trophy pitcher with unusual handle, dated 1915. Courtesy of the Charles S. Hayes family, photo by Scott Bourdon Studios.

Jarvie Shop souvenir frame made for the American Meat Packers Association, 1914. Courtesy of Chicagosilver.com.

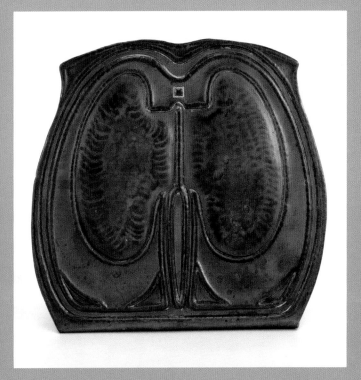

Jarvie Shop hammered copper bookend, one of a pair. Courtesy of the Charles S. Hayes family, photo by Scott Bourdon Studios.

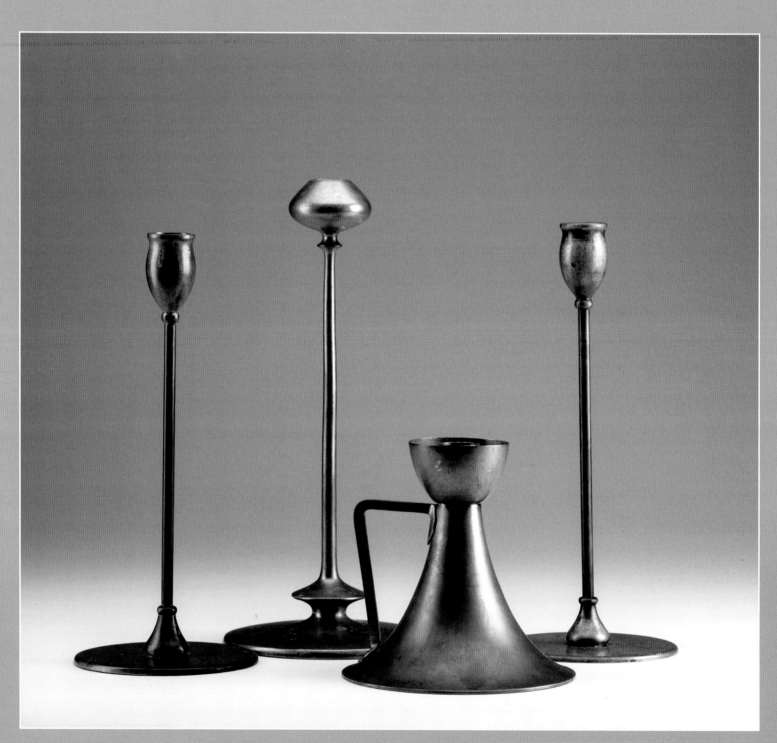

Jarvie candlesticks, two Alpha, one Beta and one Zeta, all signed Jarvie. Beta:
12.75 inches high. Courtesy of Rago Arts and Auction Center, Lambertville, NJ

Lebolt & Co. (1899–1980s)
Silver Workshop (1910–1944)

Principal
Jack Myer Harry Lebolt (1867–1944)

Chicago locations
167 S. State St., 1899–1907

101 S. State St., in the Palmer House hotel, 1907–1925

27 N. State St., 1925–1931

31 N. State St., 1932–1935

33 N. State St., 1935–1944

Known workers
William Edward Benbow, silversmith, 1911–c.1920

Hy W. Berger, jeweler, 1923

Edmund Bokor, silver chaser, 1911–1913

Nils Otto Leopold Cederborg, designer, 1916–c.1918.

Paul Christensen, silversmith, 1912 exhibit at AIC

Herbert C. Clemence, silversmith, 1912 exhibit at AIC

Katherine Cunningham, designer, 1912 exhibit at AIC

Carl Henry [Didrichsen] Didrich, silversmith, 1912 exhibit at AIC

Edwin Emil Guenther, silversmith, c.1917–1925

Knut Lawrence Gustafson, silversmith, 1914–1915

John Mathias Horsch, jeweler, 1923

Ole J. Horway, 1928–c.1938

Alfred H. Johnson, silversmith, 1923

Gustave Adolph Kratz, jeweler, c.1920–1925

H. Lau, silversmith, 1912 exhibit at AIC

H. Lem, silversmith, 1912 exhibit at AIC

Bjarne Meyer, silversmith, 1919–1920

Carl Adolph Moe, silversmith c.1912–1917

David Edward Mulholland, silversmith, 1912 exhibit at AIC

Joseph Edward O'Marah, silversmith and shop foreman, c.1911–1944

Carl Frederick Peterson, jeweler, engraver, 1918

Axel Ferdinand Petrussen, jeweler, 1928

Knute Axel Winquist, silversmith, 1928

Lebolt & Co. hallmarks. Hand Made was used on flatware (1910–c.1944) and hollowware from 1910–c.1918; Hand Beaten was used on hollowware from c.1919 to 1944. Author's collection and photo.

LEBOLT & COMPANY

NEW YORK CHICAGO

Lebolt & Co. bronze sign and photo of store locations. Courtesy of a private collector, photo by Rich Wood. (Above and below)

In 1910, Lebolt & Co. established a hand-wrought silver workshop that soon became one of the leading arts and crafts sterling silver firms in the country. Lebolt had founded Lebolt & Co. as a manufacturing jeweler in 1899 after working in the jewelry business since 1882. In 1901, Lebolt's arts and crafts jewelry designs were featured in a *Chicago Tribune* article on the "New Barbaric Fad in Jewelry," that was sweeping the city. The company prospered and opened stores in New York (c.1903) and Paris (c.1910). Lebolt employed many jewelers in its workrooms and imported diamonds and other gems, including fine pearls.

In October 1910, Lebolt & Co. opened its hand-wrought silver workshop that helped define Chicago as a national leader in silver design. An early catalog and extensive newspaper advertisements announced the shop and that its genuine hand-wrought silver could be purchased at very reasonable prices. By 1911, Lebolt & Co. hired Kalo silversmith J. Edward O'Marah to be the foreman of its silver shop. Hungarian silversmith Edmund Boker worked for O'Marah when he joined the company that summer, executing intricate repoussé floral designs on silver. O'Marah also hired William E. Benbow, a British-born silversmith, after the man proved himself by working one day for free, executing exceptional work. In 1912, Lebolt & Co. organized an exhibition of artistic hand-made silver at the annual arts and crafts show at the AIC, featuring pitchers, candlesticks, a loving cup, a vase and table ware made by a handful of Lebolt artisans and O'Marah's fellow Park Ridge silversmith colleagues David Mulholland, C.H. Didrich, and others; some of the silver may have been made in the Park Ridge Mulholland shop. Katherine Cunningham, an AIC graduate, designed all of the pieces entered in the 1912 exhibition.

Lebolt 14K carved coral cameo brooch. Author's Collection, photo by Rich Wood.

Lebolt footed tray with monogram, marked Lebolt Hand Beaten Sterling 800. 10.5 inches diameter. Author's collection and photo.

Lebolt sterling silver compote with applied monogram and marked Lebolt Hand Beaten Sterling. Dated 1922. Courtesy of the Charles S. Hayes family, photo by Scott Bourdon Studios.

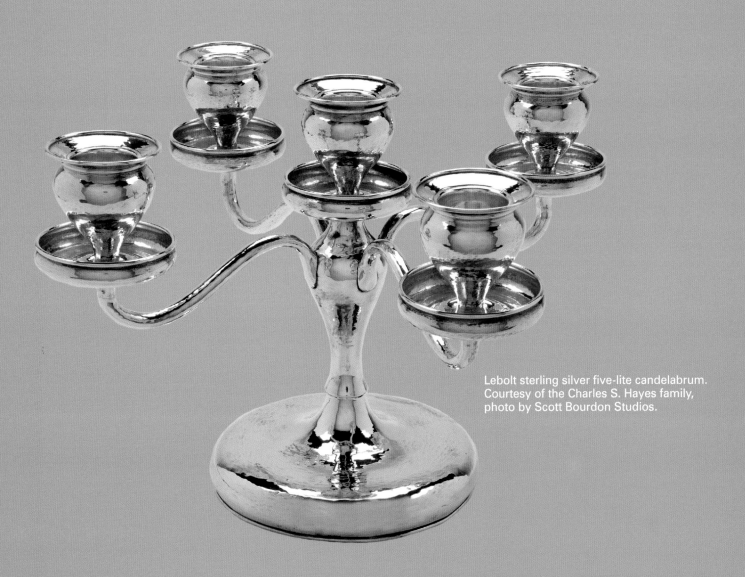

Lebolt sterling silver five-lite candelabrum. Courtesy of the Charles S. Hayes family, photo by Scott Bourdon Studios.

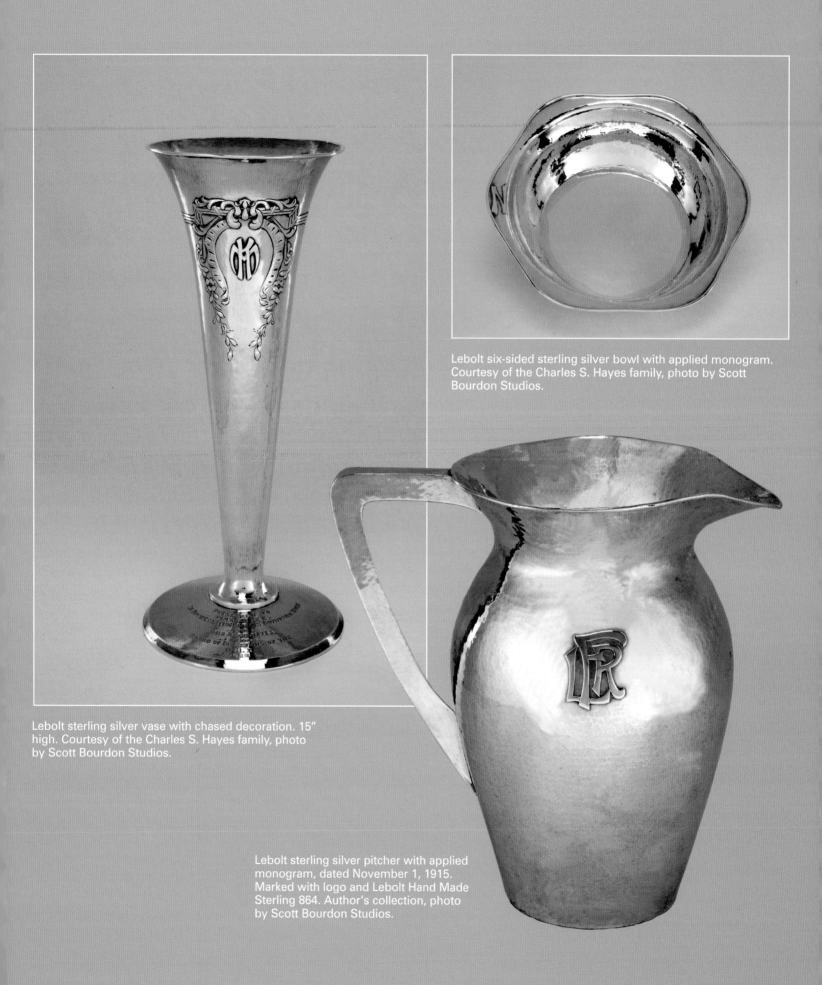

Lebolt six-sided sterling silver bowl with applied monogram. Courtesy of the Charles S. Hayes family, photo by Scott Bourdon Studios.

Lebolt sterling silver vase with chased decoration. 15" high. Courtesy of the Charles S. Hayes family, photo by Scott Bourdon Studios.

Lebolt sterling silver pitcher with applied monogram, dated November 1, 1915. Marked with logo and Lebolt Hand Made Sterling 864. Author's collection, photo by Scott Bourdon Studios.

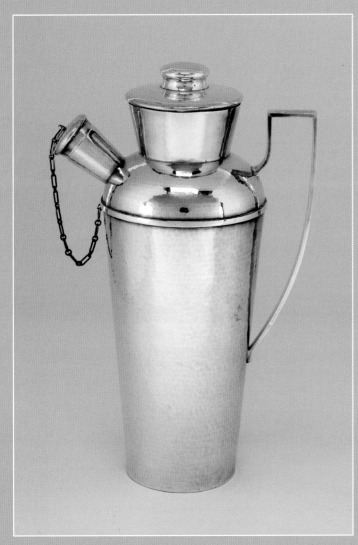

Lebolt sterling silver cocktail shaker. Courtesy of the Charles S. Hayes family, photo by Scott Bourdon Studios.

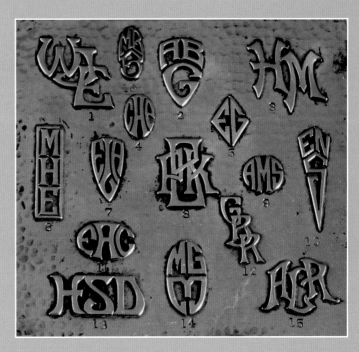

Lebolt monogram samples. Courtesy of a private collector, photo by Rich Wood.

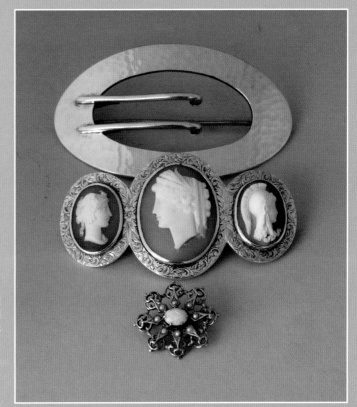

Sterling silver belt pins in hammered and cameo styles and a 14K opal brooch, all hand made and marked Lebolt. Belt pins have "C" clasps. Cameo pin 3 inches long. Author's collection and photo.

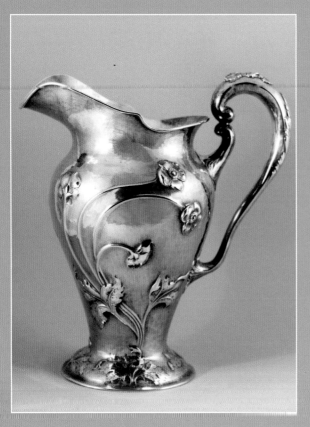

Lebolt repoussé water pitcher. Courtesy of a private collector, photo by Rich Wood.

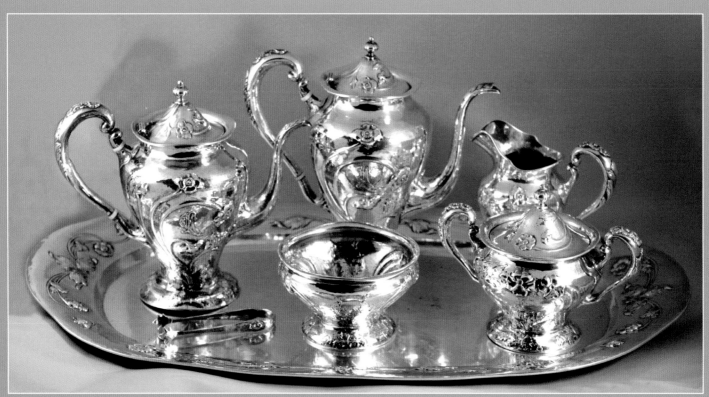

Lebolt & Co. silver service with repoussé pansies, made between 1913 and 1920. Courtesy of a private collector, photo by Rich Wood.

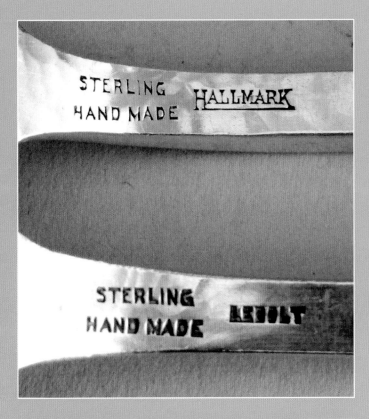

For six months between 1914 and 1915, Lebolt & Co. was a member of a hand-wrought silver collaborative called the Hallmark Store, and the moniker was added to a dozen or so newspaper advertisements in the *Chicago Tribune*. Some Hallmark silver was identical to Lebolt patterns, indicating they made and sold silver through the collaborative. A 1917 advertisement for Ullrich's Hallmark Jewelers in Evanston, Illinois, explained: "Hallmark specially produced cooperatively by the hundreds of Hallmark jewelers in quantities of many thousands...48 page catalog available."[11]

Lebolt's hand-made silver was very popular, particularly for weddings and special occasions, and featured a variety of golf trophies, flatware sets, trays, vases, bowls, loving cups, serving pieces, coffee services, tea sets, trays and candelabra. Lebolt advertised table silver "made by artists," and many of the pieces were adorned with applied silver monograms in the Chicago arts and crafts style. Lebolt's silver flatware was distinguished by a concave depression on the back of the handle near the top.

From January 1932, as the economy tumbled, Lebolt began to liquidate much of its jewelry stock to raise $4 million in capital through a series of auction sales. Temporarily buoyed by the Chicago World's Fair of 1933, the company ran into trouble again in 1934, forcing it to slash prices and file for bankruptcy. The company reorganized and continued making its hand-wrought silver until the silver shop was closed in 1944; Lebolt jewelry stores continued through the 1980s.

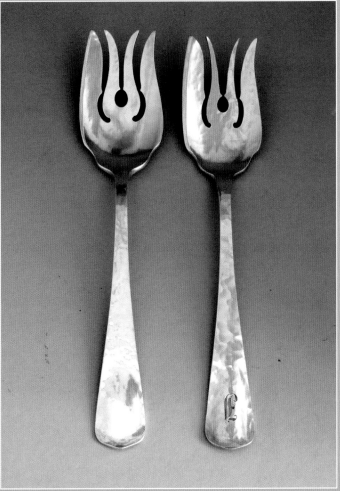

Hallmark and a Lebolt & Co. serving forks and marks. Author's collection, photos by Rich Wood.

The Odd Kraft Shop (1910–1938)

Principal

Mrs. Bertha Kade, nee Schiers (1872–1953)

From 1910, Kade was an arts and crafts worker and jeweler who operated the Odd Kraft Shop in the Hyde Park neighborhood of Chicago, specializing in hand-wrought jewelry, novelties, and a broad variety of crafts and gift items. Established at 1316 E. 47th Street as a novelty business, Kade began offering jewelry by 1913, and used slightly different names for her shop over the years, including Kade Odd Kraft Shop and Odd Kraft Gift Shop. The studio was a fixture on the South Side through the 1930s.

A Connecticut native, Bertha Schiers married Wisconsin furniture designer Otto Kade in 1896, and her second husband, Moss Barker, in 1915. She died in California in 1953.

Odd Kraft Shop hallmark. Courtesy of Chicagosilver.com.

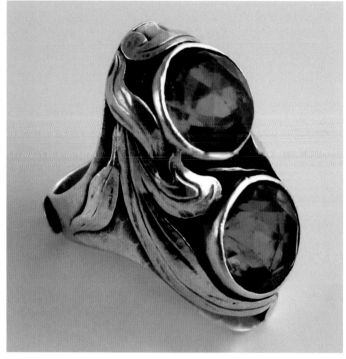

Odd Kraft Shop amethyst ring. Courtesy of Chicagosilver.com.

Odd Kraft Shop sterling silver brooches with applied leaves and flowers. Courtesy of Chicagosilver.com.

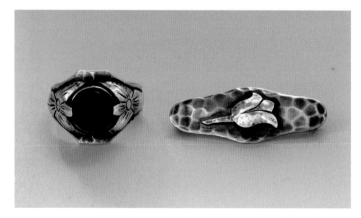

Odd Kraft Shop onyx ring and hammered pin. Author's collection and photo.

The Petterson Studios (1913–1964)

Principals
John Pontus Petterson (1884–1949), c.1913–1949

John C. Petterson (1907–2003), c.1930s–1964

Locations
6509 S. St. Lawrence, possible home workshop, 1910

5618 S. Hoyne, home workshop, 1911–1914

1926 S. Wabash, 2nd floor, 1915–1917

624 S. Michigan, #511, 1918–1919

159 N. State, #1513 Masonic Temple, 1920–1927

55 E. Washington, #423, 1928–1938

29 E. Madison, 1938–1949

Known workers
Sven Anderson, c.1925–1964

William Norris Brooks, (outsourced jewelry work), 1940s

Bjarne Meyer, 1921–c.1930

John C. Petterson, 1930s–1964

Norman H. Petterson, 1940s–1949

Leonard E. Podgorski, 1930s–1941

Joseph Robert Popelka, 1921–1930s

John P. Petterson and John C. Petterson hallmarks. Author's collection and photos.

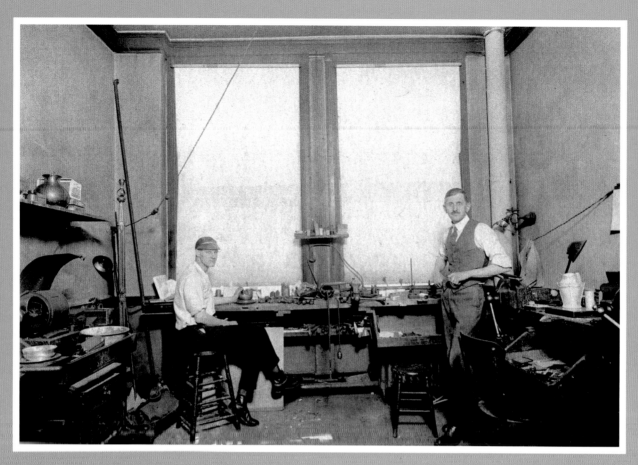

John P. Petterson (r) and Joseph Popelka (l) in the Petterson workshop, Chicago, c.1920s. Courtesy of David Petterson.

Petterson was a Tiffany & Co. silversmith when the Jarvie Shop recruited him to Chicago and into the local arts and crafts community. He executed fine and unique silver objects for Jarvie from 1910 to c.1914, and launched a Chicago studio under his own name in 1913, primarily catering to wholesale and special order clients. Petterson also was associated with the Kalo workshops around 1913 and may have taught at the Kalo School.

Born in Gothenburg, Sweden, Petterson graduated from the Royal School of Arts and Crafts, in Oslo, Norway in 1904. He apprenticed at the David Andersen company from 1899–1905, where he met his future wife, Margrethe Jacobsen, who was an enameller for the company. In September 1905, Petterson immigrated to Providence, Rhode Island, to work for the Gorham Company as a silver chaser on its Martele line, but jumped to the more desirable Tiffany & Co the following year. He married Margrethe in New York that year and worked at the old Tiffany factory in Essex, New Jersey, sharing a flat with C.D. Didrich, who became godfather to his son. Petterson worked at Tiffany until 1908 and—following a trip back to Norway—from 1909 to 1910.

In 1913–1914, silver work by the Petterson Studios was selected for inclusion in the AIC annual arts and crafts shows, following a local tradition of unveiling a new artistic company at the prestigious fall exhibits. Petterson showed a silver bowl and spoon, jewel box, candlestick, trophy, meat platter and a necklace. He exhibited in the 1921 and 1923 shows, listing Bjarne Meyer as a maker for hollowware items and Joseph Popelka for jewelry; Popelka was formerly with the Elverhoj Colony.

Petterson Studios was successful as a retail business and customers included stalwart society leaders such as the Wrigley and Morton families, but the shop excelled by catering to retail jewelers and silversmiths, fashioning a broad range of items for Hyman & Co., as well as artistic trophies and silver items for Frank S. Boyden, Boyden-Minuth, Black, Starr and Frost, Lewy Bros., Ralph Pearson's studio at the Elverhoj Art Colony, the Chicago Silver Company (after 1940), Gilbertson & Son, Russell Freeman Co., Hipp & Coburn, Spaulding & Co., Tatman Inc., and many others. In 1923, Petterson built a house at 608 Greenwood in Park Ridge, where he maintained his residence and a home studio throughout his life, in addition to his studio and retail shop in Chicago. Petterson adapted rapidly to customer trends, and in 1926 advertised "Novelty rings in gold and silver on special order; hand-wrought flatware and hollowware in sterling and bronze."

Petterson employed a variety of jewelers and silversmiths and he used the wholesale services of firms like Wm. N. Brooks for some jewelry items in the later years. When Petterson became a U.S. citizen in 1927, Frank S. Boyden and silversmith Emery W. Todd served as witnesses. In 1933, he demonstrated silversmithing for Colonial Village at the Chicago World's Fair. He was active in the Boston Arts and Crafts Society throughout his life and taught summer school metalwork classes at the University of Michigan.

Petterson introduced two simple but distinctive flatware patterns, Neptune and Elsinore, which were exhibited in New York in the 1930s. He entered into an exclusive sales agreement to sell the flatware through Black Starr & Frost, which was extended to Spaulding-Gorham in Chicago in 1940. He received awards for many of his original designs, including prizes from the AIC in 1921 and 1923; the Boston Society of Arts and Crafts in 1930; and a silver medal from the Paris International Exposition of Arts and Crafts in 1937.

Petterson avoided any mention of working for Jarvie in his published biographies, stating instead that he started his own business in Chicago in 1910. Whatever the rift, Jarvie and Petterson appear to have reconciled by October 1941 when Petterson completed a special order for him.

Petterson's wife died in 1936 and he married Frances G. Port in 1942. In 1948, he was pictured in the *Chicago Sun-Times* working on a chalice with Sven Anderson.[12] The following year, Petterson died of stomach cancer. His final wish was for his son John C. Petterson to continue making his Neptune pattern flatware, for which he had received a design patent in 1938. John C. retained Sven Anderson, producing the flatware until Anderson's death in 1964.

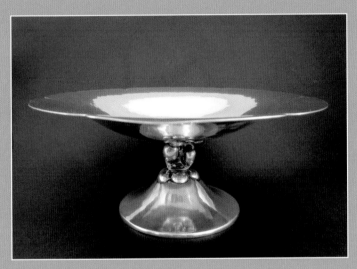

Finely hammered compote, signed The Petterson Studio with *J.P.P.* etched underneath, and Hand Made Sterling. Author's collection and photo.

Black obsidian carved intaglio necklace signed J.P. Petterson Chicago Hand Wrought Sterling. Author's collection and photo.

Sterling silver candlesticks marked The Petterson Studio Chicago. 12 inches high. Courtesy of the Charles S. Hayes family, photo by John Toomey Gallery.

Small Petterson Studio fluted bowl in the style of the Kalo Shop, marked with T-P-S logo. 5.5 inches diameter. Author's collection, photo by Rich Wood.

Petterson copper vase and tray. Courtesy of David Petterson, photo by Rudolph Henninger.

Sterling silver spoon by J.P. Petterson and ladle by his son, John C. Petterson. Author's collection, photo by Rich Wood.

*ARTISTIC
WROUGHT
SILVER*

From
**The Petterson
Studio** : Chicago

*GOLDSMITHS
SILVERSMITHS
JEWELERS*

Master Craftsmen in the
Precious Metals, Etc.

Three brochures for Petterson Studios. Author's collection. (Above and opposite page)

Petterson sterling silver paper knife inlaid with carved jade. Courtesy of David Petterson, photo by Rudolph Henninger.

Petterson sterling silver coral cameo brooch marked Handwrought, and green chalcedony brooch marked Hand Made; both marked J.P. Petterson and Sterling. Largest 2.75 inches long. Author's collection and photo.

Gold lapis lazuli and pearl ring, sterling and tiger eye ring, and sterling and tiger eye brooch from J.P. Petterson studio. Courtesy of David Petterson, photo by Rudolph Henninger.

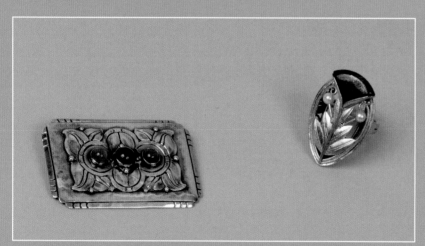

Sterling silver brooch with carnelian and ring with lapis and pearl from J.P. Petterson studio. Courtesy of David Petterson, photo by Rudolph Henninger.

Thayer and Chandler and Favor, Ruhl & Co. hallmark. Author's collection and photo.

Thayer & Chandler
Chicago
Favor, Ruhl & Co.
New York

The commercialization of hand-made metal wares and jewelry was unparalleled in Chicago and art supply companies such as Thayer & Chandler flourished by focusing on bringing arts and crafts projects to the masses. Known for its air brush technology since the Columbian Exposition, the company offered trendy kits and step-by-step instructions to create hand painted china, pyrography on wood items, home needlework, decorated leather, hand-made articles, and metal work. Around 1910, Thayer & Chandler introduced its Brass-Craft line that enabled children and adults to make elaborately pierced and tooled candlesticks and shades, inkwells, desk sets, picture frames, and useful boxes that were constructed by hand, working thin brass sheets over wood frames. In 1910, Thayer & Chandler, in partnership with Favor, Ruhl & Co of New York, introduced a special line of the kit that was copyrighted by Frederick H. Deknatel, president of the Mackie-Lovejoy Manufacturing Co. and an early resident of Hull-House. Some of the metalwork was marked T&C Chicago/F.R. & Co New York and some have the additional copyright mark "Deknatel 1910."

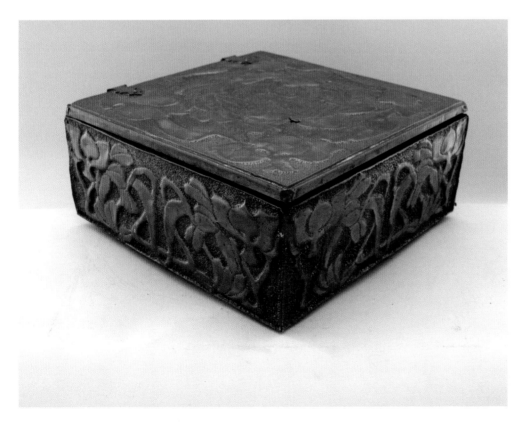

Brass hammered box and close-up detail. Author's collection, photos by Rich Wood.

Evanston Artist Network

Evanston was home to several important arts and crafts shops during the height of the movement, including the Cellini Shop, Mulholland Brothers, and the Tre-O Shop. The Hallmark Store, a collaborative operated by William P. Ullrich for artisans of hand-wrought silver items, assembled, and sold a broad selection of tableware at its downtown shop at 809 Davis Street.[1] During World War I, Lebolt & Co. participated in the collaborative, and added the Hallmark logo to advertisements. Several other known pieces of Hallmark silver reflect the work of Mulholland Bros. and Knut Gustafson.

Other studios and artisans who exhibited jewelry and metalwork in the annual arts and crafts shows at the Art Institute of Chicago (AIC) included Florence L. Ward in 1904, Virginia Bartle in 1915–1916, Mabel L. Tucker in 1915, and prominent arts and crafts jeweler and enamellist Eda Lord Dixon in 1904–1908. Rose Sears Kerr, a silversmith, made jewelry in the mid-teens. In 1925, Harry Freyermuth operated the Scarab Studio, a short-lived arts and crafts gift store and gallery. Helen Louise Crain made hand-wrought jewelry in 1930 and served as a metalwork artisan at the Colonial Village during the 1933 World's Fair.

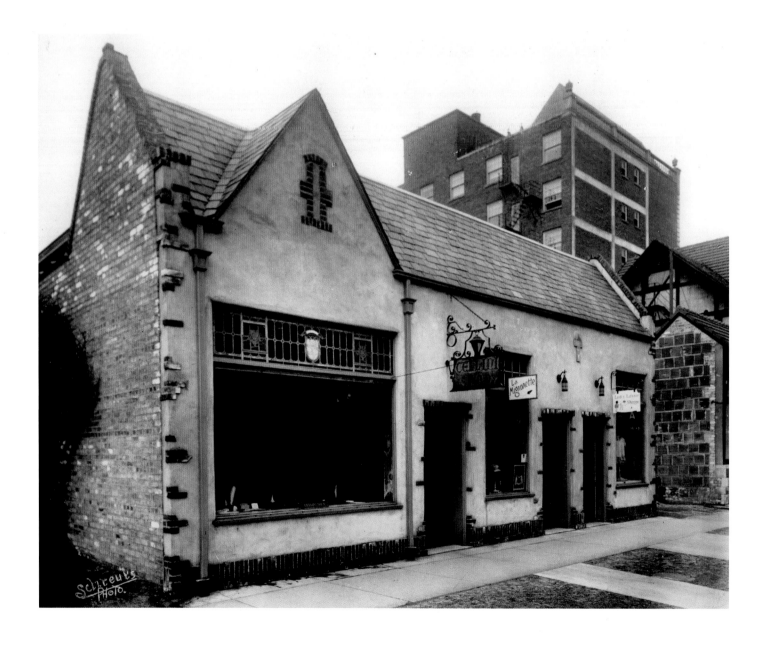

Cellini Shop mark, Cellini with Mulholland logo, and Cellini Craft logo. Later silver plated items made by Hans Grag were signed with his name in script. Author's collection and courtesy of Chicagosilver.com.

The Cellini Shop (1914–1978)
Cellini Craft (1933–1957)
Evanston, Illinois

Principals
Ernest Joseph Gerlach (1889–1978)
Margery Woodworth (1884–1973)
Walter Bernard Gerlach (1894–1977)
Hans Max Alexius Grag (1903–1965)

Locations
1604 Chicago Ave., Evanston 1914–1917
528 Davis St., 1917–1922
622 Church St., 1923–1925
Orrington Hotel, 1730 Orrington Ave, 1925–1946
1527 Chicago, 1946–1969
616 Church, after 1969

Known workers
Eugene Bergmark, Cellini Craft, silversmith, 1948
William Conrad, Cellini Craft, jeweler and metalsmith, 1930s–1950s
Wilhelmina Coultas, Cellini Shop, designer, 1917–1919
Mabel T. Favinger, Cellini Shop, jewelry designer, 1930–1933
Ernest J. Gerlach, jeweler and manager, Cellini Shop, 1914–1967
Walter Gerlach, designer and manager, Cellini Shop, 1919–1967
Hans Grag, co-founder and silversmith, Cellini Craft, 1933–1952
Herman Grag, metalworker (and father of Hans), Cellini Craft, c.1938–1948
Joseph R. Popelka, Cellini Craft, designer, 1948
Ella Runge, Cellini Shop, Buyer, 1948
Richard Strong, silversmith, Cellini Craft, 1948
Alfred "Fred" Francis Tonry, silversmith, Cellini Craft, 1940–1948
Margery Woodworth, designer, Cellini Shop, 1914–1917

Known silver manufacturing partners for the Cellini Shop
Carl henry Didrich, Mulholland Brothers, and the Randahl Shop

The Cellini Shop was an important hand-wrought jewelry and gift studio in Evanston that was founded by Margery Woodworth and Ernest Gerlach in 1914. The pair had met when they worked together at the Tre-O Shop in Evanston. The Cellini Shop featured hand-wrought jewelry as well as a broad range of gift and craft items including decorative leather, lamps, book ends, Sheffield plate, hand-blocked linens, holiday cards, and original drawings and prints by well-known artists. Business was steady, and, in 1916, the duo rented much larger space in the building. From 1916, the Cellini Shop advertised exquisite hand-wrought sterling silverware and hollowware made by the Mulholland Brothers.[2]

In 1917, Woodworth left the Cellini Shop to operate an interior design company in Wisconsin with her sister. Wilhelmina Coultas took over as the main designer for the studio, and she also ran business operations while Gerlach served in World War I.

In 1919, Ernest and his brother Walter Gerlach returned from service and Walter became a partner in the business, serving as a designer and shop manager. The Mulholland Bros. continued to supply the store with hand-wrought silver until it closed its workshop in 1920; the Gerlachs then turned to C.H. Didrich, the Randahl Shop and others to provide much of the silver, copper and pewter metalwork items that were sold in the store.

Silver and metalwork sold at the Cellini Shop was always hallmarked, but signed jewelry has not been identified. (Later jewelry marked *Cellinicraft* was from an unrelated company.)

In 1933, Walter Gerlach and Hans Grag, a talented silversmith who had studied and apprenticed in Hamburg, Germany, established a manufacturing division of the Cellini Shop to produce hand-wrought silver and artistic metalwork. Called Cellini Craft, the division introduced Argental, an innovative aluminum alloy that was ideal for decorative household objects. Cellini Craft also entered into a national distribution partnership with Max Willie, selling its wares from coast-to-coast. Cellini Craft items proved to be enormously popular, and Gerlach and Grag rapidly introduced the latest design features into their products, including Bakelite, modern plastics, artistic tiles, and art deco styling. In 1941, silver made by Cellini Craft silversmiths was featured at a special exhibit at Potter-Mellen Studios in Cleveland; items included a popular silver oval dish with beaded decoration, a canapé server, and a pastry server. Cellini Craft focused more on Argental

than sterling silver during World War II through the 1950s, reflecting changing consumer tastes. In 1969, the Cellini Shop was acquired by the Randahl Shop, but continued to operate under its name in Evanston until it closed in 1978.

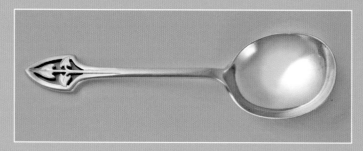

Sterling silver leaf pattern spoon marked Cellini Shop and the Mulholland anvil logo. Courtesy of Chicagosilver.com.

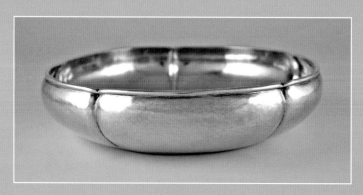

Sterling silver fluted bowl in the style of Kalo, marked Cellini Shop Evanston Hand Wrought Sterling, c.1920s. Courtesy of Chicagosilver.com.

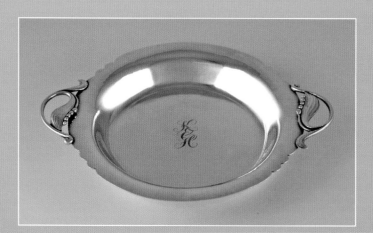

Sterling silver bowl with applied hand-hammered handles, marked Cellini Shop Hand Wrought Sterling, c.1930s. Courtesy of Chicagosilver.com.

Cellini Craft sterling silver small server. Courtesy of Laura Utrata, photo by author.

Cellini Craft lobed bowl, signed Handwrought Argental MW Cellini-Craft 104. Author's collection.

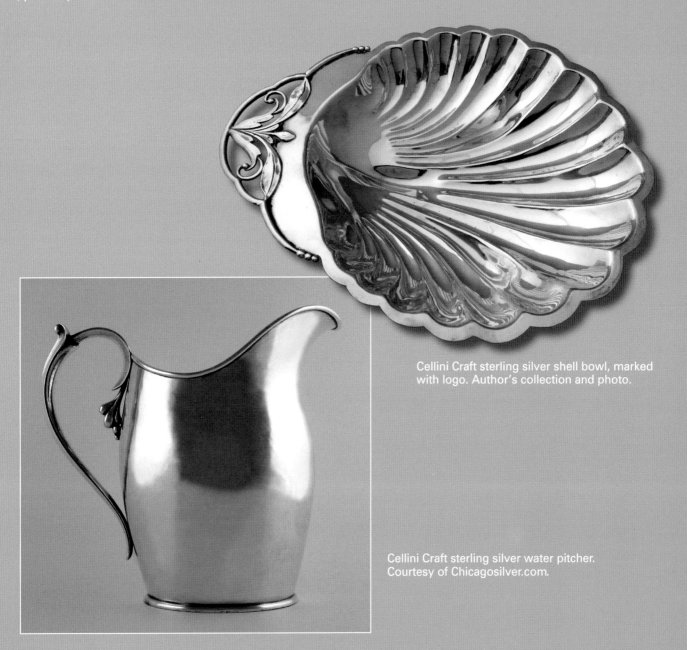

Cellini Craft sterling silver shell bowl, marked with logo. Author's collection and photo.

Cellini Craft sterling silver water pitcher. Courtesy of Chicagosilver.com.

Eda Hurd Lord Young Dixon (Mrs. William Sanborn Young; Mrs. Lawrence B. Dixon) (1876–1926)

Dixon was an award-winning jeweler and enameler who studied with James H. Winn of Chicago and Alexander Fisher of London. She grew up in Evanston and married William Young in 1896; following a divorce, she married Lawrence Dixon in 1908. By 1912, she had moved from Evanston to Riverside, California, and operated a leading jewelry studio with her second husband.

Dixon exhibited throughout the country and in the annual shows at the AIC. She was a member of the Detroit and Boston Arts and Crafts Societies and the Chicago Artists' Guild. In 1920, George Booth, a wealthy Detroit arts and crafts proponent and founder of Cranbrook, gave a silver and enamel box and hand mirror she made to the Detroit Institute of Arts, which were later sold at auction.[3]

Eda Lord Dixon hand mirror in silver, ivory, and enamel, c.1908. From *Palette & Bench* (March 1909). Courtesy of Boice Lydell.

Duncan Studios (c.1925–1930s)

Principal
Arthur William Duncan (1886–1929)

Duncan was a wealthy Evanston banker who discovered his artistic side later in life. By 1925, he became an artist and operated a gift studio in Winnetka. The shop featured interior decorations and sold art metal, including C.H. Didrich's hand-wrought pewter tulip candlesticks, which were marked Duncan Studios. It is unknown if Duncan made other hand-wrought silver items marked Duncan or if these were made by Didrich or another silversmith from the Chicago network. Duncan died in 1929, and his wife Elizabeth operated the gift studio into the 1930s before transitioning into an interior design studio.

Duncan Studios hallmark. Courtesy of Cobblestone Antiques.

John Adams Comstock Jr. was a Chicago native and Evanston architect before he joined the Roycroft Colony in Aurora, NY. around 1905. In 1908, he and his sister Catherine established the Companeros in Santa Barbara, CA. In 1909, the Companeros exhibited in the Shotwell Building exhibit with other leading Chicago jewelers and crafts workers. Their jewelry strongly resembles the Carence Crafters. Courtesy of Boice Lydell.

Mulholland mark and Mulholland Brothers anvil mark (c.1914–20). Author's collection and photos.

Mulholland Brothers (1914–1920)

Principals
David Edwards Mulholland(1886–1966)
Walter S. Mulholland (1889–1961)

Known workers, Evanston and Aurora
William E. Benbow, silversmith, c.1920–c.1922
James Charles Campbell, silversmith, c.1916–1918, 1920–1924
Charles Chambellan, silversmith, 1917
Edgar Colter Davis, silver chaser, 1916–1923
Ernest Gerlach, jewelry instructor, 1915–c.1917
Alfred H. Johnson, silversmith, c.1916–1920
Lyman F. Mulholland, silversmith, 1920
Daniel E. Mulholland, silversmith, 1912

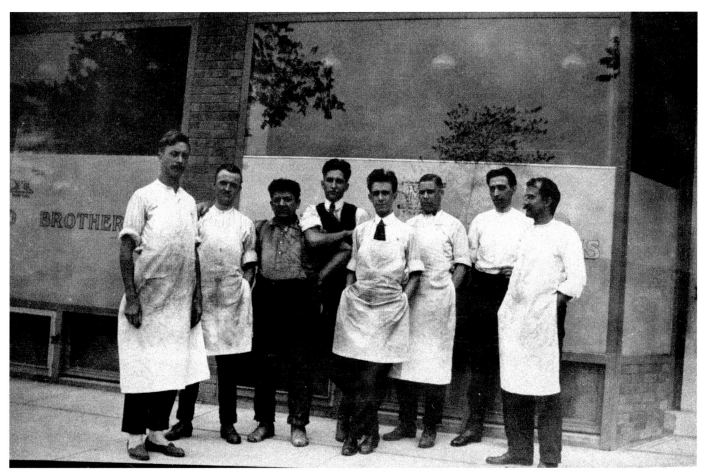

Mulholland silversmiths outside the shop, c.1918. The two men in the center, wearing neckties, may be Ernest and Walter Gerlach. Courtesy of David Petterson.

In 1914, veteran entrepreneurs David and Walter Mulholland established the Mulholland Brothers in Evanston after leaving the Park Ridge Kalo Community. The shop rapidly became known for its distinctive silver hollowware, flatware, trophies, fluted bowls, and finely executed repoussé and strap work. The company hired a team of skilled silversmiths and focused on special commissions for a broad array of retail jewelers. Mulholland Bros. provided hand-wrought silver to the Cellini Shop; some of the silver from this period was marked with both Mulholland's anvil hallmark and the Cellini Shop logo. Mulholland Bros. also made a direct-to-consumer line of flatware called Easterling, which may have been its own creation or from a partnership with another company.

The Mulhollands trained a cadre of apprentices to keep up with the strong demand for their wholesale and special order silver, and they structured their business based on a "school within a workshop" model. A 1915 trade magazine advertisement touted 40 full-day summer classes in silversmithing:

> The Silversmiths Guild of Evanston, 1020–1022–1024 Church Street, operated in connection with the noted studios and shops of Mulholland Brothers, makers of the famous Easterling Hand-wrought Silverware. Students have access to these shops.[4]

Ernest Gerlach of the Cellini Shop taught hand-wrought jewelry classes for the Guild and spent time in the Mulholland workshops. When David and Walter Mulholland enlisted in World War I, Ernest and Walter Gerlach helped operate the business until they joined the service as well.

At the 1917 annual AIC show, the Mulhollands and their craftsmen—J.C. Campbell, Charles Chambellan, Edgar C. Davis, and Alfred Johnson—won the coveted Municipal Art League Prize for a silver chased compote with a geometric border design; a chased child's cup; a fluted and chased vegetable dish; an ivory and silver chased and pierced server; and a silver chased salad fork. A glowing salute in the *Evanston News* noted that they had previously won an award for a $700 Gothic chalice, which was on display in their workshop. Also in 1917, Lewy Brothers, a Chicago jeweler and one of the Mulholland's many wholesale clients, exhibited the M.M. Rothchild Championship Cup in silver, designed and made by the Mulhollands, Chambellan, and Davis.

In 1917–1918, the Mulhollands served in World War I. After the war, they resumed their work at the silver shop, but the post-war economy took its toll. In August 1920, they dissolved the company and withdrew its $200,000 in capital stock. They bought the Aurora Silver Plate Co. and renamed it Mulholland Brothers, turning out stylish, hammered, fluted and chased designs in plated hollowware. In 1921, Mulholland Bros. Silver Co. exhibited at a trade show touting its Westminster pattern and "200" line. In c.1924, the brothers sold the business, and its new owners renamed it the Mulholland Silver Co. Walter and David later joined the Oneida Community in New York. In the late 1920s, David and Walter went to work in the steel industry, and David received several high-profile patents related to polishing inventions.

Portrait of Walter Mulholland, c.1915. Courtesy of the Mulholland family.

Portrait of David Mulholland. Courtesy of the Mulholland family.

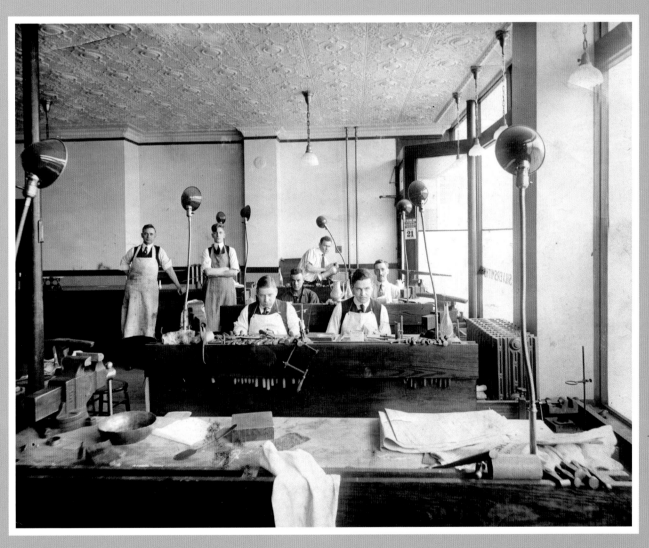

Interior of the Mulholland Brothers workshop in Evanston, March 1916. Walter Mulholland shown working on a large vase at the back. Courtesy of the Mulholland family.

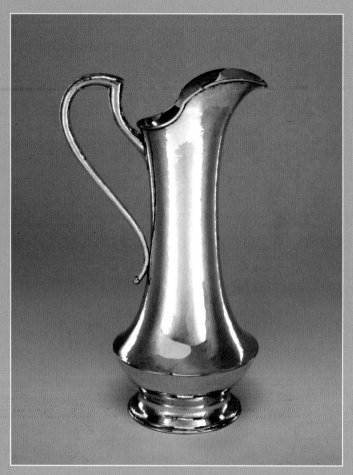

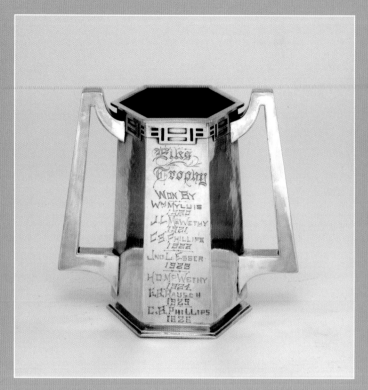

Mulholland Brothers engraved sterling silver trophy cup with geometric Prairie School border, signed with anvil logo, c.1920. Courtesy of the Charles S. Hayes family, photo by Scott Bourdon Studios.

Mulholland Bros. tall sterling silver pitcher, signed with anvil logo. 14 inches high. Courtesy of the Charles S. Hayes family, photo by Scott Bourdon Studios.

Mulholland Bros. sterling silver two-handled cup with deeply carved floral design, signed with anvil logo. Courtesy of the Charles S. Hayes family, photo by Scott Bourdon Studios.

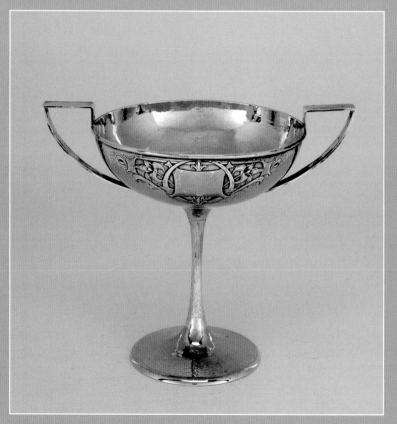

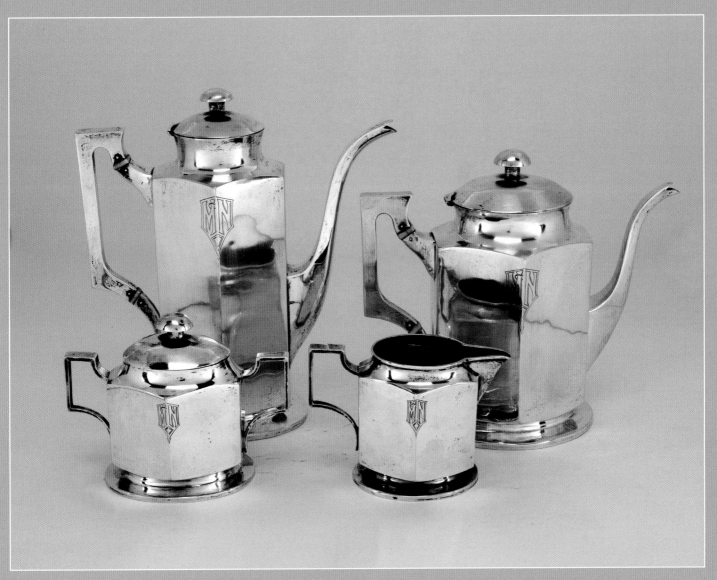

Tea and coffee service by Mulholland Brothers. Courtesy of the Charles S. Hayes family, photo by Scott Bourdon Studios.

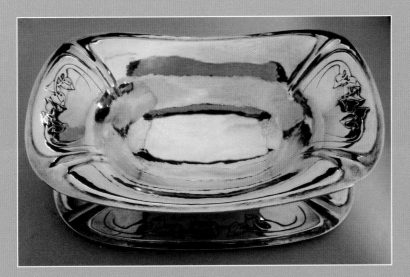

Mulholland bowl and under plate with repoussé decoration.
Collection of Meredith Wise Mendes and Michael Levitin,
photo by author.

Easterling sterling silver fork, butter knife, coffee spoon, and sugar scoop, marked with Mulholland anvil logo and an Easterling/Mulholland cloth bag. Author's collection, photo by Rich Wood.

Mulholland Bros. sterling silver server with applied "W" and two spoons. The spoon on the right is marked Hallmark, a collaborative that Mulholland Brothers participated in. Author's collection and photo.

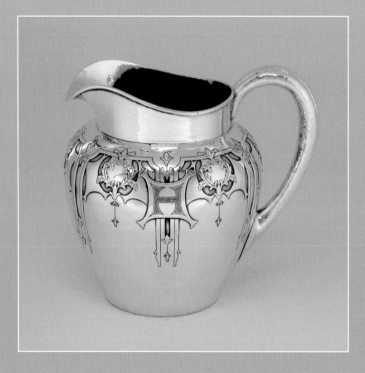

Mulholland Bros. sterling silver pitcher with an intricately carved leaf design and "H" monogram, signed with anvil logo. 7.5 inches high, 8.5 inches wide. Courtesy of the Charles S. Hayes family, photo by Scott Bourdon Studios.

Business card for Harry Freyermuth at the Scarab Studio, c.1925. Author's collection.

The Tre-O Shop (1908–c.1929)

Principals

Clara Cole Flinn (1879–1945)

Hope McMaster (Mrs. Wm. Clinton French) (1884–1966)

Margery Woodworth (1884–1973)

Known workers

Clara C. Flinn, designer and jeweler, 1908–1929

Ernest Gerlach, jeweler, 1912–1913

Louise Goffe, jeweler, 1909

Haga, Krisfoffer, jeweler, 1909–1910

Karl Henry Koch, designer and jeweler, 1915–1916

Julie Mayer, designer and jeweler, c.1916–1929

Hope McMaster, designer and jeweler, 1908–1910

Axel Petrussen, jeweler, 1908–1909

Margery Woodworth, designer and jeweler, 1910–1913

Tre-O Shop logo from the Tre-O design notebooks. Courtesy of Boice Lydell.

A fixture on the Evanston arts and crafts scene, the Tre-O Shop was a model for successful women entrepreneurs. Founded by two alumnae of the Art Institute of Chicago, Clara C. Flinn and Hope McMaster, the shop produced a broad array of jewelry and craft items and exhibited in the annual AIC shows from its inception. In 1910, McMaster left the partnership and was succeeded by Margery Woodworth, another AIC alum and Evanston-based designer and jeweler. In 1912, Ernest Gerlach joined the company and formed a strong working relationship with Woodworth; in 1914, the two left the company to establish the Cellini Shop. Around 1916, Kalo designer and jeweler Julie Mayer joined the Tre-O Shop. The company advertised hand-made jewelry in Evanston directories through 1929.

Based on a three-volume design book of original drawings and exhibition listings, the Tre-O Shop made bracelets, necklaces, brooches, pendants, hatpins, fobs, rings, coat clasps, cufflinks, pins, and other jewelry items in gold, silver and copper. Items often were set with stones such as moss agate, turquoise, brown jasper, and lapis lazuli. Metalwork exhibited at annual shows included salt spoons, brass bookends, and a variety of copper items. Most of the jewelry and metalwork made at the Tre-O Shop appears to have been unsigned, although items might be found with the tree logo featured in its design book (see photo).

Flinn, the daughter of a journalist and editor of the *Christian Science Monitor*, worked as a public school teacher before she returned to the AIC, graduated with a degree in decorative design, and opened the Tre-O Shop in 1908. She was active in the AIC alumni association and served on the metalwork jury for several of the annual shows. In c.1929, she merged the Tre-O Shop into C.D. MacPherson, a chic interior design and art store in Evanston. Flinn became president of the company and excelled as an interior designer; Mayer also was an interior designer for the firm. In the late 1930s, Flinn's furniture was selected for *American Contemporary Design*, an exhibition at the Metropolitan Museum in New York. Flinn continued innovative design work until her death in 1945.[5]

Karl Henry Koch (1878–1932)

Born in Hanau, Germany, a city noted for its silversmiths and jewelers, Koch immigrated to Chicago in 1906. By 1907 he worked as a designer and jeweler for the Marshall Field & Co. Craft Shop. From 1915–1916, he was a designer and maker for the Tre-O Shop and his work was featured in the annual arts and crafts shows at the AIC. From 1916, he operated his own jewelry studios on the north side of Chicago until his death. His shop marks have not been identified.

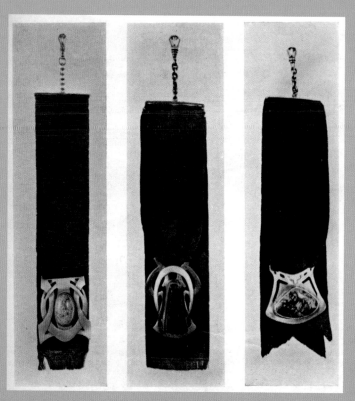

Watch fobs by Hope McMaster, Axel Petrussen, and Clara Flinn. From *Palette and Bench* (March 1909). Courtesy of Boice Lydell.

Drawing of a necklace from the Tre-O design notebooks. Courtesy of Boice Lydell.

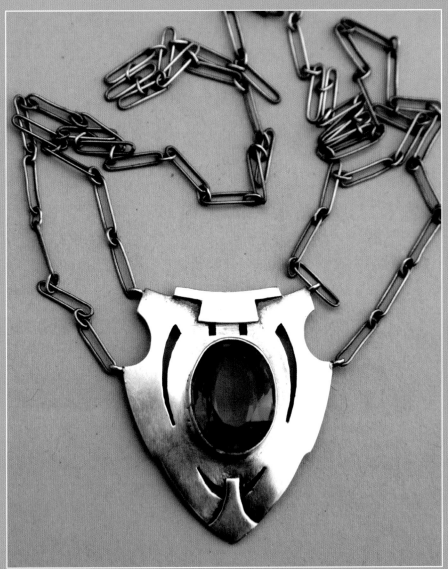

Sterling silver and amethyst necklace shown in the Tre-O Shop design notebooks. Courtesy of Boice Lydell.

Oak Park Artist Network

Situated nine miles west of downtown Chicago, Oak Park became home in the late 19th Century to many artisans, painters, illustrators, sculptors, furniture makers, leather workers, jewelers, metal workers, crafts workers, and architects.

Metalworkers and jewelers who helped define the artistic heritage of the community included Frank Lloyd Wright, who lived in the city from 1889 to 1909 and whose copper designs were included in exhibitions around the turn of the century. Other notables included Fred Sandberg and Jessie Preston, as well as Hannah Beye Fyfe, Helen McNeal, Albert Budde, Grace M. Peebles, John Spelman, Frank S. Needham, and Lee Watson, all of whom were instrumental in founding the Oak Park Art League and Guild of Applied Arts.

Manual arts training in local high schools served as a principal vehicle to learn jewelry making and metalwork in the suburbs, in addition to private classes or study at one of the Chicago schools. Frank S. Needham taught manual arts at the Oak Park-River Forest (OPRF) High School from 1902 to 1918 and was head of the department from 1906. He was noted for his gold, silver and copper jewelry in local exhibitions. Lee M. Watson moved to Oak Park in 1907 and taught jewelry and metalwork at the OPRF High School for decades, including a stint as head of the department, beginning in 1918.

Copper urn designed by Frank Lloyd Wright for the Edward C. Waller House, River Forest, Illinois. The urn was executed by James A. Miller and Brother in 1899. 18" high, 19" diameter. Courtesy of Leslie Hindman Auctioneers.

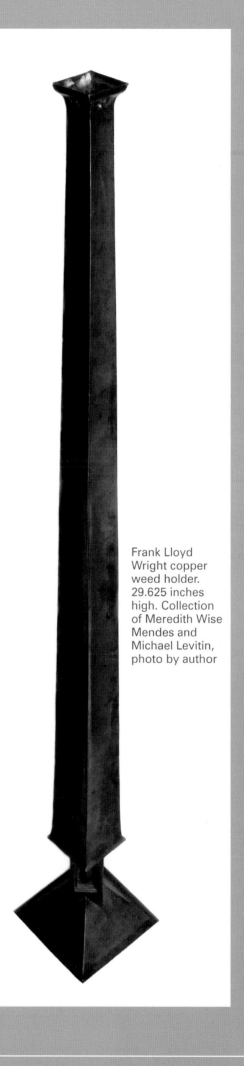

Frank Lloyd Wright copper weed holder. 29.625 inches high. Collection of Meredith Wise Mendes and Michael Levitin, photo by author

J. Shiffin Fine Arts, a gallery and art store at 122 N. Oak Park, was an important venue for displaying and selling arts and crafts items, metalwork, and jewelry from local and national artisans. During the 1909 holiday season, the shop featured a large line of works from the Forest Craft Guild. By 1914, Elmer Grable bought the store and opened Grable's Art and Gift Shop, which for decades expanded the tradition of exhibiting and selling original art works. By the 1920s, Grable's also private labeled some of the items that it sold in its galleries, including C.H. Didrich's innovative tulip candlesticks in pewter and silver.

Grable's Art and Gift Shop hallmark that appeared on a pewter candlestick designed and executed by the C.H. Didrich Shop. Author's collection and photo.

Frederick W. Sandberg (1852- before 1920)

Oak Park denizen Fred Sandburg was one of the earliest and best known repoussé art metal silversmiths in the region. Born in Sweden, Sandberg came to the United States in the late 1870s, and said he acquired his silver skills by studying in Europe. In 1898, he lectured on artistic silver, and he was one of only two Chicagoans who exhibited in the 1900 Paris Exposition. He showed hammered repoussé silver and gold jewelry and metalwork. In 1901, with the support of Mrs. Bertha Palmer, Sandberg brought the exposition to Chicago, where he delivered a series of six lectures at the Art Institute of Chicago (AIC) on *l'art nouveau* in the industrial arts. Sandberg, who was also a journalist, wrote frequently for the *Chicago Tribune* on art and antiques. At the turn of the century he taught metalwork at the AIC. In 1904, he said he was involved with the arts and crafts department of the World's Fair in St. Louis, which included a strong representation of Chicago artists and craft workers. In December of that year, he exhibited and lectured on repoussé and enamel at the AIC, showing an extraordinary chased bowl resting on the heads of three pelicans. From January 1905, Sandberg appeared in Chicago society matron Frances Glessner's personal journal, and she frequently bought work that he made in his Oak Park home workshop. In 1905, he exhibited an abundance of silver jewelry in the fall show at the AIC. By the following year, Sandberg's interest in metalwork began to wane, and he sold his hand-made silver and enameling tools to Glessner, focusing on his newspaper career until he died around 1920.[1]

Hallmark of Frederick W. Sandberg. Courtesy of Rago Arts and Auction Center, Lambertville, NJ.

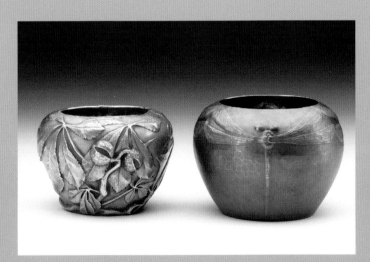

Frederick W. Sandberg parcel-gilt silver embossed cabinet vases. Exhibited in the 1904 Art Institute of Chicago annual arts and crafts show. Each signed *FWS*. 2" x 3" and 1.75" x 2.75". Courtesy of Rago Arts and Auction Center, Lambertville, NJ

The Studio, 5905 Erie Street, Chicago

Principal
Helen Frances McNeal (1879–1930)

Chicago-born McNeal was a jeweler, metalworker, designer and teacher who operated The Studio out of her home in the Austin neighborhood of Chicago, adjacent to Oak Park. In 1901, she studied decorative design at the AIC with Hannah Beye and Edna Coe. She also received a degree from the Pratt Institute in Brooklyn, where she was awarded a gold medal. A fixture on the local and national exhibition scene, her work at the AIC annual shows included gold and silver necklaces, pendants, scarf pins, brooches, rings, pendants, carved ivory and a silver box. By 1920, she was the director of a vocational society for the handicapped. She taught jewelry and metalwork at John Marshall High School from 1923 until her death in 1930.

Lee M. Watson (1872–1959)

Trained at the University of Maine and the Massachusetts School of Art in Boston, Watson was a leader in the Arts & Crafts Movement in Oak Park, trained dozens of students, exhibited and juried metalwork at the annual arts and crafts shows at the AIC and operated his own studio on Lake Street. His exhibited work featured repoussé copper and enamel, hammered copper, and gold and silver jewelry set with semi-precious stones. In 1908, Watson also designed the official school emblem for the Oak Park River Forest (OPRF) High School.

Lee M. Watson hallmark. Courtesy of Judy Atwood, photo by author.

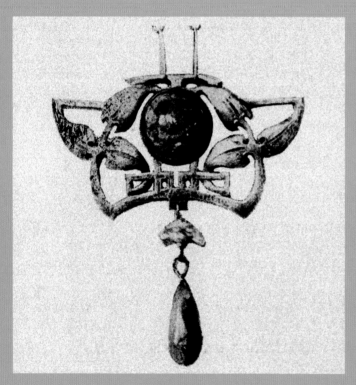

Helen McNeal necklace illustrated in the *Chicago Artists' Guild* (1915). Courtesy of the Chicago Public Library.

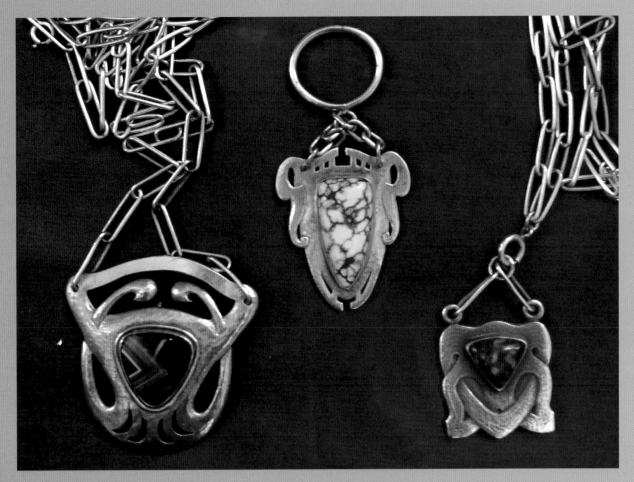

Watson carved silver pendants and fob set with stones.
Courtesy of Judy Atwood, photo by author.

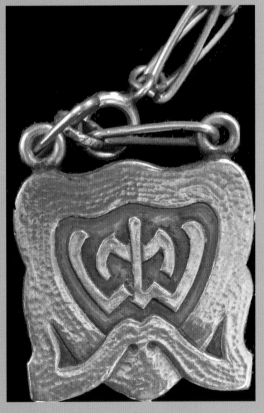

Watson pendant back showing monogram design and original drawing from
artist's design sketch collection. Courtesy of Judy Atwood, photos by author.

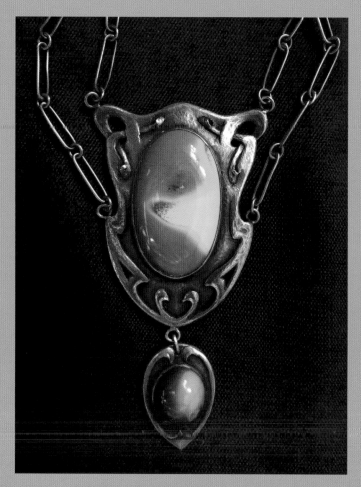

Watson carved gold and green stone necklace. Courtesy of Judy Atwood, photo by author.

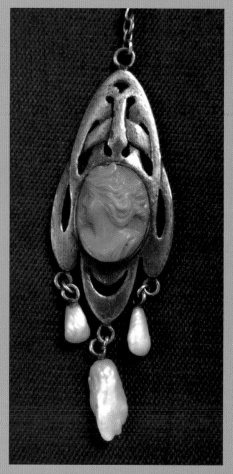

Carved silver, coral cameo, and pearl pendant with paper clip chain by Watson, unsigned. Courtesy of Judy Atwood, photo by author.

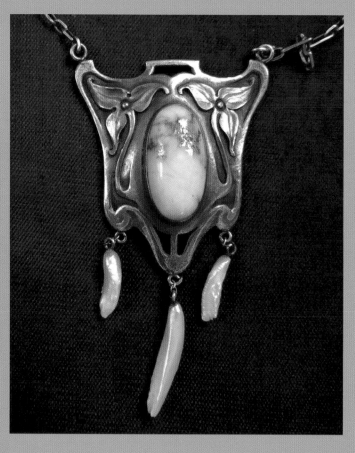

Watson silver and abalone belt pin with applied decoration, unsigned. Courtesy of Judy Atwood, photo by author.

Carved silver pendant with pearl and white stone by Watson, unsigned. Courtesy of Judy Atwood, photo by author.

Postcard designed to be hand-colored, copyrighted by L.M. Watson, 1910. Courtesy of Judy Atwood.

Watson hammered copper tea kettle with carved ivory knob and pierced handle. Watson exhibited this item in the 1908 annual AIC show. Courtesy of Judy Atwood, photo by author.

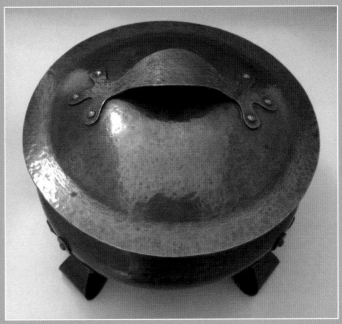

Watson hammered copper round covered dish; Watson exhibited this item in the 1908 annual AIC show. Courtesy of Judy Atwood, photo by author.

Watson repoussé copper and wood bookend. Courtesy of Judy Atwood, photo by author.

John "Jack" Adams Spelman (1880–1941)

Spelman studied at the AIC and was an accomplished painter throughout his life. From c.1912 to 1917 he also was a noted jewelry craftsman who exhibited in the annual arts and crafts shows at the AIC, as well as many exhibitions in Oak Park. His work included gold and silver rings, pins and pendants, usually set with semi-precious stones. In 1915 Grable's of Oak Park held a special exhibition and sale of his hand-wrought jewelry.

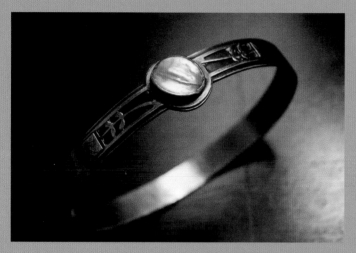

Spelman sterling silver bracelet with mother-of-pearl, unsigned. Courtesy of Sharon Marston Wise.

Albert T. Budde (1864–1935)

Budde showed his jewelry at the AIC in 1914, and he was a frequent exhibitor in Oak Park.

Isabel Ray Sutcliffe (1892–1935)

Sutcliffe moved to Oak Park with her family in 1903 and studied manual arts at the high school. In 1911 she debuted at the annual arts and crafts show at the AIC with a collection of silver jewelry set with lapis lazuli, garnet, pearls and jade, of which she named the individual items Trifolio, Helena, Daucous and Feuilles. She also exhibited her hand-wrought jewelry in Oak Park.

Veterans Occupational Metalwork and Jewelry Programs

In the aftermath of World War I, occupational programs for wounded soldiers were designed to assist in physical rehabilitation and provide meaningful, self-sustaining careers for hundreds of thousands of men throughout the country. Many women—particularly those trained in jewelry, metalwork, and the arts and crafts—taught occupational and vocational programs at government and civilian hospitals, clinics, and military institutions. Civic organizations and the corporate sector also were active supporters of training programs.

In Illinois, Chicago jeweler James H. Winn established a training program that included study for teachers of wounded veterans called the Apprentice's School for the Chicago Manufacturer's Association. The Kalo Shop, frustrated over some of the trifling training programs sweeping the country, offered a course in metalwork as noted by a reporter: "Mrs. Clara Barck Welles of the Kalo Shop has given her studio workroom for a class in instruction to teach the wounded useful arts, as the making of toys and trifling objects is not enough of a serious occupation to provide a livelihood for men." [1] The Kalo course and use of its studios were designed for teachers who wanted to pursue careers in the emerging arena of occupational therapy for wounded veterans. Offered at no charge, the course featured instruction by well-known craftsmen in silversmithing, metalwork of all kinds, basket weaving and various crafts.

Beginning in 1918, Fort Sheridan in north suburban Chicago offered vocational training for thousands of former service men from Illinois, Wisconsin and Michigan. Fredericka Hayden oversaw the Jewelry Craft department, which made arts and crafts style items. In June 1919, the Central States Division of the Art Alliance of America, based in Chicago and associated with Leonide C. Lavaron, assembled the first extensive exhibition in the country of work made by wounded veterans and the disabled. Held at the Art Institute of Chicago with a theme of occupational and commercial reconstruction, the exhibit featured jewelry, metalwork, woodworking, weaving, basketry, toys, illustration, and a range of crafts.

Milwaukee-Downers College, a women's school in Wisconsin, sprang to action after the war, and, from 1918

to 1920, offered an occupational training degree for women in the crafts, including a 16-week course in metalworking, jewelry and silversmithing. Taught by former Kalo artisan E. Mabel Frame, graduates quickly were hired as occupational teachers in military hospitals and civilian institutions.

In 1918, Martha Alberta Montgomery, an art teacher at downstate Decatur High School (Decatur, Illinois), was hired as a reconstruction aide at Walter Reed General Hospital in Washington, D.C. and eventually became one of the country's best known instructors of veterans in vocational metalwork and jewelry. At Walter Reed, Montgomery's highly successful students included Hans Sorensen, a hand-wrought jewelry artisan; metalworker Joseph T. Yurkunski, who presented a silver jewel case to First Lady Florence Harding in 1921; and Ralph O. Grimm, one of the finest silversmiths and jewelers in the Washington, D.C. area. Montgomery became the chief superintendent at Walter Reed, and in the 1940s, she worked in occupational therapy in Iowa.

In 1937, the Veterans Craft Exchange opened in Chicago to sell copper and silver metalwork, jewelry, leather, and craft items made by wounded veterans. Exquisite hand-wrought silver jewelry sold at the shop was mentioned in the press made by "Benedict," but work examples and marks have not been identified.

Grimm Studio (c.1920–1935)
Washington, D.C.

Principals
Ralph Orion Grimm (1889–1935)
Martha Alberta Montgomery (1886–1978)

Grimm studied silversmithing, metalwork and jewelry making from Alberta Montgomery for six hours a day over four years at Walter Reed General Hospital in Washington, D.C. Born in Santa Barbara, California, Grimm had worked as a miner in Colorado before he enlisted in World War I. He lost both of his legs during the Meuse-Argonne Offensive in France, which was the final battle of the conflict, just four days before the armistice was signed that ended the war. Grimm served in the 89th Division (355th Infantry) of the American Expeditionary Forces and later used the Division's insignia of a W in a circle to brand his jewelry and metalwork, likely in honor of his friends who died in the battle. [3]

Grimm opened his first studio across the street from Walter Reed and made finely hammered copper and silver wares, including dishes, bowls, candlesticks, ladles, flatware and jewelry. Some of his notable works included silver chalices and pendant crosses for the Washington Cathedral. In 1928, his work was featured in an exhibit by the Washington Society of Arts and Crafts, which also included a silver tray made by his mentor, Alberta Montgomery; both artisans also showed their work in a 1933 exhibit in Washington, D.C.

Grimm never recovered from his war memories and committed suicide in 1935, leaving a wife and a step-daughter. He was buried at Arlington National Cemetery with full military honors.

Ralph O. Grimm hallmark, which includes the insignia for the 89th military division. Author's collection, photo by Rich Wood.

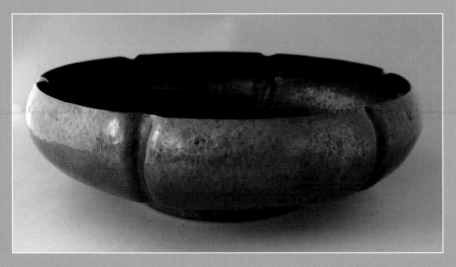

Grimm hammered copper bowl. Author's collection and photo.

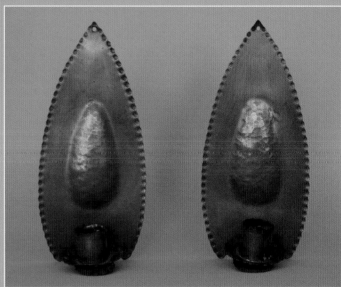

Grimm copper sconces. Author's collection, photo by Rich Wood.

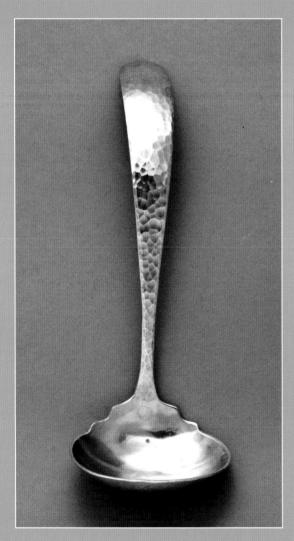

Grimm silver ladle. Author's collection, photo by Rich Wood.

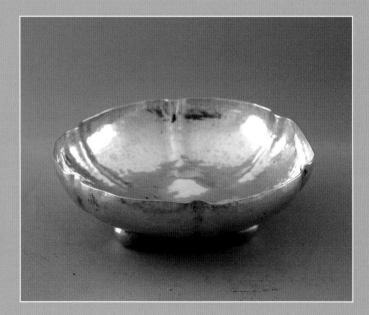

Grimm silver footed bowl, 4 inches diameter. Author's collection, photo by Rich Wood.

Jewelry Craft (c.1920–1935)
Fort Sheridan, Illinois

Principal
Fredericka Emma Hayden (Mrs. Edward Drew Gourley) (1893–1983)

A native Chicagoan, Hayden studied at the Chicago Academy of Fine Arts and became an instructor at the school. She also established an arts and crafts studio in Chicago before she joined the occupational therapy staff at Fort Sheridan and served as a reconstruction aide. She was in charge of the Jewelry Craft department, which taught soldiers metal work and jewelry making. Later Hayden married Edward Gourley, a colleague from art school, and raised a family in north suburban Chicago.

Jewelry Craft hallmark. Courtesy of Boice Lydell, photo by author.

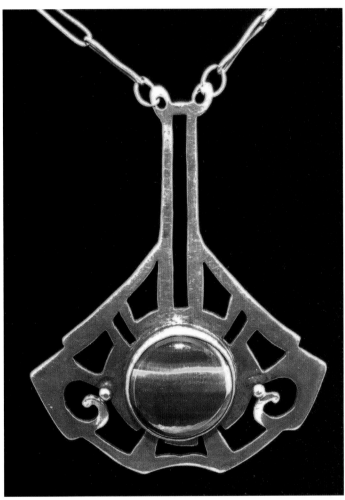

Jewelry Craft necklace. Courtesy of Boice Lydell.

Photos of jewelry made in the occupational teacher's training program in Milwaukee. From the Kronquist Scrapbook, author's collection.

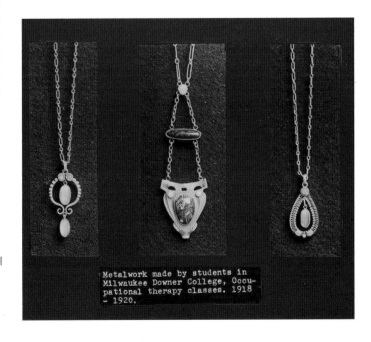

Metalwork made by students in Milwaukee Downer College, Occupational therapy classes. 1918 - 1920.

Regional Arts and Crafts Industries

Illinois

Outside the Chicago area, Illinois arts and crafts industries were focused around educational institutions, reformatories and urban centers. Shops ranged from small studios, such as Ye Arts and Crafts Shop in Rankin, Illinois, to large enterprises like the Illinois State Reformatory. Many early students were trained at the Bradley Polytechnic Institute in Peoria under the direction of designer, crafts worker and author Adelaide Mickel, who also made jewelry in 1912, and metalworker and author Arthur F. Payne.

Rockford was another center of arts and crafts activity. In 1905, Louise D. Hill moved to Rockford from Evanston to open Ye Gyfte Shoppe, which featured decorative household objects and hand-wrought jewelry for some 30 years. The shop was modeled after the studios in the Chicago Fine Arts Building, and Hill sold a broad collection of jewelry and metalwork, including Jarvie candlesticks as well as jewelry that she selected from a variety of artisans. The shop hosted exhibitions of works by local crafts workers, including a 1906 show of hand-wrought jewelry by Florence Knowlton from Freeport, Illinois. Knowlton, a former manual arts teacher and one of the leading metalworkers and jewelers of the region, participated in many local exhibitions. In 1910, she moved to Portland, Oregon, and served as the master craftsman for the Portland Society of Arts and Crafts. She operated an important metalwork, jewelry and gift shop in Portland until her death in 1945.

Rockford was also fertile ground for the Kalo Shop, and by 1908, the registrar of the School of the Kalo Workshop recruited jewelry students in the city. Public school art teacher Marion Haskins attended the Kalo School and designed and made jewelry in Park Ridge from 1912–1913. In 1920, under her married name Marion Haskins Evans, she taught jewelry making at the Rockford Guild, which was a crafts organization headed up by Dudley Crafts Watson, with the assistance of artist and master craftsman Herman Sachs.

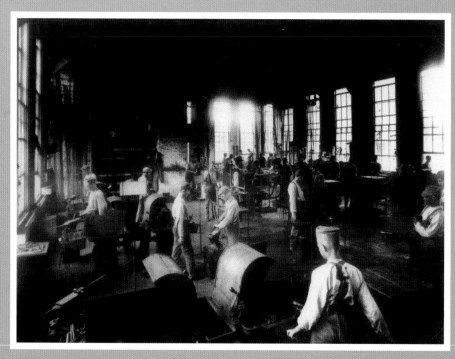

Interior view of ironworks factory, portfolio #66, n.d. Thomas F. Googerty, designer. Thomas F. Googerty Collection, Ryerson and Burnham Archives, The Art Institute of Chicago. Courtesy of The Art Institute of Chicago.

Thomas Francis Googerty (c.1863–1945)

Illinois State Reformatory for Boys, Pontiac, Illinois (Pontiac Correctional Center)

Googerty hallmark. Drawn by the author from his signed work.

Googerty was a metalworker and master craftsman who brought the principles and inventiveness of the Arts & Crafts Movement to legions of boys and young men incarcerated at the Illinois State Reformatory. Googerty also taught summer school at the Stout Institute in Menomonie, Wisconsin, alongside Minneapolis colleagues Maurice Flagg and Harold Boyle, among others. He published dozens of articles and several important books on metal forging that are still popular today.

Artistically, Googerty exhibited his works at nearly every annual AIC show from 1907 to 1923, winning a prize in 1921. He was a master craftsman at the Boston Society of Arts and Crafts and exhibited in the 1915 Panama-Pacific Exposition in San Francisco. His original work included copper vases, paper knives, and porringers, silver pedestal dishes, a silver sugar and creamer, silver bowls, wrought iron, steel, and copper candlesticks, steel toasting forks inlaid with copper, and many ornamental iron items. His jewelry included copper, bronze, and silver brooches, and a silver necklace. A blacksmith by training, Googerty's design class drawings show that he attended art school from c.1903 to 1905, which may have been the AIC.

Born and raised in Pontiac, Googerty was very active in civic affairs and was one of the founders of the Sons of Pontiac. His work in the reformatory began in 1894, when he was hired to start a forge shop, which modeled a French atelier. According to Miller (1999), Jane Addams of Hull-House was instrumental in passing the bill that established the manual training program at the reformatory. The author further said that some of Googerty's students became highly successful metalsmiths and that their work was signed with ciphers. Also according to Miller, Googerty took special pride in his African-American students, whose works he often exhibited in shows and featured in magazine articles.[1]

Googerty worked as a blacksmith at the penitentiary up until the day of his death at the age of 82.

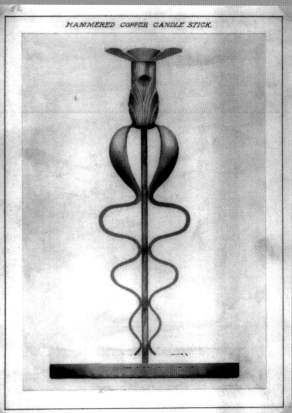

HAMMERED COPPER CANDLE STICK.

FEB. 26. 05. THOS. GOOGERTY CLASS D-B 478528.

Hammered copper candlestick, portfolio #90, 1905. Thomas F. Googerty, designer. Thomas F. Googerty Collection, Ryerson and Burnham Archives, The Art Institute of Chicago. Courtesy of The Art Institute of Chicago.

Toasting forks, portfolio #61, n.d. Thomas F. Googerty, designer. Thomas F. Googerty Collection, Ryerson and Burnham Archives, The Art Institute of Chicago. Courtesy of The Art Institute of Chicago.

ELECTRIC WALL LIGHT.

FEB. 26-05. THOS GOOGERTY CLASS D.B. 478528

Electric wall light, wrought iron copper thistle, portfolio #89, 1905. Thomas F. Googerty, designer. Thomas F. Googerty Collection, Ryerson and Burnham Archives, The Art Institute of Chicago. Courtesy of The Art Institute of Chicago.

Hallmark for Arthur F. Payne. Courtesy of Fred Zweig.

Arthur Frank Payne (1876–1939)
Bradley Polytechnic Institute, Peoria, Illinois

Payne was a skilled artisan and leading academic who taught the art of functional industrial design at leading institutions throughout the Midwest. His crafts work included hand-wrought copper bowls, jewelry in chased and acid-etched designs, desk accessories, and a broad range of silver, copper and brass items.

Born in Birmingham, England, Payne immigrated to the United States with his family in 1888, settling in Connecticut, where he trained as a silversmith. After his marriage, he moved with his family to Ohio. From 1905 to 1909 he served as the director of the Columbus School of Arts and Crafts; from 1909 to 1916, instructor and then assistant professor in the Manual Arts Department at Bradley Polytechnic Institute in Peoria, Illinois; and after a stint in Pennsylvania, from 1919 to 1923, he headed up the Education Department at the University of Minnesota where he was active in the Minneapolis Handicraft Guild. Payne racked up many degrees along the way, earning a bachelor of science from Bradley in 1915, a PhD from the University of Chicago in 1916, a master's at Columbia University in New York in 1917 and a doctorate in education from Harvard in 1919.

Payne was a prolific author and wrote the popular *Art Metalwork with Inexpensive Equipment*, which included illustrations of items from the Kalo Shop in Chicago, the Columbus School, and designs associated with the Minneapolis Handicraft Guild. Following his distinguished career in arts and crafts, Payne later specialized in psychology and lived in New York from the late 1920s until his death in 1939.

Hammered copper bowl marked A.F. Payne. Courtesy of Chicagosilver.com.

Lucien Carpenter Shellabarger (1868–1943)
Home Workshop, Decatur, Illinois, active 1923–c.1930s

Shellabarger was a wealthy industrialist who delved into artistic metalwork in the 1920s–1930s. He studied with noted Chicago silversmith C.H. Didrich and became highly proficient at making silver, copper, brass and pewter bowls, trays, candlesticks, tea sets, and similar items in his large and well equipped garage workshop. He exhibited his work at the art institutes in Decatur and Springfield, Illinois, and gave a lecture on metalworking at the AIC. In a 1927 exhibit in Decatur, he showed 100 items in brass, copper, and silver. His work was strongly influenced by Didrich, including a variation on Didrich's classic tulip candlesticks, fluted bowls, and applied monograms. In 1930, Margaret Craver, a noted jewelry designer and nascent metalsmith from Kansas, studied with Shellabarger in his studio, adding a practical side to her art education; she later became one of the most influential silversmiths in the country. [2]

Hallmark for Lucien C. Shellabarger. Author's collection and photo.

Two brass trays with applied monograms, signed L.C. Shellabarger. Courtesy of Chicagosilver.com.

Copper pen tray, brass paper knife, and sterling silver bangle bracelet, all signed L.C. Shellabarger Hand Wrought. Author's collection and photo.

Ye Arts and Crafts Shop
Rankin, Illinois (c.1905–1930s)

Principals
Annette Irwin (1873–1933)
Annie Irwin (1868–1941)
William J. Irwin (1870–after 1931)

A photography and craft studio, Ye Arts and Crafts Shop sold a broad range of jewelry, leather, metalwork, and craft items. The Irwins, a brother-sisters team, were all skilled photographers and crafts workers. The shop principally was run by the sisters, as William was also an engineer. From 1900 to 1904, Annie taught at the progressive Biltmore School in North Carolina, which incorporated forestry, nature, design, and crafts into the curriculum. [3] The Irwins incorporated many of these ideals into classes on the large family estate in Rankin, "a naturalist's paradise." The name of Ye Arts and Crafts Shop appears on letterhead in the the collection.

Annette Irwin, acid etched and hammered brooch, unsigned. Courtesy of Boice Lydell.

Arts and Crafts Exhibit

Miss Annette Irwin of Rankin will hold her annual exhibit of Fancy Work, (both Stamped and Finished), Hand Wrought Leather and Metal Work at _____

Will you call? It is an excellent opportunity to prepare for Xmas

Annette Irwin arts and crafts exhibition card. Courtesy of Boice Lydell.

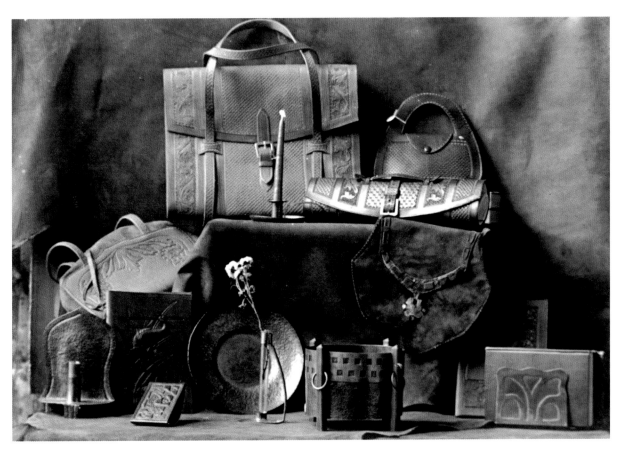

Annette and W.J. Irwin, photo display of hand-crafted leather and metalwork, signed on the back, "Made by Annette and W.J. Irwin." Courtesy of Boice Lydell.

Indiana

Janet Payne Bowles (1872–1948)

Bowles was known for a highly distinctive style of metalwork and jewelry that was more stylistically aligned with modernism than pervasive motifs in the arts and crafts. Some of her handmade works resembled items made by Madeline Yale Wynne. In 1912, the Indianapolis native returned to the city with her children following an East Coast sojourn and a rocky marriage. She taught metalwork and jewelry at her alma mater, Shortridge High School. She soon became one of the best known hand-wrought metalworkers and jewelers in Indiana, and exhibited widely, including several of the annual shows at the Art Institute of Chicago and the 1915 Panama Pacific Exposition. Her jewelry, metalwork and sculptures were admired by the media, including *International Studio*.[1] Her motifs in gold and silver, some with enamel and semi-precious stones, were characterized by strong Celtic influences. Her work was marked JANET PAYNE BOWLES.

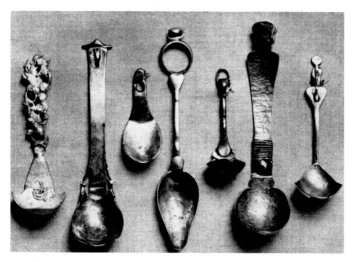

Photograph of gold spoons made by Janet Payne Bowles for J. Pierpont Morgan. Courtesy of Chicagosilver.com.

Dyer Arts and Crafts Shop
Indianapolis, Indiana (active c.1906–after 1910)

Principal
Charles B. Dyer (1878–after 1930)

Charles B. Dyer, a manufacturing jeweler in Indianapolis from 1900, established an evening arts and crafts school and a shop with his father to promote the making of hand-made jewelry by local aspiring artisans. The school was an outgrowth of the failed Indianapolis Arts and Crafts Society, which lasted barely a year, from 1905 to 1906. Dyer noted that there were so few local crafts workers that almost all of the items were sold on consignment from other regions. Dyer's school, based in his workshop, taught the use of tools and how original designs could be executed in metal. Launched in 1906, the school grew from five pupils to seventy-five students just two years later. The semi-annual exhibitions of the school became social affairs, including artistic copper plate invitations, and nearly everything produced during the semester was sold to benefit students. One show included over 300 items of jewelry, bronze and copper work. Dyer noted: "Most of the workers are so interested in the work that they have their own workshops and tools at home, and a number of them have not only produced some very creditable pieces but have made good money in doing it."[2] Dyer made a variety of arts and crafts jewelry, including sterling silver brooches, rings, and pendants, as well as hand-wrought monogram and society items in gold and silver.

Charles B. Dyer hallmark. Author's collection and photo.

Sterling silver and agate brooch by Dyer, signed with his hallmark. Author's collection and photo.

Jewelry box from the Charles B. Dyer shop. The agate brooch came with the box. Author's collection and photo.

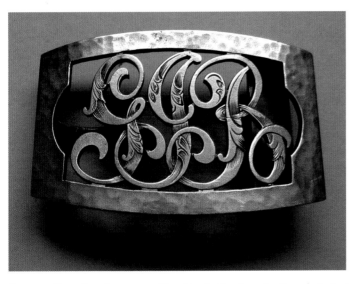

Dyer sterling silver hammered buckle. Author's collection and photo.

Interlaken School

Rolling Prairie, Indiana (1907–1917)

The Interlaken School, an industrial training school for boys modeled after German rural education homes, was located on Silver Lake in LaPorte County. Founded by Dr. Edward A. Rumely and managed by superintendent Raymond Riordon, the school included metalworking, and craft items likely were sold in an associated crafts shop. Interlaken also operated a summer school for boys.

In 1911, the Roycrofters, a famous metalwork community in East Aurora, New York, announced that Riordon would also be in charge of the Roycroft School of Life for Boys, in addition to his responsibilities at Interlaken.[3] By 1914, Riordon left both institutions, and established a school under his own name in Ulster County, New York. In 1917, amid anti-German bias, the U.S. government took over the Interlaken School to establish a military training center, and it ceased operations.

In addition to the script hallmark, crafts work made at the Interlaken School have been found stamped with the name in block letters in a straight line.

Mark for the Interlaken School, LaPorte, IN. Courtesy of Boice Lydell, photo by author.

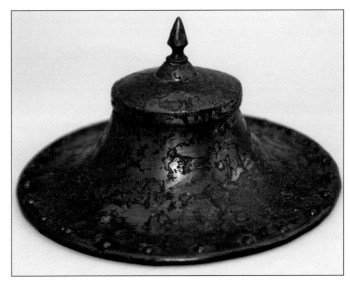

Copper etched inkwell from the Interlaken School. Courtesy of Boice Lydell.

Iowa

Loomis and Wood and the Loomwood Craft Shop
Cedar Rapids, Iowa (1911–c.1913)

Principals
Kate Terry Loomis (Mrs. Charles Calvin Loomis)
(1875–1957)
Grant DeVolson Wood (1891–1942)

The Loomwood Craft Shop, co-founded by Kate Loomis and Grant Wood, was a jewelry and metal work studio that operated out of a basement workshop at the Loomis home on Bever Street. The shop made jewelry and copperwares including lanterns, fireplace screens, decorative copper panels, candlesticks, light fixtures, and lanterns. In 1912 "Loomis and Wood" was selected to exhibit at the annual arts and crafts show at the AIC, and they showed a side light, sconce, and Newell Post with trillium designs and a copper oval picture frame. In July 1913, a newspaper article referred to the studio as the "Loomwood Craft Shop." Cedar Rapids hosted a metalwork exhibit that fall that featured works from the shop, including a repoussé bookrack, beaten copper trays, silver shoe buckles, and jewelry by Loomis. Wood was credited with copper fireplace panels called "Youth" and "Age," a tall vase, a unique tea kettle, a copper sconce in a trillium design, and a small jewel box with repoussé pinecones on the cover, as well as rings, cuff buttons, and watch fobs.[1]

Wood, born in Anamosa, Iowa, attended Washington High School in Cedar Rapids. In 1909, he studied with Ernest Batchelder at the Minneapolis Handicraft Guild Summer School and considered it the best educational experience of his life. He returned to the Guild upon graduation from high school in 1910, only to discover that his beloved mentor wasn't there, as Batchelder had launched his own summer school in Pasadena, California.[2] Wood lived in Minneapolis and studied under the new director, Maurice I. Flagg, but soon returned to Iowa. Before forming a partnership with Loomis, Wood biographer Garwood (1944) also noted that he had made metalwork in the Barry workshop in Cedar Rapids.

In July 1913, the Loomwood Craft Shop, located in Loomis's home, hosted a meeting for the Cedar Rapids Sketch Club that featured esteemed painters Julian Lars Hoftrup and Armand Wargny. Hoftrup and Wargny had agreed to teach summer school classes on Wednesday and Friday afternoons, and Wood organized an additional weekly Sunday afternoon session for those who worked during the week. Wood gave Hoftrup a silver spoon he made, possibly in payment for instruction or simply as a gift. The spoon is marked with a previously unknown "W." Further discoveries may determine if this was an earlier work by Wood, possibly from the Barry workshop, or a personal mark he used at Loomwood for smaller articles.

Grant Wood and Kate Loomis, Calendar Stand, c. 1911–1912. Copper, 4.375 x 4.625 x 1.5 inches. Cedar Rapids Museum of Art, Gift of Mrs. Arthur Salzman. 94.25.

In the 1914 AIC annual show (see Volund Crafts Shop), Wood also designed three silver jewelry items set with stones that were made by Cedar Rapids artisans and friends Marvin D. Cone, Henriette Vonracek, and Olga Vondracek. Other known metalworkers and jewelers—all of whom participated in the 1913 Cedar Rapids show—included Donald Barry, Mary Fuller, Alice D. Miner, Hildegarde Hubbard, Gail Stubbleheld, H.C. DeWitt, Elizabeth Cock, and Bertha and Daniel W. Warren. One of Daniel Warren's items, a large copper salver, was made in collaboration with Wood.

Loomis was an energetic and independent woman. After the Loomwood Crafts Shop, she owned and operated the first Cadillac dealership in Cedar Rapids; she later managed an apartment complex. By the time she died in 1957 at the age of 81, she was considered "probably the most active woman in the history of Cedar Rapids' business, municipal and civic life."

Grant Wood silver spoon that was given to J. Lars Hoftrup, c. 1913. The spoon is 6 inches long. Front, back and close-up view of the hallmark. Courtesy of Parnilla Parmer Carpenter, Pine City, NY. Photos by Lisa Boesen, Minneapolis, MN.

The Odd Shop
Des Moines, Iowa (1906–c.1918)

Principals
Florence Matilda Weaver (1879–1957), 1906–1917
Angelina St. John (1881–after 1935), 1910–1917
Luella Tupper (1870–after 1956), 1912–1917

The Odd Shop, founded by designer and interior decorator Florence Weaver, was a major Des Moines arts and crafts studio that featured hand-wrought jewelry and a broad array of crafts. Weaver had graduated from the AIC and studied at the Minneapolis Handicraft Guild before starting the venture. Her sister Lillian and friend Luella Tupper were also noted as co-founders, but lived in Oak Park, Illinois, until 1910 and 1912, respectively. In 1910, Angelina St. John, who had studied jewelry making at the Kalo Workshops in Park Ridge, Illinois, was a craftsman for the Odd Shop. In the 1910 annual AIC show, Weaver and St. John showed a silk tapestry bag set with a metal mount and turquoise matrix; in 1914, they exhibited jewelry and bookplates that were noted in two reviews.[4] In 1914–1915, Weaver also served as a metalwork juror for the AIC shows, which was considered a great honor. A newspaper advertisement for the shop showed a logo with a letter "S" inside of a letter "O," but jewelry examples have not been identified.

The Odd Shop flourished as a jewelry, crafts and interior design studio until 1917, after which the name was abandoned. Weaver & Tupper operated as an interior design firm until 1922, when it merged with Harris-Emery, a major Des Moines department store. Weaver and Tupper led the interior design practice of the store, and St. John also worked with the team. When Harris-Emery was acquired by Younker Brothers in 1927, the women led the design business under the Younkers brand.

In the summer of 1932, Weaver studied at Grant Wood's famous Stone City Art Colony and School.[5] She continued as a designer at Younkers, but also became a noted watercolor artist. In 1949, she moved to La Jolla, California, and died there in 1957. In the 1940s, Tupper moved to Denver, Colorado, where several of her family members lived, and she was listed in directories through 1956. St. John was listed in Des Moines directories through 1935.

Kansas and Kentucky

TOPEKA, KANSAS

Kansas metalwork and jewelry workers were not included in the early craftsmen directories from 1906 to 1916, although this early candlestick from Topeka shows that some very capable artisans were experimenting in metals.

Candlestick mark from Topeka, Kansas. Author's collection and photo.

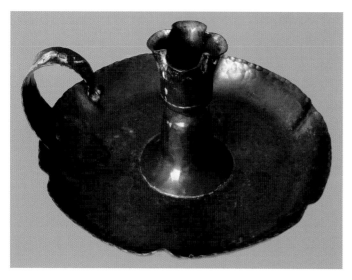

Brass and copper hammered candlestick marked EHJ Topeka. Author's collection and photo.

Margret Craver (Mrs. Charles C. Withers) Wichita, Kansas (1907–2010)

From 1930, Margret Craver was an important force shaping the arts and crafts metalwork and jewelry industries in Kansas. A graduate of the University of Kansas, she worked in New York and Texas as a jewelry designer and took up individual study with a variety of skilled silversmiths and metal artisans. She studied with Lucien Shellabarger from Illinois in 1930,[1] Leonard Heinrich from the Museum of Modern Art in 1932, Arthur Neville Kirk from Michigan in 1936, Baron Erik Fleming of Sweden in 1938, and many others. From 1935 to 1944, she taught metalwork at the Wichita Art Association. During World War II, she volunteered at the Great Lakes Naval Hospital[2] outside of Chicago and she organized the jewelry and metalwork classes for Walter Reed Hospital in Washington, D.C. After the war, Craver worked for metal company Handy & Harman, wrote several important booklets on silversmithing, and designed a broad array of jewelry and metal items. In 1950, she married Charles Withers, president of the Towle Silversmiths, and worked as a consultant for the company. From the 1950s to the 1970s, Craver's work helped define the realm of modernism in jewelry and metal work.[3]

Machine works may be good in design, but they cannot warm the heart with an emotional expression. Mass production for profit does not satisfy those discriminating people who want an individual piece, or the only one of its appearance in existence.
—Margaret Craver, 1941

Craver hallmark. Courtesy of Skinner Inc., www.skinnerinc.com. In addition to the mark shown above, Craver also used the mark of a "C" inside of a six-lobed flower.

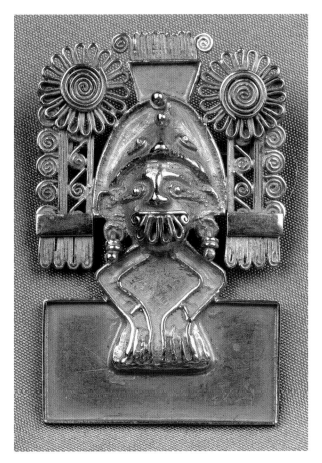

Early Margret Craver 14K brooch. Courtesy of Skinner Inc., www.skinnerinc.com.

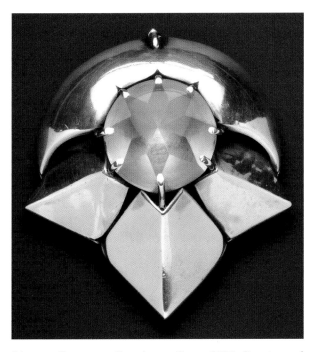

Margret Craver sterling dress clip, c. 1936. Courtesy of Skinner Inc., www.skinnerinc.com.

The Arts and Crafts Co., Inc., (1904–1910)
The Missess Bruce, Novelties (1911–1912)
Louisville, Kentucky

Barbour Bruce (1863–1925)
Preston Pope Bruce (1867–1945)

The Bruce sisters operated the Arts and Crafts Company in Louisville for nearly a decade before transitioning to teaching and interior design. Barbour, a 1902 rare woman graduate of MIT, was the president of the crafts studio, and Preston served as the secretary and treasurer. Crafts work from the company included these hammered and acid etched copper bookends. The mark consisted of a paper label, which may explain why few artifacts have been discovered. Preston worked as an interior designer into the 1930s.

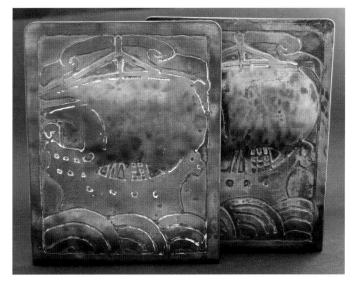

Pair of acid-etched and hammered copper bookends in an ark design by the Arts and Crafts Co., with a paper label. Courtesy of Boice Lydell.

Michigan

WESTERN MICHIGAN

Western Michigan was the center of the arts and crafts metalwork and jewelry industries in the state, due in large part to Forrest E. Mann and the Forest Craft Guild. Grand Rapids, a national center for innovative arts and crafts furniture manufacturing, was the nexus for the movement, connecting surrounding communities into a philosophical and economic powerhouse to fuel the industry. In 1902, Women's Club members from Grand Rapids formed a formal Arts and Crafts Society, and exhibits included metalwork by the following year.

In 1903, Muskegon, about 40 miles northwest, recruited Edward A. Bending to be the new principal of the Hackley Manual Training School. He had been a very active member of the flourishing arts and crafts society in Dayton, Ohio, and was instrumental in forming the Muskegon Society of Craftsmen. He also recruited Forrest Mann from Dayton to teach summer school and, eventually, Mann made the Grand Rapids area his home.

From 1904, Mann and Ednah Sherman Girvan were two of the earliest known arts and crafts jewelers in the Grand Rapids area. In 1905, one of Mann's students at the Port Sherman summer school, Eugenia B. Babcock, went on to study at Columbia University and then at the Art Institute of Chicago; she became a renowned jewelry artisan and teacher in the Grand Rapids schools and the School of Arts and Industry. She exhibited in the prestigious 1909 AIC arts and crafts show, featuring a silver filigree pendant with turquoise and pearls, a copper repoussé door knocker in a wave design, and a silver pendant set with amethyst and yellow carnelian.

Other hand-wrought jewelry and metal workers mentioned in later press reports included Blanche M. Utley, who taught art in the public schools and operated the Yubie Shop in Grand Rapids, which featured hand-wrought jewelry. In 1907–1908, Kalamazoo artisan Anna B. Morrison, an AIC grad, displayed etched copper bookends, trays, and book racks—some with an acorn or boat motif—in the annual shows at the AIC. A life-long metalworker and designer, Morrison was active in the Chicago Artists Guild and the National Society of Craftsmen.

Other metal artisans, many of whom were also art teachers, included Agnes Van Buren, Elizabeth Grant, Caroline Sheldon, Bertha Belknap Bliss, Clara Nebel, Alice McCall, Carrie Ward, and Juliette M. Traill. Stickley Brothers, a famous mission furniture manufacturer, offered a line of Russian hand-beaten copper that was made in its Grand Rapids workshop.

Clayter, Frederic Charles (1890–1978)

Clayter, who excelled in art metal work and jewelry at the Hackley Manual Training School and graduated in 1910, furthered his studies at the Pennsylvania School of Industrial Art (PSIA) in Philadelphia. In 1914, at the age of 24, he received top honors and press coverage for a hand-wrought silver and jeweled chalice he made as a student in Philadelphia. Clayter exhibited his jewelry in Muskegon and at several of the annual AIC shows. In 1914, following a summer in London where he studied enameling, he taught at the University of Pittsburgh. Later he taught at the PSIA and the Carnegie Institute of Technology.[1] He made art metal and jewelry well into his 80s.

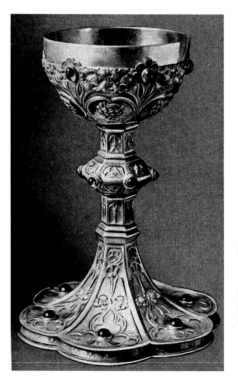

Silver chalice set with amethysts by Frederic C. Clayter. From *Pennsylvania Museum and School of Industrial Art, Annual Report* (1914).

Forest Craft Guild (1908–c.1918)
Grand Rapids, Michigan

Principal
Forrest Emerson Mann (1879–1959)

Locations
94 La Grave Street, Grand Rapids, 1904 (Forrest E. Mann and Ednah S. Girvan)

3 N. Ionia St., Grand Rapids, 1905 (Forrest E. Mann and Ednah S. Girvan)

Mann & Decker, (Forrest E. Mann and Judson Decker), 184 E. Fulton, Grand Rapids, 1905–1906

Sherman Shop, 3 N. Ionia St., Grand Rapids, 1906

Grand Rapids School of Applied Arts, 147 Monroe, Grand Rapids, 1907

Forest Craft Guild, office and salesroom at 195 S. Division St., workshop at 216 Bartlett, Grand Rapids, 1908–1912; 8 Barlett, Grand Rapids, 1913–c.1919

Known workers
George L. Ackley, jeweler, 1910

Ferdinand Beyne, coppersmith, 1910

Cornelius M. Bremer, coppersmith, 1911

Vinnie G.Chase, jeweler, 1910

Bert H. Lamberts, jeweler, metalworker and coppersmith, 1908–1912

Leon Laubscher, coppersmith, 1911

Burton A. Mann, designer, 1907–c.1915

Jeanette Sears Mann, jeweler, manager, 1910–c.1919

Egbert Miedema, coppersmith, 1911

Gerrit R. Posthuma, jeweler, 1910–1913

John Ruardi, jeweler, 1909

Ward C. Shackelton, jeweler, 1911–1912

Garnish Sikrey, coppersmith, 1908

Martin Theunisse, jeweler, 1911

Bert Vent, jeweler, 1911

Peter Vry, coppersmith, 1910

Forrest Mann was a major force in the arts and crafts metalwork and jewelry industries sweeping the Midwest after the turn of century, and he helped build a vibrant artists colony in Western Michigan.

Born in Deering, Maine, Mann graduated from the Pratt Institute Brooklyn in 1902 and moved to Dayton, Ohio, where he taught applied design at the Arts and Crafts Society. He traveled to England and visited the Birmingham School of Art, C.R. Ashbee's Guild of Handicraft, and Dove's Bindery and Press run by T. Cobden-Sanderson's. His Dayton workshop employed a woman bookbinder, a male art glass expert, and three apprentices. In 1904, Mann was recruited to teach the arts and crafts summer school at the Hackley Manual Training School in Muskegon, Michigan, and he toyed with the idea of moving his workshop from Dayton to Muskegon. [2] That fall he taught a winter arts and crafts course in Grand Rapids and joined forces with jeweler and metalworker Edna S. Girvan, an artist and jeweler whom he met at the Dayton Arts and Crafts Society. In 1904–1905, they exhibited silver jewelry in the annual arts and crafts shows at the AIC, listing a Grand Rapids address each time. At the 1905 Detroit Exhibition of Applied Arts, Mann showed all metalwork items, assisted by Judson Decker.

Mann became the director of the Grand Rapids Arts and Crafts Society and the School of Design, and he was the instructor for the Muskegon Society of Craftsmen, where he managed the workshop. In 1905, Forrest, his brother Burton (the director of the Columbus Arts and Crafts Society), Judson Decker of the Pratt Institute, and Elizabeth Troeger of Muskegon established a summer school at Port Sherman on Lake Michigan that was geared towards manual training teachers. The classes reflected Mann's varied artistic interests and included applied design, composition, art pottery, metal work, modeled leather, woodcarving, basketry weaving, knife work, and outdoor sketching in charcoal, pastel, and water color. By February 1906, Mann operated arts and crafts workshops in Grand Rapids, Kalamazoo, and Muskegon; the latter had 18 pupils. The following month he organized an exhibit of leather, acid-etched brass, hammered brass, and pottery for a meeting in Chicago of an association of manual-training teachers. He also established a Grand Rapids studio called the Sherman Shop, and his work included pottery, metalwork, jewelry, and modeled leather; his jewelry was featured in the *International Studio*. [3]

From 1907, Mann focused almost exclusively on making hand-wrought jewelry, while his students designed and produced jewelry and a broad range of arts and crafts articles. That year he established the Grand Rapids School of Applied Arts and a related cooperative studio that

produced jewelry, metalwork, pottery, and crafts for the commercial market. By 1908 this studio evolved into the Forest Craft Guild with a branch in New York City, which he later touted as a "National Society for Craftsmen."

The Forest Craft Guild first appeared in directories and newspapers in 1908, although Mann said the enterprise began in 1906. [4] The Guild employed a body of craftsmen who prided themselves on hand-wrought original designs in wood, leather, and metal, including gold and silver jewelry and household decorations. Goods were sold locally and through a national network of hundreds of galleries and gift shops, including Grable's in Oak Park, Illinois.

In March 1912, the Forest Craft Guild announced a removal sale of its art wares and jewelry from Grand Rapids to the former Tiffany Studios in New York, and Mann left on a tour of Spain a few weeks later with noted Grand Rapids artist Mathias Alten. [5] The Guild continued in Grand Rapids with a much lower profile after the move; in October 1912, the Guild sought to hire women to color cards and folders. The bulk of the traditional craft items were made in New York. From 1913, Mann spent much of his time in New York but was still listed in Grand Rapids directories through 1916; Burton Mann managed a branch of the Forest Craft Guild from Petoskey, Michigan. In 1915, Jeanette Sears—whom Forrest later married—was a jewelry artisan who managed the Guild in Grand Rapids. Around 1919 the Manns closed the Grand Rapids facility and Jeanette joined her husband in New York; Burton Mann established a national art goods wholesale network from his home in Petoskey, Michigan. The Forest Craft Guild continued in New York into the 1920s, and Mann offered individual jewelry and crafts classes in New York through 1937; he and his wife returned to Grand Rapids by 1941.

Copper frame with dark green stones, marked Forest Craft Guild, photo of Forrest E. Mann. Courtesy of Chicagosilver.com.

Forest Craft Guild and German Silver hallmarks that appeared on many Forest Craft items. Courtesy of Chicagosilver.com and Boice Lydell.

Original box from the
Forest Craft Guild.
Courtesy of Boice Lydell.

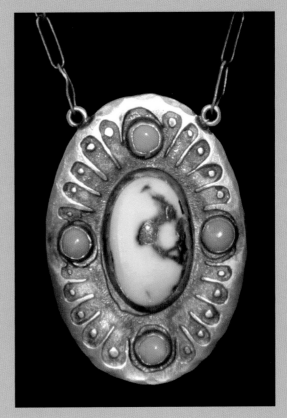

Forest Craft silver, coral, and turquoise pendant
with paper clip chain, unsigned. Shown in Marek
(1999). Courtesy of Chicagosilver.com.

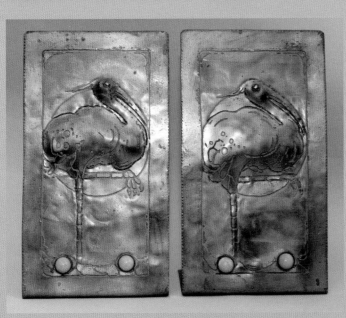

Forest Craft pelican brass bookends,
unsigned. Courtesy of Boice Lydell.

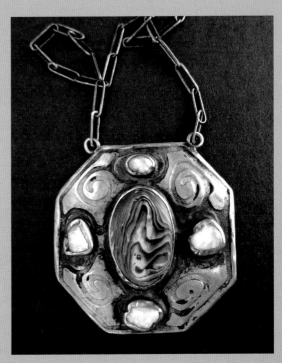

Forest Craft silver, abalone, and pearl pendant
with paper clip chain, unsigned. Shown in Marek
(1999). Courtesy of Boice Lydell.

Forest Craft copper peacock bookends with glass stones, marked Forest Craft Guild. Courtesy of Boice Lydell.

Five stick pins by the Forest Craft Guild. Courtesy of Boice Lydell.

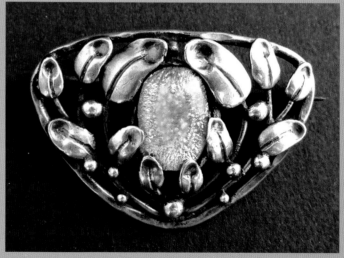

Forest Craft blue brooch with leaves. Courtesy of Boice Lydell.

Yubie Shop

Grand Rapids, Michigan (1914–1920s)

Principal

Blanche Mae Utley (1882–1965)

Blanche M. Utley was a public school art teacher and noted maker of hand-wrought jewelry who operated the Yubie Shop in downtown Grand Rapids. A reporter noted at the time that the shop logo on the door of the little studio was comprised of a scarab body and the head of a mummy; she added that Utley sold jewelry to stores in seven states and made as much money as many of the leading businessmen in the city. [6] In 1918 Anna Thwait joined her studio. In the 1920s, Utley married H. Kent Miller and was widowed by 1930; she died in Michigan in 1965. Her work and signatures are unknown.

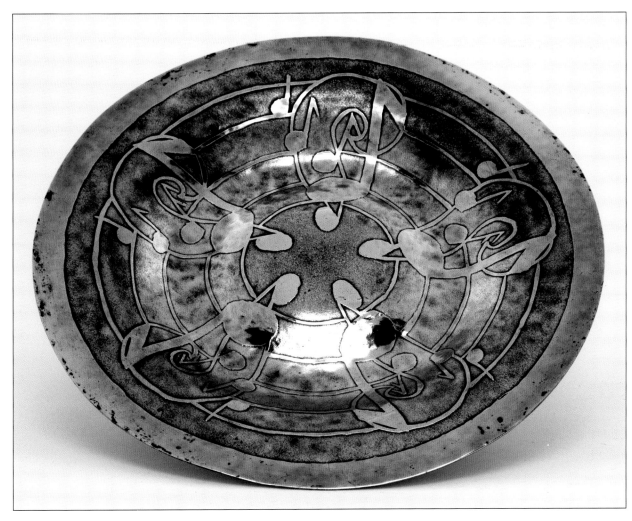

Acid-etched pewter plate with musical motifs representing the Grand Rapids style, from a Grand Rapids estate, unsigned. Author's collection, photo by Rich Wood.

DETROIT

After the turn of the century, Detroit began to embrace the ideals of the Arts & Crafts Movement as represented by a handful of artists and industries. Pewabic Pottery, founded in 1903 by Mary Chase Perry and Horace Caulkins, rapidly became known as a national leader in arts and crafts pottery wares and ceramic jewelry. The Detroit Society of Arts and Crafts, founded in 1906, was an important vehicle for establishing a culture of art entrepreneurship in the city, and it attracted many outside jewelers and metalworkers at exhibitions. Detroit artisans specializing in jewelry and metalwork were much less represented and few examples of their work have been identified. Ethel Spencer Lloyd was a prominent jeweler in the early years, and other metal craft artisans mentioned in historical records include Gertrude P. Spencer, Stella S. McKee, and Jeannette Guysi, who was also an art teacher in the Detroit Public Schools. In 1916, the DSAC featured a special exhibit of Guysi's gold jewelry set with precious stones. In 1911, Anne I. R. Cheney won top prizes at the Indianapolis State Fair for her silver and copper metalwork and hand made jewelry. Cheney, a graduate of the Pratt Institute, was active in Detroit from c.1908–1912, before establishing a studio in Chicago; she later taught at schools in Kansas, Montana, and Michigan. Elizabeth Hadjisky from Detroit showed a covered silver bowl in the 1922 traveling exhibition of American handicrafts, and John Brennan was an active coppersmith at least from the 1930s.

Ethel Spencer Lloyd (1875–1964)

Born in Albany, New York, Ethel Spencer Lloyd and her sister Bertha Elizabeth Lloyd were well known for decades as arts and crafts artisans in Detroit. By 1884, the Lloyd family had moved to Detroit where Ethel attended high school and later earned a teaching degree from Columbia University in New York. Ethel initially taught music before she and her sister delved into the crafts. While Bertha specialized in leatherwork and embroidery, Ethel studied with noted Chicago jeweler, James H. Winn, and Boston silversmith George E. Germer. She was active in the formation of the Detroit Society of Arts and Crafts and also was a member of the Boston Society of Arts and Crafts (BSAC) and an active exhibitor in the annual AIC shows. From 1905 to 1911, she exhibited her jewelry

in Detroit, Chicago, and Boston, showing carved silver items variously set with moonstones, pink tourmaline, and amethysts, and a gold and Oriental pearl ring. In October 1919, Lloyd featured ecclesiastical silver at a special exhibit in Detroit, along with such notable East Coast silversmiths as Germer, Arthur Stone, James Wooley, J. Kirchmayer, and others. Throughout her career, Ethel made jewelry, as well as ecclesiastical pieces for a variety of churches and religious organizations, although specific examples of her work are unknown. In addition to her metalwork, she worked as a cataloger for the Detroit Children's Museum for many years, retiring in the 1940s. Ethel died in Highland Park, Michigan, in 1964 and was buried in Albany, as was her sister Bertha.

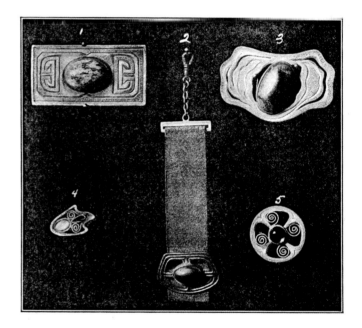

Ethel Spencer Lloyd copper and silver jewelry shown in *Good Housekeeping* (Nov. 1906). Courtesy of Chicagosilver.com.

Detroit Society of Arts and Crafts (1906–1975)

Locations
47 Watson Street, 1916–after 1956
37 Witherell Street, 1911–1916
122 Farmer Street, 1906–1911

Detroit hosted its first exhibition of arts and crafts in 1904 in conjunction with the Museum of Art, as well as a much larger show the following year. In 1906, show organizers established the Detroit Society of Arts and Crafts (DSAC) to "encourage good and beautiful work as applied to useful service." George Booth, wealthy business manager for the *Detroit News* and a bookbinder, served as the first president of the organization. An exhibition and sales room was opened at 122 Farmer Street and the Society eventually built a noteworthy facility at 47 Watson Street. [7]

The second annual DSAC show featured many of the leading jewelers and metalworkers from Boston, Buffalo, Chicago, Cleveland, Dayton, Detroit, Grand Rapids, New York City, and Philadelphia, as well as artisans from California and London.

Detroiters in the exhibit included Charles B. King, Ethel Lloyd, Katherine Shearer, and Katherine G. Slenean, as well as L.H. Martin, A.C. Armstrong, and Louise Andrews from the Thomas Normal Training School.

The extraordinary breadth of the works was not to be duplicated, because the DSAC aligned more closely with Boston-area artisans in subsequent years. This occurred because some members of the DSAC thought that works had to conform to an ideal as opposed to creative forays into the arts and crafts. The DSAC adopted the Boston Society's strict guidelines for acceptable works. According to writer and historian Joy Hakanson Colby, the DSAC

Detroit Society of Arts and Crafts, Watson Street building, postcard. Author's collection.

reprinted part of a 1906 *Boston Society of Arts and Crafts* report to justify their actions. The infamous attack on arts and crafts jewelry and metalwork said in part, "With some noteworthy exceptions, the designs of the objects sent in for approval show lack of knowledge and study...It is *l'art nouveau* indeed, the work of the untrained, undeveloped, unstocked brain and the faltering hand. Silver surrounds odds and ends, scraps of stones which have no intrinsic value, and copper surrounds opals."

Chicago area members of the DSAC included Rose Dolese from the Wilro Shop and Eda Lord Dixon from Evanston, Illinois, and later Riverside, California. In the 1909 DSAC exhibition, Detroiter Ethel Lloyd Spencer showed a silver and amethyst cross; no other artisans from the Midwest were represented while Boston jewelers and metalworkers showed a plethora of works.

In 1917, New York and Massachusetts jeweler Grace Hazen took one of the studios along the courtyard in the Watson Street building, where she made jewelry and taught several students. In 1927, the Art School of the DSAC hired British silversmith Arthur Nevill Kirk to teach metalwork, and from 1929 to 1933, he headed up the new Silver Shop at the Academy of Art at Cranbrook, where he worked with noted designer Eliel Saarinen. Kirk fashioned many ornate ecclesiastical pieces.

Brennan's Little Copper Shop

Highland Park, MI (c.1932-)

Prncipals
John J. Brennan (1871–1940)
David J. Brennan (1918–2005)

Born in Seneca Falls, New York, John Brennan moved to the Detroit area from Boston around 1916 to work in the booming Michigan manufacturing industry. A pattern maker, he worked for Burroughs Adding Machine Company and pursued artistic copper metalwork in his off hours. He was a member of the Philadelphia Society of Arts and Crafts. By the 1930s, he established and ran Brennan's Little Copper Shop at 167 Avalon Street in Highland Park, fashioning hand-wrought copper bowls, trays, and specialty items made from engravers' copper plates. His son, David J., also worked as a pattern maker in the Detroit area and assisted his father with the shop for many years.

Hallmarks used by John and David Brennan. Courtesy of Fred Zweig.

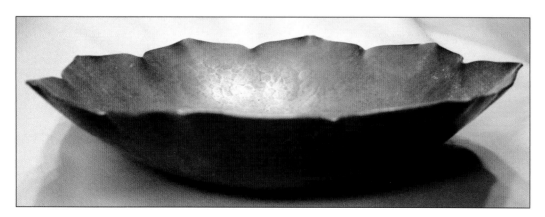

Hammered copper bowl with scalloped edge, marked with David Brennan logo. Courtesy of Fred Zweig.

Minnesota

Minneapolis was the center of the Minnesota arts and crafts movement. Building on a long history established by the Minneapolis Society of Fine Arts (1883), the Chalk & Chisel Club (1895) and the Society of Arts and Crafts (1900), the city became an important exhibition and networking venue for Midwestern jewelers and metalworkers.

The early arts and crafts exhibitions featured an abundance of hand-wrought jewelry and metalwork from Chicago's finest artisans, showing the strong and collaborative alliance between the two cities. The Minneapolis Handicraft Guild (1904) was paramount in establishing the innovative and distinctive indigenous metal wares that made the city famous during the Arts & Crafts Movement and with modern-day collectors. In 1905, the Guild established a summer school that filled a vital training need for budding craft artisans throughout the Midwest. [1] The school was directed by Ernest A. Batchelder from Pasadena, and James H. Winn from Chicago taught jewelry. In 1907, the Society of Fine Arts launched its first jewelry and metalwork class, taught by Jessie M. Preston from Chicago with assistance from Minneapolis metalworker Mary E. Simpson. Nettie Bryant, one of the students, won an award from the Society for her hammered copper wares. Others associated with the school—including Mary Lockwood, J. Ellsworth Painter and Klara Holter—won awards in various Minnesota exhibitions for their metalwork and jewelry; Elizabeth Hofflin was a jeweler associated with the Society.

The best known Minnesota arts and crafts jeweler was Ida Pell Conklin, a New York woman who arrived in the state before the turn of the century. She studied at the Pratt Institute and she taught jewelry and metalwork at the Handicraft Guild and later at the University of Minnesota. She moved to Pasadena in 1925 and taught at Pomona College until her retirement. Conklin was a member of the Boston Society of Arts and Crafts (BSAC) and exhibited throughout the country. A 1915 ad shows her hallmark as a letter I over a letter P next to a large letter C, but it is unknown if her jewelry and metalwork was signed. [2]

Florence D. Willets was known for her pottery, jewelry and metalwork. Born in New York, Willets moved to Chicago with her family and graduated from the Art Institute of Chicago around the turn of the century, where she subsequently was hired as an instructor. From 1905, Willets taught summer school at the Handicraft Guild before making Minneapolis her home for the remainder of her professional career. Her work was featured in numerous exhibitions throughout the Midwest, including jewelry in 1906 and a copper coffee set in 1909 at the annual AIC shows. She taught in Minneapolis through the 1920s, retiring to California. Her work has not been identified.

Detroit native Douglas Donaldson studied metalwork and enameling with Laurin Harvey Martin of Massachusetts before becoming a manual arts teacher in Joliet, Illinois, where he worked from 1904 to 1907. He also studied with Chicago jeweler James Winn and was recruited to teach at the Guild from 1908 to 1909. His characteristic enameled and repoussé metalwork and jewelry was featured in many exhibitions, and some may have been signed with his Gothic DD mark. [3] Donaldson's sister Ethel also was a jeweler at the Guild and taught at North High School around 1908 to 1920 before moving to Los Angeles.

In 1909, metal worker Edgar L. Perera, a craftsman member of the BSAC, advertised a collection of authentic scarabs and Egyptian antiques in exclusive designs and artistic mountings from his Minneapolis studio, and his extraordinary work was featured in an article in the *International Studio*. [4] A native of Egypt, he had immigrated to Minneapolis in 1895 and exhibited at the 1915 Panama-Pacific Exposition, where much of his work was stolen. By 1917, he had moved to New York.

St. Paul, Duluth, and several other cities also had active metalworker and jewelry artisans and studios. In 1908, Amy Robbins Ware established the Orchard Crafts Guild at her estate in suburban Robbinsdale, Minnesota. Award winning jewelers from St. Paul included Rosemarie M. Hanson, Florence Huntington, Aurelia Rising, and Casper Sole, although examples of their work are unknown.

Minneapolis Handicraft Guild (1904–1918)

Instructors and Guild artisans noted for metalwork and jewelry

> Ernest A. Batchelder, design, director of the summer school, 1905–1909
>
> Harold L. Boyle, silversmith and instructor, 1910–1912
>
> Mary Moulton Cheney, design, metalwork, jewelry, and teacher, c.1905–1918
>
> Ida Pell Conklin, jeweler, metalworker, instructor, 1906–1918
>
> Douglas T. Donaldson, jewelry, metalwork, instructor, 1908–1909
>
> Ethel A. Donaldson, jewelry, metalwork, instructor, 1908–1918
>
> Louise Towle Donaldson, metalwork, 1908–1909
>
> Harriet S. Flagg, jewelry, 1910–1912
>
> Flagg, Maurice Irwin, director of the summer school, 1910–c.1918
>
> Margareth E. Heisser, metalwork, c.1900–1908
>
> Harry S. Michie, metalwork instructor, c.1908–1909
>
> Florence D. Willets, jewelry, metalwork, instructor, 1905–1918
>
> James H. Winn, jewelry instructor, 1905–1907

Minneapolis Handicraft Guild marks. Courtesy of Boice Lydell and Fred Zweig.

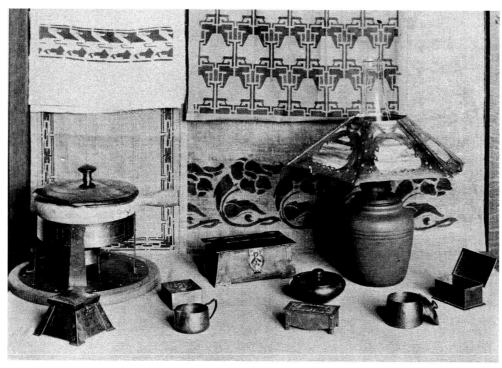

Display of Handicraft Guild metalwork and crafts. From *Palette and Bench* (Oct. 1908). Author's collection

Known works signed with the Handicraft Guild logo were predominantly made in copper—hammered, etched, or cut out—and included bookends, candlesticks, lamps, bowls utensils, letter racks, smoking sets, and jewelry boxes, in addition to brass candlesticks, paper knives, silver caddy spoons, and porringers. At the 1906–1911 annual arts and crafts shows at the AIC, Handicraft Guild artisans Ida P. Conklin, Florence D. Willets, Ernest Batchelder, Harold L. Boyle, Douglas Donaldson, Ethel Donaldson, and Louise Towle were variously singled out for some of their works, including gold and silver jewelry, a silver spoon, copper with enamel sconce, lamp and shade, etched copper, and a copper coffee set. It is unknown if these items were marked and, if so, with the maker's mark or that of the Handicraft Guild. In 1918, the Handicraft Guild was taken over by the University of Minnesota and became an important part of the art education department.

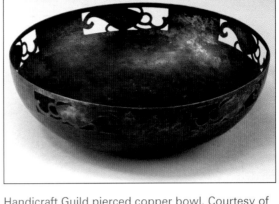

Handicraft Guild pierced copper bowl. Courtesy of Rago Arts and Auction Center, Lambertville, NJ.

Handicraft Guild repoussé copper and green stone vanity box. Courtesy of Boice Lydell.

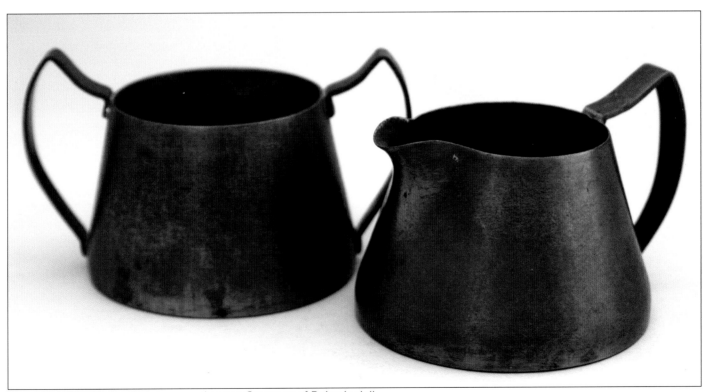

Handicraft Guild copper creamer and sugar. Courtesy of Boice Lydell.

Nettie Bryant (1879–1934)

Born in Elk River, Minnesota, Bryant studied at the Minneapolis Society of Fine Art from 1906–1908 and became a proficient metalworker. In c.1916, she moved to Portland, Oregon, with her mother and aunt and taught school. She worked out of a home studio and also was a milliner. She died in Portland, Oregon, in 1934. Bryant's work was unsigned.

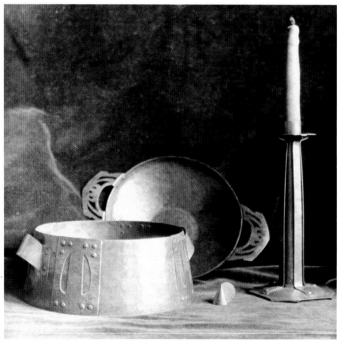

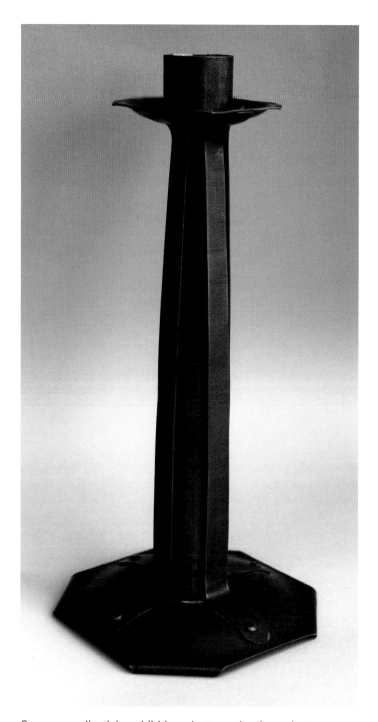

Copper candlestick, exhibition photo, and artisan photo. Bryant's niece, Leah Bryant, wrote on the back of photos: *Aunt Nettie on left, taller of the two; Aunt Nettie's copper work, I have candleholder and snuffer.* Courtesy of Boice Lydell.

Missouri

KANSAS CITY

Bertha Lynde Holden was one of the earliest known arts and crafts jewelers and metal workers in Kansas City. A Missouri native, born in 1868, she studied at the AIC and was active in the CACS at Hull-House. At the turn of the century she shared a home with designer Edith Sheridan in Chicago and exhibited her works throughout the Midwest and Boston; she was noted for inlaid metals and enamels. She also made jewelry for Florence D. Koehler, including a copper and agate scarab buckle that was featured at the 1901 Minneapolis show. In c.1903, she returned to Kansas City, operated a studio though 1908, and helped organize a local Arts and Crafts Club. She later married and lived in Philadelphia.

Delle H. Miller was a prominent Kansas City metal work artisan and instructor who graduated from the Armour Institute in Chicago and taught design and craft work in the Manual Training High School in Kansas City and the Kansas City Fine Arts Institute. From c.1913 to 1916, she also taught leather, metal work, and jewelry classes at the Applied Arts Summer School in Chicago. Other Kansas City artisans included silversmith Henry H. Jeffreys and metal worker Jessie L. Burbank, both of whom were members of the BSAC. From 1917 to 1919, Jeffreys, a long-time manufacturing jeweler in the city, listed his studio as the Artcraft Jewelry Shop.

ST. LOUIS

St. Louis was home to the 1904 World's Fair, called the Louisiana Purchase Exposition, which attracted millions of visitors. Organizers assembled outstanding exhibits that represented some of the major crafts workers of the day, including Jane Carson and Frances Barnum from Cleveland, as well as James Winn, Christia Reade, Clara P. Barck, Grace Gerow, and Rose and Minnie Dolese from Chicago. The World's Fair inspired a nascent arts and crafts movement, and Charles Percy Davis taught design and applied arts—including metalwork—at the Washington University School of Fine Arts.

By 1905, Mary Louise Garden moved from Chicago to St. Louis where her brother Edward was an architect. She was a graduate of the AIC, a member of the CSAC, and, in 1903, she had exhibited an unusual copper Japanese lantern that was pictured in *The House Beautiful*. While

in St. Louis, she exhibited a copper lamp in the 1905 AIC alumni show. From at least 1908 to 1911, she owned an operated an art goods company in St. Louis that likely featured her artistic metalwork and copper. [1]

In the fall of 1908, brothers David and Walter Mulholland established a metalwork studio in Kirkwood, a St. Louis suburb. Other arts and crafts jewelers and metalworkers included Washington University School of Fine Arts instructors Leola Bullivant and Ruth Barry, [2] and later jewelry artisans Gladys Skelly and Maria Regnier.

In 1938, German silversmith Otto Frederick Dingeldein established St. Louis Metalcrafts, which produced silver, gold, and plated wares, including many ecclesiastical pieces. Falick Novick of Chicago made some silver pieces for the shop in the 1940s.

Scarab buckle by Bertha Holden, hand mirror by Margarethe E. Heisser and porringer by Madeline Yale Wynne exhibited in Minneapolis. *Brush and Pencil* (March 1901). Author's collection.

Louise Garden Japanese-style copper lantern. From *Brush and Pencil* (Jan. 1903). Author's collection.

D. & W. Mulholland

Kirkwood, Missouri (1908–1909, 1910–1911)
Punta Gorda, Florida (1911–1912)

Principals
David E. Mulholland (1886–1966)
Walter S. Mulholland (1889–1961)

In the 1890s, Ohio denizens David and Walter Mulholland moved with their family to St. Louis, Missouri. In 1906, David graduated from high school and attended Washington University School of Fine Arts. Two years later, he took classes at the Minneapolis School of Fine Arts and the Handicraft Guild summer school under the direction of Ernest Batchelder. In the fall of 1908, David returned to St. Louis, and—with his brother Walter—established the D.&W. Mulholland shop in the Sugar Creek community in Kirkland, Missouri. In 1909, they both studied at the Worcester Art School in Massachusetts under former Chicago metalwork and jewelry instructor Edmund B. Rolfe. David, identified as a jeweler, joined the Arts and Crafts Society of Boston that year. In 1910, the brothers returned to Kirkland and briefly operated their studio before moving to Florida with their parents. In 1911–1912, they operated a jewelry and silversmith studio in Punta Gorda. In the spring of 1912, David and Walter moved to Park Ridge, Illinois, where they were associated with the Kalo Shop until they launched their own workshop in the fall. In 1914, they moved to Evanston and established the Mulholland Brothers, a leading silversmith company (see Evanston section).

Walter Mulholland working on a bowl, c.1908. Note the scarab fob hanging from his belt. Courtesy of the Mulholland family.

Business card from the Sugar Creek Mulholland shop. Courtesy of the Mulholland family.

Gladys Gertrude Skelly (1901–1974)
St. Louis, Missouri

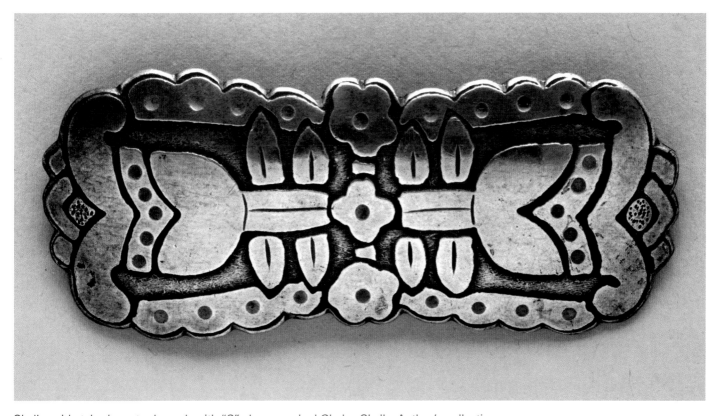

In 1920, Skelly attended the School of Fine Arts at Washington University. She became a noted jeweler and metalworker and, from 1932 through the 1940s, she won many prizes for her crafts work. She was a member of the Boston Society of Arts and Crafts, the New York Society of Craftsmen, and the St. Louis Artists Guild. She remained active through the 1960s. In 1942, she married Walter J. Goetz, although she continued to use her maiden name in the art world. She died in St. Louis in 1974.

Gladys G. Skelly hallmark. Author's collection and photo.

Skelly acid etched pewter brooch with "C" clasp, marked Gladys Skelly. Author's collection, photo by Rich Wood.

Maria Regnier (1901–1994)
St. Louis, Missouri

Regnier, a native of Hungary, was a well-known St. Louis jeweler and silversmith for more than 20 years. She had immigrated to the United States in 1921 and studied at Washington University in St. Louis, the Rhode Island School of Design, and the William Dixon School in New York. From 1938 Regnier was active on the exhibition circuit. In the 1950s her work was featured in New York, at the AIC, and in Florida. In 1953, a reporter noted that she taught silversmithing at the Central School for the Deaf in St. Louis.[3] Regnier married Warren Krimmel of Arkansas and moved there by 1962, continuing her work as a silversmith.

Maria Regnier hallmark. Courtesy Chicagosilver.com.

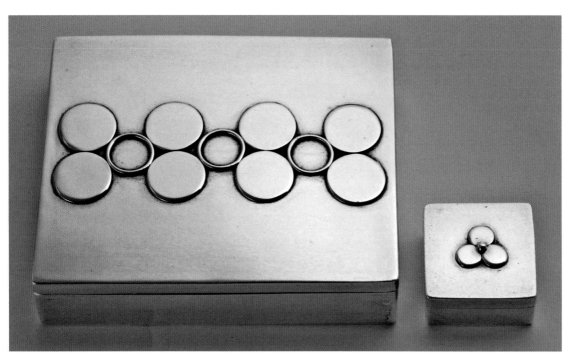

Two sterling silver boxes with applied decoration by Maria Regnier. Courtesy of Chicagosilver.com.

Carson and Barnum hallmark used at The Arts and Crafts Shop. The letters refer to the two principals, Jane Carson and Frances Barnum. Courtesy of Chicagosilver.com.

Mildred Watkins's hallmark. Her work is marked with the sailboat, her name, or both. Additional marks may be identified, reflecting the various partnerships of the women she worked with over the years. Courtesy of Chicagosilver.com.

Ohio

The most notable work from the Ohio arts and crafts metalwork and jewelry industries came from the Frost Arts and Crafts Workshops in Dayton; Theodore Pond's students at the Ohio Mechanic's Institute; Robert Sturm and several women in Cincinnati; and Horace Potter, the Rokesley Shop, the Arts and Crafts Shop, Mildred Watkins, and Anna Wyers Hill from Cleveland, all of whom were associated with the Cleveland School of Art (CSA). The CSA, which traced its roots back to 1882, played a major role in the development of a robust and unique metalwork and jewelry community of artisans in the city and throughout the state. Most of the notable Cleveland crafts workers graduated or taught at the school (which became the Cleveland Institute of Art in 1948). Long-time faculty member Louis Rorheimer was in charge of the decorative design course, and he also operated an influential interior design studio for many years. The Cleveland Museum of Art (CMA), established in 1913, also became an important vehicle for the promotion of the Arts & Crafts Movement and helped solidify Cleveland as the center of Ohio's progressive art industries that flourished until World War II.

CLEVELAND

The Arts and Crafts Shop (1902–1906)
Carson & Watkins (1907–1908)
Mildred Watkins (1909–1958)

Principals

Jane Carson-Barron (1879–1942), active 1903–1941

Frances Barnum-Smith (1874–after 1930), active 1903–1906

Mildred G. Watkins (1883–1968), active 1903–1958

Carson, Barnum and Watkins

Jane Carson, Frances Barnum, and Mildred Watkins were a major impetus in the nascent hand-wrought jewelry and metalwork industries in Cleveland, producing innovative jewelry, silver and enamel wares. [1] In 1902, CSA graduates Carson and Barnum co-founded the Arts and Crafts Shop, an important design studio where Watkins worked from 1903. Watkins, who had studied with Laurin Hovey Martin after graduation from the CSA, became a partner in the business in 1905. Carson and Barnum exhibited at the first AIC show, and, in 1904, they exhibited silver jewelry, a tazza, an alms dish, and flatware at the prestigious World's Fair in St. Louis. Other exhibited works were noted for the use of enamel and striking designs. In 1906, Carson and Watkins exhibited at the fall AIC show after Barnum-Smith left the partnership on the birth of her son. In 1907, Carson & Watkins, manufacturing jewelers, opened in the city; however, the venture was short lived. Carson married and the studio closed down, although she stayed active in crafts work. In 1908, Carson-Barron, considered the first person to take up art metal work in Cleveland, became president of the Decorative Art Club and showed her enameled jewelry in many exhibitions. In 1934, she exhibited salts, peppers, and salt spoons in silver and enamel at the CMA, and in 1941, a needlepoint bag mounted in silver.

In 1908, Watkins taught summer school in Oregon at the invitation of the Portland Arts and Crafts Society. She operated a studio there for three summers. In 1909, she won the top prize for jewelry and silverware at the Alaska–Yukon–Pacific Exposition, also called the Seattle World's Fair.

In Cleveland, Watkins produced a wealth of hand-wrought items and operated several studios over the years, including a 1934 studio with Dorothy Kirsop, a recent graduate and talented crafts worker. Watkins did not consider such alliances as permanent, as she noted that each time she started a studio with a companion they soon married and left the partnership. Her partners included Anna Wyers who became Mrs. Wyers Hill, Florence Bard, who became Mrs. Frank N. Wilcox, and Julia Davies, who became Mrs. J.R. Driver.

Watkins, who never married, remained an active silversmith and a pioneer in enamel work. She exhibited for decades and inspired others to pursue jewelry and crafts work. From 1918–1953, she also taught at the CSA (the CSA became the Cleveland Institute of Art in 1948). Her last known exhibitions were in the late 1950s. She died in a nursing home in 1968.

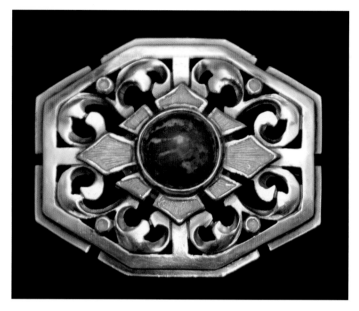

Watkins sterling silver brooch with enamel and a green brown stone. Courtesy of Chicagosilver.com.

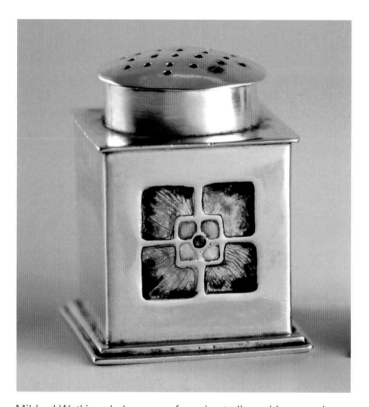

Mildred Watkins shaker, one of a pair, sterling with enamel. Courtesy of Chicagosilver.com.

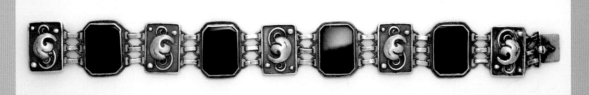

Carson and Barnum sterling silver panel bracelet with black onyx. Courtesy of Chicagosilver.com.

Watkins sterling silver ladle with a cut-out "H" monogram. Courtesy of Chicagosilver.com.

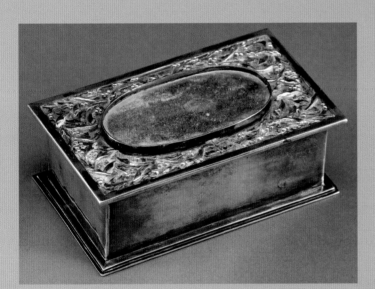

Mildred Watkins silver and enamel box. Courtesy of Skinner Inc., www.skinnerinc.com.

Sterling silver napkin ring chased with tall ships and three amethyst stone flags, marked Mildred Watkins. 1.25 x 1.75 inches. Courtesy of Rago Arts and Auction Center, Lambertville, NJ.

H.E. Potter (1899–1909)
Potter Studio (1909–1928)
Potter Bentley Studios (1928–1933)
Potter and Mellen (1933–2008)

Principal
Horace E. Potter (1873–1948)

Known workers
Nathan Brody, 1919
William Burgdorff, 1904–1906
Ferdinand Burgdorff, 1904–1906
Burton, John Sidney, 1923–1928
Harold Griffith, 1928
Carl Kurz, c.1910–1921
Louis Mellen, 1925
Henning Neukler, 1928
Florence E. Loomis Potter, 1913–1928
Emil Prevratsky, 1919–1922
Hugo E. Robus, 1906–1907, 1919
Wilhelmina P. Stephan, c.1905–1907

Potter hallmarks H.E. Potter, Potter Studio, Potter Bentley Studios, and Potter and Mellen. Courtesy of Chicagosilver.com.

Horace Potter operated one of the most successful and prolific arts and crafts metalwork and jewelry shops in the Midwest, employing dozens of artisans. He exhibited large collections of hand-wrought items at the annual shows at the Art Institute of Chicago (AIC) and in Boston, as well as most major shows throughout the country. An 1898 graduate of the Cleveland School of Art, Potter also taught at the school from 1900–1909, alongside senior faculty member Louis Rorheimer. He studied with Amy M. Sacher in Boston before establishing a design studio in Cleveland under the name H.E. Potter.

From 1905–1907, the first rendition of the Potter Studio reflected a partnership between Horace E. Potter and Wilhelmina Stephan. They exhibited jointly at the AIC and at the first annual show at the CSA with their student assistants, William and Ferdinand Burgdorff and Hugo E. Robus. From 1909, reporters first referred to the "Potter Studio," noting repoussé, enamel, and gem-set artistic jewelry. Potter took on several different partners over the years as reflected in the different company names until it finally closed in 2008. [2]

Potter Studio sterling silver tea caddy spoon with enamel. Courtesy of Chicagosilver.com.

Potter Studio sterling silver box with green stone. Courtesy of Chicagosilver.

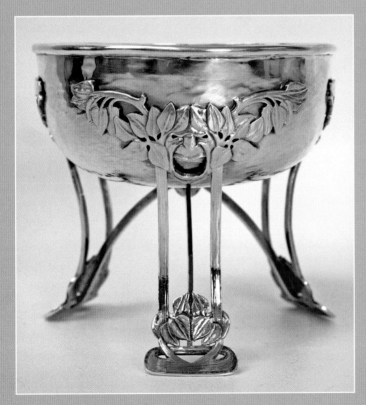

Sterling silver pedestal bowl with folate decoration, marked Potter Studio. Courtesy of Cobblestone Antiques.

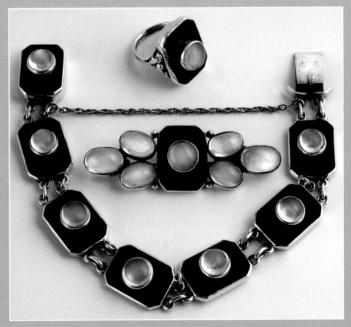

Potter Mellen sterling silver bracelet, brooch, and ring with onyx and moonstones. Courtesy of Chicagosilver.com.

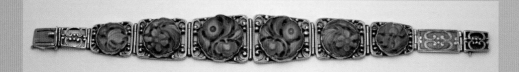

Potter Studio gold and carved jade bracelet. Courtesy of Chicagosilver.com.

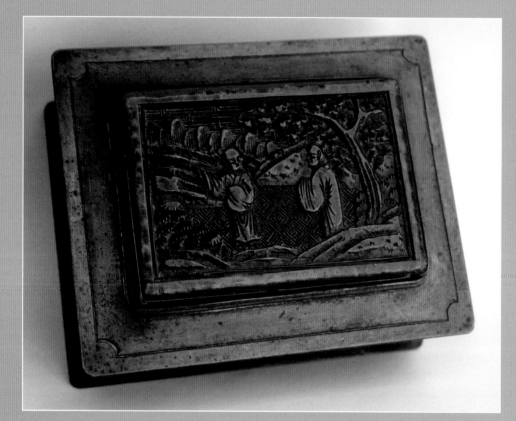

Potter Studio brass box with carved red cinnabar. Courtesy of Boice Lydell.

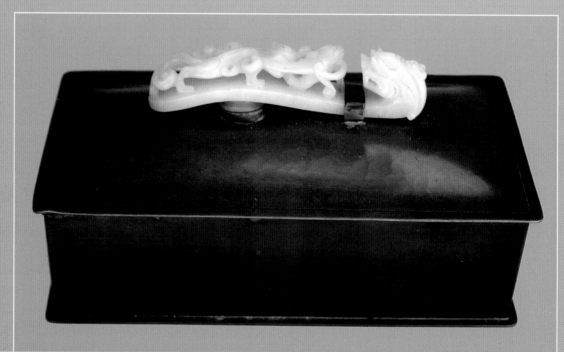

Potter Studio hammered copper box with carved oriental jade handle. Courtesy of Boice Lydell.

Wilhelmina P. Stephan (c.1878–1942) c.1904–1930s

Stephan was a graduate of the CSA who also studied with Alexander Fisher of London. She excelled as a silversmith and jeweler. In 1905–1906 at the AIC, she and Horace Potter exhibited diverse wares that included silver mustard pots, tea strainers, pitcher and tray, a silver and enamel box, a copper carved and enameled vase, spoons, a copper box, and several pieces of jewelry. In 1907, they jointly exhibited in Boston, while Stephan exhibited under her own name at the AIC later that year. Stephan taught arts and crafts, and her students included Rose Sears Kerr of Evanston, Illinois. She operated a hand-wrought jewelry and crafts business in Cleveland at least from 1911 to 1926, and was listed as a designer and maker for the Rokesley Shop in the 1914 annual show at the AIC. In 1927, she opened a new shop next to her studio in Cleveland Heights, with assistant Margaret Jackson, that featured hand-wrought jewelry and weaving. Stephan died in Cleveland in 1942. [3]

Sterling silver hammered and carved tea bag holder with Stephan hallmark. Courtesy of Chicagosilver.com.

Wilhelmina Stephan hallmark. Courtesy of Cobblestone Antiques.

Stephan hammered sterling silver brooch with floral motif. Courtesy of Cobblestone Antiques.

Hadlow, Blakeslee, and Smedley (1904–1909)
The Rokesley Shop (c.1909–1926)

Principals
Mary Blakeslee (1875–1964) 1904–1913
Caroline Hadlow (Vinson) (1878–1953) 1904–1926
Ruth A. Smedley, (1882–1920) 1904–1920
Louis Rorheimer, (1872–1939), 1904–c.1920
Wilhelmina P. Stephan, 1914

Hadlow, Blakeslee, and Smedley—later renamed The Rokesley Shop—was an important and visible studio that helped define the early arts and crafts jewelry and metalwork industries in Cleveland. Co-founded by Caroline Hadlow, Mary Blakeslee and Ruth Smedley in partnership with CSA decorative design instructor Louis Rorheimer, the shop was touted as one of the Rorheimer-Brooks Studios, an avant-garde interior design practice. The name Rokesley was derived from an assemblage of letters from their last names. Although a partner, Rorheimer maintained a very low profile at the Rokesley Shop and appears to have been more of a financial backer and designer than an active participant in the operations of the company.[4]

The Rokesley Shop manufactured hand-wrought copper and silver jewelry, as well as decorative items, frequently adorned with enamel. The shop exhibited in the annual shows in Chicago, Boston, Seattle, and many other venues. In 1913, Blakeslee left the partnership; Cleveland metalworker Wilhelmina Stephan was listed as a designer and maker in 1914. Smedley died in 1920, leaving Carolyn Hadlow Vinson to carry on the tradition of the shop and she was the only artisan listed for the Rokesley Shop in a 1926 CMA exhibit.

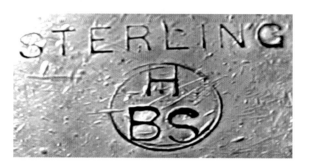
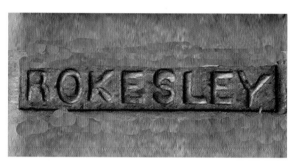

Hadlow, Blakeslee, and Smedley, and Rokesley hallmarks. Courtesy of Chicagosilver.com.

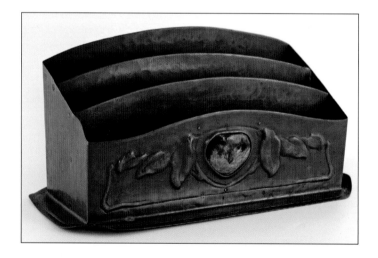

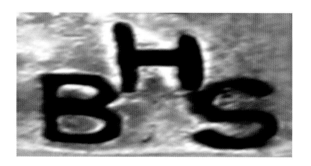

Rokesley hammered and chased copper letter box and pen tray, decorated with enamel. Courtesy of Chicagosilver.com.

Rokesley sterling silver tea strainer, and a napkin ring and spoon with bird motifs. Courtesy of Chicagosilver.com.

John Sidney Burton (1878–c.1934)

Born in England, Burton was an important Midwestern jeweler, metalsmith, and enameler who was active in the Chicago Artists Guild, the Boston and Detroit Societies of Arts and Crafts, the New York Society of Craftsmen, and the Philadelphia Guild of Applied Arts. Burton left his East Aurora, New York, studio and went to Ohio during World War I to work for a manufacturing firm, quickly becoming immersed in the local arts and crafts community. He lived and exhibited in Cleveland from 1916 until his death in 1934, operating his own studio and working for Potter Studio at least from 1923 to 1928.

In 1921, his silver bowls with enamel and his gold and silver jewelry were featured at the annual AIC show. In 1922, he won two first prizes from the CMA for similar work. In 1923, he showed a carved gold cross pendant, a gold pendant with carved ivory featuring a little boy, and a silver and enamel pendant with carved ivory at the Exhibition of American Handicraft. In 1934, his Cleveland compatriots featured a memorial exhibit of his works at the CMA annual show. [5]

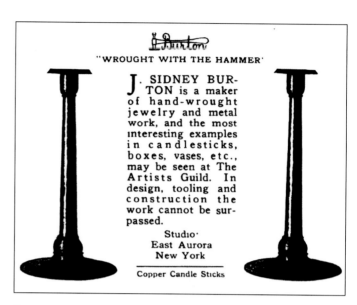

"WROUGHT WITH THE HAMMER"

J. SIDNEY BURTON is a maker of hand-wrought jewelry and metal work, and the most interesting examples in candlesticks, boxes, vases, etc., may be seen at The Artists Guild. In design, tooling and construction the work cannot be surpassed.

Studio·
East Aurora
New York

Copper Candle Sticks

Burton advertisement in the Chicago Artists' Guild, 1915, when he maintained a studio in East Aurora, NY. Courtesy of Chicagosilver.com.

John Sidney Burton hallmark. Courtesy of Chicagosilver.com.

Sterling silver napkin clip by John S. Burton, dated February 15, 1917. Courtesy of Chicagosilver.com.

Anna Wyers Hill (1879–1933)
Watkins & Wyers, 1914
Wyers Studio, 1918–1933

Wyers, born in Holland, studied at The Hague, the Academy for Drawing in Berlin, and with metal worker Alexander Fisher in London (at the same time Cleveland student Wilhelmina Stephan was there). In 1910, she won a gold medal in Brussels for her metalwork. She emigrated to New York and established a short-lived studio that was destroyed by fire, then moved to Cleveland in 1913. By the following March, she co-founded Watkins & Wyers. She soon left the partnership after the birth of her son David Hill. From 1918, she operated her own studio and exhibited broadly. A prolific artisan, she won 13 prizes from the CMA and, in 1923, she won the AIC Frank G. Logan Medal for Applied Arts. Her work included enameled metal jewel caskets, repoussé silver items, etched copper and jewelry.[6]

Hallmark of Anna Wyers Hill. © The Cleveland Museum of Art.

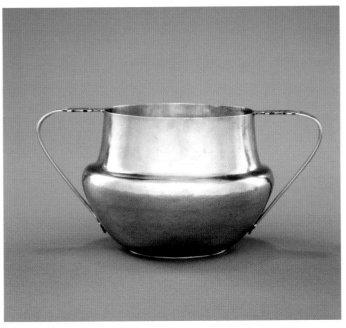

Sugar bowl and cream pitcher, c.1920. Designed and made by Anna Wyers Hill (American). Silver, bowl: 8.3 x 17.2 x 11.6 cm; pitcher: 10.9 x 15.1 x 9.3 cm. The Cleveland Museum of Art, The Mary Spedding Milliken Memorial Collection, Gift of William Mathewson Milliken. © The Cleveland Museum of Art.

CINCINNATI

Theodore Hanford Pond (1872–1933)
Ohio Mechanics' Institute, Cincinnati, Ohio

In September 1916, well-known craftsman and teacher Theodore H. Pond organized a new jewelry course at the Ohio Mechanics' Institute that was sponsored in part by the Cincinnati Wholesale Jewelers' Association. The work of his students was featured in the *Jewelers' Circular*, a leading trade magazine, including the striking vase and watch holder that is pictured here, which was signed with Pond's mark. Another copy of the vase is held by the Minneapolis Institute of Arts.[7] Multiple copies of the piece suggest that students made and sold their work through the Pond Studio, as was done with the major workshops of the time, including the Kalo Workshops, the Forest Craft Guild, and the Minneapolis Handicraft Guild.

Pond, a graduate of the Pratt Institute, was known for his ability to start new programs. He previously established a class in decorative design at the Rhode Island School of Design; the Department of Applied and Fine Arts at the Mechanics' Institute in Rochester, New York; and, in c.1908, the Department of Applied Design and Fine Arts at the Maryland Institute in Baltimore. In 1911, he left institutional teaching to establish the Pond Applied Arts Studios in Baltimore before he accepted the position in Cincinnati. By 1922, the consummate teacher and artisan was the director of the Akron Art Institute. From 1922 to 1928, he served as the director of the Dayton Art Institute, before returning to Akron in 1929. In addition to directing the Institute, he taught art at the University of Akron. Pond was elected to the rank of master craftsman by the Boston Society of Arts and Crafts (BSAC). He died in 1933; his widow, Marian G. Pond, died in New York in 1977.

Theodore Hanford Pond marks. Kwo-neshe means "dragonfly" in several American Indian languages. Courtesy of Chicagosilver.com.

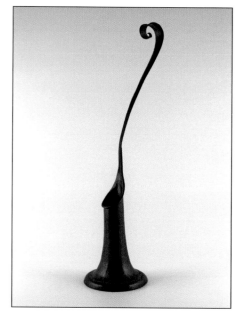

Hammered copper vase and watch holder made at the Ohio Mechanics' Institute and marked Kwo-neshe Hand Wrought Pond. 17 1/2" high. Courtesy of Chicagosilver.com.

Work of Pond's students at the Ohio Mechanics' Institute, c.1916. Note the copper vase and watch holder. From the *Jewelers' Circular* (July 1917). Courtesy of the University of Michigan Library.

Robert E. Sturm (1874–1964)

Sturm was a Cincinnati silversmith noted for his finely hammered arts and crafts silver, including some with applied monograms. Born in Ohio to German immigrants, Sturm operated a studio in the city from 1890 through the 1930s. Some of his work is reminiscent of Chicago silversmiths, but his ties to the city are unknown. His son, also named Robert E., worked in his father's shop while he was growing up, but focused on engineering for a professional career. Sturm died in Cincinnati in 1964.

Sturm hallmark. Courtesy of Chicagosilver.com.

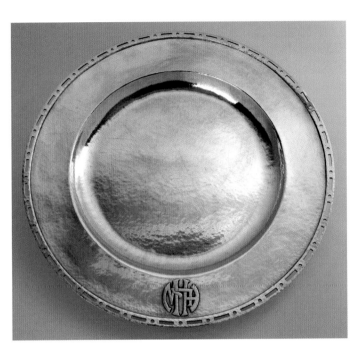

Sterling silver platter with pierced border by Robert Strum. Courtesy of Douglas Rosin Decorative Arts, Chicago.

Sterling silver server by Robert Sturm. Courtesy of Chicagosilver.com.

Other Cincinnati Artisans

Several Cincinnati women were noted as silversmiths, metalworkers, and jewelers in annual directories and as craftsmen members of the BSAC. In 1907, Elizabeth R. Kellogg exhibited jewelry at the annual AIC show, featuring an Egyptian style silver necklace set with scarabs, bloodstone, jade, and agate and a repoussé brass buckle in a grape design. Kellogg, in addition to her metalwork studio, worked as the librarian for the CMA for many years. Elizabeth Worthington and Evelyn R. Hooker were BSAC silversmiths who were active at least from 1910 to 1913. Hooker, born into a wealthy Cincinnati family, later served with the Red Cross and the American Fund for French wounded soldiers during World War I. Works by the women and their marks are currently unknown.

Also from Cincinnati, Maria Longworth Nichols, the founder of Rookwood Pottery, expanded into metal work, as did Edward T. Hurley, another Rookwood worker (see: Boram-Hays, 2005). In addition to works shown by the Cincinnati Pottery Club, Mary Louise McLaughlin exhibited etched copper and brass at the 1893 Chicago World's Fair.[8]

E.T. Hurley bronze plate with five turtles. 5.5 inches diameter. Courtesy of John Toomey Gallery.

Dayton Society of Arts and Crafts (1902-)
Dayton, OH

Principal
Brainerd Bliss Thresher (1870–1950)

Thresher was a wealthy industrialist and world traveler who became entranced with the power of art and the emerging handicraft movement. He was active in promoting arts and crafts training in Dayton and became a very successful jeweler and crafts person, being noted in many of the leading publications of the era. From c.1903, his gold and silver work, some with ivory and coral, was well regarded in local and national exhibitions, including the AIC. He and his wife were also members of the BSAC.

In March 1902, Thresher gave a rousing talk at the Present Day Club that was instrumental in establishing the Dayton Arts and Crafts Society. Thresher was elected president and his wife, Mary Low Colby, served as secretary. The principle aim of the Society was to train workers in the handicrafts and build a community of crafts workers. Courses began with a summer school taught by Hugo B. and Eva M. Froelich. Eva was a graduate of the first jewelry class organized at the Pratt Institute.[9] In the fall, the Society hired Forrest Emerson Mann—another Pratt graduate who operated a studio in Dayton—to be in charge of the curriculum. The following year, roughly 100 students enrolled for the classes. In 1904, jewelry and metalwork artisan Ednah S. Girvan worked with Mann at the Society until he moved to the Grand Rapids area that summer. Classes at the Dayton Society were then taught by art metal instructor Albert R. Lache and others in subsequent years.

Thresher remained a pivotal supporter and organizer of all things artistic in Dayton throughout his life; he died in 1950.

Ednah Sherman Girvan Higginson (1873–1963)

Born in California, Ednah Girvan studied art metal work in Boston, New York, and England, becoming a noted arts and crafts jeweler. In 1904, she worked at the Dayton Society of Arts and Crafts, probably as a jewelry instructor. Forrest E. Mann was the director of the Society. Later that fall and the following year, she and Mann designed and made jewelry that was shown at the annual AIC show, listing a Grand Rapids address, although there is no other evidence that Girvan lived in the city. By 1905, she was in New York before returning to Santa Barbara, California, in 1906. She was active with the BSAC and, in 1907, married former Chicago architect Augustus B. Higginson, who had moved to Santa Barbara. Higginson was the widower of her first cousin Frances Girvan. At least through 1912, Ednah maintained a prominent art metal work and jewelry studio in Santa Barbara. The Higginson's had one son named George Girvan; Ednah died in 1963.

Girvan carved belt clasp from *The Keystone* (Sept. 1906). Author's collection.

Girvan necklace and clasp from *Good Housekeeping* (Nov. 1906). Courtesy of Chicagosilver.com.

Jewelry by Brainerd Thresher, c.1904. Photo courtesy of Chicagosilver.com.

Frost Arts and Crafts Workshops (1908–1914)
Dayton, Ohio

Principal
George Winfield Frost (1876–1972)

Founded by George Frost, the Frost Workshops created classic arts and crafts jewelry and metalwork in hammered and acid-etched copper and brass. The company flourished until the onset of World War I.

In 1900, Frost graduated with a degree in mechanical engineering from The Ohio State University. About 1906, he moved to Dayton, Ohio, and lived with his parents and sister while operating a small electrical-component manufacturing and supply company. By 1908, he and a small band of part-time artisans tinkered in the arts and crafts in their off hours, using a rudimentary, single-story building called the Frost Arts and Crafts Workshops. Later that year, an ambitious traveling art goods salesman admired his work and took about a dozen samples to show to his art studio clientele. The response was exceptional, as dealers in nearly every section of the country placed orders for several hundred articles, overwhelming the part-time artisans. They gave up their day jobs, and pursued the arts company full time; his father, John W., served as the treasurer. In 1909, the Frost Workshops won two gold medals for metalwork in the Alaska-Yukon-Pacific Exposition held in Seattle. Buoyed by its success and strong customer demand, the Frost Workshops moved into a large three-story building that fall. [10]

In addition to artistic metal wares and jewelry, the Frost Workshops sold a broad range of arts and crafts supplies, gemstones and tools for the home market, including easy-to-make kits. In 1911, George married Mary Eulalia Block, who may have assisted with the workshops. The business closed by the end of 1914, and Frost went to work for manufacturing and engineering companies in Dayton before moving on to the Shanklin Manufacturing Co. in Springfield, Illinois. He received patents for some of his mechanical inventions and lived in Springfield until his death.

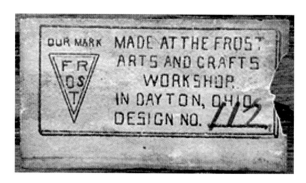

Paper label for the Frost Workshop, showing Frost triangle mark. Courtesy of Boice Lydell.

Frost Catalog 82 cover. Courtesy of the Winterthur Museum Library online collection.

THE FROST
Arts and Crafts
Workshop
Where are made
by skilled Craftsmen
beautiful things in
Copper, Bronze, Brass
Iron and Silver.
Workers in Art Glass
Tooled Leathers, Rare
Woods, Precious and
Semi-Precious Stones.

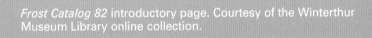

Frost Catalog 82 introductory page. Courtesy of the Winterthur Museum Library online collection.

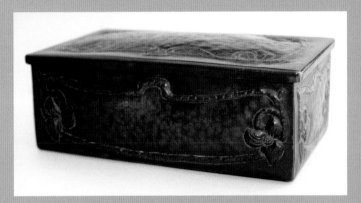

Frost hammered and chased copper box. Courtesy of Boice Lydell.

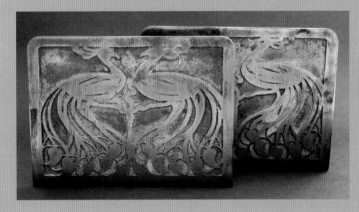

Frost metal bookends in a peacock design. Courtesy of Boice Lydell.

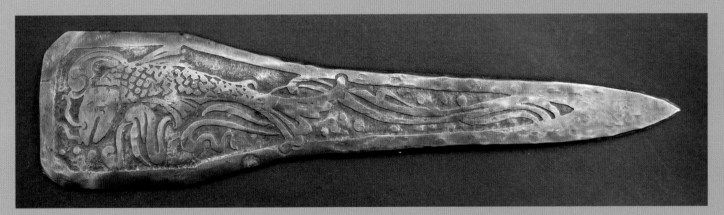

Frost paper knife with an acid-etched fish design. Courtesy of Boice Lydell.

Five stick pins, all signed with the Frost logo. Courtesy of Curators Collection, photo by Rich Wood.

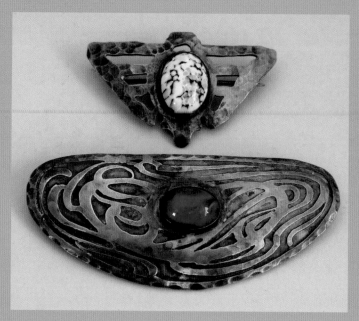

Two Frost acid-etched brooches with blue glass stones. Larger one 3.5" long. Author's collection and photo.

Frost brooch in original box. Courtesy of Boice Lydell.

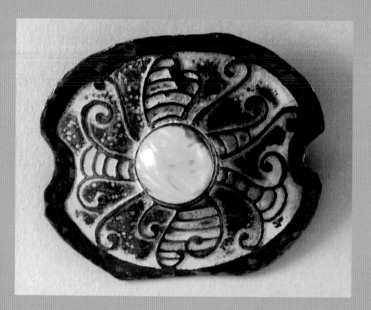

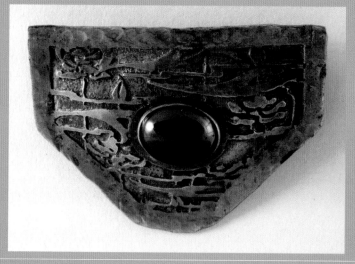

Frost etched and hammered brooches with green and red glass stones. Courtesy of Curators Collection, photos by Rich Wood.

Wisconsin

The Milwaukee area was the center of the Wisconsin arts and crafts metalwork and jewelry industries. A 1902 exhibition featured works from Milwaukee, Chicago, New York, and Boston; Cyril Colnick was noted for his wrought iron in the April issue of the *Sketch Book*. Other well-known artisans included Caroline Seton Ogden, a Milwaukee metalworker who was active at least from 1903 to 1912. Ogden exhibited leather, hammered copper and brass wares in the 1903 and 1906 annual shows at the Art Institute of Chicago (AIC), as well as other venues in the Midwest and in Boston, where she was a member of the Society of Arts and Crafts and the National Society of Craftsmen.

Agnes Bassett, an early AIC graduate, featured copper jewelry in the 1906 AIC arts and crafts show, and operated a design studio in Fond-du-Lac for many years. The earliest known Wisconsin arts and crafts jeweler was Sarah Ellen Posey, who showed her hand crafted pearl jewelry at the 1893 Chicago World's Fair. [1]

In June 1907, Anders H. Anderson, who trained at the AIC, and Johannes Morton founded the Racine School of Fine Arts, which focused on a mix of fine and applied arts, including painting and hand-wrought gold and silver jewelry. The pioneering effort was designed as a school within a workshop, and they sold their wares in an arts and crafts shop associated with the school. [2] In July 1912, Anderson and Morton moved the school, workshops, and a small band of artisans to Milton-On-Hudson in New York, changing the name to the Elverhoj Art Colony. [3]

Although Milwaukee had an active art students league from 1896, few organizations existed to promote an arts and crafts industry. Things began to change from 1911 to 1913, when the area underwent a transformation with the establishment of several key jewelry and metalwork training programs for women and men. In 1911, Elsa Ulbricht, who trained in Wisconsin and at the Pratt Institute in Brooklyn, offered courses in jewelry, metal work and silversmithing at the School of Fine and Applied Arts. In 1913, the Milwaukee-Downer College, a leading school for women, hired Elizabeth G. Upham to teach its first classes in jewelry and silversmithing. [4] She trained a cadre of students, served as a metalwork juror at the 1915 AIC annual show, exhibited metalwork in local shows, and became a pioneer in occupational therapy. Metalworkers and jewelers who trained at the college included Evelyn P. Ellsworth, who worked as a designer and jeweler for the Kalo Shop in Chicago and later taught at the Allendale Shop of the Allendale School for Boys in Lake Villa, Illinois. [5] Florence Beckler and Ethel Davis, representing Milwaukee-Downers College, showed gold and silver jewelry in the 1914 AIC arts and crafts show. In 1917, Beckler also operated a metal novelties studio in Milwaukee.

In 1913, metalsmith Emil F. Kronquist settled in Milwaukee and soon became the most influential manual arts teacher in the state. He taught men and women at the Milwaukee Vocational School, Washington High School, Milwaukee School of Art, Milwaukee Area Technical College, summer school at the Stout Institute, and in many private classes. In 1919, Kronquist won top honors for his metalwork at the Wisconsin Society of Applied Arts (WSAA) annual exhibition.

A group of local art leaders founded the WSAA in 1916, based in Milwaukee. The goal was to promote original design and workmanship throughout the state. The first annual exhibition of works was held in November, and future shows helped promote indigenous craft and design industries.

In 1919, E. Mabel Frame, following a one-year apprenticeship at the Kalo Shop in Chicago, helped put Wisconsin silversmiths and jewelers on the map when she won the prestigious Albert Heun prize at the annual AIC show for a silver coffeepot, creamer, and sugar with an applied monogram. With the $50 prize, she later fashioned a matching silver tray. Frame also exhibited in the 1921 annual show at the AIC. Her work included a silver, enamel, and sapphire pendant, six silver spoons, a copper pen tray, and a woven pillow cover.

In the 1920s–1930s, jewelry and metalwork, especially works in pewter, were well-represented in the WSAA shows. Some of the metalwork artisans included Clara M. Severance of Madison, who won the 1930 top prize for her metal items and a silver pendant, Virginia Brockett, Dorothy Cochrane, L.H. Heise, Willi Knapp, J.C. Polzer, J.A. Mould, William E. Davis, Lowell W. Lee, and wrought iron maestro Cyril Colnick. Silver metalwork was shown by Chicago artisan C.H. Didrich, as well as Wisconsin artists E. Mabel Frame, William H. Noyes, Haldon L. Thurn, and Elizabeth Upham Davis. Jewelers included many women associated with Milwaukee-Downer College, as well as Sigrid Bodelson, Gertrude Allen, Leslie M. Phillis, and Gerda Meier.

Several silversmiths who worked in Chicago made Wisconsin their home, including Gustav E. Andersen, who probably produced his distinctive flatware for many years before he opened a home studio in 1957.

The 1930s heralded a new wave of metalwork and jewelry studios, including the Handicraft Shop of Northland College in Ashland, founded by Nathaniel Beech Dexter (1930); Cabin Craft jewelry, founded by Dorothy Hoiso Miller in Ephraim (1933); and Glander Copper, founded by Erhard Glander in Wauwatosa (1932) before it moved to Saukville (1937).

Racine School of Fine Arts, 1907–1912
Racine, Wisconsin
The Elverhoj Colony, 1912–c.1939
Milton-On-Hudson, New York

Principals
Anders Hansen Anderson (1874–after 1930)
Johannes Morton (c.1879–after 1930)
Joseph Popelka (c.1893–1975)
James Scott (c.1893-)

Businesses at Racine
The Zodiac, Racine, Wisconsin, c.1908–1912
The Art Shop, The Arts and Crafts Shop, 525 Monument Square, Racine, Wisconsin, 1912–1914

Denmark-born Anders Anderson immigrated to the U.S. in 1894. He studied at the AIC for three years, was the director of the Greenville and Ionia Art Colony in Michigan, and studied in Europe for two years before he came to Racine to establish his school and artist colony. Johannes Morton, an accomplished painter who studied at the Royal Academy of Fine Arts in Copenhagen, arrived in the U.S. in 1907 and joined Anderson as an instructor at the school. Both were jewelers and painters, characteristics they found in two Racine pupils, Joseph Popelka and James Scott. The Racine School maintained close ties to its southern neighbors and frequently invited Chicago artisans to lecture and teach at the school.

In 1911, 18-year-old Popelka won first and second place prizes for his jewelry at the Wisconsin State Fair while Scott won an award for his painting.

The Racine School of Fine Arts operated a jewelry shop called The Zodiac. In 1912, an ad announced a successor shop called The Art Shop:

Continuing the Arts and Crafts Shop formerly conducted by the Racine School of Fine Arts, we are pleased to announce our formal opening Saturday, May 11, 1912. We will carry the Zodiac line of hand-wrought gold and silver jewelry, the excellence of which is well known and will in addition offer for sale the work of our own shop.

Carl A. Hanson was the manager of the new concern, and the shop also offered hand-made copper items, baskets, pottery, card novelties, statuary, art reproductions, and picture framing. In 1913, the shop was referred to as The Arts and Crafts Shop.

Popelka and Scott moved with Anderson and Morton to New York and lived in the Elverhoj Colony. In December 1912, Chicago's O'Brien Galleries hosted a special exhibition of Elverhoj's Flora Americana jewelry. In 1914, Elverhoj, represented by Morton, Popelka, and Scott, exhibited 28 jewelry items and a silver repoussé plate at the annual AIC show. The following year, Elverhoj won the prestigious gold medal for jewelry at the 1915 Panama-Pacific Exposition in San Francisco.

Popelka and Scott served in World War I; Scott returned to live in the Elverhoj Colony. Popelka returned to Racine and soon worked for Chicago silversmith John P. Petterson, whom he knew through Ralph M. Pearson at the Elverhoj Colony. Petterson Studios displayed a gold and lapis ring made by Popelka at the 1921 annual arts and crafts show at the AIC. By 1948, Popelka was the designer for Cellini Craft and its new line of artistic wares. He died in San Diego in 1975.

By 1930, Morton moved to New York City with his wife and worked as an interior decorator. In 1934, the Elverhoj Colony went into foreclosure, and, in 1939, it was sold to followers of the controversial cult leader, Father Divine.

Esther Mabel Frame (1879–1972)

A life-long resident of Waukesha, Frame was one of the best known women silversmiths and jewelers in Wisconsin. She also was a noted teacher in jewelry, metalwork and crafts; she helped organize occupational therapy at Milwaukee-Downers College during the war and taught many of the courses. She remained at school until her retirement in the 1940s and she continued to exhibit her previous works through the 1950s.

Born to a wealthy and prominent family, Frame invested heavily in her educational experiences. She studied with Elizabeth G. Upham at Milwaukee-Downers College, Charlotte R. Partridge at the Layton School of Art, William Varnum at the University of Wisconsin-Madison, and Emil F. Kronquist at the Milwaukee State Normal School. Summer studies included the Applied Arts Summer School in Chicago, the Commonwealth Art Colony in Boothbay Harbor, Maine, and the Church School of Art in Chicago. Of all her education, Frame said that most valuable practical experience in art metal work was obtained through a year's study at the Kalo Shop in Chicago.[6] From c.1917 to 1918, she served an apprenticeship under shop masters Carl Henry Didrich and then Peter L. Berg. Frame's famous coffee set, pictured in a newspaper article, shows strong Kalo influences. In 1933, Frame also won the top prize for a silver tray, pewter porringer, and a silver compote from the annual show of the WSAA. Her marks are unknown.

Esther Mabel Frame

Emil Fritjoff Kronquist (1882–1974)

Kronquist was an exceptional jeweler and silversmith who worked for Leonide C. Lavaron and launched his own company in Chicago before embarking on a manual arts teaching career in Oklahoma and in Milwaukee, Wisconsin. His greatest contributions to the Arts and Crafts Movement were seen through his legions of students and by his popular instructional books that brought art metal work to the masses.

Born in Sweden and raised in Denmark, Kronquist completed a five-year apprenticeship in Copenhagen in 1902 and received a scholarship to study at the London County Council School of Arts and Crafts. He particularly excelled in repoussé work, and won a top $100 prize for a chalice in 1903; he used the money visit the 1904 World's Fair in St. Louis and to move to Chicago.

He operated a jewelry studio at 167 Dearborn in Chicago with Herman Moline, and he was one of the makers for Lavaron in the 1906–1907 annual exhibitions at the AIC, which featured gold and silver necklaces, brooches, rings, a bracelet, lamps and candlesticks that she designed. In 1906, Kronquist made an exquisite carved gold brooch set with pearls for his fiancée, Helga Birch (see photo).

In c.1908, the Kronquists moved to Oklahoma, where Emil taught and oversaw the industrial arts training program at the Northwestern State Normal School. By 1913, they had moved to Milwaukee where Kronquist helped establish the jewelry and metalwork industries through his extensive teaching and studio work. In 1926, he published *Metalcraft and Jewelry*, a tremendously popular book for teachers and students. From 1927, he worked as an industrial designer for Moe-Bridges, an electric fixture company, for several years before resuming teaching and working in his studio. He retired in 1951 but frequently gave lectures and taught private classes throughout his life.

Kronquist hallmarks. Courtesy of the Milwaukee Area Technical College.

Emil Fritjoff Kronquist

James Scott amethyst sterling silver necklace, unsigned, from the estate of the Scott family. Courtesy of Chicagosilver.com.

Kronquist 18K gold brooch carved and then chased, made for his future wife Helga in 1906. Courtesy of the Milwaukee Area Technical College, photo by author.

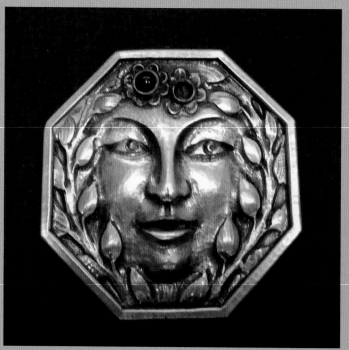

Kronquist repoussé sterling silver brooches, rooster and goddess set with stones. Courtesy of the Milwaukee Area Technical College, photos by author.

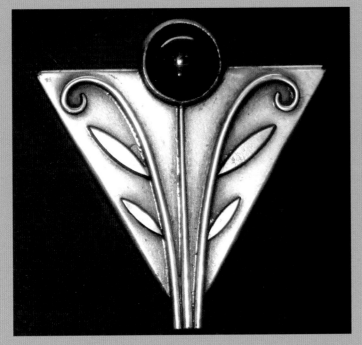

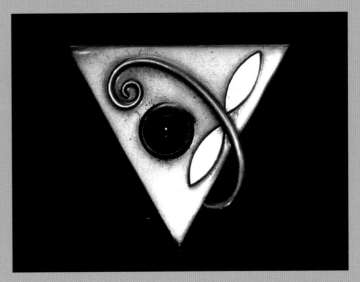

Kronquist sterling silver brooches with carnelian and chrysoprase, decorated with applied metalwork. Courtesy of the Milwaukee Area Technical College, photos by author.

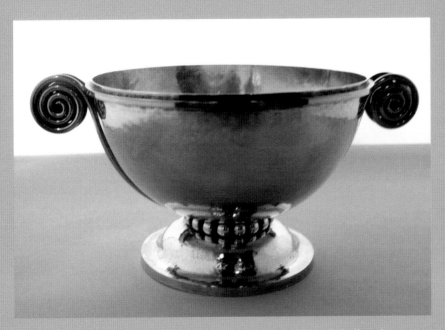

Kronquist sterling silver bowl with handles, signed with both hallmarks. Courtesy of the Milwaukee Area Technical College, photo by author.

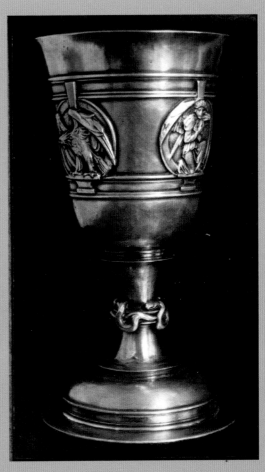

Award-winning chalice Kronquist made in London, 1903. 9 inches high. From Kronquist scrapbook, author's collection.

Gustav Engolf Andersen (1883–1962)

In 1903, Norway-born Gustav Andersen immigrated to Chicago before moving to Bristol, Massachusetts, where he worked as a silversmith. By 1920 he settled in Madison, Wisconsin. In the 1940s, he worked for the Cellini Shop in Evanston, Illinois. In 1957, he opened a studio in his Madison home at 4348 Bagley, which he operated until his death. Andersen specialized in making two distinctive patterns of sterling flatware, called *Ivy* and *Karen*, which he sold to leading jewelry stores throughout the country, and which were later acquired by Old Newbury Crafters.[7] His work was marked G. ANDERSEN.

Hallmarks of Northland Craft Shop (1930–c.1950s), Cabin Craft (1933-72), and Glander Copper (1932–c.1970s) Courtesy of Boice Lydell and author's collection, photos by author.

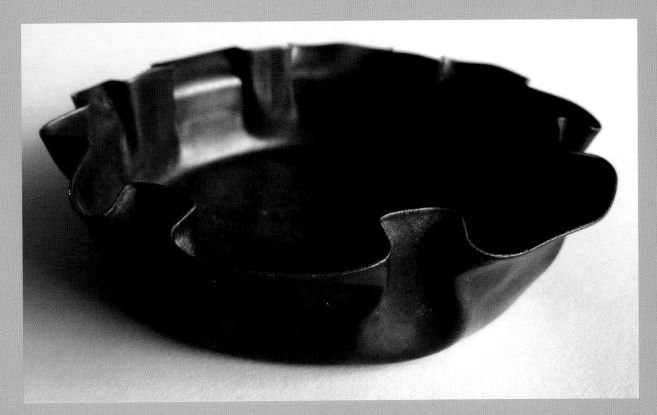

Glander copper dish. Author's collection and photo.

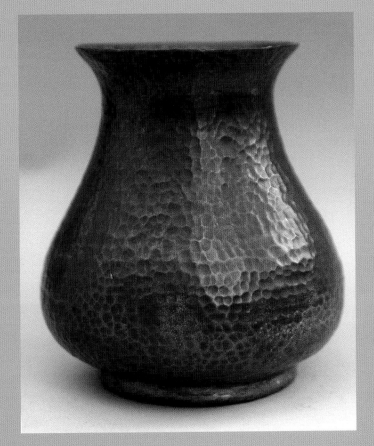

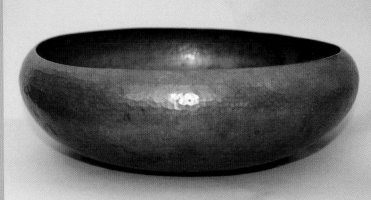

Northland copper bowl and vase. Courtesy of Boice Lydell.

VII

Mystery Marks

The late Milo M. Naeve, former curator of American Art and the Art Institute of Chicago (AIC), illustrated a Martelé style coffee service and tray that was made for a Chicago family in *A Decade of Decorative Arts* (1986). The set was marked B.S.C/WC/Handwrought, identical to the marks shown at right. Noting that the WC mark had been attributed to William Codman twice by Sotheby's, Naeve contacted Charles H. Carpenter, author of *Gorham Silver*, who dismissed the notion that the set was made by Codman Sr. or Jr., likely not realizing that William Codman Jr. was a silver designer for Spaulding & Co. in Chicago. B.S.C. is an unknown retailer, but Naeve concluded that it was not the Bixby Silver Co. of Providence, Rhode Island, as that was a retail silver plate company and B.S.C. was probably a Chicago company.[1]

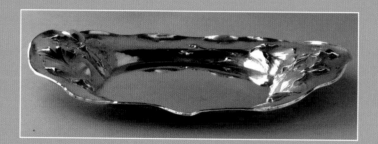

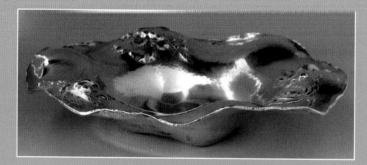

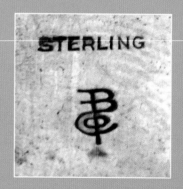

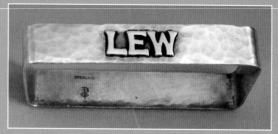

Chicago-style sterling silver napkin ring with applied monogram, marked with a letter cipher. Might represent William E. Benbow and Company, however, the family is unfamiliar with the mark. Author's collection and photos.

Floral repoussé bowl marked B.S.C and engraved with a WS signature; Hand Wrought is also engraved on some of the pieces. Sotheby's attributed these marks to William Codman. May represent William Codman Jr. (See Spaulding in Chapter 5.) Author's collection and photos.

Many jewelry items are marked with a back-to-back CC. The broad variety of styles indicates many different makers and years. The jewelry might represent Clemencia C. Cosio Hall before and after the TC Shop. Author's collection and photos.

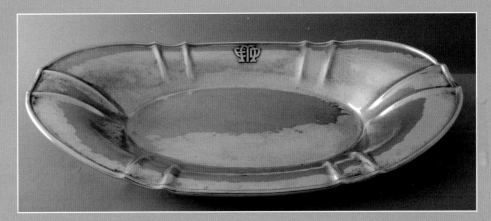

Mulholland style bowl with applied monogram, probably from Park Ridge, IL, c.1912. Marked with the letters DM with a four-leaf clover. Possibly David Mulholland prior to establishing the Mulholland Brothers or another silversmith associated with the Kalo School. Author's collection and photos.

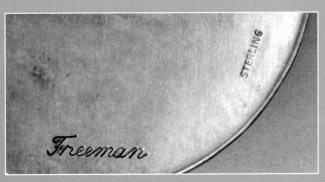

Sterling and enamel jewelry marked with Freeman in script. Brooch was purchased with an original Kalo Shop felt pouch. Jewelry may be a 1930s style attributed to Russell Freeman of Chicago. Author's collection and photos.

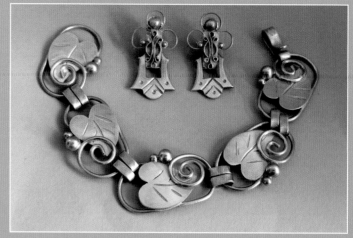

Sterling silver jewelry signed Holston Hand Wrought. The earrings are similar to Enoch Olsson's work and the bracelet is similar to New York-area silversmiths in the 1940s. Author's collection and photos.

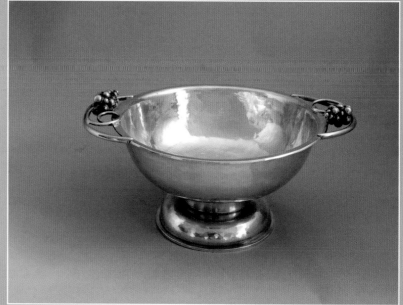

Sterling silver bowl with applied grape decoration signed Hunt. Previous owner stated it was made by a woman silversmith from Wisconsin. Author's collection and photos.

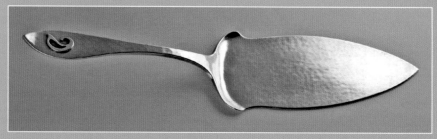

Sterling silver server marked OH. Might be Ole Horway, a Kalo and Lebolt silversmith. Courtesy of Chicagosilver.com.

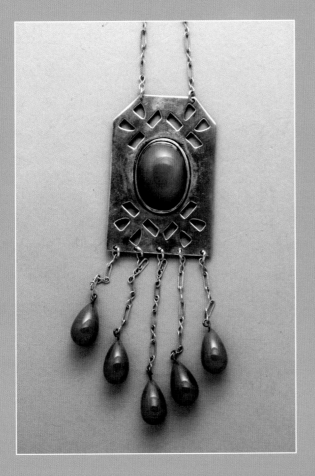

Many jewelry items set with green chrysoprase or chalcedony are marked with a letter M in a triangle. Courtesy of Chicagosilver.com and author's collection.

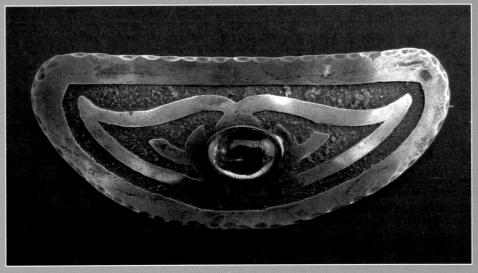

Acid-etched brooch marked SDS. Possibly from the Grand Rapids, Dayton or Chicago area. Courtesy of Boice Lydell, photos by author.

A handful of Chicago-style sterling silver table items are marked with the letters WOK. This specific Hand Wrought stamp was associated with the Chicago Silver Company. Items are likely by a Chicago retail jeweler. Author's collection and photos.

Appendix 1

Known Workers for the Kalo Shop

Silversmiths

Bjarne Becker Andersen, 1912–1919
Sven Wilhelm Anderson, 1910–c.1916
Bjarne Axness, c.1909–1943
Peter L. Berg, 1909–c.1936
Robert R. Bower, 1921–1970
Edward Harry Breese, 1913–c.1916
John H. Cook, 1917–1918, 1920–1930s
Carl Henry Didrich, 1912, 1916–1918, 1920–c.1922
Henri Anton Eicher, 1908–1915
Esther Mabel Frame, c.1917–1918
Isadore Victor Friedman, 1909–c.1912
Raymundo Gomez, c.1958–1970
Edwin Emil Guenther, c.1910–1914
Ole Horway, 1917–c.1918
Einar Johansen, 1925–1934
Walter Kichura, 1936–1941, 1946–c.1970
Ivan Loukacheff, c.1959–1966
David E. Mulholland, 1912
Walter S. Mulholland, 1912
Arne Myhre, c.1909–1960s
Yngve Olsson, 1915–1918, 1920–1970
Joseph Edward O'Marah, 1908–c.1911
Daniel H. Pedersen, 1914–c.1964
John Pontius Petterson, c.1913–1914
Julius Olaf Randahl, 1907–1914
Henry A. Strater, 1910–c.1914
Emery Walter Todd, c.1908–1910
Clarence Willie, c.1910–1914
Edmund C. Zerrirn, c.1908–1914

Women designers, crafts workers, and jewelers

Dorothy Atwell, student and jewelry designer, c.1911–1914
Gertrude Atwell, student and jewelry designer, c.1911–1914
Frances Margaret Augustine, (Mrs. Herman Schimpff), student, jewelry designer, c.1922
Helena Barck, designer and manager, 1905–1930s
Mildred Belle Bevis, (Mrs. Marshall W. Hanks) designer, jeweler and instructor, c.1909–1913
Hannah Christabel Beye, designer and jeweler, c.1904–1908
Mary F. Brown, student and jeweler, c.1913–1914
Edna Coe, designer and jeweler, c.1909–1913
Agnes Dyer Cox, designer, 1902

Mabel Conde Dickson, designer and jeweler, 1902–1903
Minnie Dolese, designer and leather worker, 1901
Rose Dolese, designer and leather worker, 1900–1901
Anne Pond Doughty, designer, jeweler and manager, c.1916–1922
Evelyn P. Ellsworth, designer and jeweler, c.1908–1912
Grace Darling Gerow, designer, leather worker and jeweler, 1900–1907
Bertha Hall, designer, 1900–1901
Marion Bell Haskins, (Mrs. John Henry Evans), student, designer and jeweler, 1912–1913
Claudia E. Kellogg, designer, manager, and investor, 1906–c.1910
Julie Mayer, designer and jeweler, 1910–c.1914
Esther Lydia Meacham, (Mrs. Harold W. Ward), student, designer, jeweler, instructor, c.1910–1914
Evelyn, T. McCarrer, designer and investor, 1906–c.1910
Bessie McNeal, (Mrs. Reginald Boice Calcutt), designer, 1900–1901
Metta Frances Morse, (Mrs. Leo H. Junker), designer and metalworker, 1905
Ruth Raymond, designer and leather worker, 1900–1903
Florence E. Rice, designer and leather worker, 1902
Angelina St. John, student and jewelry designer, c. 1908–1909
Amy Sanders, jewelry designer, c. 1909–1911
Josephine Stevenson, wood chip carver, 1902
Helen M. White, designer, c.1915–1917
Catherine M. Wood, student, crafts worker, c.1907–1909
Dorothy M. Wood, (Mrs. Bjarne H. Lunde), student, jewelry designer, c.1910–1914
Myrtle Wood, student, jewelry designer, c.1910–1914
Marie L. Woodson, crafts worker, c.1901–1902

Men jewelers

Robert R. Bower, jeweler and manager, 1921–1970
Kristoffer Haga, jeweler and foreman, c.1913–1914
Matthias William Hanck, jeweler and instructor, 1908–1910
Arthur W. Scott, jeweler, c.1910–1918, 1920–c.1925
Henry Richard "Dick" Sorensen, jeweler, 1908–1913
Victor Weinz, jeweler, 1910–c.1913
Grant Wood, student, jeweler, 1913–1914
William Wood, jeweler, c.1910–1914
Peter M. Young, jeweler, c.1908–1913

Endnotes

Chapter I: Grand Beginnings

1. Boston quote: "Current Art," *Chicago Tribune*, Oct. 23, 1892.

2. Truman (1893)

3. Palmer quote: Weiman (1981) p.582

4. Jewelry and metalwork at the Fair: Not all exhibits at the Fair were listed in the official catalog. See: "Women's Work in the Applied Arts, II," *The Art Amateur,* v.29 (Nov. 1893). Sarah E. Posey was married to Oliver Perry Posey and later moved to Los Angeles. Ann Van Oost and her husband John were British artists who moved to New York at the time of the Fair. For McLaughlin metalwork, also see: "Work by a Talented Lady," *New York Times*, Oct. 27, 1892.

5. Arts and crafts society: "Artists Form a Union," *Inter-Ocean*, Chicago, July 5, 1892; "To Instruct Skilled Artisans," *Chicago Tribune*, July 7, 1892; "For a School of Art and Industry," *Chicago Tribune*, Feb. 2, 1893

6. Ashbee in 1897: "Hull-House Exhibition," *Chicago Inter-Ocean*, April 25, 1897

7. San Francisco: "The Arts and Crafts: It's First Exhibition in San Francisco," *Overland Monthly and Out West Magazine*, V.27 (March 1896)

8. Chicago and Boston: See: Braznell (1993)

9. Wynne: "A Gifted Chicago Woman," *Chicago Tribune*, Jan. 26, 1896

10. For information on Millet and the Chicago School of Architecture, see: Van Zanten (2000), pp: 77-79; Evon, Darcy L., "Rediscovering Louis Millet: a Chicago pioneer; Architectural treasures still can be found in city;" and "Millet empowered a generation of female designers," *Chicago Sun-Times,* April 12, 2004. Didn't sign his work: Interview with Julia Brannon and Julian "Jay" Hawes in 2006.

11. Eugene Train (1832–1903), known as the honorary architect of Paris, designed the Lycee Voltaire, the Croquis of the School of Fine Arts, and the College Chaptal. The latter building is a good example of incorporating ceramic and metal into the design, and Train was the first to do this on an important building. He won the first Duc Prize and was awarded the Legion of Honor.

12. Regrettably for future historians, Millet disdained signing his work, and criticized firms that did so, including Tiffany & Co. Millet impressed this tradition onto many of his students, who also failed to sign their work in their early years.

13. For a picture of Bennett, see: "Women to Revive Old Art," *Chicago Daily Journal,* May 14, 1914, AIC Scrapbook. For photos of her jewelry: *"Art," Chicago Evening Post,* Dec. 17, 1904, and a copper hanging lamp: "What Artists are Doing," *Chicago Evening Post*, Aug. 12, 1902; and the dragonfly trophy: *Chicago Record Herald,* Dec. 10, 1905, AIC Scrapbook.

14. Art Craft Institute (Chicago, Ill.), [Miscellaneous pamphlets]. Chicago History Museum. "How to Earn Money at Home," by T. Vernette Morse, *Chicago Tribune*, March 31, 1907. Morse wrote several leading craft books and developed a strong china painting program at the Art Craft Institute; examples of china are marked Art Craft Studios/Chicago.

15. Chicago gay life, see: Baggett (2000), Anderson (1970), and the *Social Evil in Chicago* (1911:295-98).

Chapter II: Hull-House

1. In 1888, Charles R. Ashbee founded the Guild and School of Handicraft at Toynbee Hall, the pioneer university settlement house located on the east end of London. His intent was, "to train men and boys in the higher sides of technical education; that is to say where the workman is engaged in making beautiful things." Artistic output included hand beaten copper, brass and silver metalwork and jewelry, and the Guild was represented in the earliest exhibitions of the Arts and Crafts Society held in London. See: "Among the Poor of Chicago," by Joseph Kirkland, *Scribner's Magazine,* Vol. XII, No. 1, July 1892, "Chicago's Toynbee Hall," *Chicago Tribune*, June 21, 1891, Bliss, Howard, "Fine Art in East London," *Christian Union*, May 17, 1888 and "The House," *Art Amateur,* 24, no.1, (Dec. 1890). American Periodicals Series Online, pg. 18.

2. "The Chicago Arts and Crafts Society," *Catalogue of the Eleventh Annual Exhibition of the Chicago Architectural Club,* Held at the Art Institute, March 23 to April 15, 1898.

3. Peattie, Elia W., "The Artistic Side of Chicago," *The Atlantic Monthly*, December 1899, 828-834.

4. "Woman Works Silver," *The Weekly Wisconsin,* Milwaukee, Jan. 27, 1900.

5. Darling (1977) reported that Glessner briefly started lessons with Wynne in Oct. 1904. I wasn't able to find a reference to Wynne in Glessner's journals, although she wrote detailed entries for her lessons with Sandberg and Fogliata. According to her journals, Glessner had her first silver lesson in December 1904, but she does not note the name of her instructor. See: Glessner Papers. Also see, "Mrs. Glessner, Social Leader 60 Years," Dies, *Chicago Tribune*, Oct. 20, 1932.

6. For Klapp, see: "Work of a Woman," *Chicago Tribune*, Sept. 18. 1898, "Woman's Work at Paris Fair," *Chicago Tribune*, June 6, 1900 and "Art Notes," *New York Times*, March 21, 1902.

7. "The Labor Museum at Hull-House," by Jessie Luther, *The Commons*, 7, no.70, (May 1902) pp:1–12.

8. "Making Hand-wrought Copper and Silver," *Brush and Pencil* v. 3: (Oct. 1898-March 1899)148–152. For The Mushroom Shop and Kenilworth, see: "Artists' Studios Changing Into Workshops," *Chicago Tribune*, Jan. 13, 1901 and Hall et al. (1941).

9. Wynne told a reporter that the Deerfield (MA) Society of Arts and Crafts, of which she was the president, was the first arts and crafts society established in the country of any importance, founded in 1896, but it was actually called The Deerfield Society of Blue and White Needlework. See: "Arts and Crafts Societies," *Washington Post*, Sept. 24, 1905. 1899 in Chicago: *Catalogue of Paintings*, Inter-State Industrial Exposition, Chicago, Seventeenth Annual Exhibition, (September 4th to October 19th 1889). Obituaries: "Death of Henry Winn," *Springfield Weekly Republican,* Jan. 27, 1916, "Madeline Yale Wynne Dies," *Springfield Weekly Republican,* Jan. 19, 1918 and Peattie, Elia W., "Death Claims Chicago Writer in the South," *Chicago Tribune*, Jan. 19, 1918.

10. Protégé of Jane Addams: Letter to Sharon Darling from Irving F. Friedman, Jan. 26, 1978, Chicago History Museum archives.

11. Falwick Novick papers [manuscript], 1915–1954 (bulk 1940–1950), Chicago History Museum and "Silver Worker Discovers Gold in Chicago Toil," *Chicago Tribune*, April 8, 1945.

Chapter III: The Fine Arts Building and Artisan Studios

1. See Peattie (1911) and Duis, Perry R. "Where is Athens Now?

The Fine Arts Building 1898 to 1918." *Chicago History* (Summer 1977).

2. "New Club of Bohemian Spirits," *Chicago Tribune*, Feb. 17, 1895

3. For Preston, see: "The Lady of the Candlestick," no date, c.1898, newspaper article in the Preston Scrapbook, Ryerson and Burnham Library, Art Institute of Chicago; "Art Notes, Miss Jessie Preston is sailing for France to join Miss Grace Gassett in her reconstruction work for wounded soldiers," *Chicago Evening Post,* Feb. 12, 1918: "Near The French Front," *Oak Leaves,* Oak Park, IL, Aug. 10, 1918: and Jessie M. Preston scrapbook, ca. 1911–1943. Ryerson and Burnham Archives, Art Institute of Chicago.

4. McCauley, Lena, "Art and Artists," *Chicago Evening Post*, Oct. 2, 1913. The Mayan pendant was pictured in Sargent, Irene, "The Work of Albert Wehde, Craftsman and Traveler," *The Keystone*, 34 (Oct. 15, 1912). The Wrigley family no longer owns the pendant.

5. "Handicrafters About to Hold Unique Traveling Exhibit Here," *Chicago Tribune*, October 23, 1910.

6. "Chicago Women Who Are Doing Things," *The Reform Advocate*, V. 39 (May 21, 1910), pp: 695-707.

Chapter IV: The Kalo Shop

1. "Half a dozen girl graduates," *Chicago Post,* October 12, 1900, "Six Women Graduates of the Art Institute," *Chicago Times Herald*, Oct. 21, 1900, and "Artists' Studios Changing Into Workshops," *Chicago Tribune*, Jan. 13, 1901.

2. Information from Chicagosilver.com, which owns some of the corporate ledgers of the Kalo Shop.

3. Interviews with Stanley Hess, Katherine Hess, and Jane Thompson over the course of several months in 2003.

4. "Art and Artists," *Los Angeles Times,* Jan. 26, 1908. Also see: "Stunning Exhibit Shown by League," *Decatur Review,* Apr. 21, 1908 and "Art and Artists," *Chicago Post,* Apr. 25, 1908.

5. Advertisement, *Palette & Bench* V.1 (June 1909:214). Chronology of the Kalo Arts Crafts Community House and School established through interviews, *Chicago Metal-Smiths* files, newspaper articles, census and court records. Also: Reed, Grace Hibbard, *Pennyville to Park Ridge*, manuscript, n.d. c.1945; Salman, Carroll, *Grant Place home is a beautiful link to city's past,* n.d., both courtesy of the late James Bornhoeft and Evon, Darcy L., "Saving this old house: Time running out to preserve historic Park Ridge arts home," *Chicago Sun-Times*, Jan. 15, 2007.

6. See "Webb C. Ball display of silver from the Kalo Shop," *Cleveland Plain Dealer,* Dec. 9, 1913 and "Kalo Silver Exhibit at the Webb C. Ball Co.," *Cleveland Plain Dealer,* Apr. 30, 1914.

7. Interview with Katherine Hess, 2003.

8. "Mrs. Clara B. Welles, Silversmith," *Christian Science Monitor,* Oct. 3, 1924.

9. Dozens of articles mention Clara Welles and her role in Votes for Women. Of the most important: "Heirlooms to the Melting Pot," *Chicago Tribune,* July 31, 1914; "Pageant at Washington Biggest Thing Yet Attempted by the Suffragists," *Chicago Tribune,* March 2, 1913; "Suffrage Parade Leader, Illinois Women Marchers and 'General' of Hike to the Capital," *Chicago Record-Herald*, March 4, 1913; "5,000 Women March Beset by Crowds," *New York Times,* March 4, 1913; "Hoodlums Vs. Gentlewomen," *Chicago Tribune,* March 5, 1913; "Illinois Women Participants in Suffrage Parade: This State Was Well Represented in Washington," *Chicago Tribune,* March 5, 1913; "Jeering Mobs Are Silenced by Illinois Women in Parade," *Chicago Tribune,* March 9, 1913; and "House Passes Suffrage Bill; Dunne Promises Signature," *Chicago Tribune* June 12, 1913.

10. The house was razed on March 16, 2007. See: Evon, Darcy L., "Clara Welles' workshop slated for demolition," *Chicago Sun-*

Times, June 20, 2005 and "Prize Winning Architecture," *Chicago Tribune,* Feb. 24, 1924.

11. Cited in Kelly (2006).

12. Boykin, Elizabeth MacRae, "Modern Silver Put on Display," *New York Sun,* Apr. 10, 1937 and "Work of Talented Chicago Silversmith Has Classic Simplicity and Grace of Line," *Chicago Tribune*, May 9, 1937.

13. Paul Somerson and I determined that the Chicago/New York mark was used from 1912 to 1916 based on a survey of an extensive collection of dated silver. The Kalo Shops/Chicago was used early in 1912 and Chicago/New York by the fall of 1912. I retraced the history of the leases and locations from newspaper articles and city directories, which indicated the store was there from 1912–1916. The 1914–1918 date reported by Darling (1977) stemmed from an interview with Robert Bower and a misinterpretation of a common saying of Welles, that she signed a lease in New York when World War I started. In reality, she signed a lease at a new location, 130 W. 57th Street, which the Kalo Shop moved into in 1915. Welles closed down the New York store at the end of 1916. See: "Big Rental on Fifth Avenue," *New York Daily Tribune*, Dec. 10, 1911.

The Park Ridge Artist Colony

14. Sharon Darling only mentioned a "Wolund Shop" in *Chicago Metal-Smiths* (1977). Later researchers misidentified and misinterpreted marks, works and individuals. I identified a second Volund Shop that was founded by B.B. Andersen and identified his BAB logo, which has been wrongly attributed to a "Heinrich" Eicher or an "Anna" Eicher. Andersen's family-owned silver was marked with his BAB logo, Daniel Pedersen's individual mark, and several variations of the Volund mark, reflecting the different years it was made. The name of the Volund Crafts Shop was first published in the modern literature in an excellent book by Jane Milosch (2005) based on consultations with the author.

Provenience and attributions: The candlesticks marked Volund (which were acquired after the Milosch book was published), are consistent with Grant Wood's known work and came from an estate just east of Cedar Rapids, IA. I compared the hammer marks on the candlesticks with those on lanterns apparently made by Grant Wood and believe they were made by the same tools. Further, Andersen, Pedersen and the Volund Shop did not make this style of candlestick, which is similar to Roycroft Princess candlesticks, and they barely worked in copper. (The Volund Shop made Kalo style silver-plated copper bowls with applied sterling monograms, but other copper pieces are unknown.) The necklace in the possession of the Cedar Rapids Art Museum has solid provenience and was known to be the work of Grant Wood, although it is unsigned.

There is no evidence that Grant Wood designed any of the silver for Andersen's Volund Shop, and Garwood's (1944) account of their relationships suggests the contrary. The Minneapolis Institute of Art attributed a late and complicated silver set to Grant Wood and Kristoffer Haga (see Olivarez et al. 2000) that most certainly was made by Andersen's Volund Shop, and it should be celebrated as such. I haven't been able to determine Haga's involvement with Andersen's Volund Shop, but the men were very close and many of the Chicago metalsmiths worked for several shops at the same time. It is possible and even likely that Haga made jewelry for the second shop after the war; the Volund Shop also employed additional silversmiths and jewelers that have not been identified. More information may shed light on these relationships.

15. Interviews with Bernice Ocken, Bjarne S. Andersen and Laverne and Mervyn Bridges, September-December 2002 and April-June 2003. Andersen used his BAB logo occasionally while at the Volund Shop and also after the shop closed. A BAB server

with a characteristic strap work handle on eBay was dated 1928. Also see: "Jeweler Erects 3D Apartment in Edison Park," *Chicago Tribune*, July 3, 1927 and "Varied Career for Motel Operator," *Daytona Beach Sunday News-Journal*, Nov. 29, 1970.

16. *Chicago Metal-Smiths* papers, Chicago History Museum.

17. I am grateful to Vivian Møller for providing information on Asta Eicher, her mother Anna N. Larsen, photos of Asta's hand-painted and signed china and the hand-written Park Ridge postcard. Asta signed her china with block letters AE; signatures on her oil paintings have not been identified. I consulted hundreds of newspaper articles, church records, probate records, criminal records, and vital records to reconstruct the Eicher's lives but omitted citations due to space constraints.

18. Garwood (1944). For detailed information on Grant Wood and his paintings, see Evans (2010).

19. *An Illustrated Annual of Works by American Artists & Craft Workers 1915–1916*, The Artists Guild Galleries, Fine Arts Building, Chicago. I am grateful to Sara K. Nuernberger, who found detailed property ownership information on land owned by Haga and Podkasick in Wisconsin.

20. See pp. 54, 57 and 61 in Schiffer & Drucker (2008) for photos of Bjarne Meyer jewelry from a 1944 Georg Jensen New York catalog, although the works are not identified by the name of the artist.

Kalo Arts and Crafts Entrepreneurs

21. See: "Keen Interest in Water Colors, Hand-wrought Silver Also Being Shown," *Decatur Sunday Review*, January 4, 1925; *Catalogue of the Ninth Annual Exhibition of the Milwaukee Art Institute,* Wisconsin Society of Applied Arts, Nov. 3-30, 1926; and "Metal Hobby Adds Thrills," *The Decatur Review*, October 27, 1929

22. Thanks to Mark Szyndrowski for establishing that Horway also worked for Lebolt.

Chapter V: Chicagoland Business Districts

1. 1904 ad: Marshall Field & Co. archives. See: "A Genuine Craft Shop," *Illustrated Review*, V.I, (Dec. 1908).

2. From c.1903, wholesale silver in similar and identical patterns to the later Marshall Field & Co. Colonial silver line appeared with a host of retailers. The pieces were marked with 925/000 in a cartouche or Sterling in a cartouche, as well as the name of the retail merchant on some of the pieces, including Marcus & Co., Shreve, Crump & Low, Daniel Low & Co., J. E. Caldwell and Theodore Starr of New York. The 925/000 mark also appeared on several pieces of classic arts and crafts jewelry from c.1906; Field's opened its retail lines of Colonial silver and its Craft Shop in December 1907.

3. See: "Art Finds Way Out in Hard Fight," *The Chicago Defender*, Feb. 25, 1922; "Oldtimers Reinacting 1924 World Series," *Washington Post*, Sept. 2, 1951; "Tower Ticker," *Chicago Tribune*, Sept. 4, 1951; "Baseball Jeweler," *Ebony* (Oct. 1956); "Jeweler is Ball Players' 'Diamond in the Rough,'" *Chicago Tribune*, Aug. 3, 1958

4. "W.N. Brooks Hand-Wrought Jewelry," *Advertisement, Picture and Art Trade and Gift Shop Journal*, Sept. 1, 1916; Family interviews, 2011; Petterson ledgers, 1940s, collection of Cobblestone Antiques, Arlington, IL; obituary, *Chicago Tribune*, May 27, 1955.

5. In 1895, Jarvie divorced Fannie M. Egbert on the grounds of desertion, a common argument for divorce at the time. His son Robert L. Jarvie (1889–1960) lived with his maternal grandmother, and there was no indication Jarvie had any further contact with him; his death certificate listed his parents as unknown. Jarvie

also stated in a letter that he had no children to carry on the family name. Divorce notice: "Superior and Circuit Courts—Decrees," *Chicago Tribune*, March 18, 1895. Letters: Robert R. Jarvie, May 16, 1913 to Dr. William Jarvie in Gloucester, MA and February 4, 1914, to "Deareth Jarvie," Ryerson and Burnham Libraries, Art Institute of Chicago.

6. Jarvie claimed to a reporter that he was inspired and totally self-taught when he made his first lantern, in much the same way he claimed years later to have invented the Aberfoyle rug. See: "An Appreciation of the Work of Robert Jarvie," *The Craftsman*, Dec. 1903. Jarvie said in a 1917 Chicago Artists' Guild bio that he had studied with Ryder, which likely was a typo for Ryden, who was a Krayle craftsman and instructor at the Art Craft Institute. Ryden instructed students in modeling and casting as well as metalwork, skills that Jarvie used in making his early candlesticks.

7. Jauchen arrived from Hamburg on October 3, 1909, but his record said he had also been in the United States earlier in 1909, and he also arrived in New York in July 1908. The book was presented in April 1909. Jauchen's bio, published for his summer school teaching position at Berkeley, said that he previously was the manager for Jarvie Art Metal Works from 1909 to 1910, and that he was an independent craftsman from 1910 to 1912. Jauchen moved to San Francisco by 1911, when he was listed in the city directory. He taught summer school at Berkeley from 1912 to 1913. Jauchen later established Jauchen's Olde Copper Shop in San Francisco.

8. "Chicago Craft Worker Honored," *Rockford Register-Gazette,* May 8, 1909 and "City Brevities," *Rockford Register-Gazette*, June 16, 1909. The cup was identified as designed by Elmslie in *Michigan Alumnus*, 15 (1909), Hathitrust Digital Library.

9. For letter, see Jarive papers at the AIC. Gustafson also noted that "the previous [silversmith] had worked there five years," which may indicate that Petterson continued to do work for Jarvie after he announced his own studio, which catered to wholesale and retail customers. A family questionnaire filled out by John C. Petterson in 1977 also indicated that Petterson worked for Jarvie until c. 1914, Chicago History Museum.

10. "From Here and There," *Chicago Evening Post*, Feb. 26, 1918.

11. "The Hallmark Store," advertisement, *Evanston News-Index*, Dec. 19, 1917. "The Hallmark Store" was added to Lebolt & Co. ads in the *Chicago Tribune* from November 1914-February 1915.

12. "Shortage of Craftsmen Acute Throughout Nation," photo by Fletcher Wilson. Chicago Sun-Times, Nov. 28, 1948

Evanston

1. Hallmark: "The Hallmark Store," advertisement, *Evanston News-Index*, Dec. 19, 1917

2. Cellini Shop: see: Advertisements, *Evanston News-Index*, Aug. 31, 1916; Sept. 23, 1916; Oct. 5, 1917. Cellini Craft at Potter-Mellen: "Hand-Wrought Silver by Cellini Craft," advertisement by Potter and Mellen, *Cleveland Plain Dealer,* Oct. 19, 1941

3. Lord Young hand mirror: "Art Institute Exhibition," Palette and Bench, v. 1, (Dec. 1908) pg: 143. In 2012, the Cranbrook Academy of Art said that the items were sold at auction. See: *Annual Report of the Art Commission of the City of Detroit*, 1920. http://www.dalnet.lib.mi.us/dia/collections/dma_annual_reports/1920.pdf

4. Advertisement, *Manual Training and Vocational Education*, V. 17 (1915–1916). Award: "Silversmiths in Win for Evanston," Evanston News-Index, Nov. 2, 1917. Mulholland Brothers Silver Co: "Exhibits at the A.N.R.J.A. Convention," *Jewelers' Circular,* Sept. 21, 1921

5. Flinn: Obituary, *Chicago Tribune*, March 20, 1945

Oak Park

1. Sandberg: see: *Official Catalogue United States Exhibitors, International Exposition Paris,* English Edition, Paris: Societe Anonyme Des Imprimeries Lemercier. (1900). Bertha Honore Palmer was the Illinois representative to the exposition.

"Shows Rare Artwork, F.W. Sandberg Exhibits Repoussè Design and Enamels at Art Institute," *Chicago Post,* Dec. 17, 1904. (Includes photo of pelican bowl.) See Glessner papers (1905–1906).

Veterans Occupational

1. "Art Notes," *Chicago Evening Post,* Feb. 12, 1918 and "Handicrafts for the Disabled," *Magazine of Art,* V.9, No.2, (May 1918), pp. 297–298.

2. "Legion Auxiliary to Open Veterans' Craft Exchange," *Chicago Tribune,* December 12, 1937

3. For a picture of the 89th Division Insignia, see: "American Decorations and Insignia of Honor and Service," *National Geographic Magazine,* (December 1919) pg. 516. Also see:

"Tribute By Pershing," *Washington Post,* Nov. 3, 1919; "Maimed Soldiers Expert In Crafts," *Washington Post,* Feb. 13, 1921; "Wounded Soldier Learned trade of Decatur Woman," *Decatur Review,* April 2, 1922; and "Veteran Found Suicide by Gas; Maimed in War," *Washington Post,* Feb. 24, 1935.

4. See: "News of Society," *Chicago Tribune,* Jan. 10, 1919; "Art Triumphs," *Chicago Tribune,* March 6, 1920; "Vocational School at Fort Sheridan," Grand Rapids Press, April 25, 1921.

Chapter VI: Regional

Illinois

1. For photos of Googerty work see: "Some Ornamental Iron Work from the Illinois State Reformatory," *American Blacksmith,* V.14 (March 1915); Miller (1999) and Googerty (1937).

2. "Young Designer Comes to Study Working in Metals with Lucien Shellabarger," *Decatur Herald,* Dec. 14, 1930

3. *Stories of a Prairie Town : History of Rankin, Ill.-Vermilion Co.* http://archive.org/stream/storiesofprairie00rank/storiesofprairie00rank_djvu.txt

Indiana

1. "Her Metalcraft Spiritual," by Rena Tucker Kohlman, *International Studio,* Oct. 1924. Also see: "Maude Adams to Use Weapon in Play," *Indianapolis Star1,* June 4, 1910; "Art & Artists," *Indianapolis Star,* Feb. 18, 1912; "Indianapolis Women Win in Many Lines of Business and Professions," *Indianapolis Star,* Sept. 6, 1922; "Pioneer in Precious Metal Design," *Repository,* Canton, OH, Jan. 30, 1927. For a comprehensive biography and illustrated review of her work see: Shifman, et al. (1993).

2. Wodiska (1909). Also see: "Indianapolis," *Jewelers' Circular,* May 20, 1908, v. 56, Pg. 75; "Indianapolis Letter, Optical Trade," *Keystone Magazine of Optometry,* V.2, 1910, pg. 676; and "New Arts and Crafts Society in Indianapolis," *Brush & Pencil,* V. 16, no. 5, Sept. 1905.

3. "Interlaken and the Roycrofters," *The Fra,* edited by Elbert Hubbard, v.7, no.3, June 1911

Iowa

1. "Metal Work Display at the Art Exhibit," *Cedar Rapids Gazette,* Nov. 25, 1913.

2. The common story is that Grant Wood went to Minneapolis after graduating from high school in 1910, based on Garwood's account (1944). However, Garwood erred on the date because Batchelder was not in Minneapolis in 1910, as he launched his own school in Pasadena, CA that summer. As Wood surely studied with Batchelder, it must have been in 1909. See: Garwood

(1944). For back-to-back advertisements for the summer schools, see: "Summer Schools," *School Arts Magazine,* V.9, pg. XIII, (1910) (books.google.com) the first ad is for the Handicraft Guild Summer School, under the directorship of Maurice I. Flagg, June 13-July 16. The second ad is for the "Batchelder Craft Shop, School of Design and Handicraft, Pasadena, CA, Ernest A. Batchelder, Director. Summer classes in June and July."

3. "Well Known Artists to Aid the Sketch Club," *Cedar Rapids Gazette,* July 12, 1913. If Grant Wood had gone to the Kalo Shop in the spring of 1913 as reported by Garwood (1944), he returned to Cedar Rapids for the summer, as he took lessons from Hostrup and Wargny. Wood was enrolled at the AIC in October 1913 and launched the Volund Crafts Shop with Kristoffer Haga in June 1914. For information on Hoftrup, see: Lars Hoftrup and Armand Wargny: A Retrospective of Drawings, Paintings and Prints. April 14-May 31, 1978, Arnot Art Museum, Elmira, New York (1978).

4. See: "Will Start Arts and Crafts Shop, Young Woman Decorator Institutes a Novelty, Has Hand Made Jewelry," *Des Moines Daily News,* October 15, 1906; Occupants of the Utica Building, advertisement showing logo, *Des Moines Capital,* Jan. 20, 1910; "Miss Florence Weaver Prominent in Art Circles," *Des Moines Daily News,* Nov. 13, 1910; "Industrial Art at the Art Institute of Chicago," L. M. McCauley, *Art and Progress,* Vol. 6, No. 1 (Nov., 1914), pp. 28–29; "Exhibition of Industrial Art at the Art Institute," Evelyn Marie Stuart, *Fine Arts Journal,* Vol. 31, No. 5 (Nov. 1914), pp. 546-551; and "Women Trust Each Other in Their Affairs," *Des Moines Daily News,* Sept. 10, 1916.

5. *When Tillage Begins: The Stone City Art Colony and School,* published by the Busse Library, Mount Mercy University, Cedar Rapids, IA http://projects.mtmercy.edu/stonecity/index.html

Kansas and Kentucky

1. "Young Designer Comes to Study Working in Metals With Lucien Shellabarger," *Decatur Herald,* Dec. 14, 1930.

2. Falino and Markowitz (2004).

3. See: "Social Whirl," *Hutchinson Kansas News Herald,* July 3, 1938; "Crafts in Kansas," *Kansas City Times,* Dec. 24, 1941; Craver, Margret, "The Crafts in Kansas," *The Kansas Magazine* (1942); "Art of the Modern Silversmiths," *New York Times,* Aug. 1, 1948; "Titled Artisan Says Silversmithing Dwindling," *Boston Herald,* Aug. 1, 1948; "Remembering Margret Craver Withers," http://www.modernsilver.com/rememberingmargretcraverwithers.htm

Michigan

1. "Successful Graduate of Hackley Manual Ranks Institution as One of Best in Country," *Muskegon Chronicle,* Jan. 9, 1914; "Muskegon Boy Wins High Honors at Art School for Work in Jewelry Designing," *Muskegon Chronicle,* July 8, 1914; "Muskegon Youth, Graduate of Hackley Manuel, Now Instructor at University," *Muskegon Chronicle,* Sept. 26, 1914.

2. "Pleads for Simplicity," *Muskegon Chronicle,* Aug. 8, 1904; "Workshop for Arts and Crafts May be Moved to Muskegon," *Muskegon Chronicle,* Sept. 23, 1904.

3. See: "Prepare for Opening of Summer School of Arts and Crafts," *Muskegon Chronicle,* June 3, 1905; "Port Sherman on the Lake," ad in the *Grand Rapids Press,* July 1, 1905; "School for Arts and Crafts Will Exhibit at Chicago in May," *Muskegon Chronicle,* Feb. 1, 1906; "Society and Personal," *Kalamazoo Gazette,* June 17, 1906; "Works in Metals, Rare Art Produced by Forrest Emerson Mann in His Odd Studio," *Grand Rapids Press,* April 21,1906; "Grand Rapids Artists and Writers," Grand Rapids Press, January 1, 1907.

4. "Purposes of the Forest Craft Guild," *Grand Rapids Press,* Feb. 18, 1909; "Forest Craft Guild Gift Shop and Tea Room," advertisement with photograph of the shop, *Grand Rapids Press,* Dec. 6, 1910.

5. "Unprecedented Sale of Jewelry. Art Metal. Art Pottery and

Leather Goods, Forest Craft Guild," advertisement in the *Grand Rapids Press*, 11-8–1911 and "Forest Craft Guild Removal Sale," advertisement, *Grand Rapids Press*, March 8, 1912.

6. See: "Reopen Arts and Crafts Studio," *Grand Rapids Press,* Sept. 24, 1914; "Women Who Lead the Way, Blanche M. Utley—Creator of Beautiful Jewelry," *Oregonian,* Jan. 29, 1916.

7. "How Arts and Crafts flourished in industrial Detroit," by Vivian M. Baulch, *The Detroit News*, Dec. 9, 2000

Minnesota

1. See: "Summer School of the Handicraft Guild," *The Craftsman*, v.8, May 1905, pg. 266–267; "Handicraft Guild of Minneapolis, 4th Annual Summer School of Design and Handicraft," *School Arts*, V. 7, No. 9, (May 1908) p. 843.

2. See page 185 in Anderson (1994).

3. Donaldson Gothic DD mark: Detroit Institute of Arts (1976:85)

4. "Edgar L. Perera," Advertisement in the *International Studio*, V. 36, (Feb. 1909), p. 22. For a photo of Perera's work see: "Signor Perera's Egyptian Collection," *International Studio*, V. 36, (1909) and "Jewelry of a Tuscan Craftsman: Edgar Perera," by A. Rainey, *House Beautiful* V.35 (Dec. 1913), pp.28–29.

Missouri

1. Louise Garden, born in Toronto, was the sister of Prairie School architect Hugh Garden and her brothers Frank and Edward were also architects. Edward moved to San Francisco in the fall of 1911 and Louise may have gone there or back Chicago after 1910.

2. See: Binder and Steiner (1980).

3. "Silversmithing Seminar Set For Art Festival," *Sarasota Herald-Tribune,* Jun 12, 1953 and http://www.oldstatehouse.com/ernie_deane/photo-gallery/default.aspx?categoryID=264

Ohio

1. See: "Women Learn to Work in Metals," by Mildred Watkins, *Cleveland Plain Dealer*, May 15, 1910; "Mildred Watkins Outstanding Artist in Making Jewelry and in the Art of Silversmithing," by Grace V. Kelly, *Cleveland Plain Dealer*, Jan. 28, 1934; and "Mildred Watkins, 85, Dies; Widely Known Enamelist," *Cleveland Plain Dealer*, April 8, 1968.

2. See: "Opens Way For Artists And Art," *Cleveland Plain Dealer,* Apr. 29, 1906; "Art and Artists," by Jessie C. Glasier, *Cleveland Plain Dealer,* Feb. 24, 1907; "Art and Artists," by Jessie C. Glasier, *Cleveland Plain Dealer,* March 29, 1908; "Critic Tells of Paris Art Students," by Grace V. Kelly, *Cleveland Plain Dealer,* Oct. 28, 1928; "Takes Over Art Shop," *Cleveland Plain Dealer,* March 31, 1933; "Frederick A. Miller, 86, Well-Known Silversmith," *Cleveland Plain Dealer,* Jan. 11, 2000; Hawley (1996); and "When Artists and Craftsman Were One: Horace E. Potter and Arts & Crafts Silver in Cleveland," by Marting, Leslie G., *Silver Magazine* (May/June 2005) pp 30-36.

3. See: "Opens Way for Art and Artists," *Cleveland Plain Dealer,* April 29, 1906; "Girls, Experts at Weaving, Have Display and Workshop," by Grace V. Kelly, *Cleveland Plain Dealer,* Sept. 11, 1927.

4. See: "The Annual Arts and Crafts Exhibit at the National Arts Club, New York," *The Craftsman,* (Jan 1908); "The Rokesley Shop," advertisement, *Cleveland Plain Dealer,* June 28, 1911; "Art Museum Buys Rare Old Crucifix," *Cleveland Plain Dealer,* Aug. 15, 1926 (info on Stephan, Wyers, Watkins, Potter, Rokesley) and Hawley (1996).

5. *An Illustrated Annual of Works by American Artists & Craft Workers, 1915–1916,* The Artists Guild, Fine Arts Building: Chicago; *A National Association of Artists and Craft Workers,* 1917, The Artists Guild, Fine Arts Building: Chicago; for jewelry: "The Annual Exhibition," *The Bulletin of the Cleveland Museum of Art*, Vol. 9, No. 5 (May, 1922), pp. 70-88; and "Exhibition of

American Handicraft," *Jewelers' Circular,* V.85, no.2, January 24, 1923. Burton at Potter: "Varied Crafts Exhibits at May Show," *Cleveland Plain Dealer,* May 27, 1928. Burton Memorial Exhibit: "Pottery and Enameling in May Show," by Grace V. Kelly, *Cleveland Plain Dealer,* May 27, 1934.

6. See: "Cleveland Woman Works Pretty Designs in Metal," *Cleveland Plain Dealer,* Oct. 27, 1918; "An Old World Artist," *Springfield Republican,* Nov. 14, 1918; and "Anna Wyers Hill, Art Worker, Dies," *Cleveland Plain Dealer,* Aug. 3, 1933.

7. "Work of the Jewelry Classes at the Ohio Mechanics' Institute at Cincinnati, O.," *Jeweler's Circular,* 74, no.24 (July 18, 1917) pg. 39; "Theodore Hanford Pond, Craftsman," by Warren Wilmer Brown, *International Studio,* V. 47 (Sept. 1912), pp: 93-95; MIA Vase: http://www.artsmia.org/viewer/detail.php?v=12&id=6987

8. "Women's Work in the Applied Arts II," *The Art Amateur*, V.29 (Nov. 1893), p. 154

9. See: "The Arts & Crafts Movement," *Bulletin of the Department of Labor*, 1904, Volume 9, Issues 54-55; pages 1597–1622; "The Work of an Amateur Goldsmith: Brainerd B. Thresher," by Irene Sargent, *The Keystone*, V. 26 (Sept 1905), pp. 1417–1420; Drury (1909) and "Some Recent Work by Mrs. Hugo Froehlich," by Eva Lovett, *International Studio*, V.32 (Sept. 1907) pp. 91-94.

10. "Frost Arts and Crafts Workshop," Cats. 52 and 82, 1911. Winterthur Museum Library http://archive.org/details/catalogue8200fros

Wisconsin

1. "Women's Work in the Applied Arts II," *The Art Amateur*, V.29 (Nov. 1893), p–154

2. "Racine School of Fine Arts," advertisement, *Racine Journal,* June 14, 1907; "The Art Shop," advertisement, *Racine Journal News*, May 10, 1912; advertisement, *Racine Journal News,* March 21, 1913; shop is referred to as "the Arts and Crafts Shop."

3. The Elverhoj Colony, founded nine years ago at Racine, WI, now in its third year in NY, from: *School Arts Magazine,* Worcester, MA, V. XV, No.1, (Sept. 1915). "Flora Americana, the New American Jewelry," by Guy Aldrich, *Art: A Monthly Magazine*, by O'Brien Galleries, published in *The Trimmed Lamp,* Chicago, (Dec. 1912). Larson, Hanna Astrup, "The Craft Work on the 'Hill of Fairies,'" *Craftsman,* V.30, no.6, (Sept. 1916).

4. Some of the work by Upham's students shown in the *Industrial Arts Magazine* (v.5, 1916) is strikingly similar to the Kalo Shop, and I suspect she studied and worked there sometime between 1908–1913, before she was hired to teach at Milwaukee-Downer College in 1913.

5. "War Worker of Ambulance Corps Here," *San Diego Union*, Oct. 11, 1919

6. For bio and Kalo influence, see Wascher (1927). Coffee set: "Personality of the Week: Miss E. Mabel Frame," *Waukesha Daily Freeman,* Oct. 16, 1954; "Mabel Frame Winner in Art Exhibit," *Waukesha Freeman,* April 6, 1933; and "Annual Exhibit Offers Articles of Many Types," *Waukesha Daily Freeman*, Oct. 28, 1953.

7. "Hammering Hammerer Makes Exquisite Silver," *Wisconsin State Journal,* Jan. 24, 1960. "Storm Fatal to Silversmith G.E. Andersen," *Wisconsin State Journal*, Jan. 7, 1962

Chapter VII: Mystery Marks

1. Three letters from Milo M. Naeve and Charles H. Carpenter, October 1983, Courtesy of the Art Institute of Chicago. See: Naeve, Milo M., *A Decade of Decorative Arts,* Art Institute of Chicago (1986) pg.95; Fine Art Nouveau, Sotheby's New York, Catalog, Nov. 12 & 13, 1980, Auction item #359; and Art Nouveau & Art Deco, Sotheby's York Avenue Galleries, Catalog, Feb. 4 and 5, 1981, Auction item #184.

Bibliography

Special Collections

Art and artists of Chicago, Scrapbook [microform], Ryerson and Burnham Archives, Art Institute of Chicago.

Chicago Art Silver Shop and Art Metal Studio [graphic]., Art Metal Studios (Chicago, Ill.), 1912-ca. 1929. Chicago History Museum.

Chicago Jewelers and Silversmiths, misc. catalogs, author's collection.

Chicago Society of Decorative Art records [manuscript], 1877–1895., Chicago History Museum.

Darling, Sharon, papers, Chicago Metalwork, Chicago History Museum.

Elverhoj brochure, Milton-on-Hudson, author's collection.

Florence Reynolds Collection related to Jane Heap and *The Little Review,* 1881-1978, Special Collections Department, University of Delaware. (Includes photos of Jane Heap's jewelry.)

Glessner family papers,1851–1960 (bulk 1864–1881). Series 1. Journals of Frances M. Glessner & diary of Helen Macbeth (transcripts, box 1-6). Chicago History Museum.

Googerty, Thomas F., Collection, ca. 1902–1909. Ryerson and Burnham Archives, Art Institute of Chicago.

Heuermann, Magda papers, 1876–1962, Archives of American Art, Smithsonian Institution.

Heuermann, Magda, collection of portrait miniatures, archival collection, Paul V. Galvin Library Archives, Illinois Institute of Technology.

Jarvie Shop, The: the Fine Arts Building, Chicago, Illinois, USA: [catalog] and Jarvie papers, Ryerson & Burnham Archives, Art Institute of Chicago.

Kronquist, Emil F., scrapbook, Metal Craft and Jewelry by Emil F. Kronquist and His Students, Book 2, 1902–1950. Author's Collection.

Marshall Field & Co, Chicago, catalog #146 (wholesale), Jewelry, Diamonds, Ariston Watches,Silverware, Clocks, Cut Glass, Etc., 1909–1910.

Novick, Falwick (sic) papers [manuscript], 1915–1954 (bulk 1940–1950), Chicago History Museum.

Preston, Jessie M., scrapbook, ca. 1911–1943. Ryerson and Burnham Archives, Art Institute of Chicago.

Randahl, Julius O., collection of visual materials [graphic].ca. 1925–1969. Chicago History Museum.

Wisconsin Designer-Craftsmen. 1916. Wisconsin Designer Craftsmen records, 1916–1973. Archives of American Art, Smithsonian Institution.

Wood, Grant, Scrapbooks, 1900–1962, Archives of American Art, Smithsonian Institution.

Books

Addams, Jane. *Twenty Years at Hull-House with Autobiographical Notes.* New York: The Macmillan Company, 1911.

Andersen, Timothy J. *Eudorah M. Moore, and Robert Winter: California Design 1910.* Santa Barbara: Peregrine Smith, 1980.

Anderson, Marcia G. "Art for Life's Sake: The Handicraft Guild of Minneapolis." in *Art and Life in the Upper Mississippi, 1890–1915.* Ed., Michael Conforti. Newark: University of Delaware Press, 1994) pp:122–213.

Anderson, Margaret C. *My Thirty Years' War; the Autobiography: Beginnings and Battles to 1930.* New York: Horizon, 1970.

Ark Antiques Catalogs, Fine, Early 20th Century American Craftsman Silver, Jewelry & Metal, 1991–2004.

Arts and Crafts in Detroit 1906–1976 : the Movement, the Society, the School. Detroit Institute of Arts, November 26, 1976-January 16, 1977, exhibition, Detroit: The Detroit Institute of Arts, 1976.

Barter, Judith A. *Apostles of Beauty: Arts and Crafts from Britain to Chicago.* Chicago: Art Institute of Chicago, 2009.

Beaudette, E. Palma. *Des Plaines, Park Ridge, Mount Prospect.* Chicago: J. Schoenenberger & Sons, 1916.

Bennett, Frances Cheney. *History of Music and Art in Illinois including Portraits and Biographies of the Cultured Men and Women Who Have Been Liberal Patrons of the Higher Arts.* Philadelphia: Historical Pub., 1904.

Binder, Deborah J., and Mary Ann Steiner. *St. Louis Silversmiths.* St. Louis, MO: Museum, 1980.

Boram-Hays, Carol Sue. *Bringing Modernism Home: Ohio Decorative Arts 1890–1960.* Columbus Museum of Art, Ohio University Press, 2005.

Bowman, Leslie Greene, and Edgar W. Morse. *Silver in the Golden State: Images and Essays Celebrating the History and Art of Silver in California.* Oakland: Oakland Museum History Dept., 1986.

Braznell, W. Scott. "Metalsmithing and Jewelrymaking, 1900–1920." In *The Ideal Home 1900–1920: The History of Twentieth-century American Craft* by Janet Kardon. New York: H.N. Abrams in Association with the American Craft, 1993) p.55-63.

_____. "The Influence of C.R. Ashbee and His Guild of Handicraft on American Silver, Other Metalwork, and Jewelry." In: *The Substance of Style: Perspectives on the American Arts & Crafts Movement* by Bert Denker. Winterthur, DE: Henry Francis Du Pont Winterthur Museum, 1996.

Clark, Robert Judson. *The Arts & Crafts Movement in America, 1876–1916: An Exhibition Organized by the Art Museum, Princeton University and the Art Institute of Chicago.* Princeton, NJ: Princeton UP, 1972.

Colby, Joy Hakanson. *Art and a City: A History of the Detroit Society of Arts & Crafts.* Detroit: Wayne State University Press, 1956.

Darling, Sharon S., and Gail E. Farr. *Chicago Metalsmiths: An Illustrated History.* Chicago: Chicago Historical Society, 1977.

Drury, A.W. *History of the City of Dayton and Montgomery County, Ohio.* Chicago: S.J. Clarke Pub., 1909.

Elliott, Maud Howe. *Art and Handicraft in the Woman's Building of the World's Columbian Exposition.* Chicago: Rand, McNally & Co., 1894.

Evans, R. Tripp. *Grant Wood: A Life.* New York: Alfred A. Knopf, 2010

Falino, Jeannine, and Yvonne Markowitz, "Margret Craver: Foremost Among 20th Century Jewelers." In: *Women of Metal: the 49th Washington Antiques Show.* Washington, D.C.: The Thrift Shop, 2004.

Falk, Peter H. *Who Was Who in American Art: Compiled from the Original Thirty-four Volumes of American Art Annual—Who's Who in Art, Biographies of American Artists Active from 1898–1947.* Madison, CT: Sound View, 1985.

Googerty, Thomas F. *Decorative Wrought Iron Work,* Peoria, IL: The Manual Arts Press, 1937.

Hall, Lucy Duncan, Louise Kirkland Sanborn, and Dorothy Sears. *Artists in Living: Ann and Vibe Spicer.* Chicago: Ralph Fletcher Seymour, 1941.

Hawley, Henry. "Cleveland Craft Traditions." In: *Transformations in Cleveland Art 1796–1946*, by William Robinson and David Steinberg. Ohio University Press., 1996.

Heap, Jane, Florence Reynolds, and Holly A. Baggett. *Dear Tiny Heart: The Letters of Jane Heap and Florence Reynolds.* New York: New York UP, 2000.

Kahler, Bruce Robert. *Art and Life: The Arts & Crafts Movement in Chicago, 1897–1910.* Thesis (Ph.D.): Purdue University, 1986.

Kaldis, Laurie Eglington. *Portrait of an Artist: The Paintings and Jewelry of Florence Koehler, 1861–1944.* Providence: Museum, 1947.

Kaplan, Wendy. *The Art That Is Life: The Arts & Crafts Movement in America, 1875–1920.* Boston: Little, Brown, 1987.

Keane, Theodore John, and Charles Collins. *Friendly Libels.* Chicago: Cliff Dwellers, 1924.

Kelly, Caroline. *The Kalo Shop: a case study of handwrought silver in the twentieth century.* Thesis (M.A.): Cooper-Hewitt, National Design Museum and Parsons School of Design, 2006.

Kirkham, Pat. *Women Designers in the USA, 1900–2000: Diversity and Difference.* New Haven: Yale UP, 2002.

Koplos, Janet, and Bruce Metcalf. *Makers: A History of American Studio Craft.* Chapel Hill: University of North Carolina, 2010.

Kreisman, Lawrence, and Glenn Mason. *The Arts & Crafts Movement in the Pacific Northwest.* Portland, OR: Timber, 2007.

Krekel-Aalberse, Annelies. *Art Nouveau and Art Deco Silver.* New York: H.N. Abrams, 1989.

Kronquist, Emil F. *Metalcraft and Jewelry.* Peoria: Manual Arts Press, 1926.

Lambourne, Lionel. *Utopian Craftsmen: The Arts & Crafts Movement from the Cotswolds to Chicago.* Salt Lake City, Utah: Peregrine Smith, 1980.

Levy, Florence N, ed., *American Art Directory. American Federation of Arts.* New York: R.R. Bowker, 1898–1920.

Madsen, Axel. *The Marshall Fields.* New York: J. Wiley, 2002.

Marek, Don. *Grand Rapids Art Metalwork, 1902–1918.* Grand Rapids, MI: Heartwood, 1999.

Meyer, Marilee Boyd. *Inspiring Reform: Boston's Arts & Crafts Movement.* Wellesley, MA: Davis Museum and Cultural Center, Wellesley College, 1997.

Miller, Howard S. *Forging Character, Forging Iron: The Work of Thomas F. Googerty.* National Ornamental Metal Museum, 1999.

Milosch, Jane, ed. *Grant Wood's Studio: Birthplace of American Gothic.* Cedar Rapids, IA: Cedar Rapids Museum of Art, 2005.

Morgan, Anna, *My Chicago.* Chicago: Ralph Fletcher Seymour, 1918.

Olivarez, Jennifer Komar, Corine A. Wegener, and Roger G. Kennedy. *Progressive Design in the Midwest: The Purcell-Cutts House and the Prairie School Collection at the Minneapolis Institute of Arts.* Minneapolis, MN: Institute of Arts, 2000.

Payne, Arthur F. *Art Metalwork With Inexpensive Equipment.* Peoria, IL: The Manual Arts Press, 1914 and 1929.

Peattie, Elia Wilkinson and Ralph Fletcher Seymour.*Book of the Fine Arts Building.* Printed for the Building, 1911.

Pristo, L. J. Martelé: *950–1000 Fine Gorham's Nouveau Art Silver.* Phoenix, AZ: Heritage Antiques, 2002.

Robinson, William H., and David Steinberg. *Transformations in Cleveland Art, 1796–1946.* Cleveland, OH: Cleveland Museum of Art, 1996.

Schiffer, Nancy, and Janet Drucker. *Jensen Silver.* Atglen, PA: Schiffer Pub., 2008.

Schon, Marbeth. *Modernist Jewelry 1930–1960: The Wearable Art Movement.* Atglen, PA: Schiffer Pub., 2004.

Schultz, Rima Lunin, and Adele Hast. *Women Building Chicago 1790–1990: A Biographical Dictionary.* Bloomington: Indiana UP, 2001.

Schwartz, Sheila. *From Architecture to Object: Masterworks of the American Arts & Crafts Movement.* New York, NY: Hirschl & Adler Galleries, 1989.

Seymour, Ralph Fletcher. *Some Went This Way: A Forty Year Pilgrimage among Artists, Bookmen and Printers.* Chicago: R.F. Seymour, 1945.

Shifman, Barry, W. Scott Braznell, and Sharon S. Darling. *The Arts & Crafts Metalwork of Janet Payne Bowles.* Indianapolis Museum of Art in cooperation with Indiana University Press, 1993.

Social Evil in Chicago; a Study of Existing Conditions with Recommendations by the Vice Commission of Chicago: A Municipal Body Appointed by the Mayor and the City Council of the City of Chicago, and Submitted as Its Report to the Mayor and City Council of Chicago, The. Chicago: Gunthorp-Warren Printing Co, 1911.

Sorensen, H.R. and S.J. Vaughn. *Hand-Wrought Jewelry.* Bruce Publishing Co: Milwaukee, 1916.

Stone, Wilbur Macey. *Women Designers of Book Plates.* New York: Published for the Triptych by Randolph R. Beam, 1902.

Trapp, Kenneth R. *The Arts & Crafts Movement in California: Living the Good Life.* Oakland, CA: Oakland Museum, 1993.

Triggs, Oscar Lovell. *Chapters in the History of the Arts & Crafts Movement.* Chicago: The Bohemia Guild of the Industrial Art League, 1902.

Truman, Maj. Benjamin C. *History of the World's Fair.* Philadelphia: Mammoth Publishing Co., 1893, p.161.

Van Zanten David. *Sullivan's City: The Meaning of Ornament for Louis Sullivan.* New York: W.W. Norton, 2000.

Venable, Charles L. *Silver in America, 1840–1940: A Century of Splendor.* Dallas: Dallas Museum of Art, 1995.

Volpe, Tod M., and Beth Cathers. *Treasures of the American Arts & Crafts Movement, 1890–1920.* New York: H.N. Abrams, 1988.

Wascher, Arthur E., *Who's Who in Music and Art, Milwaukee.* Milwaukee: Advocate Publishing Company, 1927.

Wehde, Albert. *Since Leaving Home.* Chicago: Tremonia Publishing Co, 1923.

Wehde, Albert. *Chasing and Repoussé.* Chicago: Tremonia Publishing Co, 1924.

Weimann, Jeanne Madeline. *The Fair Women: The Story of the Women's Building, World's Columbian Exposition, Chicago 1893.* Chicago, IL: Academy Chicago, 1981.

Wendt, Lloyd and Herman Kogan. *Give the Lady What She Wants! The Story of Marshall Field & Co.* Chicago: Rand McNally & Co, 1952.

Wodiska, Julius. *A Book of Precious Stones; the Identification of Gems and Gem Minerals, and an Account of Their Scientific, Commercial, Artistic, and Historical Aspects.* New York: G.P. Putnam's Sons, 1909.

Acknowledgments

This book would not have been possible without the support and encouragement of many individuals and institutions, including artisan families, researchers, collectors, friends and colleagues, arts and crafts dealers, auction houses, museums, research institutes, universities, public libraries, county archives, historical societies, and online databases. I am especially grateful to the numerous people who opened up their homes to me and helped reconstruct the lives of their ancestors through a myriad of memories, records, photos, and artifacts.

Dan Miller edited the first draft of the manuscript and made many helpful suggestions and improvements. Co-founder of the Chicago Innovation Awards and former business editor of the *Chicago Sun-Times*, Miller was critical in moving this project forward from its inception. Also, several field trips taken with Dan, his wife Michele, and Reta Kikutani led to some exciting discoveries in the Park Ridge Artist Colony. David Scott, an expert freelance editor in the Chicago area, copy edited an early draft of the manuscript and made many helpful improvements. I am especially grateful to Kathy Krick, who served as the design and photography manager for the book. Erin Konley assisted with earlier design work.

Paul Somerson, founder of Chicagosilver.com, provided support, encouragement, advice, editorial suggestions, research, and expert photographs that were instrumental in completing this book.

Boice Lydell provided access and research support to a rare collection of artifacts, identified new crafts workers and shops, and helped expand artisan representation in several of the regional sections of the book.

Charles S. Hayes gave access to his special collections, photographic support, and an unwavering commitment to this project. Mark Szyndrowski provided access to his collection, original research, new information on artisans and artifacts, and, along with his wife Mary Klassen, was (Mark is now deceased) a wonderful supporter of this effort. Stanley Skwarek and Barb Dumke from Cobblestone Antiques provided access to order books and special collections. Aram and Rosalie Berberian, formerly of Ark Antiques, Ira Simon, John Toomey from Toomey Gallery, and John P. Walcher formerly from Leslie Hindman Auctioneers and now with Toomey Gallery, were very helpful in research and in identifying artifacts. Fred Zweig, a noted metalsmith, identified new artisans, and provided photographs and research support that were invaluable.

Special thanks for their assistance goes to Jane Milosch, director, Provenance Research Initiative, Smithsonian Institution, and formerly curator of the Cedar Rapids Museum of Art and Brandy Culp, former Andrew W. Mellon Curatorial Fellow in the Department of American Art at the Art Institute of Chicago. I also wish to thank Tony Jahn, former archivist for Marshall Field & Co., and the phenomenal curatorial staff of the Chicago History Museum.

Special thanks are owed to the Andersen family; the late Bjarne B. Andersen, Jr.; Judy Atwood and her children Jessica, Jeff, and Andrew; the Axness family; the Beye family; the late James Bornhoeft; the Bower family; Craig Bowley, Inc., Julia Brannon; the Breese family; Laverne and the late Mervyn Bridges; the Brooks family; the late Irving and Shyrel Citron; Amanda DeSilver; Richard DeSilver; the Didrich family; Mary Fyfe Engelbrecht; the late William Frederick; the Friedman family; James and Barbara Fyfe; Julian "Jay" Hawes; Stanley and the late Katherine Hess; Augustus Higginson, Jr.; the Kahn family; Reta Kikutani; the Lebolt family; Michael Marienthal; Jean and Ed McCabe; Meredith Wise Mends and Michael Levitin; the Meyer family; Vivian Møller of Denmark; the Mulholland family; the late Bernice Ocken; Burton Olsson, Russell and Mary Baber Olsson, and the late Daniel Olsson; Joseph O'Neil; David and Sharon Petterson; Arden Phair; Holly and Stephen H. Randahl; the late Margarette Randahl; the Reade family; the Sorensen family; the Stein family; Jane and Page Thompson; the Ullman family; John David van Dooren, Rector of the Episcopal Church of the Atonement; William Voss; Mary Schimpff Webb; the Wehde family; Sharon Marston Wise; Kerri Whitaker; and Michael Wright.

Additional friends and colleagues who supported this effort included David Hiller, Pat McCann, Lorraine Miller, Laura Utrata and many others. Special thanks to the Kalo Foundation of Park Ridge and its founder Betsy Foxwell, as well as members of the board of directors. A tour of Crabtree Farm, an extensive private collection of arts and crafts buildings and artifacts, was helpful in putting the British and Chicago movements into context.

The Chicago Historical Society provided access to records from Sharon Darling's seminal work, *Chicago Metal-Smiths* and additional archives and records housed in their Research Library. Collections and research assistance from the Marshal Field & Co Archives; Ryerson and Burnham Libraries at the Art Institute of Chicago; the Newberry Library; the Chicago Public Library; the University of Illinois at Chicago Richard J. Daley Library; the University of Chicago Regenstein Library; Northwestern University Special Collections; the Evanston History Center; the Des Plaines Historical Society; the Cedar Rapids Museum of Art; the Cedar Rapids Public Library; and the Smithsonian Institution were instrumental in the completion of this book. Other important institutional resources included the Cook County Court Archives; Illinois Institute of Technology; Spertus Institute; St. Augustine College; University of Wisconsin at Madison; the Milwaukee Public Library; the Minneapolis Institute of Art; Iowa State University Library; West Virginia University; Clarksburg-Harrison Public Library; the Dayton Public Library; the University of Michigan Libraries; and the Grand Rapids Public Library. In addition, Ancestry.com, America's Historical Newspapers, *Chicago Tribune* archives, ChroniclingAmerica.com, Fold3.com, Gale NewsVault, GenealogyBank.com, GoogleBooks, Los Angeles Times archives and Proquest Historical Newspapers were particularly helpful.

Photography

Photographs were scanned from books published prior to 1924. Professional photographs were provided by the author; Chicagosilver.com; Boice Lydell; Stanley Skwarek; Rich Wood Photo of Ann Arbor, Michigan; Scott Bourdon Studios of South Bend, Indiana; Rudolph Henninger of Phoenix, Arizona; the late Bruce Brewer of Tallahassee, Florida; Frank Blau Photography; and Fred Zweig of Tucson, Arizona. Use of photographs provided by the Art Institute of Chicago, Cedar Rapids Museum of Art, the Cleveland Museum of Art, Evanston History Center, John Toomey Gallery, Leslie Hindman Auctioneers, Skinner, Inc., Douglas Rosen Decorative Arts, and Rago Arts and Auction Center are noted in the item captions.

Index